VISUAL ART

A Critical Introduction

James M. Carpenter
COLBY COLLEGE

Harcourt Brace Jovanovich, Inc.
New York San Diego Chicago San Francisco Atlanta London Sydney Toronto

Copyright © 1982 by Harcourt Brace Jovanovich, Inc.

ISBN: 0−15−594935−7
Library of Congress Catalog Card Number: 81−85551

Printed in the United States of America

To my wife, Dorothy

Preface

This book is intended for young people and any others who are attracted to works of art but are not sure what to look for or how to talk about what they find in them. Though its argument is in good part analytical, the aim is to enhance the enjoyment of art. For in a marvelous way that no one has ever explained, the emotional or aesthetic values in art can be greatly heightened by the kind of understanding that this approach to a work of art can achieve.

After a chapter of general introduction, the analytical approach begins with a study of visual organization, both abstract and representational. The next several chapters of Parts One and Two propose general concepts and a basic vocabulary for the visual analysis of works of art without regard for their historical settings, inviting readers to use their eyes before becoming concerned with chronology. The works shown are from different times and places and are done in many different mediums, yet they are linked by a recurrence of similar principles of visual organization that demonstrates that responsiveness to visual order is a universal human trait.

One of the decisions that had to be made was whether to include a discussion of the materials and techniques of art in the text itself. It seemed inappropriate to interrupt the systematic study of perception with such information, important though it is, and so descriptions of the major techniques have been placed in the Glossary.

Analysis is further developed in Part Three, "The Expressiveness of Art." Some points raised in the introductory chapter are examined in closer detail with the help of comparisons: how artists manage to breathe life into art, the variety of ways they interpret the world, and what their art means to different people in different times and places—including our own. This last point is developed further in Part Four, an overview of the history of Western art. As this story is told, many of the works analyzed earlier are reintroduced—this time in their historical context.

In addition to providing a basis for understanding and a guide for what to look for in works of art, I have tried to encourage the development of a critical attitude. Criticism, after all, is not something to be practiced only by critics; we

all engage in it whenever we try to articulate our ideas about things (as opposed to our opinions). Along the way I hope that readers will find themselves moved to ask such questions as what value art has for individuals and societies, and why one work of art seems more successful than another that resembles it. Ultimately, I believe that the most valuable thing this book can do is to encourage its readers to make decisions about quality in works of art and to put their new knowledge to use in expressing their own responses—for without the feelings of individuals there would be no such thing as art.

It was my good fortune to have studied in the Department of Fine Arts at Harvard when Arthur Pope was teaching there, and this book owes more to his ideas and perceptiveness than to any other source. While most of his ideas about design were not published, he recorded his major thoughts about color and about representation in art in *The Language of Drawing and Painting*. Chapters Two through Six in the present book derive much of their content from Pope's teaching, though my own teaching experience at Colby College has resulted in various modifications of some of his terms and concepts. As with all teachers, my own development owes a great deal to my students, for learning is one of the notable benefits of teaching. At Harvard I also worked with Jakob Rosenberg, the author of *On Quality in Art*, whose ideas come into parts of

Chapter Seven but whose influence is much deeper than that. So many books, teachers, students, and friends have shaped my knowledge of art history that it would be impossible to acknowledge all of them, but I would like to express my special thanks to those individuals who directly assisted me in the preparation of this book. Samuel P. Cowardin of Clark University and Carl N. Schmalz of Amherst College read portions of it and made valuable comments. William B. Miller read all of the manuscript, and many of his suggestions have been accepted. Germaine L. Fuller helped me greatly with Chapter Ten, and Stephen Carpenter prepared the Glossary. Dorothy Glendinning and Margaret Wickes did much of the typing. I am also grateful to Colby College for the travel grants that made it possible for me to see the originals of many of the works in this book.

Many people in the College Department of Harcourt Brace Jovanovich made valuable contributions to the creation of this book. William Dyckes and Susan Joseph helped shape the text, and Robert Karpen, Arlene Kosarin, and Barbara Salz were responsible for its physical form. Nina Gunzenhauser encouraged me greatly in the early stages of the project, and Albert Richards kept up my morale in the later ones. It has been a pleasure working with all of them.

James M. Carpenter

Contents

VISUAL ART

A Critical Introduction

1
Introduction

A work of art is a kind of idea—but one that is expressed in visual terms rather than in words. The verbal expression of an idea requires finding a combination of words, phrases, sentences, and other elements of writing or speech that will communicate a thought. The visual expression of an idea requires just as demanding a search for the most effective elements of communication, but the artist works with colors, lines, masses, and other visual elements. In this book the aim will be to gain an understanding of art by studying how visual elements are combined and how images are created so that they effectively communicate ideas in the works we will study.

Subject Matter and Its Interpretation

Let us begin the search for understanding by looking at a painting done in Italy in the 1440's, Domenico Veneziano's *The Annunciation* (Fig. 1-1). In it, the angel Gabriel, God's messenger, is telling the Virgin Mary that she is the pure woman chosen to bear the child who will become the Saviour. It is a key event in the New Testament. The story of the Annunciation is not, however, the idea that Domenico expressed. It is the *subject matter*—what the picture is about. And while subject matter is interesting and important in its own right, what is more important for us to understand is the *interpretation*—what the artist had to say about the subject matter and the way in which it was said.

The first thing we notice about Domenico's version of the Annunciation is its simplicity. The setting is spare and the two characters reveal little emotion. Except for the halos and the angel's wings there is nothing supernatural, nor is there any dramatic action connected with the arrival of the angel. And yet, even in this small black-and-white reproduction we can sense a certain calm, order, and mystery—a definite feeling that something holy is taking place.

To discover how Domenico arrived at this effect we will have to take a closer look at the painting. We can begin by describing what we see: an enclosed courtyard placed before us like a stage, the long wall and the horizontal lines in the

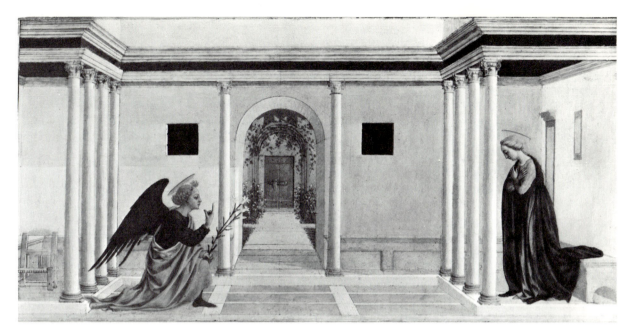

1-1 Domenico Veneziano, *The Annunciation, c.* 1445. Tempera on panel, 10½″ × 21¼″. Fitzwilliam Museum, Cambridge, England.

pavement parallel to the front of the picture and the columns and receding lines arranged to appear at right angles to that, moving directly away from us, the viewers. The walls are almost blank, the windows black squares, and the columns smooth and simple. We look through the archway into a walled garden with a closed gate and an arbor with flowers. Mary and Gabriel are nearly as simple, a pair of solid-looking forms who seem motionless. Mary apparently has just risen from a bench on which part of her robe still rests, and her bowed head and folded arms suggest that she has recognized the divine nature of her visitor and may have even heard his words.

The simplicity and restraint we find in the painting are important to Domenico's interpretation. Most other artists of his time introduced more action—some showed Mary turning away from a book, or expressing fear or surprise, while Gabriel might be shown landing with fluttering wings and stirring drapery. (An *Annunciation* painted some 150 years later indicates the dramatic intensity some artists have brought to this subject—see Figure 13-21.) None of these signs of emotion or drama are found here, though some of the traditional symbolism connected with the

subject is present. The lilies carried by the angel and the closed door of the garden would have been understood by people of the time as symbolic of the purity of the Virgin. But other symbols are left out, such as the dove of the Holy Spirit or the apparition of God, which were often present, along with an indication of a supernatural light. Domenico selected very carefully what to include in order to arrive at his quiet and simple interpretation.

Form

The term *order* was mentioned in summarizing our first impressions of the painting. To discover more about this we must explore further the purely visual aspect of the picture without reference to the subject matter. This visual aspect of a work of art is called its *form,* a term that refers in particular to the ordering of the visual elements. As this book develops, many of the components of artistic form will be studied; the major distinction to be made now is between *abstract organization* and *representational organization.*

Abstract organization is concerned with the

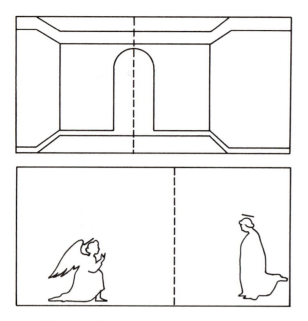

1-2 Balance in *The Annunciation*.

arrangement of the colors, lines, masses, and so on that are the vocabulary of visual expression. It begins with the overall shape of the work of art—in this case a rectangle. Domenico began with a rectangle twice as wide as it is high, and if he had chosen the most obvious arrangement he would have placed the doorway directly in the center and the figures at equal distances from it. Instead, he chose to place the arch and the garden gate off-center to the left and compensated for the imbalance by placing the two figures off-center an equal distance to the right. The two diagrams in Figure 1-2 indicate these different axes of balance, which fall on either side of the central axis of the painting as a whole. The equilibrium resulting from the resolution of the two opposing centers is the most important part of the painting's abstract organization. It allowed the artist to use such obvious symmetry as the two square windows either side of the doorway without having a too-obvious total effect.

Domenico's representational organization was just as admirably conceived and his choice of elements just as selective. His consistent use of perspective makes the space of the courtyard and the garden apparently capable of holding the figures and the architecture. The figures, like the columns, seem convincingly round because they

are lighted from one side. The artist's selectivity is evident here because there is no obvious source of light from the right. Such a source would have cast a shadow from the right wall onto the Virgin. There are, in fact, no shadows cast by the figures or columns either; clearly Domenico was not interested in every aspect of light but only in the way it produces a sense of solidity in the figures and objects, as we can see in a detail of the angel (Fig. 1-3). Yet he did want to create the impression of a gentle sunlight entering the courtyard, so he allowed one shadow to fall on the wall behind the angel and on the ground beneath the archway. With such freedom from visual actuality no wonder the scene looks somewhat removed from the everyday world.

To get a broader view of the kinds of things that can be expressed in the visual arts let us examine another picture in a similar way. *Before the Race* (Fig. 1-4), painted more than four hundred years later by the French artist Edgar Degas, presents a very different kind of subject matter and does it in a very different way. No story is involved, just the depiction of the race horses and their riders assembling before the start of a race. Compared to the static poses and careful placing of the figures in *The Annunciation*, this

1-3 Detail of *The Annunciation*.

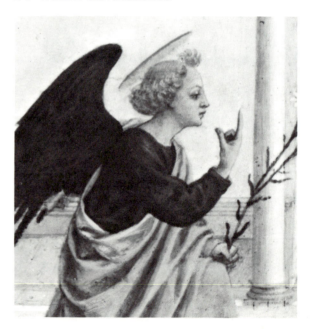

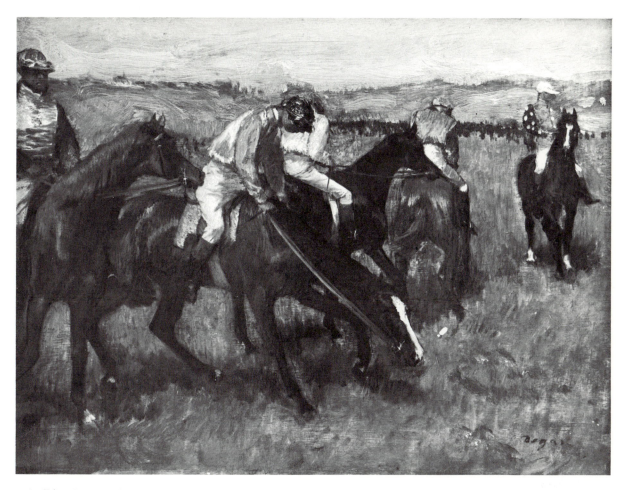

1-4 Edgar Degas, *Before the Race,* c. 1882. Oil on panel, 10½" × 13¾". Sterling and Francine Clark Art Institute, Williamstown, Massachusetts.

scene is extremely informal. Part of one horse and rider is cut off at the left and the horses are massed on one side and heading in different directions. The two jockeys at the center overlap in an accidental way as if the scene were going to change in the next second. If this were a photograph we would call it a snapshot.

Degas' interpretation of this subject is as selective in its way as Domenico's. Everything here speaks of energy and movement: the twisting of the horse at the left, the tensed neck of the center horse, and the springiness of the rear legs of the one that is moving away from us—an effect heightened by its swishing tail. And though it resembles a snapshot, one could spend a lot of time around racetracks and probably never take a

photograph that captures the nervous energy of the horses as well as this painting does. This is partly due to the fact that Degas made hundreds of drawings of horses and jockeys, observing their movements, shapes, and textures, as well as the remarkable physical union between horse and rider that was of particular interest to him.

Abstractly, this painting is much less obvious in its organization than *The Annunciation.* The key to the abstract organization here is the overall diagonal, designed to lead the eye across and into the space of the picture. All five horses are brought together by conforming to a shape that follows this diagonal. Smaller diagonals, formed by the horses' legs, necks, and reins, and the bodies of the jockeys, keep the movement going

within this somewhat unifying shape.

We tend to "read" this picture from the left, beginning with the cut-off horse and rider and following the arch of the neck toward the center. The overlapping pair of horses and colorful jockeys hold our interest in the center for a longer period of time, partly because of the many alternative routes their bodies offer. Movement continues to the right and back into depth until it is stopped by the horse at the far right, who returns our attention to the foreground.

Degas' representation of light is far more realistic than Domenico's. The somewhat diffused

1-5 Detail of *Before the Race.*

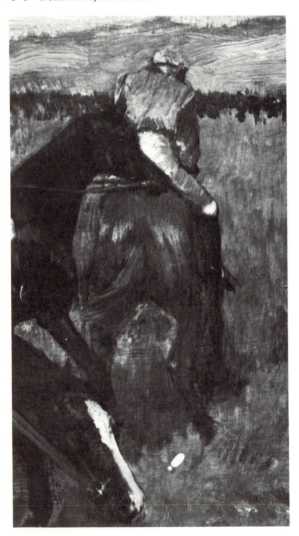

sunlight casts shadows on the ground as well as producing the reflections on the sleek coats of the horses and the colorful silk shirts of the jockeys. His brushwork is much bolder; instead of describing details its quick application eliminates many, but contributes to the expression of movement (Fig. 1-5). Such effects as the rippling of the shirt and the sheen on the horse's rump are momentary and could not be convincingly rendered by the painstaking application of paint found in *The Annunciation,* which encourages us to linger over every detail.

Each of these paintings is "all of a piece"—that is, it is organized both abstractly and representationally to produce the convincing interpretation of its subject that we find in it. For this reason it is a successfully realized visual idea.

Material and Technique

Like all works of art these paintings are material objects, and we must consider their physical nature as well as their images and their formal characteristics. Both are painted on wooden panels with *pigments* (color in powdered form) mixed with a *binder* (to fix them to the surface). *The Annunciation* was painted using a *tempera* technique; that is, the binding medium was egg yolk mixed with water, the most common technique in Italy during the fifteenth century. Tempera paint dries quickly and cannot be changed once it has been put down. It is best applied with strokes of a pointed brush and lends itself to making lines, as we can see in the angel's face and the sharp edges of the architecture. For large areas like the walls, paint is applied layer upon layer so that the individual strokes disappear. When modeling is necessary, as in the angel's face and neck, the smooth gradations are produced by the blending of light, medium, and dark strokes. The linear basis of this technique is visible when we look closely at the angel's hair or at the transitions in the modeling of the columns. Everything about the painstaking method of painting in tempera lends itself perfectly to the kind of picture that Domenico painted.

Before the Race was painted in an oil technique, which means that the pigments were mixed with

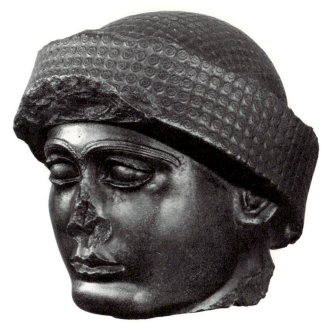

1-6 *Head of Gudea,* Lagash, *c.* 2100 B.C. Diorite, 9″ high. Museum of Fine Arts, Boston (Francis Bartlett Donation).

an oil that dries slowly so that the paint can be worked with the brush. In the hillside behind the jockey in the detail shown we can see how the paint partially blends as one stroke is laid beside or on top of another while it is still wet. Because these are bolder strokes, fewer are needed in the painting as a whole than in *The Annunciation.* We note that the paint has more texture, a result of the fact that oil has more body than egg yolk and holds a larger proportion of the pigment as well as retaining some lines from the hairs of the brush. These characteristics of direct oil painting enabled Degas to apply his paint with boldness and spontaneity so that his technique reflects the energy we saw in other aspects of the work.

Pictures have been painted on walls and in books, their pigments mixed with wax, glue, acrylic, and other binders. Sometimes their surfaces are colored and given texture by objects pasted on them as well as by pigments. There is also a great variety of techniques used to make *prints,* multiple copies of a picture printed with a metal plate, wooden block, porous stone, stencil, or other object. In all these techniques the materials and how they are worked determine to some degree how a picture will look—as we have seen in these two paintings.

A vast range of materials has been used in the making of sculpture, and because of its three-dimensional nature the material affects the form of the final product in an even more basic way. This can be seen by comparing a work in stone with one in metal. A portrait head of Gudea (Fig. 1-6), a Mesopotamian ruler of the third millennium B.C., was carved from a stone called diorite, and the artist apparently responded to this very hard stone almost as a jeweler would (the head is smaller than life-size). It was worked into rounded forms, pattern was introduced into the hair and eyebrows, and the edges of eyes and mouth were made precise and sharp. The big circle of hair surrounds the skull, emphasizing the full rotundity of the head, and the curves of forehead, cheek, and chin are almost geometric in their simplicity. Yet their geometry is relieved by the definite suggestion of bone structure beneath the surface. The curves of eyes and eyebrows are very regular and the small spirals in the hair are exactly repeated. The polishing of the surface, which did not entirely smooth the slightly granular texture, adds another quality of stone to the finished work. In this sculpture we cannot separate the material and workmanship from the purely visual, or formal, aspect of the work.

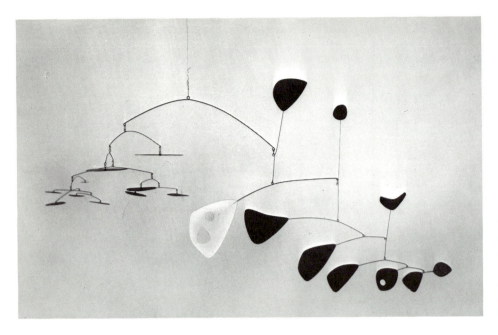

1-7 Alexander Calder, *Zarabanda*, 1955. Mobile (painted sheet metal, metal rods, and wire), 33″ × 89½″ × 21½″. Hirshhorn Museum and Sculpture Garden, Washington, D.C.

We can say the same about Alexander Calder's *Zarabanda* (Fig. 1-7). This work is different from the others we have seen because it has no subject matter and represents nothing—it is abstract art. Calder called such works *mobiles* because everything in them is able to move. The two sections of the sculpture—one with vertical fins, the other horizontal—are of nearly equal weight even though one side appears larger. They are balanced to allow a dipping motion, one side rising as the other falls, and to permit the entire work to wheel around the point at which it is suspended. These movements are passed on to the various parts, which are hung in ways that allow them a degree of independent motion. A breeze or any other force can set the mobile going. The equilibrium of the whole, whether in motion or not, is part of the form of the work, along with the purely visual lines, colors, and shapes. Calder has invented shapes which themselves have "fluid" outlines. Their free-form curves seem echoes of the curving movement of the parts and of the unexpected aberrations in this movement. We enjoy these playful forms in motion because we understand the forces that enter into them: the equilibrium of all the parts, the delicacy, yet strength, of the wire and thin metal, and the interdependence of all the movements. The visual idea grows directly out of the properties of the materials and the techniques used to put them together.

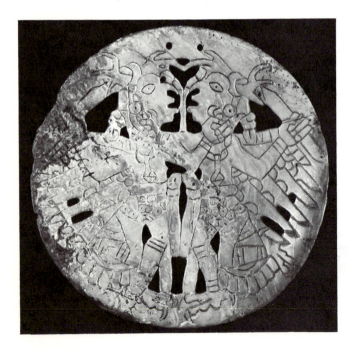

1-8 Engraved shell gorget, Native American, Dallas culture, Tennessee, c. A.D. 1200-1600. Diameter, 4½″. Frank H. McClung Museum, University of Tennessee, Knoxville.

Tension

A study of visual organization gets us closer to works of art but it does not reveal all the mysteries of art. In fact, nothing we can say in words about works of art ever comes close to the actual experience of them, which cannot be translated from a visual into a verbal language. A book can merely point the way toward more complete understanding and more complete enjoyment.

One of the aspects of art that the concept of organization does not seem to explain is an apparent conflict existing within the work of art itself. Consider a work done several centuries ago by an American Indian (Fig. 1-8). It is a gorget, a neck or chest decoration made from a shell and incised with images of two dancers wearing the wings and feet of eagles and antlers on their heads. Objects are held in their hands and the inside arm of each overlaps the other figure. Their mouths are open, as if they were singing or chanting as they dance. As we try to make out the rather confused overlapping of the figures we find ourselves suppressing a strong urge to see the object simply as a circle with abstract patterns of lines and spaces. It is virtually impossible to see the abstract pattern and the image of the men simultaneously. What we experience instead is a *tension* between them. The pattern belongs more to the object because it has been achieved by cutting through the shell, while the image is more dependent on the fragile network of lines.

Tensions of some sort are always found in works of art—what we noticed about the balance of the figures and the setting in *The Annunciation* is a kind of tension, a pull toward the left being countered by a pull to the right—but in some works tension is more pronounced than others, as we shall find in a later chapter that concentrates on this topic. It is particularly felt in works that have a strong object-character.

Nude with a Guitar (Fig. 1-9) by Jacques Lipchitz can also be seen as an image and as an object. Although there are no features or even hands and feet, we can recognize this as a reclining figure, with the head supported by an arm.

1-9 Jacques Lipchitz, *Reclining Nude with Guitar*, 1928. Black limestone, 16⅜″ high. Promised gift and extended loan to The Museum of Modern Art, New York, from Mrs. John D. Rockefeller, 3rd.

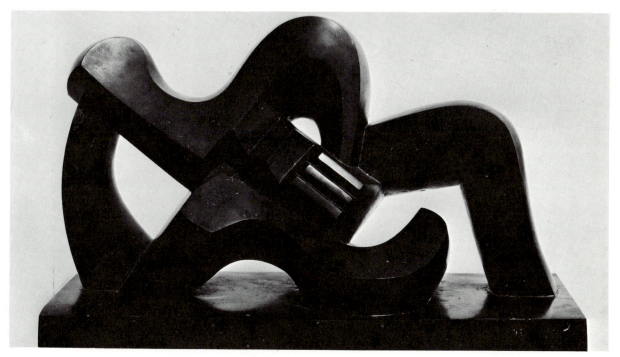

When we see it as a figure, we can perceive the joints and limbs, and even feel the weight of the head against the arched forearm. At another moment, however, we may be more aware of the sculpture as an object of hard polished stone—one solid piece, base and all. The degree to which the artist has abstracted the forms—that is, turned the natural shape of an arm or leg into one that is angular or curved—increases the likelihood of our seeing the work as shaped stone.

To some extent all works of art are objects. Even the two paintings we have considered are ultimately flat surfaces covered with paint, but the illusion they create of figures in space is so strong that the object-character is secondary. With the Lipchitz, the fact that there are so few details and that we can look at the sculpture from every side and receive many different impres-

sions of its shape makes the object-character more pronounced. Yet the figure-character never entirely disappears, and this pull in opposite directions—toward different interpretations—is the most important tension in the work.

Purpose

All works of art have a purpose. In some cases the purpose is fairly specific, as it would be with a stone portrait of a king or a painting of an important event, and in some cases it is not so specific, as with an abstract sculpture. The purpose of a work of art usually has an effect on its form. The flat shape and the holes at the top of the gorget were, for instance, determined by the fact that it was made to be hung from the neck and displayed

1-10 Frank Lloyd Wright, *Fallingwater*, Mill Run, Pennsylvania, 1936–39.

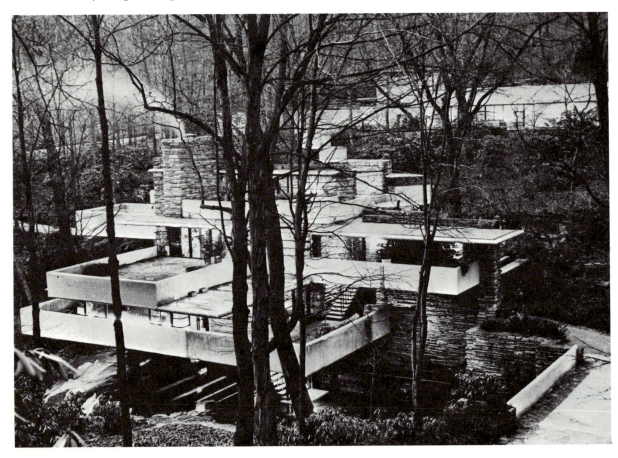

on the chest. The effects of an object's purpose on its form can be seen in virtually any everyday object: pots for wine or water, textiles for clothing, and furniture. The effects of purpose are particularly visible in buildings, for form in architecture is largely determined by purpose; office buildings tend to be tall and composed of similar units, government buildings try to appear impressive, artists' studios are arranged to admit the even light from the north.

Private homes, by and large, are simply designed to fit a standard lot and provide certain utilities and spaces. Frank Lloyd Wright's Kaufmann House (Fig. 1-10), now known as *Fallingwater*, went far beyond these minimal requirements for a house. It was built in the woods above a waterfall and its purpose was to serve as a home away from the city, where a family could live in a casual manner. Its form fulfills the purpose extremely well. As the diagram shows (Fig. 1-11), one side is set close to a rocky background and the main floor is chiefly given over to a large living room. The walls nearest the stream are mostly glass. The living room leads to a large terrace that hangs over the waterfall, and from it a stairway is suspended over the pool behind the falls. On the second level a large terrace thrusts out at right angles to the lower one from the main bedroom, and the two other bedrooms have smaller terraces. The third floor has a suite with yet another terrace. The way in which the house relates to its surroundings reflects a love of outdoor living. The waterfall can always be heard and the pool is easily accessible. With large windows and glass doors connecting the interior and exterior, one is always conscious of the dramatic natural setting.

While the core of the house was built with roughly hewn local rock that relates it to the surroundings, the huge slabs of the terraces were constructed out of steel beams and reinforced concrete—two modern materials that provide the extra strength needed for the dramatic leap into space that makes this house one of the most exciting ever built. Wright himself described it as "the first house in my experience to be built of reinforced concrete—so the form took the grammar of that type of construction." Because the size and shape of the terraces both blend and contrast with the natural surroundings, and be-

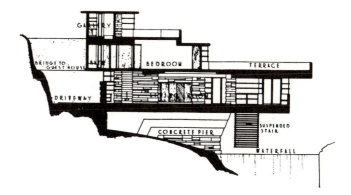

1-11 Cross-section of *Fallingwater*.

cause the line between indoors and out is so difficult to define, we have the conflicting impression of a house made of native materials and nestled into the woods and one that boldly brings modern technology into the wilderness.

One reason that we study art history is to discover specific purposes for which works of art were made as a means to a better understanding of them. Until the modern period most paintings, for instance, were ordered by a patron from an artist for a particular place and of a certain size. Domenico Veneziano produced his *Annunciation* under such circumstances, as we shall learn in a later chapter. The underlying purpose of any art is to satisfy a need in human beings; the order in art partly satisfies the search for order in life, and the excitement that art's tensions and its sensuous materials can create provides stimulation that is an essential part of life. We need only to train our eyes and our minds to be sensitive to them.

The aim of this chapter has been to provide some common grounds of inquiry within the immensely diverse field of the visual arts. In examples of painting, sculpture, decorative art, and architecture from four thousand years of history we have seen that we need to understand the *relationships* among different aspects of each work in order to get closer to it. The interpretation of subject matter is inseparably related to its form. Form, in turn, is partly determined by the materials and by the techniques. This formal aspect of art is enlivened by tensions within the work. And finally, all of these are, to a greater or lesser degree, affected by the purpose for which the work was made.

PART ONE

ABSTRACT ORGANIZATION

Whether a work of art is primarily an image, an object, or a useful structure, it possesses a visible form. The first two parts of this book are mainly concerned with form, and a fuller sense of the meaning of this term, if not a full definition of it, will emerge as we proceed. The third part of the book examines expression, or meaning, in art. At many points it will be evident that it is not possible to consider the formal and the expressive separately, simply because a work of art is an entity and our aesthetic experience of it is a *total* response. Only by assuming an analytical attitude can we break a work of art down into parts—as was done when separating image from object in the Indian gorget and the Lipchitz sculpture. The only way to resolve these different perceptions, we saw, is to return to the whole, with all its tensions. But we return with greater understanding.

The reason for moving through formal analysis into expression is that form lends itself to understanding more than expression does; it is less variable with the individual perceiver. A terminology descriptive of the formal aspects of art can therefore be rather closely agreed on, while terms that evoke meanings are bound to be less specific in their connotations.

Chapters Two, Three, and Four deal with visual organization in abstract (that is, nonrepresentational) elements such as line, shape, volume, and color. Chapter Two begins with a study of *decoration*, the term for the visual enrichment of an object that already possesses a form of its own—a pot or a wall, for example. Chapter Three is about *composition*, which is organization that involves the total creation of the object's form. Chapter Four deals with organization in color.

2
Principles
of
Design

Design is the creation of visual order, and it is a basic concern of all artists and designers. It will also be our basic concern in the next few chapters because by studying closely how the principles of design work we will have begun to link seeing with understanding.

Works of art are amazingly rich in visual relationships but their complexity is based, ultimately, on a few simple abstract elements. The most basic of these are shape, size, interval, and direction. (And color, which will be examined in a separate chapter.) *Shape* refers to the general outline of an area or a thing, although the terms *mass* or *volume* are sometimes used when speaking of three-dimensional shapes. *Form* is also occasionally used for three-dimensional shapes, though one must be careful not to confuse it with the broader use of the term in Chapter One. *Size* and *direction* have the same meanings as in everyday language, and *interval* refers to the space between things, again its common usage.

Most abstract visual organization is achieved by applying to these abstract elements four principles of design: uniformity, sequence, grouping, and balance.

Uniformity

The simplest approach to visual order is to make everything the same. This is the basis of the principle of *uniformity*, and it can be illustrated most easily with a diagram. Figure 2-1 shows how three simple geometric figures can be given order by uniformity.

For an example of uniformities in a work of art, we can examine an Islamic prayer niche, or *mihrab* (Fig. 2-2). It is basically a flat wooden panel opening into a curved niche, and the surfaces are decorated with patterns which emphasize the flatness of the wall and the curve of the niche. The patterns are based on a system of cross-cutting of lines that produces the basic shapes as well as the all-over character of the design, which continues indefinitely until it reaches the frame (Fig. 2-3).

The shapes thus produced are called *motifs* and are analogous to the repeated themes of the same name in music. They are simple enough to be

2-1 The Principle of Uniformity. Uniformities of shape (a), size (b), interval and size (c), direction (d), and shape, size, interval, and direction (e).

readily perceived as units and distinctive enough to be readily recognized when they recur. Most decorative design is based on a repetition of motifs—which in this case involves a combination of shape uniformity and uniformity of interval. The artist of the mihrab would have achieved more complete orderliness if the two closely related motifs of the six-pointed star and the hexagon that occur in the center above the arch had been continued indefinitely. There would have been greater uniformity in the shapes and in the directions of the lines. Instead, numerous variations were introduced. By breaking away from the dominant 60- and 120-degree angles to a 90-degree angle, new directions, including verticals, were introduced and several new shapes were created.

By introducing these variations the artist opted for less order and more diversity. We can conclude from this that design is more than a simple process of ordering. Complete order can result in complete monotony. Disorder or diversity can provide the vital spark that stimulates the observer, but it also adds to the danger that a work of art will become chaotic, and therefore no longer capable of being perceived as an entity. The designer or artist always walks this tightrope between organization and diversity, order and chaos.

2-2 Portable wooden mihrab from the Masshad of Sayyida Ruqayya, A.D. 1154-60. Museum of Islamic Art, Cairo.

2-3 Motifs in the mihrab.

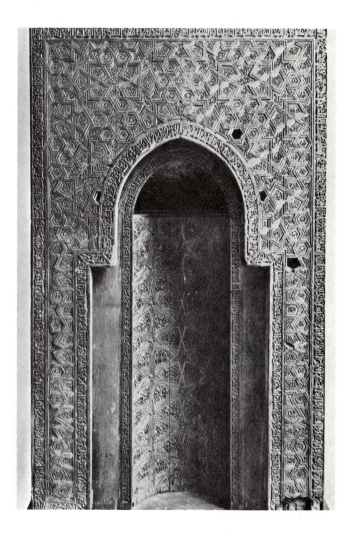

The introduction of greater diversity does not necessarily increase the disorder; it may add a new type of order. Here, for instance, the several new shapes created by the variations mentioned are repeated: two of these are the rectangles on the flat wall and the large circles which intersect each other within the niche. The overall design has been enriched by the number of ordered relationships and chaos has been avoided.

An Italian textile of the fourteenth century (Fig. 2-4) is similar in that it is an all-over pattern, but instead of being completely abstract its motifs derive from nature. One could identify two types of motifs here, the larger ones of the rams, pelicans, and flowers themselves, and the many smaller ones made up of such distinctive details as the pelicans' crests, the rams' horns, or the starlike flowers. As we scan its surface our attention constantly shifts in an unpredictable way

2-4 Italian dalmatic (detail), fourteenth century A.D. Silk with gold threads; height of repeat, 10½″. Victoria and Albert Museum, London.

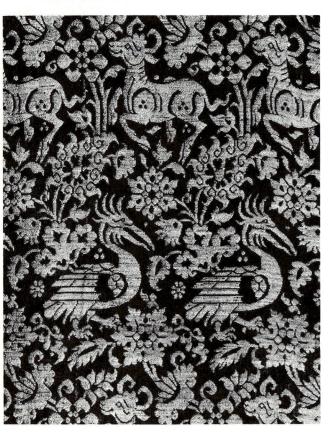

from one to another of these motifs, but when it centers on one it tends also to pick up the repetition nearby. All are filled with a liveliness that comes from the many tight curves and sharp points as well as the absence of any quiet resting place for our vision.

These are shape uniformities that we have been noting; of equal importance is the general uniformity of interval. Nothing overlaps and nothing is allowed to get too far from its neighbor. And even though the interval uniformity resulting from these choices is not mathematically precise, it is definitely felt to be constant—the term *general uniformity* seems to express what we see. To keep a sense of the same treatment in the animals and birds, the lights are also cut into by darks, notably by the patterns introduced into their bodies. Occasionally the same motif is found in both light and dark, for instance the three dots on the rams, repeated between their back legs, and found again behind the pelicans' necks. Finally, there are uniformities of direction in the upright plants, the rightward movement of the birds, and the leftward movement of the rams.

To fully appreciate decorative art of this sort we should remind ourselves that textiles were made to be used—as coverings for tables or altars or as garments; this one was made into a vestment for a priest or bishop. When used in this manner it would fall into folds that would complicate the pattern and vary the light and shadow falling on it, thus enriching the effect of its colored silk and bits of gold thread.

If we move from examples of decorative art to a painting such as Georges Braque's *The Portuguese* (Fig. 2-5) we realize that we are responding to similar stimuli. Here nothing is as predictable as it was in the other works, especially the interval relationships, but we find repeated motifs like the arcs and near-circles, and repeated directions like the verticals and some dominant diagonals. Shape uniformities occur in the right angles, the obtuse, and the occasional acute angles, and are echoed in the letters *BAL* at the top. There is more diversity because of the suggestion of a represented figure and the illusion of overlapping planes, but the abstract visual order is clearly important.

Sequence

Order can also be introduced when the elements of a work are arranged in some sort of progression. Rather than having the order diffused throughout a visual field, as is the case with uniformities, this order is perceived in a series of changes. Such organization is known as *sequence,* and there are three types that can be identified.

The simplest sequence is *continuity,* a directional pull that, like a thread, links portions of a visual field. In the painting by Braque there are several lines that are broken and then continued, particularly the two steep diagonals from the lower corners to the upper center. Such continuities are perceived as connecting elements in the design.

In one recent work of environmental sculpture, the form is primarily determined by a continuity. This is *Running Fence* (Fig. 2-6) by Christo, a Bulgarian-born artist who, with the help of many assistants and the cooperation of the landowners, erected a white nylon curtain in the hills north of San Francisco in 1976. It was thoroughly photographed during the two weeks that it was there, and the photographs remain as the record of what must be the longest continuity in art, done for its own sake and not, as in the case of the

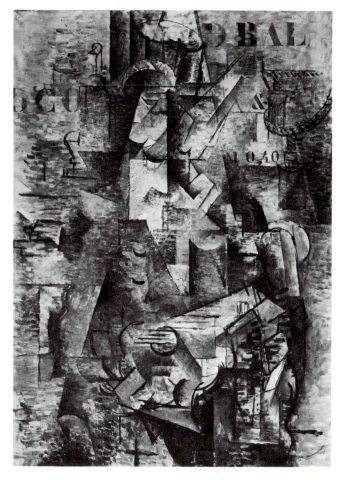

2-5 Georges Braque, *The Portuguese,* 1911. Oil on canvas, 45⅛″ × 32⅛″. Kunstmuseum, Basel.

2-6 Christo, *Running Fence,* 1972-76. Nylon, steel, cables, and hooks, 18′ high, 24 miles long. Marin and Sonoma counties, California. Dismantled after two weeks.

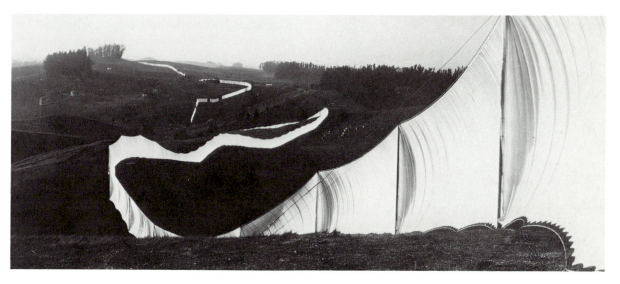

Great Wall of China, for other purposes. The thin white line (as it appeared from the air) was nearly twenty-five miles long, the west end of it tapering into the Pacific. Seen up close it was an eighteen-foot high sheet, billowing in the wind and, as it followed its meandering course, tracing the contours of the land. Its compelling continuity was given variety by different colors and shapes produced by sun and wind.

An example of early Greek art, a vase painting of a footrace (Fig. 2-7), illustrates a second type of sequence. *Gradation* is regular change, and it too can be felt in all of the abstract elements. Here we feel it especially in the intervals. Beginning on the left we find a fairly large interval between the first two runners, but this is followed by a regular gradation of intervals between

2-7 Amphora, Greece, sixth century B.C. Terracotta, 24½" high. The Metropolitan Museum, New York (Rogers Fund, 1914).

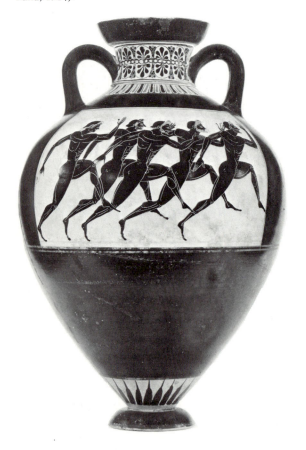

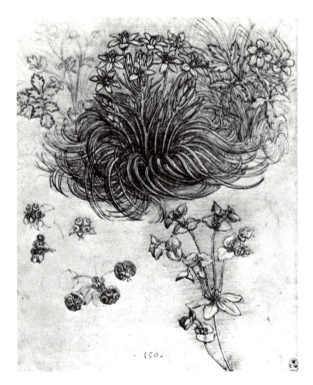

2-8 Leonardo da Vinci, *Star of Bethlehem and Other Plants,* c. 1505-08. Red chalk, pen, and ink, approx. 8" × 6½". Royal Library, Windsor Castle. Reproduced by gracious permission of Her Majesty the Queen.

legs and between bodies. The light background between the feet grows by regular increments, and the light shapes in the regions of the thighs and the torsos change gradually from triangular to polygonal. The positive areas of the dark figures meanwhile maintain their shape uniformity, almost like abstract motifs.

Gradations abound in nature. They are almost always present in natural forms that are universally recognized as beautiful, such as feathers and ferns. The spirals of shells are the most perfect natural gradations known, involving constant change of shape and direction. Artists who depict nature often intensify the orderliness they find there. Leonardo da Vinci's drawing of a Star of Bethlehem plant (Fig. 2-8) is rich with strengthened gradations: in the center the stems sprout upward with their directions grading from a left tilt to a right tilt; in the circle of leaves below

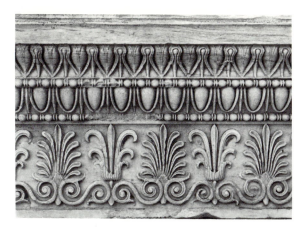

2-9 Frieze from the Erectheum (detail), Athens, fifth century B.C. Approx. 20″ high.

there is a regular gradation of curved shapes at the left and another set curving in the opposite direction below. In the right-hand section of the leaves a series of reversing curves, again with gradation of direction as well as shape, is laid over a set of simple curves below. The interplaying of the different groups of forms is one of the things that gives the drawing a sustained interest.

The third kind of sequence is *alternation*, which is the progression in the repetition of two or more elements. It is frequently found in architectural decoration like this section of a frieze from a Greek temple (Fig. 2-9). In the top band alternating directions are especially felt—both up and down and slanting left and right. In the next band the alternating sizes and shapes of the "egg-and-dart" border dominate. And in the wide bottom band it is clearly the alternating shapes of the palmette and flower that establish the order. Each of these latter motifs is itself highly ordered, being composed of gradations of size, shape, and direction in the individual petals or leaves. Then the two symmetrical motifs are accommodated to each other, one tapering upward and the other downward to produce nearly equal intervals between them.

A more dynamic alternation is to be found in a piece of textile from Java, executed in batik (Fig. 2-10). The all-over pattern of circular shapes is based on the uniform intervals of repeated squares. Within the circles the motif of the fish alternates in both the vertical and horizontal directions. That is to say, each fish is a mirror image of the ones directly above, below, or to either side of it. As our eyes skip across this flip-flopping field, we are reminded of musical rhythms. No matter which way we go, we experience an alternating "beat" in moving from image to image.

One of the principal uses of sequence in art is to imply movement. In the Leonardo drawing the enhancement of gradations and the natural curves of the leaves produce a swirling effect that suggests the blowing of the wind—or a spirit in the plant itself. We know that the drawing cannot move, yet we feel the distinct sensation of movement. An elusive problem in analyzing visual perception is that of separating form and

2-10 Javanese batik (detail). Cotton; height of repeat, approx. 15″. Museum of Fine Arts, Boston (Denman W. Ross Collection).

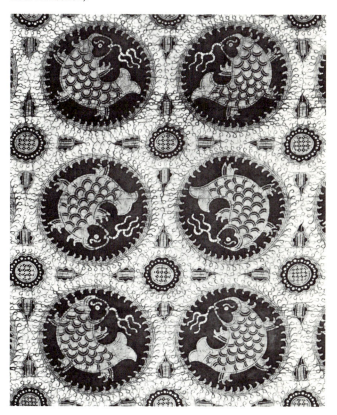

feeling. If we examine a Chinese scroll of a dragon moving through water (see Fig. 7-21), we can describe its effects in two ways. With our attention directed to the *form*, we might point out the gradations in the reversing curves in the water and in the dragon's neck and tail, and the differences between the flatter curves in one and the tighter curves in the other. If we focus on the *feeling*, we would speak about the sense of movement—smoothly flowing in the water and jerky and dynamic in the dragon. A description of the abstract qualities of form is not an account of the expression of movement and energy, but form and feeling are ultimately inseparable.

Grouping

The third system of ordering that we shall examine in detail in this chapter is called *grouping*. It is felt in the larger parts of a work compared with the two already discussed, relying not on pervasive patterns or repetitions but on prominent relationships among these parts. A simple diagram can illustrate grouping (Fig. 2-11).

All three types of grouping can be seen in Vermeer's *Lady Writing a Letter* (Fig. 2-12). First, the lady and the table and chair form one large unit by *proximity*. The two women are linked by the fact that they are both human beings and because their relationship is part of what the picture is about—their *likeness* seems the key to their grouping. At the same time their attention diverges: the lady focuses on her letter and the maid looks out the window. Two *closure* groupings also exist within the picture (Fig. 2-13). In

the more powerful, the maid forms part of a unit with the window: the directions of both the top and bottom lines of the sash seem to embrace the maid's head and arms. This is reinforced both by the psychological connection between the two (she is looking at something outside) and by the way that the bright light of the window illuminates one side of her, almost suggesting a physical bond. The other closure is effected by the connection of the figures with the painting on the wall: the continuous line that seems to flow from the letter writer up and around the figure group in the painting and down to the maid's shoulder connects the two women in a different way. It is the interplay of groupings that makes the experience of this painting so rich. Nothing can be seen singly for long; and no one configuration dominates another.

Grouping is a common enough term which is simply made a little more specific by defining it in this way. If we examine the grouping of stars into constellations we will find forces attributable to proximity and closure especially evident, with likeness being felt in the tendency of brighter stars to separate from fainter ones and thus be seen together.

Winslow Homer had an exceptional ability to see groupings in his subjects, which became a part of the design of his paintings. In the watercolor *Sloop, Bermuda* (Color Plate 1) the two figures in the center group by proximity. Several likeness groupings relate parts of the composition. The shapes of the sloop and its tender are alike in the curves of the prows and the symmetrical shapes of the sterns. The curve of the sail is echoed in the dark stripe on the sloop's hull. The directions of the boom and oar are alike, and the warm

2-11 Types of Grouping. Proximity: triangle and circle; likeness: circle and rectangle; closure: triangle and quadrilateral.

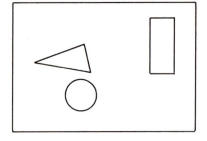

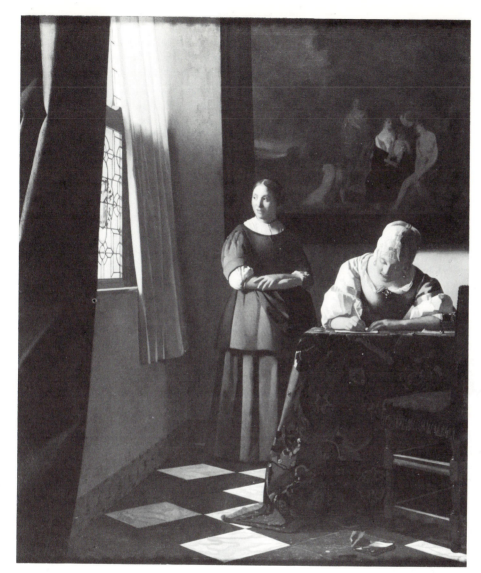

2-12 Jan Vermeer, *Lady Writing a Letter with Her Maid*. Oil on canvas, 28" × 23¼". Collection Sir Alfred Beit, Blessington, Ireland.

2-13 Likeness (above) and closure in the Vermeer painting.

color of the tender recurs in the garment slung over the boom and in the mast. A loose feeling of closure exists in the overall shape defined by the guy ropes and the line where boats and water meet.

When organizing a painting by means of grouping, it is not necessary for all three types to be of equal importance. Jacob Lawrence's *Cabinet Makers* (Color Plate 2) emphasizes likeness grouping by means of color. Five chief colors are used, and each one occurs four or more times.

Our attention tends to settle on one part of the picture for a moment, say one of the figures, and as soon as the blue makes itself felt we are then drawn, as if by a magnet, to one after another of the blue areas. A similar thing happens if our eyes land on a red, or a black, or a white. Because of this tendency to group the same colors, our attention is made to bounce around to all parts of the picture and we soon realize that the sense of busy activity in this carpenter shop is due as much to this as to the active poses of the figures.

Balance

The fourth principle of design to be introduced in this chapter is *balance*, which can be defined as order through opposition. The most common experience of balance is that felt within our own bodies when the opposition of weights is in equilibrium. Artists occasionally translate this sensation directly into sculpture, as Edgar Degas did in his *Spanish Dance* (Fig. 2-14). We tend to project our own sensation of balance into the dancer's pose, feeling such oppositions as the difference between the major weight falling on one foot and the other just touching the ground for stability, the thrust of the upper arm and head countered by that of the lower arm as it circles the body, and the contrast between the outward actions of hip and bent leg. (Our vicarious experience of the pose is often referred to as empathy.) A similar projection of our sense of equilibrium into sculpture is found in Antonio Pollaiuolo's *Hercules and Antaeus* (see Fig. 3-12) where the weight of

2-14 Edgar Degas, *Spanish Dance*. Bronze, 16″ high. The Metropolitan Museum of Art (Bequest of Mrs. H. O. Havemeyer, 1929. H. O. Havemeyer Collection).

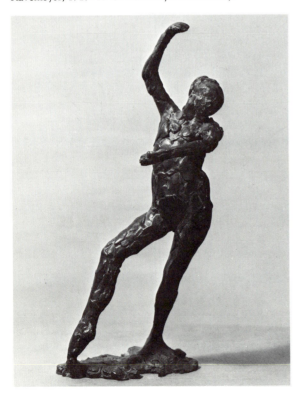

both figures is poised on Hercules' legs.

The sensation of balance can be experienced in two-dimensional works of art as well as three-dimensional ones, and in abstract as well as representational works. Just as the perception of opposing weights entered into our feeling of balance in the Degas dancer so does a perception of opposing weights enter into the viewing of any work of art. But the "weights" do not necessarily involve kinesthetic sensations in our bodies; they often are the abstract elements of shape, size, interval, direction, and color. The most obvious type of visual balance is *symmetry*—exact opposition of elements left and right of an axis. The mihrab is symmetrical: every direction and shape in the pattern is repeated, exactly reversed, either side of the central axis. In the Greek architectural frieze both floral motifs are symmetrical; the two sides of each one are mirror images of each other.

Everything that is not symmetrical is *asymmetrical*—the left and right sides do not correspond. Just as a seesaw will be in equilibrium if two people of different weights sit at the right distances from the center point, a work of art can be balanced if the elements on each side add up to an equal "weight"—meaning equal in visual attraction. An example of asymmetrical balance is a page from a book made in England in the early Middle Ages, the Lindisfarne Gospels (Fig. 2-15). Many details on this page are symmetrical, notably the two broad vertical bars at the left, which have central vertical lines interrupted by diamond-shaped motifs and elaborate terminals with a symmetrical arrangement of circular and curvilinear motifs. But the page as a whole is asymmetrical, and its balance depends on an equal interest, or visual attraction, either side of the center.

No one thing specifically balances another thing on this page—or in most asymmetrical balances. Rather, it is the whole complex which results in the equilibrium. The colorful and elaborate initial letters *I*, *N*, and *P* dominate the upper left, and crisp black letters (some with colored centers) fill the lower right. Different kinds of visual interest are felt in each portion: the initials are highly detailed and colorful while the black letters are sharper in contrast and have numerous eye-catching shapes. On the right and

bottom a return to bands with intricate patterns closes in the whole by nearly joining the bars and initials on the left. This is a page to be read, and we can make out some of the Latin words (though we may have a little trouble with the initial *N*, which has been tipped on its side, and the *P* that is almost a *B*). Knowing these peculiarities we can read most of the page without much difficulty: *In principio erat verbum et verbum erat apud dominos*, the beginning of the Gospel of St. John. Since this large and handsome book was done for members of the clergy, it is hardly necessary for such a familiar passage to be as legible as the rest of the text, and the artist let himself go in visually elaborating the words.

The examples so far have illustrated *axial balance*, or balance either side of a vertical axis. Also possible—though far less common—is *central balance* (known also as radial balance) which is keyed to the center of a work that can be viewed from any angle. The circles and the diamonds in the initials of the Lindisfarne page are instances

2-16 Shigaraki oil plate, Japan, Edo period, *c.* 1770. Pottery with painting and glaze; diameter, 8'. Fogg Museum, Cambridge, Mass. (Gift of C. B. Hoyt).

2-15 Initial page of the Book of St. John, Lindisfarne Gospels, *c.* A.D. 700. Height of design, approx. 10". The British Library, London.

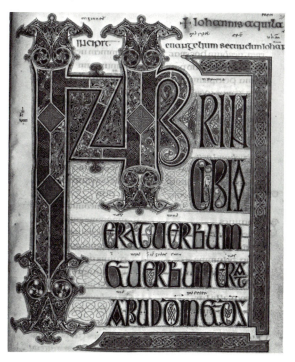

of symmetrical central balance. A large painting by the contemporary American artist Robert Indiana exhibits a less symmetrical central balance (see Fig. 16-31). The LOVE motif in the center is inverted four times on its edges to produce a cross that can be displayed in any orientation.

Central balances can also be decidedly asymmetrical. A Japanese plate of the Edo period (Fig. 2-16) feels balanced from whatever angle we may view it. As we turn it (or as it happens to be set before us) the four major parts assume different positions in relation to the center, moving outward and inward in relation to the central axis that we read into it, changing directions constantly, but always satisfying in their equilibrium.

Perhaps the most important point to emphasize in concluding this chapter is that abstract visual order is found in representational art as well as abstract art, and in painting and sculpture as well as in decorative art. In order to understand how it works it was necessary to define the terms that enable us first to describe and then to analyze visual organization. In the next chapter our attention will move from the part-to-part relationships studied in this one to the effects that abstract organization has on the work as a whole.

3
Composition

In this chapter we will look at the design of the total work of art. This kind of design is called *composition* and, like the principles that were discussed in the previous chapter, composition is a means of unifying a work of art—in this case by relating the parts to the whole. We will begin by examining another painting by Domenico Veneziano, *The St. Lucy Altarpiece* (Fig. 3-1). Domenico's *Annunciation*, seen in Chapter One, also belonged to this altarpiece, but it is much smaller than this work and was placed below it with four other narrative scenes relating to the figures in the main picture. The subject and location of the whole altarpiece had been chosen beforehand by the churchmen who were the artist's employers, and each of the saints was chosen for a reason: the three men were all patron saints of the Italian city of Florence, where the church was located, and the woman, St. Lucy, is there because the altarpiece was commissioned for a church dedicated to her. It was placed on the high altar and was therefore the focal center of the interior of the church. This was not a casual gathering of figures but one chosen for a devotional purpose, and it was therefore quite appropriate that Domenico and his patrons chose a very formal composition.

Two-Dimensional Composition in Painting

There are two traditional starting points for surface composition and Domenico made good use of both of them. The first of these is the *enframement,* or distinctive shape of the panel on which he painted; in this case a square. The second starting point is the *central axis* (or the center point itself), which we found to be important in discussing balance. Here Domenico was clearly interested in attaining a strong sense of balance through symmetry. The Virgin is exactly centered and her centrality is reinforced by the platform on which she sits, the niche behind her and the Child, the columns beside them, and the arch above. More reinforcement comes from the nearly exact correspondence of the two pairs of saints either side of the central axis. The precise

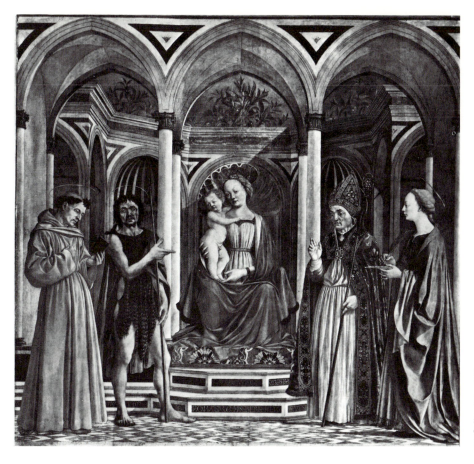

3-1 Domenico Veneziano, *The St. Lucy Altarpiece, c.* 1445. Tempera on wood panel, approx. 6′ 7½″ × 7′. Galleria degli Uffizi, Florence.

fitting of the three arches to the enframement adds a kind of finality to the arrangement. It would be difficult to imagine a more ordered composition than this one.

It appears that Domenico chose to employ such extreme symmetry for reasons that were not a question of purely abstract design. When he brought together the holy figures in his painting he was using a traditional subject, a *sacra conversazione* (holy conversation). The saints are from different periods: St. Francis, on the left, lived in the thirteenth century while John the Baptist, next to him, lived at the time of Christ. The only ways they can exist together are either in the minds of people or in heaven. The perfect symmetry of the composition is appropriate to, or expressive of, what is essentially an idea—the image is therefore referred to as ideal.

In the *Annunciation* (see Fig. 1-1) Domenico was not concerned with imagining something

ideal but with the story of the angel appearing to Mary to announce that she would conceive and bear a son. He found that off-center symmetry was more appropriate to this narrative subject with its gently dramatic interaction between the angel and the submissive Mary. Clearly the artist did not want to repeat directly below it the symmetry of the large panel.

Most paintings do not have such an architectural function nor aim to embody such an ideal content as the St. Lucy altarpiece. But a sensitivity to the center of a painting is found in many diverse instances. Claude Monet's chief intention when he painted *The Beach at Trouville* (Color Plate 18) was to record a real scene as naturalistically as he could; but notice how many of the lines converge at the center point, located at the turret at the end of the row of hotels. These are, for the most part, converging perspective lines, rather like those in the St. Lucy Altarpiece, but

they are adapted to the irregularities of the scene. There is almost a feeling of a central balance: the wedge-shaped area of water corresponds to the wedge of bushes on the right, the wedge of the beach to the wedge of the hotels. Asymmetry is found in the opposition between the foreground interest in the lower-right quarter and the open sky in the upper left. Always, though, the center point acts like a kind of anchor for the composition.

The bulky carcass hanging in the butcher shop in Rembrandt's *The Slaughtered Ox* (Color Plate 26) is depicted so that we feel its weight falling exactly along the central axis of the picture. Everything else about this painting is off-center: the rack on which the ox is hanging, the doorway with the woman's head, and the spatial recession toward the right. But the weight of the massive carcass is so thoroughly conveyed to us that it becomes the most forceful element in the picture. In the discussion of Degas' *Spanish Dance* sculpture in the last chapter (see Fig. 2-14) the point was made that we tend to respond with empathy to depicted bodily actions; here, in a related way, our kinesthetic sense is activated as we are reminded of past experiences with weight through

such details as the sagging organs, the taut skin, and the strain on the tethered legs. These experiences are then put to use in the composition by having the center of gravity coincide with the central axis.

Turning to the shape of the enframement itself we find that particularly stable works result from repeating this shape in the composition. This is what Nicholas Poussin did in *Inspiration of the Poet* (Fig. 3-2), in which the figure group forms a rectangular block that fits the whole rectangle of the canvas. The standing figures of the muse and the poet are the same distance from the edges of the picture, while Apollo, in the center, is given the stable shape of a triangle—with the help of the muse's bent leg and the cupid. The other cupid breaks the regularity of the top line of the block but not in such a way as to interfere with the stability of the whole.

Not all paintings which use a similar compositional form to Poussin's produce a similar stable effect. Picasso's *Guernica* (see Fig. 16-11) is also based on a triangular center and verticals at the extreme left and right, plus a vertical line down the center. The shattered forms that make up this composition almost conceal its stabilizing effect

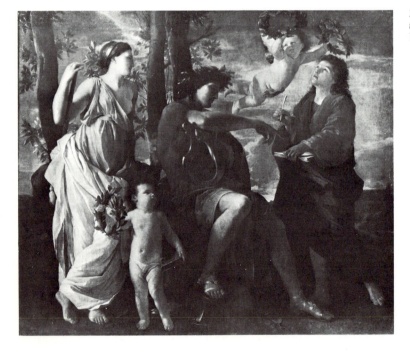

3-2 Nicholas Poussin, *The Inspiration of the Poet*, c. 1628-29. Oil on canvas, 6′ × 7′. Louvre, Paris.

but there is no doubt that the nearly hidden geometry does a lot to hold together the somewhat chaotic parts.

Rubens' *Rape of the Daughters of Leucippus* (Fig. 3-3) suggests that compositional forms themselves have the power to express dynamic energy while still serving their organizing purpose. Rather like Poussin's rectangle within a rectangle, the composition here is a square within a square—except that the inner square has been poised upon one of its points, thus becoming a diamond shape. Its edges are also more ragged. The diagonals established by these edges are repeated in the slanting bodies, inducing a movement upward and to the right that is continued by the rearing horse. This action is countered by the tumbling effect of the four figures, beginning with the uppermost man and ending with the down-thrust arm of the lower woman. Both these actions move toward the right and it is the role of the horse and the cupid on the left to return the whole to a balance.

A painting in which diagonals play an equally important but different role is Henri de Toulouse-Lautrec's *Cirque Fernando* (Fig. 15-20). Instead of the center being solid with figures it is empty, and there is a considerably looser relationship of the diagonals to the enframement. The dominant diagonal is the curve of the ring which, along with the running horse, leads us into the scene from the right and continues to the left edge where it suggests further extension beyond the frame. But the lively shape of the dancing clown and the important figure of the ringmaster take our attention back, particularly as his hand and whip connect with the horse, bringing us close to the starting point. Another diagonal, defined by the front leg and head of the horse, terminates in the light shapes at the top border (the pantaloons of a clown and apparently a hoop he is holding). This diagonal passes through the center of the picture, dividing it in a subtle way into a right side made up of more solid and closely packed forms and a left side containing flat dark shapes set against the light ground—two very different halves, but equal in their visual attraction.

Opposing and crossing diagonals are common in pictorial design. Antoine Watteau's *Fête*

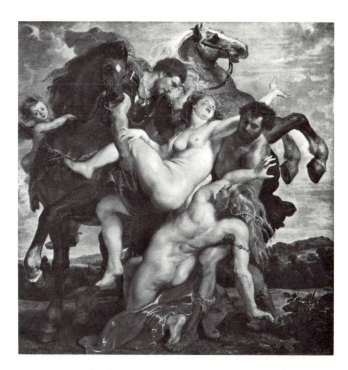

3-3 Peter Paul Rubens, *Rape of the Daughters of Leucippus*, 1617. Oil on canvas, approx. 7'3" × 6'10". Alte Pinakothek, Munich.

d'Amour (see Fig. 14-16) has a diagonal leading from the left corner of the foreground figure group upward and to the right through the heads of the standing couple and to the head of the statue of Venus. Countering this are several diagonals moving upward and to the left, some of which also pass through the heads of the standing couple. In fact, Watteau combined these intersecting diagonals with a suggested symmetry around these heads as a central point. If we cover up the left quarter of the reproduction (roughly from the left edge to the single tree) we feel these radiating lines strongly, but clearly Watteau was not interested in keeping such a symmetrical framework for his whole composition. This central point was set well to the right of the central axis of the painting.

A similar combination of crossing diagonals and symmetry thrown off-center is seen in a work by the contemporary American artist Frank Stella entitled *Darabjerd III* (Color Plate 3). Stella broke with traditional shapes in selecting an enframement; in fact he allowed the forms within the painting to determine its overall shape, which is

based on the intersection of a circle and a semi-circle of equal diameters. While Watteau achieved some of the tension in his design by opposing the centralizing figures to the far landscape, Stella achieved his by opposing the strong centrality of the nearly complete circle to the outward reach of the semicircle.

Although he does not have figures and objects with which to shape the composition, nevertheless Stella made good use of the different degrees of interest in his radiating wedges: the yellow, red, and black wedges in the upper-right quadrant exhibit the strongest contrasts and provide appropriate opposition to the extended lower-left quadrant.

An oil study for a ceiling painting, Tiepolo's *Apotheosis of Aeneas* is composed of a fairly complex series of parallel diagonals (see Color Plate 29). The picture illustrates the ascent of the Trojan warrior Aeneas into heaven after his death, and the composition encourages us to read the picture from bottom to top in a zigzag fashion. We begin with the darker and heavier images of war and the creation of weapons, moving upward with the leaning bodies toward the rock where Time, the winged figure with the scythe, turns the movement toward the left. Aeneas himself reverses this movement with his gesture toward his mother, the goddess Venus. She in turn is part of a slanting diagonal of figures, but the twist of her head and torso shifts us toward the floating figure of Mercury—whose reversed direction focuses our attention back to the figures below.

Three-Dimensional Composition in Painting

With the Tiepolo we can begin to discuss another realm of composition—the arrangement of forms within the picture's imagined space. The zigzag movement not only leads us up the picture's surface, it also leads us back in space. Venus is the most distant of the chief figures and Mercury, at the top, is floating somewhat forward of her, so that as well as returning us downward he returns us closer to the surface of the painting. The two- and three-dimensional compositions are, therefore, very similar and when speaking of

3-4 Three-dimensional composition of *The Annunciation*.

the overall composition of the painting we would be referring to both.

To make clear what is meant by *three-dimensional composition*, let us return, because of its simplicity, to Domenico Veneziano's *Annunciation*. Its balance, as we saw in Chapter One, is essentially a matter of two-dimensional composition (see Fig. 1-2), but the equally important arranging of forms in rows parallel to each other and parallel to the front plane of the picture is three-dimensional. A diagram of this arrangement is seen in Figure 3-4. Just as the two- and three-dimensional compositions of the Tiepolo had much in common so they do here, though now parallels are dominant rather than zigzags. The diagram is an interpretation of the space within the picture and cannot be simply traced as the diagram in Chapter One was. The forms have been drawn as they appear to relate to the front plane: the back wall of the courtyard and the garden gate are parallel to it, as is one set of lines in the pavement. At left and right the forward surfaces of the two porticos are virtually flush with it. We read the other dominant set of lines and planes as perpendicular to these and to the picture plane. The diagram amounts to a ground plan of the painting.

The two examples of spatial composition in painting so far discussed deal with forms that are either parallel to the picture plane (Domenico) or diagonal to the picture plane (Tiepolo). Many pictures combine both methods of ordering the

represented space. In Georges Seurat's painting, *A Sunday Afternoon on the Grande Jatte* (Fig. 15-17), many of the figures are upright, seated, or lounging in profile, thus emphasizing the vertical planes within the picture. Back in space on the right side the tree trunks and their shadows join the figures in a restatement of this parallelism. On the left side of the picture we make our way into the space by means of diagonals: the shore-line and even the cast shadows angle into space. In the distance a light-colored wall makes a strong restatement of the parallel. Seurat, then, composed his picture space by means both of successive parallels and receding diagonals, and the result is very ordered indeed.

For a more dynamic example of three-dimensional composition we turn again to Rubens and a painting known as the *Kermesse* (see Fig. 4-6). A kermesse is a Flemish outdoor festival and dance, and this one was recorded by the artist with great gusto. It is an almost chaotic scene of eating, drinking, dancing, and lovemaking that has been saved from chaos by its spatial composition. A large left-to-right diagonal into space has the greatest effect, while secondary counter-diagonals move inward from the lower right. About the only parallel that has much effect is

defined by the two trees and continued in the rear boundary of the figure mass. Then a third means of organization appears in the circular plans that are formed by some of the figure groups, and particularly by the dancers deep into the picture space on the right. They describe a semicircular arc. Parallels, diagonals, and arcs have long been three of the favorite means of organizing the spatial design in paintings.

The Rehearsal (Fig. 3-5), one of Edgar Degas' many ballet pictures, is organized primarily on the basis of arcs in space. The principal arc is that of the dancers' feet, which begins at the base of the post of the spiral staircase and continues through four pink slippers to the poised dancer in the center. This arc seems almost to have been described by a swinging radius centered in the figures at the right—which themselves appear bounded by a curve in space because the circular skirts seem sympathetic with the spatial curves. The staircase itself completes the theme of circularity. Diagonals are also important in this picture; the deepest part, on the right, is brought into the three-dimensional composition by the diagonal lines of the floor that lead toward the dancing master's colorful shirt. The more abrupt right-to-left diagonal between the seated dancer

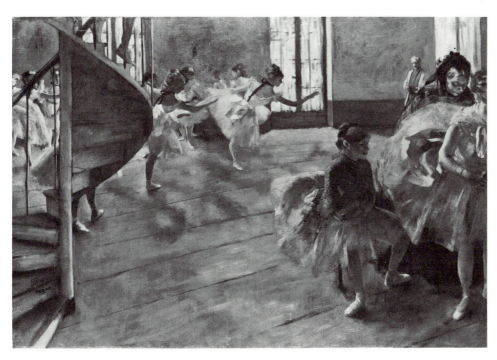

3-5 Edgar Degas, *The Rehearsal*, 1876. Oil on canvas, 23″ × 33′. Glasgow Art Gallery and Museum (Burrell Collection).

and the central dancer against the window completes the spatial organization of the picture.

Eugène Delacroix's painting of a *Lion Hunt* (Fig. 3-6) is a tangle of men and animals in which physical action is intense and the emotional pitch is high. To give order to this melee the artist laid out a kind of diamond-shaped ground plan based on diagonals that recede in both directions (somewhat like Rubens' diamond-shaped surface composition in the *Rape*). There are also numerous arcs, like that of the fallen white horse and the lioness on top of it, and reversing curves, like those of the lions' tails, that move back and forth in space. But the particular advantage gained by Delacroix's treatment is that the space swells toward the middle of the painting where the most active forms occur and the number of planes of depth is greatest. This is the spatial climax of the painting, the region toward which the "crescendos" from left and right lead. The background space is of little importance.

Such swelling of space and the attention-holding power it has can be found in many different types of painting. It was a means of spatial organization favored by the Cubists, as can be seen in

Georges Braque's *The Portuguese* (see Fig. 2-5). In this painting the space is confused; no one thing has a clear and fixed position in relation to another. Yet the feeling of spatial complexity produced by faceted planes is sometimes greater and sometimes less. This spatial richness is greatest near the central portion of the painting, where we feel the Portuguese guitar player is located, and it thins out toward the left and right edges.

Composition in Sculpture

Sculpture may be divided into two types: *round sculpture* (or sculpture in the round) and *relief sculpture*. Round sculpture is fully, or nearly fully, three-dimensional: an example is the Degas dancer in Chapter Two (see Fig. 2-14). Relief sculpture is intended to be seen only from the front and it usually has a solid background from which forms only partially emerge. Composition in relief sculpture is very much like composition in painting since there is usually a bounding enframement, though there are three-dimensional considerations as well. In round sculpture the

3-6 Eugène Delacroix, *The Lion Hunt,* 1861. Oil on canvas, 30″ × 38½″. The Art Institute of Chicago (Potter Palmer Collection).

3-7 Grave Stele of Hegeso, Dipylon cemetery, *c.* 410-400 B.C. Marble, 59″ high. National Museum, Athens.

boundary is the sculpture itself, and consequently it changes every time the observer moves.

The traditional form of relief sculpture is that seen in a marble relief carved for the grave of a Greek woman named Hegeso (Fig. 3-7). In this memorial she is depicted in a scene from her everyday life. She has just selected an object from a jewel box and is contemplating it while her attendant holds the box. The attention of the attendant is also directed toward the object in her hand (probably a jewel), so that psychologically it is the focal point of the composition. It has a similar formal role, since it is placed exactly on the central axis of the relief. On the same central axis, there also occur the point of the gable above, the object in her other hand, the stud on the chair leg, and the vertical drop of the drapery just beneath the leg. Like some of the painters discussed earlier in this chapter, the Greek sculptor felt the central axis to be an extremely significant line in the composition. Other geometric

divisions in this highly organized composition are worth noting. The horizontal of the woman's arm and the jewel box cuts the whole space in half while the other major horizontal, the chair seat, creates a square in the upper portion whose center is marked by the jewel. And finally, the lower rectangle is divided into two squares by the vertical line between the stud and the drop of drapery below.

A contemporary American sculptor, Louise Nevelson, working abstractly within the broad category of relief sculpture, has produced a series of wall-like sculptures often unified by being entirely painted in a single color. In *Black Wall* (Fig. 3-8) she used geometric parts, somewhat like the artist of the Hegeso relief, to produce a composition in which the whole has a relation to its parts because it is produced by adding them together. Any block of four or nine of these units produces a rectangle of the same proportions as a single

3-8 Louise Nevelson, *Black Wall*, 1964. Wood construction painted black, 64¾″ × 39½″ × 10⅛″. Hirshhorn Museum and Sculpture Garden, Washington, D.C.

3-9 Richard Hunt, *Drawing in Space*, 1979. Steel rods. Dorsky Gallery, New York.

unit. Yet unlike the regular patterns studied in the last chapter, each box is different from the others, though often containing similar wooden shapes such as circles, balusters, and large, curved forms. Each box is unique in its composition, containing forms ranging from flat to completely round, and in each box objects are located in several planes from the front surface to the back. The flat elements are always ranged parallel to the front and back planes of the boxes, and in this regard are rather like the Greek artist's arranging of chair, arms, box, and profile faces parallel to the front and back planes.

While much relief sculpture is designed within the space defined by strongly marked front and back planes, there are others which open up this space. An example is Lorenzo Ghiberti's *Christ Walking on the Water* (see Fig. 7-19). The decorative frame seems to be behind the nearest figures—Christ and Peter on the right—and in front of the further ones. A diagonal into this space from right foreground to left background organizes the spatial plan and along it are placed the three major groups of figures. A welded relief sculpture by Richard Hunt (Fig. 3-9) has a firm back plane defined by the upper-right corner, which is set directly against the wall. The lower-left corner is bent out from the wall to connect with the forward planes defined by the small square and the curved pieces below it. The single wire at the lower right also breaks away from the wall plane but at a flatter angle. The most complex shape is that of the wire cutting across the rectangle and angling back to the plane of the wall. The whole is like an abstract three-dimensional drawing, closed at the back and top and open toward the front planes and the bottom. What seems a simple work would appear considerably more complex if we could move back and forth and see the changing relationships.

It was said earlier that sculpture in the round differs from relief sculpture in having no enframement other than that which it defines for itself. Some round sculptures are made to be seen primarily from the front, some from viewing points covering about 180 degrees, and others from points throughout the whole 360-degree range. The latter, sometimes called free-standing, are the most difficult to present in two-dimensional pictures, but nonetheless we will begin with such a work: Aristide Maillol's seated nude entitled *Mediterranean*. In Figure 3-10 its overall

shape is a well-defined triangle. Reinforcing the overall triangle are a number of smaller ones created by the spaces between the bent arm, the bent leg, and both of these with the body, and contributing to the stable effect of the whole are the horizontals of the lower leg and bent arm. The simple geometry of the composition is not unlike Poussin's *Inspiration of the Poet*. If we could move gradually around the work we would see a transformation of the overall shape as the diagonals disappear in favor of a more rectangular whole, whether seen from the front or the back (Fig. 3-11). The base reinforces the rectangularity of the seated figure and defines the space to which the sculpture seems to belong. It is the closest thing to an enframement.

Very different in its design is a small bronze sculpture of Hercules and Antaeus by Antonio Pollaiuolo (Fig. 3-12). The work illustrates the story of a fight which Hercules could only win by holding Antaeus off the ground, for, being a child of the earth goddess, Antaeus' strength was redoubled every time he touched the earth. Comparing its composition with Maillol's, we

find little emphasis on a bounding shape because of the outflung parts; nor is the base big enough to define a block of space into which the figures can be fitted. Instead, the composition is built around a central axis, at the core of which is the fusion of the two bodies into one solid piece. The axis, furthermore, seems to coincide with the group's center of gravity. From this angle of viewing the outward movements of Antaeus threaten to unbalance the work, but an extra visual weight is supplied by the lionskin that hangs from Hercules' hips.

The *Hercules and Antaeus* illustrates how difficult it is to separate design from representation, since our most basic response to it is almost physical in nature. The same is true with Auguste Rodin's *Prodigal Son* (Fig. 3-13). Here the upthrust body becomes one with the diagonal form of the composition, which is dominant from whatever point of view we regard the work. The view shown here maximizes this diagonal with its culminating point at the clenched hand of the youth, a direction which is further emphasized by the rippling continuities that describe the sil-

3-10 Aristide Maillol, *Mediterranean, c.* 1901. Bronze, 41″ high. Louvre, paris.

3-11 *Mediterranean* (rear view).

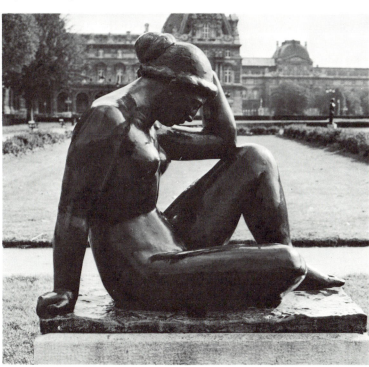

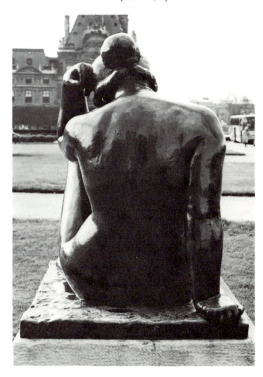

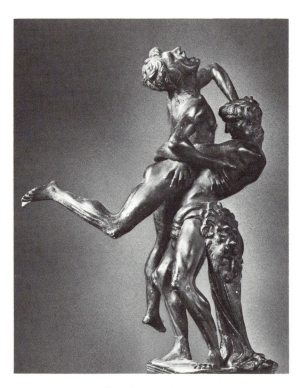

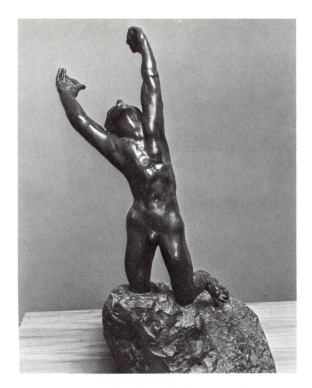

3-12 Antonio Pollaiuolo, *Hercules and Antaeus, c.* 1475. Bronze, approx. 18″ high with base. Museo Nazionale, Florence.

3-13 Auguste Rodin, *The Prodigal Son,* 1889. Bronze, 54¼″ high. The Allen Memorial Art Museum, Oberlin College, Oberlin, Ohio (R. T. Miller, Jr., Fund).

houette and the interior surfaces of the form as well. The base, which appears to be a natural rock form, is essential to the overall balance, for when the diagonal is stronger, the rock extends further beneath the unbalanced figure. And from many views a continuity is felt from the arms to the opposite legs, a kind of X-form that is made more evident by the youth's very slim torso.

Representing a fourth major type of composition in free-standing sculpture is a work whose title suggests the composition itself. *Around the Void,* by the contemporary Spanish sculptor Eduardo Chillida (Fig. 3-14), has a series of cubic forms arranged around a central void in such a manner that it always appears stable on its resting points. The right-angle junctions of many of its planes and the parallelism of others bring further order into it. The cubic uniformity is relieved by the seeming flexibility of the steel as it makes 90 and 45 degree turns. Moving around it we sense an infinite number of changes taking place in the shapes of the solids and their silhouettes and in

the shapes of the central space as well. The physical associations we found in the last three works no longer apply in this abstract sculpture; instead we are particularly aware of the material itself. The tensile strength of steel that allows a large slab to extend outward some distance without support or allows the metal to become quite thin at the bent junctions assures us that its stability is not threatened by the open center.

There is an interesting similarity between the composition of Chillida's sculpture and that of Delacroix's painting of a lion hunt. The sculpture, with its real solids and spaces, has a hollow center from which the forms jut freely into the surrounding space. The same description fits the painting, whose forms and spaces are illusions of reality. Such compositions are frequently described as *open.* In contrast, Maillol's *Mediterranean* and Poussin's *Inspiration of the Poet* can be described as *closed.* Open compositions do not necessarily have open centers; Pollaiuolo's *Hercules and Antaeus* is extremely open in the way

the forms break out from the solid core. Vice versa, the Hegeso relief, while open in the central region around her raised hand, has a closed feeling overall because of the many in-turning forms and the firm boundary of the frame. Later on we shall find these terms useful in discussing architecture as well as sculpture and painting. For instance the Renaissance church of Todi illustrated in Figure 13-12 has a closed composition, while the Frank Lloyd Wright house illustrated in Figure 1-10, with its horizontal slabs stemming from a vertical core, has an open composition.

In general, principles of composition similar to those found in sculpture apply to architecture—with the great difference that interior spaces as well as exterior shapes are designed. Composition in architecture is so strongly affected by a building's function that it can be properly discussed only when this function is taken into account—as it was in the discussion of the Wright house in Chapter One (Figs. 1-10 and 1-11).

While painting and sculpture do not have the same function that architecture does, they have other kinds of purposes that affect their compositions. At the beginning of this chapter we saw that Domenico's altarpiece has a composition that reflects its purpose, first as an image embodying ideal content or meaning, and second as a colorful central accent in the design of the church in which it was placed. To these two, the *communicative purpose* and the *formal purpose,* a third may be added that can be called its *instrumental purpose.* The painting was intended as an instrument in the actual ceremonies because of its key position above the altar, the focal center of the services. Not all works of art have the layers of purposes that this one had, but most compositions are responsive to circumstances outside the work itself.

Finally, all compositions serve purposes that can be generally termed *expressive,* for composing is not only designing the parts in relation to the whole, it is also the creation of expressive forms. The compositions of the Poussin or the Maillol are stable; of the Rubens and the Toulouse-Lautrec, dynamic; of the Hegeso relief, dignified; of the Pollaiuolo, energetic, and so forth. But before we can perceive them thoroughly as expressive forms we must understand them as abstract forms.

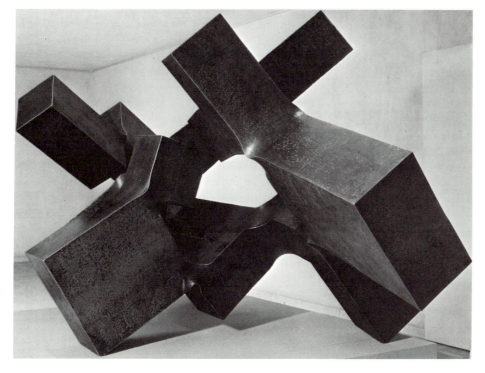

3-14 Eduardo Chillida, *Around the Void IV,* 1968. Steel, 5′ × 8′10″ × 5′6″. Kunstmuseum, Basel.

4
Color

Color is often characterized as the most sensuous aspect of vision and the one that lends itself least to analysis. Yet the method we are following—that is, to combine seeing with understanding—can be applied to color as well as to other visual qualities. It is true that color has a direct line to the senses—so much so that some contemporary artists have covered large canvas surfaces with nearly uninterrupted areas of color as if to underline the purely visual experience that color can be. There is greater challenge, however, to artist and viewer when, as with other aspects of design, more complex *relationships* among colors come into play.

Color Terminology

The first thing we shall need is a color terminology that will be useful in describing the clearly apparent differences in the color relationships in such works of art as Henri Matisse's *Goldfish and Sculpture* and Georges Braque's *The Salon* (Color Plates 4 and 5). Both pictures have strong contrasts of different sorts. In Braque's painting there are contrasts of light and dark that concentrate in the areas of the light window and the black table. In Matisse's painting there is less light-dark contrast but more contrast among different colors. Both seem to use color successfully and we sense that this has something to do with the ways in which the contrasts in each are controlled. Diversity and order are felt to be simultaneously present. More specific color terms can help us to define the differences and account for the ordering within the diversity.

Color is the broad term that refers to the distinctions we see among areas, even when these distinctions are primarily of lights and darks. We use the term *value* to separate this light and dark contrast from other kinds of contrast. The major contrast in the Braque painting is one of value.

Shifting our attention to the Matisse we find that, so far as the larger areas are concerned, the lights are less light and the darks less dark than in the Braque. The value contrasts are less emphatic than the contrasts between the blue, the blue-green and the pinkish-orange of the statuette. These are contrasts in *hue*. There are different

hue contrasts in the Braque, too, but the blue, yellow, and brown have less strength, or *intensity*. And there is no color with the very intense quality of the red of the goldfish and flowers in the Matisse.

We can complete our definitions of the three major attributes of color—value, hue, and intensity—by referring to the charts in Color Plates 6 and 7. Value refers to the relative lightness or darkness of a color; a scale of values has white at one end and black at the other. Between these extremes (white paper and black ink in these charts) there can be a large number of distinguishable value steps. This scale follows a traditional system in having nine. The gray tones approximately half way between white and black are called *middle values*; the lights are *high values*, darks *low values*. Each value step can be given a name or number for purposes of classification or notation, but for our purposes comparative designations such as "lighter than" or "darker than" and "generally dark" or "generally light" are sufficient. The term *neutral* is used to designate all grays, plus black and white—colors that have no hue.

In the lower part of Chart I, twelve different hues have been arranged in sequence and placed opposite a value scale so that the correspondence between the values of the colored tones and the neutrals can be seen. Yellow has a high value and blue a relatively low value, for example.

The sequence of hues is suggested by the rainbow or by the spectrum of hues produced by a prism. The printers' inks used here are approximations of these prismatic colors. Since the spectrum has a sequence of hues from red at one end to purple at the other, it is an obvious step to connect the two ends by mixing red and purple (red-purple) to produce a hue circle (top of Chart I). Various hue circles are possible, some with five hues distinguished and some with many more; this one has twelve, based on six hues and their intermediaries. The letter-symbols are abbreviations of the twelve hue names.

Because of the correspondence in value between the twelve hues and the seven value levels between white and black, there is a regular gradation in value in the hue circle, from highest for the yellow to lowest for the purple. This is found

on each side of the circle, the *warm hues* being on the left and the *cool hues* on the right. General usage places yellow with the warms and purple with the cools, though obviously these are very relative terms. The warmest hues are usually felt to be red-orange and orange and the coolest blue-green and blue.

Not all hue circles have the same arrangement as this one. Some place blue or blue-purple opposite yellow because of the way in which colored light mixes as compared with pigment mixtures, the basis of this arrangement. Roughly speaking, yellow and purple mix, in paints, to a neutral; so do red and green, orange and blue, etc. We shall have more to say about the two types of color mixture later.

This hue circle with its regular gradation of hues through 360° and its regular gradation of values through 180° is an idealized picture of one segment of the color world. It has rightly been called a "tempered scale." Not only is the spacing between hues open to alternative spacing, as suggested in the previous paragraph, but the values of two of the twelve hues have been juggled slightly to produce such regularity. The value of the green is slightly darker than the orange and the yellow-green slightly darker than the yellow-orange, even though they are assigned the same value here. But since the main objective of this arrangement is to provide a concept of the color world that will better enable us to understand color relationships, such regularization of relationships is defensible.

The one characteristic that all twelve colors in the hue circle have in common is that they are all of maximum intensity. They are the most intense colors of these hues attainable with the inks and with the four-color process of color mixture used in most color printing. Artists' pigments could produce all of them with greater intensity, but for purposes of understanding the principles involved these charts are very satisfactory. A single hue attains maximum intensity at one value level (or value region), which is of course the reason for the value gradation noted; these maximum intensity hues and their relation to the scale of values lead into the next chart.

Color Chart II consists of six hue triangles, in each of which the value and intensity possibil-

ities of one hue are recorded. The full intensity hue in each is placed opposite its corresponding value (the neutral scale of values has been omitted to save space). Mixture with this neutral produces the variations within each hue seen in the triangles. The further from the value level of the full intensity hue the less intensity the hue has—hence the triangular shapes.

As with the hue circle and the value scale, relatively few samples are included compared with the rich continuum of values and intensities that would be perceptible within each hue. So of the thousands of colors distinguishable by the human eye, this chart (which does not include the neutrals) shows only seventy-eight samples. Again, there is a high degree of tempering of these scales, since the full-intensity hues have different degrees of absolute intensity—red-orange being a more stimulating sensation than blue-green, for instance. But the concept of color relationships is more readily conveyed by a regular and tempered scale; in other words, by regarding intensity as a relative factor rather than an absolute contrast with neutral.

Admittedly this is a fairly complex, if ordered, arrangement of color variables. Since there are three major variables—value, hue, and intensity—the possibility arises that they may all be put into geometric relationship by means of a three-dimensional system. Such diagrams of color-space, or a *color solid*, have been evolved and exist in various forms. The color solid (Fig. 4-1) is the product of joining together twelve hue triangles by means of their one common characteristic, the neutral value scale, which runs vertically through the center of this imaginary "solid." The twelve triangles fan out in regular order from this central axis and the outward shape of the solid is made up of the regularized outside edges of all twelve, filled in with imagined intermediate triangles. Such a three-dimensional diagram does allow for the *conceptual* containment of the virtually infinite number of perceivable colors. But at this point we must leave theoretical color and return to the practical problem of discussing color relationships in art.

Limited Color Ranges

The observation was made earlier that Matisse's *Goldfish and Sculpture* had more hue contrast and less value contrast than Braque's *Salon*, or stated another way, the Matisse has a limited range of values. *Limited range* is rather like a term used in the previous chapters as a principle of organization—the term *general uniformity*. For example, we saw that many patterns consist of

4-1 Color solid. Twelve vertical radial slices are shown, each corresponding to a basic hue. The high-intensity line, omitted for simplicity, would pass through the dots on the surface of the enclosing cylinder. (Diagram of Pope Color Solid prepared by Howard T. Fisher.)

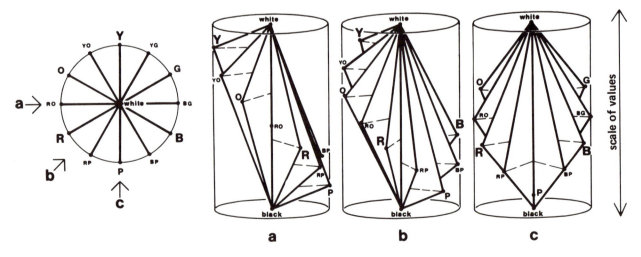

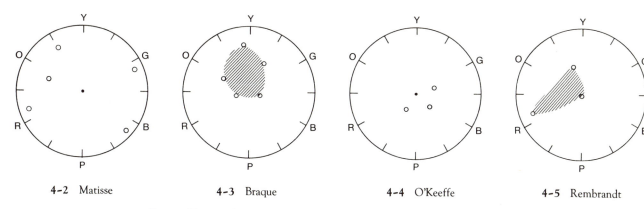

4-2 Matisse 4-3 Braque 4-4 O'Keeffe 4-5 Rembrandt

Range of hues and intensities (shaded area indicates the mixed colors).

elements that are generally uniform in shape. Such relatedness is analogous to the felt relationships resulting from Matisse's limited value range in that a unification of the whole takes place in both. And with our new color terminology we can take note of the fact that the contrasts that animate the Matisse are hue-and-intensity contrasts—that is, the differences among hues together with the relatively high intensities of each hue provide the diversity.

In the Braque there are several different hues (yellow, green, brown) but they are not very intense. The hue and intensity range is limited while the value range is wide. (In case of doubt concerning the hue area we call "brown" look at the orange and yellow triangles in color Chart II. In the more neutral samples within these triangles, particularly in the left-hand line, are found the variations of these hues called browns.)

The differences in the ranges of hue and intensity in these paintings can be graphically presented by means of a simple diagram. Suppose we use a circle to symbolize the complete range of hues and their intensities. This circle will always be oriented with yellow at the top, like a hue circle, but we are now considering it to be a plan of the color solid, leaving distinctions in value out of account (the way the plan of a house omits the dimension of height). So the circumference stands for full-intensity colors, the central point for neutral, and the area between for hues of diminishing intensity moving from edge to center. The radii stand for constant hues (for example, the line from B to the center symbolizes all

blues from most intense to least and from lightest to darkest). With Figures 4-2 and 4-3 we can indicate the range of hues and intensities in the two paintings. The hue-and-intensity range of the Matisse is recorded as being considerably wider than that of the Braque, as we saw before.

Georgia O'Keeffe's *Abstraction* (Color Plate 8) has an even more limited hue and intensity range than the Braque. The only hues are a green, a slightly purplish red, and a blue. Furthermore, all three are of low intensity—about a quarter of full intensity (Fig. 4-4). There is almost no mixing of colors with each other; the green is mixed only with white, as is the red in the triangle right of center. A slight mixing of red and blue occurs in the upper right triangle, but it is hardly enough to introduce a new hue. Because of the relative nature of color these three neutralized hues seem to grow in contrast with each other as we contemplate the work, just as the shape relationships among diagonals and flat curves, and the refined asymmetrical balance seem to gain in richness.

This latter observation suggests one reason why limited hue and intensity ranges have appealed to artists; because of the challenge of implying a wide color range while still making use of the formal unification resulting from a narrow one. A comparable limitation, which involves a dominant hue region, or *tonality,* can be seen in Rembrandt's *The Slaughtered Ox* (Color Plate 26) done entirely in red, yellow, and neutral (Fig. 4-5). The few neutral areas around the woman's head and on the floor seem almost like cool colors in this warm environment. Such relativity

of color sensations suggests that the eye is different from the camera in its great adaptability. Color film in a camera will expose very differently in different light "temperatures" (in the cooler tonality of daylight as opposed to the warmer tonality of incandescent lamplight, for instance) but the eye/brain adapts readily to either daylight or artificial light. We are only conscious of the difference if there is a direct juxtaposition of the two types of light. In painting, the effect of the eye's adaptability is that neutrality is a relative sensation—a tone that appears gray in one painting might appear to be a neutralized blue or yellow in other paintings.

The three examples shown of limited hue and intensity ranges—the Braque, the O'Keeffe, and the Rembrandt—are instances of a kind of color organization often used when value contrasts are strong, as they are in these three works.

Controlled Contrasts

For another kind of color organization we turn to a painting by van Gogh, *The Zouave* (Color Plate 9). The lower half has large areas of intense colors, particularly the red-orange pantaloons with yellow highlights. The upper half has strong value contrasts, particularly the largest areas of dark blue against white. Both halves together seem to combine the high intensities of the Matisse with the strong value contrasts of the Braque. Yet because van Gogh keeps the two strong contrasts in equilibrium—that is, so that our attention is equally attracted to both types of contrast—the effect is not chaotic but controlled. He further brings the two halves together by having the *small* red of the hat and yellow of the brocade invade the upper half and the *small* black and white of the shoes invade the lower half. The importance of size of area in color relationships will soon be discussed further.

Controlled contrasts is an appropriate term for this treatment of values and intensities. Since it is effective in emphasizing the surface of the painting we find it being used in traditions in which the decorative surfaces are felt to be important—for instance, in the mosaics and stained-glass

windows that enhanced wall surfaces in the Middle Ages. In the sixth century the emperor Justinian had the church of San Vitale built in Ravenna, Italy. A section of the apse of this church has a mosaic of the emperor making an offering to the church, attended by soldiers and churchmen (Color Plate 23). The large flat figures are set against a gold and green background. Rather like the van Gogh this mosaic is dominated by two kinds of contrast: the dark brown (with bits of purple in it) worn by Justinian and the attendants on his left produces strong value contrasts with the white robes, while the hues worn by the soldiers—dominantly oranges and greens—are closer in value but strong in intensity contrasts. Note the repetition of the orange and green in the censer held by the cleric on the far right, and the dark-light contrast carried into the feet of the soldiers.

This means of controlling contrasts is found in the inner pattern of the double border below the figure-group, which consists primarily of the contrasting hues of red and blue-green while the outer one is made up of neutral value contrasts. Together they both emphasize the surface—just as the different types of contrast within the figures do.

Another example from the Middle Ages is a twelfth-century window from Chartres Cathedral (Color Plate 10). The starting point of the color organization is the dark of the surrounding stone and the grid of iron bars. The lightest colors make the strongest contrast against the dark. They are therefore used sparingly, while the darkest colors—mostly reds and blues—are used in larger quantities. The blue and red backgrounds frequently alternate: in the top section the seated Virgin and Child are against blue, while on either side the blue-clad angels are seen against red. But the reds and blues clearly dominate all other colors and the lighter areas act as accents. There is thus a size-contrast relationship that has the effect of equalizing the visual attraction of all parts of the window. When there is an emphasis it tends to reinforce the symmetry by a moderate concentration of the larger lights in the central vertical row.

Whether by control of contrasts or adjustment of sizes (and usually both of these enter in), the

result is color which enhances a two-dimensional surface. The general term *decorative color* is useful to describe the equalizing of attractions that characterize a surface-conscious use of color, whether medieval or modern.

Color and Space

Color can also be used to enhance the three-dimensional aspect of a painting. Rubens' *Kermesse* (Fig. 4-6) is a work that makes effective use of color to increase the illusion of depth. It is a scene of peasants celebrating a holiday in an unrestrained way. Much of their action with its spiraling motion and strong foreshortening helps create a sense of movement back into the picture space. So does Rubens' use of color. In the detail of dancing couples (Color Plate 11) the dancers are arranged in a semicircle in space with two spiraling couples marking the center of the arc. To make the couples in the center and at the ends of the arc appear closer, Rubens placed three intense reds at these points. Combined with the

reds are the black and white worn by the central women and the quite intense pale blues at each end of the arc. Moving backward into space from these points, the colors are less intense, so that the two furthest figures are nearly gray. The reduction is gradual: notice how the pink on the second woman in from the left acts as an effective intermediary in placing her between the first and the third. The result of such sensitive choosing of colors for each plane is a convincing thrusting of forms forward and back in space—the exact opposite intention from either Matisse or the artist of the Ravenna mosaics.

Inherent intensity (the reds and blues) and contrast (the blacks and whites) are the color means by which forward planes are established here. The reds play an especially important role because of what seems to be a special power to advance forward. Warm colors in general, when they are fairly intense, seem closer to us than cool colors do. A glance back at Chart I reveals that the left side of the chevron of hues tends to float forward in comparison with the right side. This is an optical effect, due to the fact that the red wave

4-6 Peter Paul Rubens, *Kermesse*, c. 1635-36. Oil on panel, approx. 60″ × 104″. Louvre, Paris.

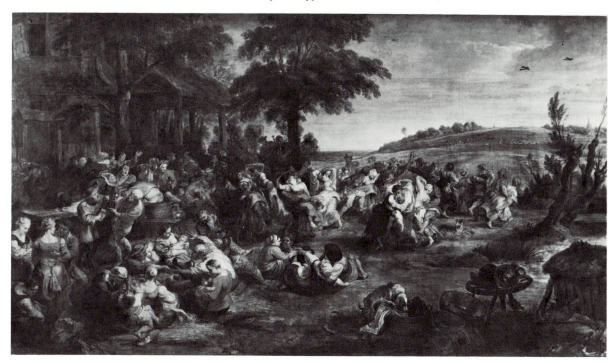

lengths are longer than the blue wave lengths and hence bend less in the lens of the eye. A pronounced result of this difference in focal length is seen in some examples of "optical art" such as Richard Anuszkiewicz's *The Fourth of the Third* (Color Plate 12) in which the direct juxtaposition of red and green creates a vibration in our perception of the colors. Another optical effect is found here: the apparent shift in hue of the red ground, which is actually constant, as the squares change from green to blue. The sensation of a more purple red in the blue region, in contrast to the more orange red in the green region, is the result of an optical mixture of colors known as a *spreading effect*. The green warms the red while the blue cools it, and the red affects both of them.

Other Types of Color Organization

Some of the color effects we have considered have a relation to other aspects of form. For instance, the uniformity of attraction in a stained-glass window is partly due to the all-over character of the design. Limited color ranges, as noted, are analogous to general uniformities, such as those of shape or direction, because they relate all parts to the whole, namely the dominant tonality. Color is of course often involved in balance, since visual attractions of all kinds enter into balance. Color likeness can also affect groupings, and alternations can be used in color as well as they can be in shape or direction.

One of the more interesting parallels is the one that exists between gradations in color and other visual elements. Gradation, or regular change, is perceived in hue, value, and intensity. The order in gradation is especially apparent when two or all three of the attributes are changing, as in a rainbow or in our color charts. The charts and the color solid are, in fact, the product of a spatial ordering of the principles of uniformity *and* gradation in the attributes of color. Any movement along a straight line or a regular curve in the charts (or solid) involves a gradation of hue, value, or intensity or any combination of these. It is easier to see than to explain gradations. Flower petals, sunset skies, atmospheric effects changing with distance, the passage from lights to shadow on a colored object—all these are everyday experiences of color gradations—and many artists make good use of this kind of organization.

Cézanne's *Still Life with Geraniums* (Color Plate 13) is filled with color gradations—those involving changing hues are the most apparent. On the table top there are numerous gradations, sometimes referred to as modulations, of color, chiefly from warmer lights to cooler darks. With different hues there are similar modulations in the background and on the flower pot. But most obviously there are hue gradations on the apple and the pear where they accompany the value gradations of the modeling. The sequence from red-orange through yellow to green on the pear is regular enough to remind us of the upper half of a hue circle, while at the same time effectively modeling the form of the fruit.

A comparable use of gradations to achieve color richness is found in Italian painting of the late Middle Ages and Early Renaissance. In Giovanni di Paolo's *Dance of Salome* (Color Plate 14) the modeling of the forms is accompanied by different types of color gradations. Salome, at the lower right, has a gown that grades from red in the shadows to white in the lights. The robe on which Herod sits, at the far left, is similarly modeled. One of the figures on the other side of the table has a robe that models from red-orange in the shadow to yellow in the light while the dark green robe on the figure beside him models toward black. The two figures at the extreme right repeat these contrasting treatments. The green-black combination appears again in the upper background. Finally the floor consists of two interplaying color gradations: the yellow squares become lighter moving upwards while the green-gray borders become darker. These various gradations, varied but equal in attraction, combine with the flat colors in the steps and the background and with the details in the table region, including the head of John the Baptist, to produce decorative color of a high order.

We found in Chapter Two that gradations in patterning produce a sense of movement as the eye follows the direction of change. The same is true of color, and this was used very effectively

by the Italian Futurist Umberto Boccioni in his *Dynamism of a Soccer Player* (Color Plate 20). Hue and value gradations are interwoven here in a rich complex of forms in which color contributes as much to the sense of movement as the forms themselves.

Color Effects and Painting Techniques

Artists have explored many more effects of color than we can discuss here. Some of these will be considered in later chapters but one more should enter the discussion now. It has to do with the application of color to a surface in small varied strokes or pieces rather than in broad simple areas. Both the Ravenna mosaic and the Cézanne painting have some of this quality which, since the period of Impressionism, has been called *broken color*. It refers especially to an effect of fusion of many small separate color sensations into a large general tone of more or less uniform color. An extreme example of such fusion can be observed in any of this book's color reproductions, which are made up of thousands of tiny dots of yellow, red, blue, and black that are too small to be resolved by the eye. It is, however, the quality resulting from *near-fusion* that has been intriguing to artists of different times and places. The French Impressionists carried the effects of near-fusion to a high level of effectiveness, and in the work of Georges Seurat the principles were applied with great precision. Color Plate 15 is a detail of a study by Seurat for his large painting *A Sunday Afternoon on the Grande Jatte* (see Fig. 15-17). The color throughout is applied in small flecks which both stand out from and become fused with the general color of an area. This animated surface approaches the luminous effect of outdoor light better than if it were not broken. The grass in sunlight has flecks of yellow, yellow-green, and green, with occasional pale blues that modify the high intensities of the yellows. In the shadowed area of grass liveliness is achieved by flecks of red and blue in the green. Yellow-green dominates the sunlit area due to a spreading effect that increases as we move back from the surface. Dark green dominates the shadows in the same way. Yet even at a considerable viewing distance the flecks of different colors are never completely lost—the sense of near-fusion remains.

Monet and Seurat carried the effects of sunlight further by eliminating nearly all low-intensity colors from their palettes. Very little mixture with black is evident in the Seurat study; rather, intense colors are mixed with white or pale yellow and the darks are deep reds or blues. Referring to the color triangles again, it is as if their colors were concentrated in the regions of the top edges of each color triangle: the products of mixing full-intensity colors with white. Of course, painters have access to a vast number of actual hues other than the six used in charting colors here.

Another fact about color perception that was used effectively by the Impressionists and by Seurat is called *simultaneous contrast*. This is the tendency of one color sensation to generate its opposite in adjacent areas. A red looks more intense next to a green and a white is brighter next to a black. Since Seurat was interested in giving his colors their greatest strength he frequently placed reds against greens (see the red parasol and the man in the red jacket at the lower left in the study for the *Grande Jatte*). Similarly, reddish purples are set against their complementary colors, yellow-greens. And in value contrasts, the shadowed foreground is gradually darkened as it approaches the sunny area in order to maximize the contrast at the shadow's edge. It will be noted that the effect of simultaneous contrast is exactly opposite to that of a spreading effect, as in the Anuszkiewicz, where colors threaded through each other looked more alike than more different.

A consideration of color in painting would not be complete without mention of the role of the various mediums. Colored areas look different depending on how they are applied to a surface and the nature of that surface. This is not the place to go into details of painting techniques, but we should mention some of the ways in which colors that can be defined as identical (in hue, value, and intensity) are made to appear different because of the painting medium employed.

Color in most painting is originally in the form of a *pigment* of finely ground particles mixed with a *binder*. Oil is the binder in oil painting, egg yolk in traditional tempera painting, a water-soluble gum in watercolor, and so on. The rich effects of some oil paintings are due to the fact that the binder is thick and somewhat translucent when dry. A glossy surface is essential to this effect, examples of which include early Flemish painting (such as Color Plate 17) and the paintings of Vermeer (Color Plate 27). Specifically, high intensities at low values are what make such paintings look rich. By contrast, fresco paintings, which are done on plaster walls, have matte, or dull, surfaces and are typically rather pale in appearance (see Color Plate 16).

Oil paints can be handled both transparently and opaquely. While the differences are not always plainly evident there are conditions that enhance them. A light-colored ground can reveal transparency (see Color Plate 4), as can different textures, since more paint gathers in the hollows and less stays on the ridges (see Color Plate 24). Some contemporary artists use paint as a stain, or very thin glaze, and the canvas texture imparts small variations to the colored surface. In contrast, tempera painting has a solid, opaque surface, as in the picture by Giovanni di Paolo.

Watercolor is another medium that produces a matte surface (see Color Plate 1). Its special quality is the result of floating pigments being deposited in a film that retains some of the unevenness of the liquid state. It is also distinctive for its relative transparency—the result of light being reflected from the white paper through a film of color (called a *wash*). It is impossible to describe the difference between a color produced by a watercolor wash and an identical opaque color, but it is very apparent to the eye. An analogy is the very different sound of the same musical note as produced by a violin or a flute or an oboe. Such differences are partly lost in the process of making color reproductions in books; there is no substitute for seeing works of art in the original.

PART TWO

REPRESENTATIONAL ORGANIZATION

There is no single word that stands for the ordering of representation in art the way that *design* stands for abstract ordering. Yet without some sort of consistency in their representation, images would be as chaotic as a jumble of lines and shapes would be without uniformities and sequences. From the comparison of two paintings in Chapter One—the Domenico Veneziano and the Degas—we were able to understand the different approach to the representation of light by each painter. In the next three chapters we will study ways in which not only light but also solid form, space, structure, and other aspects of the visual world are subjected to selective processes that produce convincing images. Learning to "read" these images is almost like learning different languages—or learning different dialects within the language of representation. This is the theme of Chapter Five.

Chapter Six takes up the special problem in painting of rendering the three-dimensional world on a two-dimensional surface. In both this chapter and the previous one a question that comes to mind is: why are there different languages? Or, put another way, why do different people see so differently? While there is no simple answer to this question, it has been pointed out that painters, for instance, don't paint what they can see, they see what they can paint—that is, what is within the realm of their techniques of representation. Again, comparing representation with a language, what is expressed in words must,

in the end, depend on the available words and the ways these words can be put together. Fortunately, artists have evolved a rich vocabulary of representational means.

In Chapter Seven various solutions to the problem of creating the illusion of reality in art will be studied. How is it, for instance, that artists arrive at more convincing illusions than those of the photographer? We will find that it has to do with the fact that while the camera makes visual records, only the eye and mind can see. And because some artists see in a more penetrating way than others we shall become involved with qualitative differences among artists in this chapter. All people speak a language but only a relative few speak or write it extremely well—and the same holds true for artists.

Finally, a word should be said about the coexistence of the abstract and the representational in art. When engaged in analysis, we tend to suppress the perceptions that do not contribute to this analysis, but even though the focus will be on representation in the next three chapters this does not mean that the abstract aspects of art disappear. We are still looking at works of art that are designed and in our normal aesthetic response to them we do not separate one aspect from another any more than, when listening to music, we separate our perception of harmony from that of melody. The aesthetic attitude erases the differences that the analytical attitude forces upon us.

5
The
Language
of
Representation

We all have discovered familiar objects in natural forms, such as a piece of driftwood that looks like an animal or the side of a cliff that resembles a face. Picasso took this a step further when he brought together the handlebars and the seat of a bicycle to create a third object, his amusing bull's head (Fig. 5-1). The thrill of recognition is a compelling aspect of art, and especially when the object can be seen, like Picasso's bull, as the components themselves as well as the new way of reading them.

In early cultures there has often been an interest in pure materials and forms that is at least equal to the interest in creating recognizable images. The goblet-shaped vase from Susa (Fig. 5-2) would hold our attention as an object decorated with sure brush lines; but when we notice that the lines also depict a long-horned goat our interest is more than doubled.

These works introduce us to representation at what may be called the *recognition level*. The animals are clearly recognizable and, in the process of recognition, gain a kind of unification. Notice the different way we respond to the shapes that surround the neck of the vessel when we see them as long-necked birds and not just as vertical stripes. As birds, they exert more of a pull on our attention to see an occasional one as an individual, and we are less ready to perceive the whole set at once. Our study of representation will become involved with many similar, if more complex, instances of the unification of perception through the force of representation.

The first step into greater complexity is to consider how, in making the translation from nature into art, artists go beyond simple recognition to arrive at an internal working-together of parts that can be called *representational consistency*. As we move toward a more historical discussion in later chapters we will discover that the kinds of consistency we are about to discuss are frequently the products of cultures which have evolved different visual languages much as they have evolved verbal languages. When considering works of art as products of cultures we will use the term *style*, as we do in Chapter Ten and subsequently. But when we are trying to understand the form of the individual work of art we find the term *mode of representation* to be more useful.

5-1 Pablo Picasso, *Head of Bull*, 1943. Handlebars and seat of a bicycle, 16⅛″ high. Musée Picasso, Paris.

5-2 *Painted Beaker*, Susa, c. 5000–4000 B.C. Louvre, Paris.

For one thing, it separates the representational from the abstract character of the work, hence making it simpler to analyze.

5-3 *The Rampin Head*, Greece, c. 560 B.C. Louvre, Paris.

Modes of Representation

Our study of the modes of representation begins with three heads from a relatively brief period in a single place in which a change of modes occurred: Greece in the sixth through the fourth centuries B.C. The first, a head from the Archaic Period (Fig. 5-3), is a simple ovoid mass into the surface of which are cut the features and the patterns of hair and beard. Geometric regularity of lines and shapes and crisp, linear definition seem more important to the artist than detailed description of organic forms. The planes of forehead and cheeks are characterized by near-geometric simplicity with a clear differentiation between concave and convex surfaces. The artist was reluctant to cut deeply into the large mass, as we can see in the way the eyes come forward to

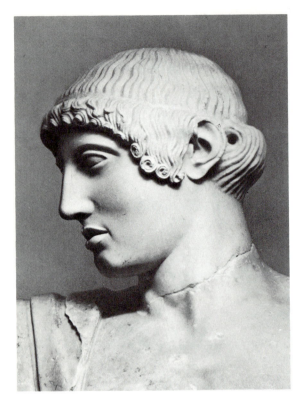

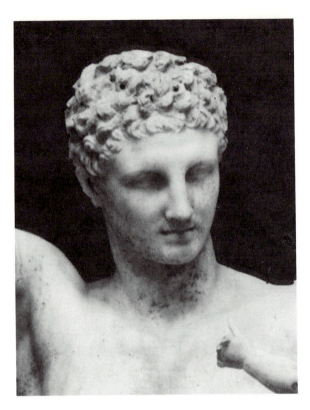

5-4 *Head of Apollo*, detail from the west pediment of the temple of Zeus at Olympia, *c.* 460 B.C. Marble, slightly over life-size. Museum, Olympia.

5-5 Praxiteles, *Head of Hermes* (detail), *c.* 330-320 B.C. Marble, over life-size. Museum, Olympia.

the same surface as the cheeks, the brow, and the bridge of the nose. Linearism makes possible the presentation of the simplified mass.

Another kind of consistency is found in the second head, an Apollo from the temple of Zeus at Olympia (Fig. 5-4). The real structure of a head and the organic relation of the features to this structure have become more important. Here the eye is set *into* the hollow between the brow and the cheek and the mouth follows the *roundness* of the lower part of the face. Sharp linear contours are no longer used to describe the lips. The curls at the edge of the hair turn under and into a different plane from that of the wavy hair above, creating a strong recession back to the forehead. The effects in this sculpture are less linear than in the Archaic work and more modeled, or *plastic*.

A third, equally consistent solution to the problem of translating a head into sculpture is found in a work by Praxiteles (Fig. 5-5). Now the

retreat from linearism is complete; Praxiteles seems to have been as reluctant to employ surface lines as the sculptor of the bearded youth was to cut deeply into the stone. The lips are defined almost completely by plastic means and the hair has lost all appearance of individual strands, being made up instead of locks that are strongly three-dimensional. The eyes are set even more deeply into their sockets than in the Apollo.

Each of these three heads employs a different mode of representation which is characterized by an internal consistency: it would be stridently inconsistent to introduce a feature of one head into one of the others, or to cap one head with the hair of another. Representational consistency reflects the recognition by an artist of a dominant point of view toward reality: it is the artist's view of what is of prime importance and what may be suppressed or omitted.

It would be useful to have a simple set of descriptive terms to refer to such differences as we

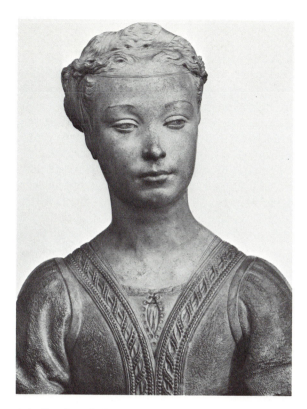

5-6 Desiderio da Settignano, *A Princess of Urbino,* c. 1475. Limestone, approx. 18″ high. Staatliche Museen, Berlin.

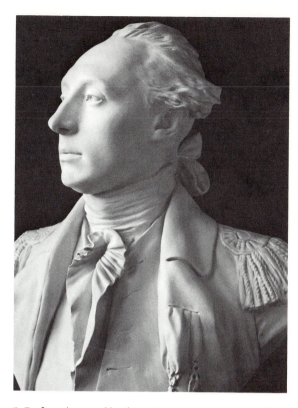

5-7 Jean-Antoine Houdon, *Marquis de Lafayette, c.* 1785. Plaster, life-size. The Athenaeum, Boston.

see in the Greek heads, but because we sense many types of differences it is difficult to choose the salient ones that will provide us with key distinctions. For instance, the Archaic head is linear, immobile, and rigid, while the head of Hermes is plastic, mobile, and fleshy. Among these differences we choose *linear* versus *plastic,* because they seem more capable of generalized application. But the head of Apollo is also plastic, so another means of differentiation is necessary between this and the Hermes. The former is more tactile, in that the very well-defined masses with their decisive edges appeal to our sense of touch. The latter depends more on direct visual perception, as the raised surfaces pick up a maximum amount of light while the hollows sink into shadows. The most effective words to designate the differences might therefore be the term *sculptural* for the Apollo and *pictorial* for the Hermes. *Sculptural representation* implies the tactile response we have to the Apollo while *picto-*

rial representation suggests the dependence on light and shadow, very much like paintings that employ lighted and shadowed areas. Both these may be contrasted with the linear mode of representation found in the Archaic head.

These are very loose designations that provide us with a foundation on which can be built more refined differentiation among examples of sculpture. Two portrait heads from later European art can be compared with the use of the same terms. A portrait by the fifteenth-century Italian Desiderio da Settignano seems basically sculptural in its interpretation (Fig. 5-6), while a portrait by the eighteenth-century French artist Jean-Antoine Houdon is more pictorial (Fig. 5-7). The clothes and the way they relate to chest and shoulders present the most obvious difference. The dress in Desiderio's lady follows the forms of her body, making its shapes even clearer by the way the linear decoration wraps around them. The jacket and shirt front of Houdon's *Lafayette* create con-

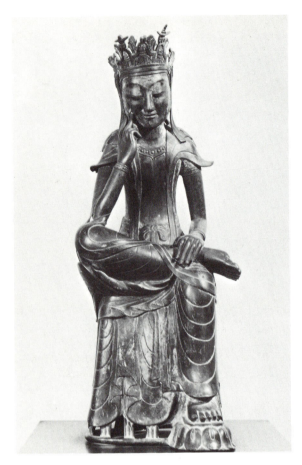

5-8 *Maitreya,* sixth to seventh centuries A.D. Gilt bronze, 30″ high. Korean National Museum, Seoul.

lines are found in the folds of the garments and the depth dimension is suppressed, as we notice in the abbreviated length of the thighs. In the face, the planes of the nose are differentiated by edges that register as lines. We would not confuse this head with an Archaic Greek head in its over-all style, but the linearity of the approach to the problem of translating natural forms into sculpture makes the two works formally related.

In a contrast similar to that which we just observed in Western sculpture, the gigantic wooden figure of a Buddhist guardian by the Japanese sculptor Unkei is strongly plastic (Fig. 5-9). Its folds are deeply carved and the face and body

5-9 Unkei and others, guardian figure from the South Main Gate at Todai-ji in Nara, early thirteenth century A.D. Painted wood, 28′ high.

stant light and shadow differences that embellish the basic forms. In the woman's face lines define the edges of masses in a clear and tactile manner, while in the man's face the surfaces of the cheek and brow ripple slightly to catch light. The spherical surface of her eyeball is preserved while in his eye the pupil is hollowed out to catch shadow and a little bead of plaster imitates a highlight—something with no tactile existence at all.

Clearly not all sculpture can be fitted neatly into these three modes of representation. Yet these do provide us with a useful set of terms to use when we are considering the consistency of an artist's approach. For example, a Korean bronze image of Maitreya, the Buddha-to-be, is strongly linear in representation (Fig. 5-8). Crisp

have strong protrusions and deep hollows, so that we can speak of this work as a pictorial translation of natural forms.

Since the differences between sculptural and pictorial modes are more difficult to grasp than the contrast of either with a linear mode, one more comparison may be useful. Michelangelo's *Medici Madonna* (see Fig. 7-16) is thoroughly sculptural. Every form of head, body, or limb is fully plastic, and yet there are very few deeply cut regions that are in full shadow. It is as if Michelangelo wanted to keep the tactile surface always in evidence. In contrast, Gianlorenzo Bernini, working a century or so later, filled his sculpture

5-10 Gianlorenzo Bernini, *Habakkuk*, 1655–61. Marble. Santa Maria del Popolo, Rome.

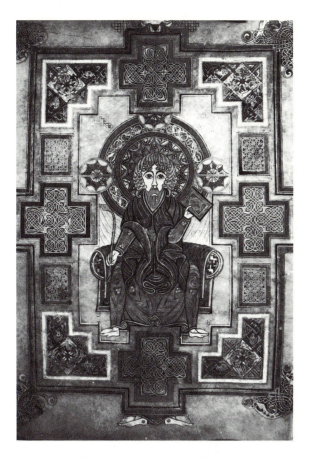

5-11 *Saint John*, page from the *Book of Kells*, Northumbria, eighth century. 13″ × 19½″. Trinity College Library, Dublin.

Habakkuk (Fig. 5-10) with deeply cut hollows which are always in shadow because Bernini took into account the source of light in the chapel when he designed his figure group. The forward-jutting limbs are just as assured of catching the light, and much of the dramatic force of the group comes from contrasting the fully lighted face of the prophet with the shadowed face of the angel.

The Linear Mode in Painting The modes of representation in painting are comparable to those of sculpture. For an example of the linear mode in painting we can look at an Anglo-Irish work of the early Middle Ages, an illustration in the *Book of Kells* (Fig. 5-11). Here the artist was concerned with conveying the basic concept of the figure of St. John and had little regard for

proportions and none for the creation of solid forms. Objects are differentiated or described by lines and by colored areas. Clearly the symmetry of the seated figure and the abstract patterning of lines was more important than a study of natural forms. Everything is consistent with the flatness of the richly decorated page, very like the page from the nearly contemporary Lindisfarne Gospels (see Fig. 2-15).

Later in the Middle Ages painters continued to employ a basically linear mode, as we can see in the Gothic manuscript page with the story of David and Goliath (see Fig. 6-8). It is no longer so purely linear, however, for there is a hint of modeling present in the garments. The form of Goliath's leg is partially described by a graded tone, for instance, which is what we mean by "modeling." Yet the line continues to have the basic function of establishing contours (i.e., significant edges and details). The lines are more flexible: note the skirt of the man removing his cloak in the last scene and how the tapered lines suggest the folds of the skirt emerging toward the bottom.

Overall, then, the mode of representation was still linear, though not as absolutely linear as the St. John from the *Book of Kells*. The language of painting was evolving toward a more plastic kind of depiction which would soon evoke the illusion of solid forms.

A rich tradition of linear representation also existed for many centuries in Asia. Typical of this tradition is the scroll *Ladies Preparing Newly Woven Silk,* possibly painted by the emperor Hui Tsung (Fig. 5-12). Compared with the St. John of the *Book of Kells,* the drawing here is quite natural—that is, the human proportions conform more closely to nature and recession is suggested by the way the figures are drawn. But definition is still based on line and *local color* (the color of

5-12 Emperor Hui Tsung (?), *Ladies Preparing Newly Woven Silk* (detail), early twelfth century. Ink and colors on silk handscroll, approx. 15″ high. Museum of Fine Arts, Boston (Chinese and Japanese Special Fund).

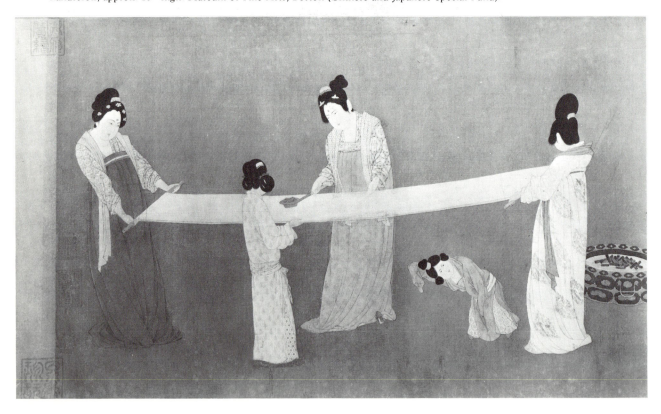

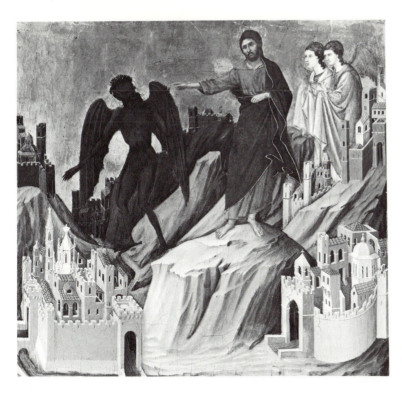

5-13 Duccio, *Temptation of Christ on the Mountain*, detail from the Maestà Altarpiece, 1308-11. Tempera on panel, 17″ × 18⅛″. The Frick Collection, New York.

objects, such as flesh, hair, and clothes), which is applied as perfectly flat tone. The strong dependence on line in this painting is closely related to the dependence found in the Korean *Maitreya*.

A different, broader treatment of line can be seen in the work of another Chinese artist, Ch'en Jung, who painted the nearly monochrome *Nine Dragon Scroll* (see Fig. 7-21). The soft, undulating lines of the water and the knobby lines of the neck and claws of the dragon still have the function of defining contours and suggesting planes in space. Tones that are not simply local colors are also found here, particularly those surrounding the dragon, but they do not convey roundness by modeling. Rather, they reinforce the lines by suggesting planes forward and back by their relative lightness or darkness. But the mode of representation remains basically linear, with the point of the brush, wider or narrower according to the artist's aims, being the means of depiction.

Linear representation comes naturally to artists or cultures dealing primarily with concepts. Much information can be conveyed visually by lines and flat tones, as children's art shows. A child's remark when asked how he made his drawings sums up the situation: "I just think of something and draw a line around the think." Yet linear representation does not belong exclusively to primitive cultures, comic strips, or children; *Ladies Preparing Silk* is a most sophisticated work, as is the art of Henri Matisse in our own century (see Color Plate 4). Directness, simplicity, clarity—such qualities seem to belong to a linear mode of representation.

The Sculptural Mode in Painting The greater the interest in the perceptual world, the more attention artists are likely to give to the development of means of creating illusions of visual reality. Dissatisfaction with linearism led the artists of the Middle Ages toward a greater plasticity. Although fragmentary modeling was sufficient for the artist of the David story, the Italian artist Duccio, only a generation later, gave greater importance to modeling and virtually eliminated the strong linear contours seen in the manuscript. In Duccio's painting of the *Temptation of Christ* (Fig. 5-13) the rounding of forms such as the hill on which Christ is standing is done by modeling and the features of the faces

are not outlined. The gold background, the disparity of scale between figures and buildings, and the traces of linearism in the clothing tell us that Duccio's approach was still very conceptual—the conveying of an idea was more essential to him than the creation of an illusion of forms in space. Nevertheless, the approach was different enough to indicate that Duccio was moving toward a sculptural mode of painting.

For a developed example of sculptural representation by the painter who more than any other established the dominance of solid forms in Italian art we turn to Giotto. His fresco painting of the *Presentation of the Virgin in the Temple* (Color Plate 16) is decidedly more sculptural than Duccio's. Each figure is modeled clearly as a separate form in relation to a general light coming from the left. The cubic forms of the temple and its steps are reinforced by having their left sides in light and their right sides in shadow. Every change in the values of the colors connotes a change in plane in the forms. Giotto was so concerned to keep the form-defining function of his tones that, while modeling shadows are of great importance, he disregarded all cast shadows (shadows of objects that fall onto the ground or other objects) because they would disrupt the forms of

the objects they fall on. Hence the large figure of St. Anne, who gently urges her daughter Mary forward, casts no shadow on the steps. Other "accidents" of light such as reflections of the source of light or of other objects on the surfaces of forms are also eliminated from this selective use of lighting to define three-dimensional forms.

In this chapter and in the following two chapters our attention is focused upon the representational aspect of art to the nearly complete exclusion of other factors, including subject matter. The subject matter of this painting is taken from the Apocryphal Book of Mary. The three-year-old Mary is shown being brought to the temple to be given up to the service of the Lord until her fourteenth year. Assisted by her mother, and with her father standing at the left, she ascends the flight of steps—also mentioned in the account—to be received by the high priest at the temple entrance.

When we use the term *representation* we are not referring to the manner of presenting this subject matter, but to the manner of representing (re-presenting) what can be called the *object matter*. By this we mean those qualities we perceive in the visible world: three-dimensional forms, the structure of objects, three-dimensional space,

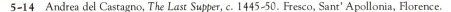

5-14 Andrea del Castagno, *The Last Supper*, c. 1445-50. Fresco, Sant' Apollonia, Florence.

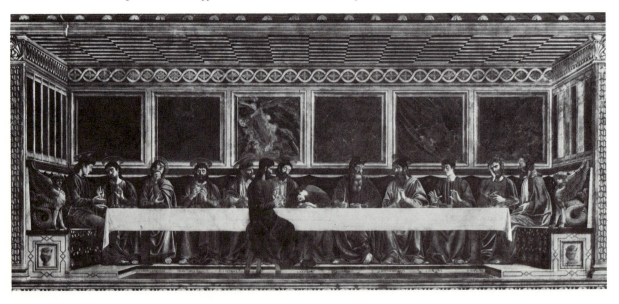

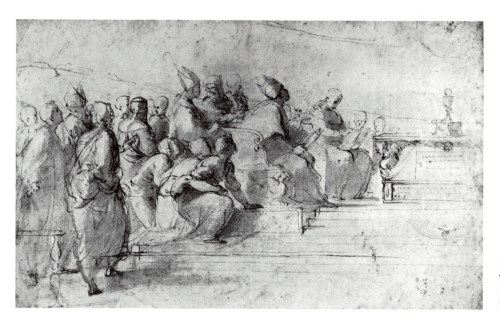

5-15 Raphael, *Study for the Disputa, c.* 1510. Pen and wash drawing. British Museum, London.

light, local colors, textures, and so forth. These and other universal qualities of nature will be the focus of our attention as we follow in a rough chronological order the evolution of representation in European art.

This concern with sculptural forms continued through the fifteenth and early sixteenth centuries in Italy, with a good deal of diversity. Some artists modeled their forms rather flatly, so that the results bore more of a resemblance to relief sculpture than round sculpture. Others rendered the forms with emphatic modeling so that their paintings simulated sculpture in the round, or in very high relief. Among the latter was Andrea del Castagno, whose *Last Supper* (Fig. 5-14) contains thirteen strongly modeled figures with stone-hard surfaces. All are given an equal degree of modeling regardless of their distance from the two windows on the right wall that are the ostensible source of illumination. Furthermore, their legs and feet, which in any natural treatment of light would be in the cast shadow of the table, receive the same amount of light and therefore are modeled just as much as their upper bodies are. We may conclude, then, that the dominant aspect of the perceptual world to Castagno was solidity—tactilely realized sculptural form.

We also notice that the forms are simplified as

well as clearly defined. There is a consistently tubular character to the apostles' clothing, and the equally simple shapes of heads and features belong to the same consistent language of sculptural form. There is a strong parallel between this kind of painting and the approach to actual sculpture seen in the Greek Apollo (Fig. 5-5).

The great clarity of these figures suggests that the artist thought of the rendering of solid form as a problem separable from other problems like composition, coloring, or expression of emotion. We do know from the many Renaissance drawings which have survived that the first steps in the evolution of a painting consisted of making studies of form. In drawings like Raphael's study for a large fresco—done about sixty years later—we see one stage in the process (Fig. 5-15). Other drawings for this fresco were done as detailed studies of individual figures, but this one is more of a compositional study, concerned with the grouping of figures and their arrangement in space. Compared with Castagno's picture, there is considerably more interest in light: note the shadows cast by some of the figures. Yet Raphael's central representational concern was with the individual forms of the figures, generalized as they are, and to this end all of the complete figures were given the same degree of modeling, each having the same degree of darkness in the

shadows. In the final painting the robes were done in several different colors, and some were lighter and some darker—but at this stage everything was treated as a basic white form. This approach to drawing, which can be called *form drawing*, simply eliminates all local colors or the values of these, that is, color values. Form drawing, thus defined, was nearly universal in the Renaissance and has been favored since by many artists who have been interested in the clear rendering of solid form. A camera aimed at people dressed in different colors must record the different color values in a black-and-white photograph, but the artist can easily "think away" local colors in order to single out three-dimensional masses. Since a black form has a minimum of modeling in nature, why shouldn't sculpturally inclined artists turn all forms white? Certainly one reason that the black-and-white mediums of engraving and etching were so popular in the fifteenth through the seventeenth centuries was that they allowed artists to distill three-dimensional form from the multicolored world and by doing so to achieve a particular kind of consistency (see Figs. 9-7 and 9-9).

The Pictorial Mode in Painting In discussing Greek sculpture we found an evolution in the modes of representation from linear through sculptural to pictorial. A similar evolution occurred in painting from the thirteenth to the sixteenth centuries. We have followed the first two steps in this process and have now come to the third. A *pictorial mode* in painting began to develop with an older contemporary of Raphael, Leonardo da Vinci, whose increasing interest in light is evident in his cartoon (a full-scale drawing for a painting) of the Virgin and child with Saint Anne (Fig. 5-16). In it there are large areas of light that have a glowing quality about them due to a lack of details in the full lights and to the prolonged half-lights that lead into them. (These produce what the Italians called *sfumato*, smoky effect.) The shadows are also large and, unlike those seen so far, obscuring. There is still a good deal of sculptural form but the sense of a tactile surface is diminished and the big light-dark effects are dominant. (We also use an Italian word for this: *chiaroscuro*, meaning light-and-dark.) The artist emphasized what we found in sculpture done in a pictorial manner—an interplay of light and shadow in the objects represented.

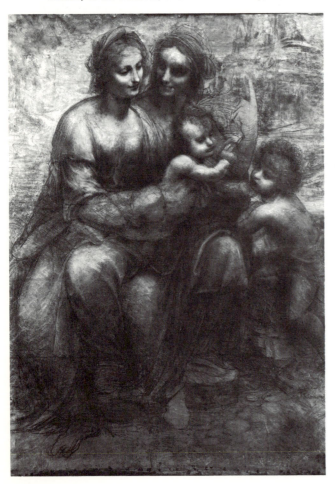

5-16 Leonardo da Vinci, *Cartoon for The Virgin and Child with Saint Anne and the Infant Saint John*, c. 1498. Charcoal on paper, approx. 54″ × 39″. Reproduced by courtesy of the Trustees, The National Gallery, London.

The *pictorial mode* of representation in painting came to maturity in the hands of several sixteenth-century painters in Venice. For example, in Titian's *Bacchanal* (see Fig. 5-17) we find a readiness to sacrifice sculptural form to effects of light as cast shadows from unidentified sources fall across figures and landscape. The central group of figures is turned into a dark silhouette against the white cloud by being thus arbitrarily thrown into shadow. The dark mass of trees at

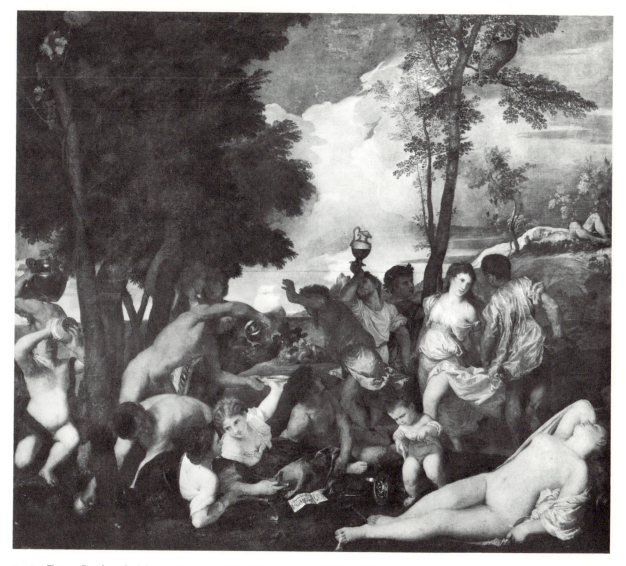

5-17 Titian, *Bacchanal of the Andrians,* c. 1520. Oil on canvas, 68¾" × 76". Prado, Madrid.

the left has a minimum of interior modeling. Areas of light seen against dark are equally significant—the sleeping girl and the dancing nymph above her, for example. This pictorial thinking made possible a greater compositional richness, since the artist was freer to manipulate his light-dark contrasts than if he had felt a primary obligation to sculptural forms. No artist of the previous century would have darkened the upper half of a figure, as Titian has the central man with upraised hand, while letting a strong light strike the drapery around his hips. And in addition to its compositional effectiveness this arbitrary treatment of light and shadow makes possible a range of dramatic expressiveness that was hardly possible in a linear or sculptural mode of representation.

For this reason, as well as for reasons of design, pictorialism was the favored approach to painting for the next two and a half centuries. Let us analyze it in another work, Rubens' dramatic *Battle of the Amazons* (see Fig. 14-1). If we look at

the illustration from some distance, the large pattern of light and dark emerges strongly: the light-colored warriors and the lighter half of the bridge are set against the dark half of the sky; the dark horses and dark half of the bridge are set against the light sky. Below, the dark Amazons and their horses merge with the shadow beneath the bridge while, on the right, the tumbling Amazons and their horses are light set against darks. Without losing a sense of reality—indeed heightening the feeling of energy and movement—Rubens has brought the expressive power of light and dark into his complex subject by means of pictorial representation. To underline this point compare the *Battle of the Amazons* with the *Battle of Friedland* by the Academic painter of the nineteenth century J. E. Meissonier (see Fig. 15-9). Rubens' painting is much more expressive of action and excitement.

The Visual Mode in Painting Our final mode of representation, a *visual mode,* is more literal in the sense that it depends more on given effects of light in nature. It was practiced alongside of pictorial representation and is often not easily separable from it—in fact, details of the Rubens are painted with close adherence to a natural light effect; it is the picture as a whole that is made up of highly arbitrary lights and shadows. When whole pictures adhere closely to the light effects of nature we need to have another term for this approach to representation: a useful, though not very descriptive term, is a visual mode. This is a shortening of a mode of visual effect, which is more descriptive but also more cumbersome.

Painting in a visual mode minimizes the conceptual element and takes into account all the major objective aspects of seeing. Its earliest manifestations in the European tradition are found in Flanders in the fifteenth century, particularly with Jan van Eyck. His portrait of Giovanni Arnolfini and his wife (Color Plate 17) presents the couple standing in the full light of a window just out of the picture to the left. Another window seen in the painting illuminates the back wall and the intricate convex mirror. All effects of light, such as the cast shadows of the slippers and the window sash, and the bride's shadow on the bed, are caused by one or both of these windows. The lady's headdress throws a reflected light onto the shadow side of her cheek and the chandelier is animated by many highlights (the term for reflections of a light source). The extent of van Eyck's interest in visual matters shows in the tiny reflection of the whole scene, including the unseen window and the painter himself, in the convex mirror on the wall. In contrast with Castagno's *Last Supper* (Fig. 5-14) the light on the wall or floor diminishes as it gets further from the source.

All these factors contribute to the unification of the whole by light, but they would not produce the high degree of illusion of forms in light and space if it were not for van Eyck's refined observation of color relations in nature. In particular, as objects are modeled from light into shadow the values *and* the intensities are systematically reduced. A lighter local color, like the flesh, models down to a medium dark while a darker local color, like the green dress, models to a very dark shadow. Further, the green and the red of the bed hold a particular degree of intensity as they move toward, but never reach, the absolute black of complete shadow. Even in the very deep darks, therefore, the green and the red are kept distinct. This kind of precision that records the very orderly way in which local colors register different degrees of illumination, with contrasts systematically lessening as shadows increase, is the primary reason for the illusion we have referred to. Technically it is the medium the artist used, namely a thick oil, that enabled him to achieve strong enough intensities in the deepest darks to match those found in the deep shadows of nature.

The view of painting as an art capable of recreating effects of light in nature was held by other artists after Jan van Eyck. Many variations occurred—in Italy around 1600 Caravaggio emphasized the strong dramatic effects that could be evoked by a spotlight type of illumination. In his *Supper at Emmaus* (Fig. 5-18) all the forms are revealed by a single specific source of light which does very little reflecting about the room and therefore produces dark and obscuring shadows. Unlike the shadows in a painting by Titian they

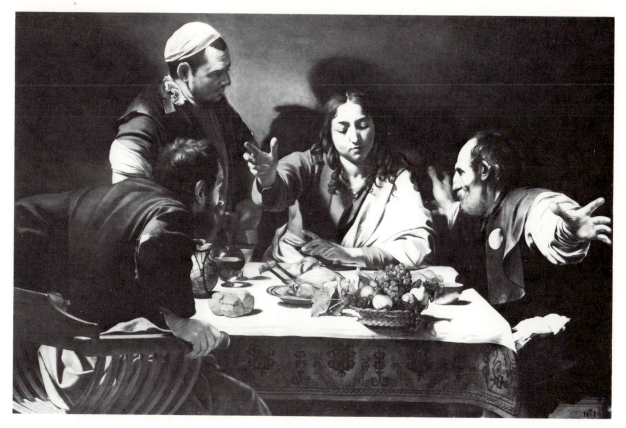

5-18 Caravaggio, *Supper at Emmaus,* late 1590s. Oil on canvas, 55″ × 77″. Reproduced by courtesy of the Trustees, The National Gallery, London.

are directly traceable to the source of light, which gives them their stronger illusion of reality. An underlying purpose of Caravaggio's art was to make religious stories more convincing than ever by having the people and the settings resemble everyday life; here the pilgrims look like regular workmen. A visual mode of representation was the obvious way of carrying out this program to a logical and consistent conclusion.

In isolating different broad manners of representation in sculpture we examined three major modes, in painting we examined four. The reason for the difference is simply that a painter can create and control light in ways a sculptor cannot; the visual mode is a mode of controlled light effect. Light may be revealed by falling on detailed, sharp-edged forms as in van Eyck's Arnolfini portrait, or it may seem actually to break up

forms as it does in Berthe Morisot's *In the Dining Room* (Fig. 5-19). In Morisot's picture we are looking into the actual source of light within the room, the window, while in van Eyck's we see only a small strip of the outdoor light itself. Instead of modeling each form clearly, Morisot's light strikes the edges of the girl placed between us and the source and reflects off her hair, her shoulders, and each side of her apron. Similar highlights come from the surfaces of floor, chair, and table. Edges are lost, as in the cupboard door at the lower left, and the light seems animated by broad strokes of the brush. Despite such differences in execution the works of both van Eyck and Morisot were painted in a visual mode.

In analyzing the major plastic modes of representation (as opposed to the linear mode) we have followed the development of painting in

Europe from the fourteenth to the nineteenth centuries. But if our categories are to be useful in the discussion of representation in general they must be applicable to other times as well. Linearism, we saw, can be used in studying east Asian art. We can find a sculptural approach in some of the surviving paintings of antiquity and in some modern works. Since the Impressionist movement a hundred years ago there has been a recurring interest in pictorialism among artists working in representational styles. Such, for example, is the case with a portrait by Alice Neel, *Nancy and the Rubber Plant* (Fig. 5-20). The artist uses firm, almost crude lines to delineate the sitter's form and features as well as the outlines of the rubber plant and chair. Yet this linearism is

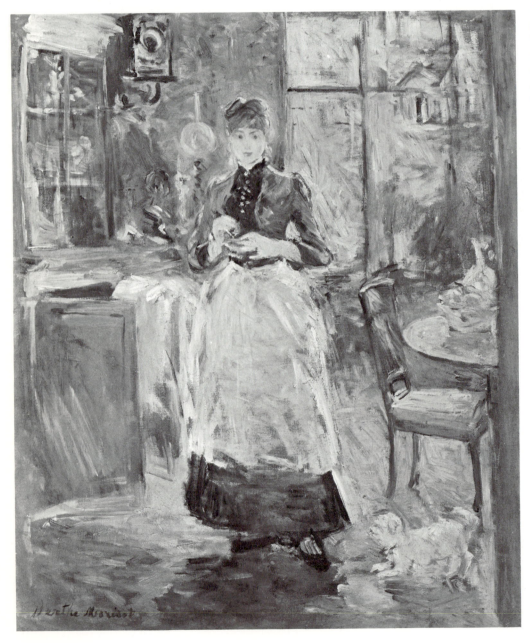

5-19 Berthe Morisot, *In the Dining Room*, 1886. Oil on canvas, 24⅛″ × 19¾″. National Gallery, Washington, D.C. (Chester Dale Collection).

5-20 Alice Neel, *Nancy and the Rubber Plant*, 1975. Oil on canvas, 80″ × 36″. Courtesy of the artist.

upper half of the painting. The full light on the knees is set into contrast with the more subtle reflected light on the face where our attention constantly returns. These various treatments of light seem more pictorial than visual, relating Neel's painting more to an artist like Titian than to Morisot or van Eyck.

The visual mode seems to have been an important part of the Western tradition from the fifteenth century to the late nineteenth century. While the mainstream of modern painting has taken other courses in the past hundred years, visual representation has not died out. Only recently a new interest in visual representation that quite frankly takes the photograph as its starting point indicates that the tradition is still alive. The Photo-Realists direct keenly perceptive eyes to seemingly unselective recording of every change in light and color, much as a camera does (see Fig. 10-15).

In concluding this account of some of the major ways in which artists organize their vision of the world we must remember that there are many intermediate areas between the categories described here. There are paintings that would be difficult to classify as linear or as sculptural, as visual or pictorial. We have seen visual paintings in which the definition is sharp, as it is with van Eyck, or diffused, as with Morisot. We noted a linear tendency in the essentially pictorial art of Neel and we can find a pictorial setting in the linear painting of Ch'en Jung. When the categories are no longer useful to us we should not try to use them. But much of the time they can suggest the consistency of the language of representation, an important aspect of visual form.

secondary to a tonal organization of the whole based on an arbitrary inclusion or exclusion of light and shadow. Cast shadows introduce a pattern on the floor and the leaf shapes animate the

6

Three Dimensions into Two

When a small child draws a ragged oval and identifies it as a dog, the first step toward spatial representation has been taken. The child thinks of this image as existing *in front of* the undifferentiated space around it, and so do we, once we recognize the image. From this simple example to the most complex two-dimensional renderings of three-dimensional forms lies the realm of pictorial space.

A few years later the child will want the drawing to tell more about a dog—how it stands or turns its head—and finds that considerable consistency is required to arrive at a convincing image. Having gone beyond the simple figure-seen-against-ground relationship, the young artist finds that certain rules will have to be followed in making the translation from the three-dimensional world to the two-dimensional surface of the paper. Some more or less consistent method of projection must be employed. In this chapter we shall explore three such methods which, like the contents of the last chapter, belong to the language of representation. Again, as in the last chapter, it is easiest to approach this topic by way of its historical evolution, since methods of projection tend to evolve from simpler to more complex. Hence our beginning point will be Egypt of the second millennium B.C.

Profile and Plan Projection

We have already spoken of certain conventions employed by some American Indian artists: to render heads in profile, shoulders full-front, and legs and feet in profile again (see Fig. 1–8). Childlike in its means of conveying simple information, this tradition of many early cultures is certainly not childish. It is instead quite rigorous in its search for the most essential qualities of a body or a face that could be recorded in a profile or frontal view. It goes beyond the basic figure-ground differentiation, suggesting pictorial space by relating forms to each other. A wall painting from a tomb in Egypt (Fig. 6–1) depicts a pond with fishes and ducks, bordered by flowers and surrounded by trees, in such a way that their relation to each other seems perfectly clear to us. Everything that shows up best in a side view is

6-1 *Pond with Ducks.* Mural painting from Thebes, Egypt, *c.* 1400 B.C. British Museum, London.

shown in profile and everything best revealed as if seen from above, like the pond, is shown in *plan.* The fact that the flowers spring from the edge of the pond and the trees from its border is told by the way they are placed above the pond and to the side of it. The lower row of trees is not upside-down but turned to what we think of as their natural upright position. We tend to interpret the lower objects as being in front of the higher objects, though the artist in no way insisted on this. The only times we are certain that one form is in front of another is when they overlap, but the artist was so little interested in questions of space that only the ducks, which come in pairs, are shown as overlapping.

The method of projection used here is certainly of the most direct sort. We know it today through its use in architectural or engineering drawings, where it is called *orthographic projection,* meaning that the lines of projection from object to image are perpendicular to the surface of the blueprint—the plane of projection. But architectural drawings have to be precise and sys-

tematic enough so that one can construct a building from them—quite a different purpose from that of rendering visual concepts—so rather than use the term which implies strict measurement, orthographic, we should use the more general term *profile and plan projection.* This covers the very free use of such a method by children as well as the more disciplined use by early civilizations.

The Greeks took over profile and plan projection from the Egyptians, combining its system with their own growing interest in the human figure in varied poses. A drinking *silen,* nicely fitted to the circular shape of the drinking vessel he decorates (Fig. 6-2), displays the pure profile of Egyptian drawing in his face and in the arm and leg on the left, but in other parts of the body some new interests are evident. The artist, wishing to produce a new pose, showed the forward thigh as if seen from the front and the foot as if seen from above; an Egyptian artist would have shown both from the side. The result is that a hidden calf is suggested and this is *foreshortened,*

6-2 Attributed to Epiktetos, *Silen with Drinking Horn,* Greece, *c.* 500 B.C. Vase painting, diameter approx. 3¾". Museum of Fine Arts, Boston (James Fund and Special Contribution).

in the complexity of forms in the figure is that the two forearms have different profiles, reflecting different aspects, again a decisive break from a conceptual rendering of things.

Diagonal Projection

In Chinese painting an interest in space emerged early and continued to evolve throughout the period corresponding to the first millennium of the Christian era. By the time of the Sung dynasty (A.D. 960–1279) a sophisticated means of spatial representation, which we may call *diagonal projection,* was well established, as can be seen in the section of a scroll painting of *Lady Wen Ch'i's Return from Captivity* (Fig. 6–3). Here all the figures are clearly located in a space defined by the layout of the buildings. (Lady Wen Ch'i is shown on the steps inside the courtyard.) The method of projection is based on a horizontal-vertical rendering of one face of the cubic forms and a foreshortening of the receding face. This reced-

that is, not shown in its full length. And in a desire to suggest some of the anatomical structure of the torso the artist had to foreshorten forms there too, although there is a quick change from a front view of the torso to a side view of the further leg. Another sign of the growing interest

6-3 *Lady Wen Ch'i's Return from Captivity* (detail), twelfth century. China, Sung dynasty. Ink, approx. 10″ high. Museum of Fine Arts, Boston (Ross Collection).

Elevation

Picture Plane

Image

6-4 Parallel projection.

ing surface is also represented on the diagonal so that *above and to the left* reads as *further back*. In general, the higher up a figure or object is placed the further away it appears to be. The figures and animals are foreshortened as the buildings are; the artist's command of rather difficult problems of foreshortening is seen in the horse in the center foreground.

We can again find a similar method of projection used today. It is a form of *isometric projection* and is like diagonal projection in that two sets of

perpendicular lines remain perpendicular in the rendering while the third, or receding set, is shown as diagonals, with above and to one side indicating further back. There is, however, no foreshortening of the depth dimension. Both orthographic and isometric systems are designed to be used strictly according to the rules, so that a building or object can be constructed from them. Methods of projection in drawing and painting, however, are to be used aesthetically, the artists' judgments and perceptions being their guides.

6-5 *Lady Wen Ch'i Taking Leave of Her Captors* (detail), twelfth century. China, Sung dynasty. Ink, approx. 10″ high. Museum of Fine Arts, Boston (Ross Collection).

This type of projection is called diagonal both because diagonals provide leading cues to reading the space and because parallel diagonals are employed in the process of projection. Suppose the problem is that of rendering a series of receding fence posts. Parallel diagonals are used to project them visually onto a flat plane, both in plan and in elevation (Fig. 6-4).

Two points about this system are worth special mention. First, the observer's position does not enter into the process of projection (as it does in perspective, as shown in Figure 6-10). This means that the observer is free to assume any position without changing the relation among objects in the picture, an ideal situation since the story of Lady Wen Ch'i was told on a scroll which was unrolled during the viewing. The second point is that there is no diminution of size with distance. The figures are all the same size and the height of the building at the upper left corner is exactly the same as that of the building at the lower right. While this makes for clarity it does impose a limitation—namely that the

amount of depth was brought to a stop by the top of the scroll. A solution was developed for this problem, which we can see in another section of the Wen Ch'i scroll (Fig. 6-5). This part of the story depicts the leave-taking of the lady from her Mongolian captors. In front of the tent is the sad parting (she had lived with her captors for several years) and in the rear are the Chinese escorts preparing for her return. The first episode is shown with everything in the same scale—in regular diagonal projection—while in the second episode everything is of a smaller scale. So, rather than the gradual diminution in size that we are accustomed to in Western art, there is an abrupt change from one size to another. There is considerable psychological truth to this way of rendering relative distance because in our normal perception of space we are not aware of a geometrical reduction in size with distance but only of a shift from larger to smaller, from more visible to less visible, from greater to less detail.

A variation on this technique is found in Chinese landscape painting, where it was used to

6-6 Tung Yuan, *Mountain Landscape with Winding Waters and Figures,* tenth century. Hanging scroll, 61½" high. National Palace Museum, Taipei, Republic of China.

6-7 *Virgin and Child Enthroned Between the Emperors Constantin I and Justinian I,* tenth century. Mosaic. Hagia Sophia, Istanbul.

represent extended space. Artists simply made a number of such shifts in scale from front to back, as we can see in this *Mountain Landscape* by Tung Yuan (Fig. 6-6). Here there are six or seven shifts in scale, creating an effect almost like continuous diminution. But again we notice that the observer's position is not fixed. Seemingly it moves higher as one looks further into the distance—a kind of rising point of view. We seem to regard each plane of depth from the same angle, hence we must be higher up if we are looking down on the distant hills from the same angle as we observed the near ones. One result of this unfixed viewpoint is that there is no horizon line; at the highest level that the water is seen, where we might expect a horizon line, there is none. Just as in the horizontal scrolls our attention is encouraged to range back and forth, so in this vertical scroll it is encouraged to range up and down. Increased contemplation results in our wandering deep into the scene and becoming entirely engrossed in the experience of space.

In the West, we find that an approximate equivalent to diagonal projection was used in the early Middle Ages in Europe. A mosaic of the

Virgin Mary designed for the church of Hagia Sophia required, in the artist's mind, a certain amount of depth (Fig. 6-7) so the platform on which she sits recedes by virtue of diagonal sides. Yet the concept of the rectangular top of this platform was important, too, and to convey this the artist made the right front corner more like a right angle than the left front corner. The result is that the receding edges of the platform diverge, and therefore seem to us almost to reverse the effect.

Western Europe had not been strongly influenced by Mediterranean culture even during the period of the Roman Empire, and the people had maintained a tradition of visual art that was much more abstract and linear. We have seen how they brought Christian imagery into this highly patterned art in the *Book of Kells* (see Fig. 5-11). The figure of St. John is represented in profile-and-plan projection that bears some resemblance to that of Egypt and early Greece. But there is a difference in this primitive figure drawing because there is even less concern with proportion and physical parts. The head is completely frontal and the feet are seen in profile, one

6-8 *David and Goliath,* French, thirteenth century. Manuscript page. The Pierpont Morgan Library, New York.

in each direction, and no diagonals are seen in his throne. The body is largely ignored—its heavy garments interest the artist more for their abstract shapes than for the way they reveal the body beneath. Clearly the interest in picture space is minimal.

Later in the Middle Ages artists treated space in the shallow but readable manner seen in the mosaic of the Madonna. In a manuscript illustrating the story of David and Goliath (Fig. 6-8) the figures are depicted with the degree of action appropriate to the events shown. There is some foreshortening: each face is seen in a three-quarter view. At the top David is about to throw a stone at Goliath, and then cuts off the giant's head with his sword. But in contrast to the Chinese treatment, there is no interest in space beyond that necessary to contain the narrative. Indeed, the two-dimensional concern is so much stronger than the three-dimensional that the frame is actually overlapped by the figures. The appropriateness of flatness in the representation when decorating the page of a book was felt by

this artist just as it was by the artist of the *Book of Kells.*

In the fourteenth century, a concern for space began to emerge. When the Italian artist Duccio wanted to expand the narration of the *Temptation* by showing in some detail the cities of the world that Satan offered to Christ, he used diagonal projection (see Fig. 5-13). He was not so concerned about the relative scale of figures and setting as were the Chinese painters, giving the figures a larger scale to match their significance. But the search for a more adequate space to accommodate the figures in paintings went on. Giovanni di Paolo's *Dance of Salome* (Color Plate 14) is typical of some of the ways in which it proceeded. The steps, the tiled floor, and the table are all viewed from a high position, yet the downward slant of the top of the wall at the left and the molding between the arches at the right are viewed from a low position. The receding lines of the tiles in the floor converge rather than remaining parallel, but the point toward which they converge has no relation to other conver-

6-9 Albrecht Dürer, illustration from the *Art of Measurement*, 1525. Woodcut. Private collection, Germany.

gences (such as the sides of the piece of wall behind the seated figures) because the observer's viewpoint is not fixed. While the space is readable enough to avoid confusion there is not yet an overall system that would enable artists to locate things firmly in a convincing three-dimensional space.

Perspective Projection

Perspective projection is a system for representing three-dimensional objects and their environment on a two-dimensional surface as they would appear to an observer in a fixed position. A woodcut by the Renaissance artist Albrecht Dürer can help us understand the principles and some of the terms of perspective projection (Fig. 6-9). In it the eye of the draftsman is fixed by the machine at the *station point* and he draws on a pane of glass which is his *picture plane*. If instead of drawing another man his problem were similar to the one we used to illustrate diagonal projection, namely a series of receding fence posts, the *lines of sight* from the tops and bottoms of the posts would intersect the picture plane in such a way as to produce images of decreasing size, as seen in Figure 6-10. The image drawn would look like Figure 6-11. Continued further, the lines of the fence posts would diminish in size to a point, *the vanishing point*, and this would lie upon the *horizon line*, which can be defined as the line where the plane of the ground and the plane of the sky appear to meet. The *point of sight* lies on the picture plane at the same point as the vanishing point.

Perspective diminution of size is more or less abrupt depending on the distance of the station point from the picture plane; a closer station point will produce a more abrupt change. A simple ratio governs the image size:

$$\frac{\text{size of object}}{\text{size of image}} = \frac{\text{distance from object}}{\text{distance from picture plane}}$$

These essential principles of perspective projection were discovered by Italian artists and

Elevation

Picture Plane

Station Point

3
2
1

3
2
1

Ground Plane

3 2 1

Picture Plane

Station Point

Plan

PERSPECTIVE PROJECTION

Horizon Line

Vanishing Point

Image

1 2 3

6-12 *Sacred Landscape*, Pompeii, first century. Fresco. Museo Nazionale, Naples.

theorists in the fifteenth century. More than a millennium earlier the Romans had come close to evolving a regular system of perspective but had not worked out the geometrical requirements of such a system. For example, a typical Roman wall painting of the first century A.D., like this landscape from Pompeii (Fig. 6-12), recognizes the location of the observer in relation to the scene, the first step in perspective thinking. The observer's eye level is *above* the bridge which the goat is about to cross and *below* the roof of the little temple just to the right of center. We know this because the receding diagonal of the bridge slopes upward and the receding diagonals of the temple roof slope downward. However, there is little attempt on the artist's part to relate these

two effects to each other or to the sketchily painted temples in the background, either by a specific location of the observer or by a controlled diminution of size with distance. While the Romans were satisfied with adding together fragments of space, artists of the fifteenth century were not.

The desire for unity in the total space was evident for some time before the geometry of perspective had been worked out. Early in the century, only about a hundred and fifty years after the manuscript with David and Goliath, the Limbourg brothers in Flanders did a series of months of the year, also manuscript pages, which are among the earliest European landscapes (Fig. 6-13). In them the artists depicted people in the

6-13 The Limbourg brothers, "Month of June" from *Les Très Riches Heures*, c. 1415. Manuscript page. Musée Condé, Chantilly.

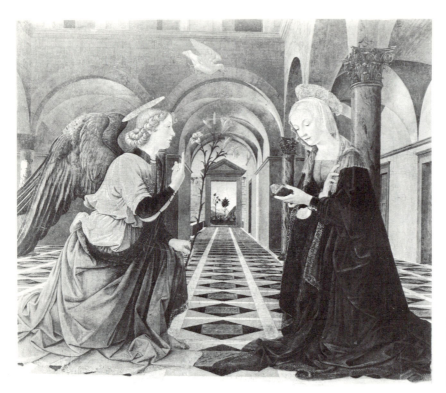

6-14 Attributed to Antoniazzo Romano, *Annunciation*, 1481. Tempera on wood, 39¾″ × 45″. Isabella Stewart Gardner Museum, Boston.

foregrounds engaged in activities appropriate to the month and in the backgrounds different castles owned by the Duke for whom they were done. This one shows buildings in Paris (the Sainte-Chapelle to the right is still standing) observed from a station point in such a way that the higher receding lines tilt down more than the lower ones. The observations are more refined than those in the Roman painting and as a result the buildings are more firmly located in space. The foreground figures are less sure in their spatial locations—the three mowers seem a bit large for their supposed positions and the trees along the river don't seem to diminish in size at all. While the projective system is in general that of perspective it is not accurately enough carried out to satisfy, say, an Italian artist of a bit later in the century.

The *Annunciation* (Fig. 6-14) was done by an unknown Italian artist who was familiar with the theory of perspective which had been worked out by several artists of the city of Florence and incorporated in a treatise on painting published by the architect Leon Battista Alberti in 1435. A close examination of this painting reveals that all the receding straight lines (those that are perpendicular to the picture plane) converge on a single point in the exact center of the picture. Theory has come to the assistance of the observant eye to produce a system that could be learned and was therefore made accessible to all European painters. Interestingly enough, we find that it immediately became subject to artists' expressive and compositional interests like the other two methods—that is, certain conventions became associated with its use.

The first two conventions brought into perspective rendering are evident here: first, that two sets of perpendicular lines are parallel to the picture plane while the third set converges; and second, that the vanishing point is located at or near the center of the picture. This second convention was soon modified as the vanishing point moved off-center, left or right, above or below. We have seen another Annunciation of the same period that places the vanishing point slightly

off-center: the small painting by Domenico Veneziano illustrated in Figure 1-1. The first convention remained in effect for more than two centuries.

Our next illustration was done in the seventeenth century and still employs two sets of parallel lines and a third set that converges in the center point. This is a ceiling painting by Andrea Pozzo in the church of San Ignazio in Rome showing St. Ignatius Loyola rising up to heaven (Fig. 6-15). The same principles of perspective outlined above are used but now the projection is done on a horizontal rather than a vertical picture plane. This means that the converging lines are not those on the ground or parallel to the ground but rather those that are supposed to be vertical: the columns and piers of the architecture. Pozzo was so eager to achieve an illusion of

the saint's movement upward into the sky that he actually marked the point on the floor where the visitor should stand. Looking up from this spot on the floor the illusion is at its maximum, though one's neck must be bent sharply backward to perceive it.

This brings us to another convention in the use of perspective projection—the convention that does *not* ask us to be at the station point to get the effect of space. Pozzo is exceptional in indicating where the station point is; the great majority of artists using perspective recognize that the spatial relationships are clear enough without demanding that the observer be at the exact distance from the picture plane and directly in front of the point of sight.

So far all the perspective constructions illustrated have been examples of *one-point perspec-*

6-15 Andrea Pozzo, *The Entrance of St. Ignatius into Heaven*, 1691-94. Fresco. San Ignazio, Rome.

6-16 Giovanni Battista Piranesi, Plate 8 of *Prisons*, first state, *c.* 1745. Etching. Private collection.

tive—that is, they placed two sets of lines parallel to the picture plane and only one set converged toward a vanishing point. *Two-point perspective* is an extension of this technique that soon became common. The eighteenth-century Italian etcher Piranesi used it to create spatial complexities in views of imaginary prisons. One of these (Fig. 6-16) shows clearly that only one set of parallels in the subject remains parallel in the picture, namely the verticals, while the receding sets converge toward vanishing points on each side and well beyond the edge of the etching. The principles remain the same as with one-point perspective; the only change is that the picture plane is no longer parallel to one set of wall surfaces.

The next logical step in rendering cubic forms in perspective would be to bring the third set of parallels toward a vanishing point, resulting in three-point perspective. It happens this has seldom been done in painting, probably because the

idea of tilting the picture plane had little appeal to artists, but it often occurs in photography. A photograph of New York by Berenice Abbott (Fig. 6-17) suggests the dramatic possibilities of the tilted camera. The three vanishing points are well outside the picture—upper right, upper left, and lower left—and provide the framework for the striking design.

Perspective constructions have often been freely modified by artists. In his *Rape of Europa* (see Fig. 13-20) Titian assumed an eye-level station point for the foreground figures but when he painted the far shore with its small figures he showed them as they would look from a much higher point. When Francesco Guardi painted a view of Venice (see Fig. 14-21), he deliberately exaggerated the perspective convergence of certain buildings to intensify a sense of three dimensions at selected points in space. The central building exhibits a convergence along the portico

6-17 Berenice Abbott, *Wall Street, showing East River, from roof of Irving Trust Company*, 1938. Photograph. Museum of the City of New York.

that is far greater than the size changes in the figures around it. If the divergence were continued to the foreground, for instance, the height of the columns would be about three times larger in comparison to the figures than they now are. Similarly, the domed building on the far shore shows an abrupt convergence that intensifies the space immediately around it.

So the willful modifications of perspective by early modern painters were more a change in degree than in kind of distortion. In van Gogh's painting of his bedroom (Fig. 6-18), he intensi-fied the space around each piece of furniture by so exaggerating convergences that no one perspective system controls the whole. In addition, he assumed a very close station point, so that we nearly see his toes in the foreground. Later we will consider some of the expressive reasons for such distortion, but the degree of distortion is what concerns us now.

At the same time as van Gogh, Paul Cézanne was also experimenting with modifying traditional perspective. His willingness to vary the station point to achieve different effects is shown

6-18 Vincent van Gogh, *Bedroom at Arles*, 1888–89. Oil on canvas, 29″ × 36″. Art Institute of Chicago (Helen Birch Bartlett Memorial Collection).

6-19 Juan Gris, *Bottle and Pitcher*, 1912. Oil on canvas, 21¾" × 13". Kröller-Müller Museum, Otterloo.

in his *Still Life with Geraniums* (Color Plate 13) in which the back edge of the table is higher on the left than on the right rather than continuing at the same level, and the top opening of the flower pot seems rounder than its base, when in correct perspective it should be a flatter curve. Cézanne's decisions in these areas seem to be based on an interest in relating shapes and colors to each other in a particular region of the painting rather than on an interest in maintaining a systematic perspective scheme.

In the early years of the twentieth century painters who were part of the Cubist movement took the final step of negating logical space. In the still life *Bottle and Pitcher* (Fig. 6-19), Juan Gris tended to fuse objects with the background rather than separate them from it. The four objects are still somewhat distinct, but empty space within and around them is minimized. For instance, the triangular shadows inside the bowl and glass are less suggestive of hollow openings than they are of positive flat forms. A few years

6-20 Juan Gris, *Still Life with Newspaper*, 1916. Oil on canvas, 28¾" × 23⅝". The Phillips Collection, Washington, D.C.

later in the same artist's *Still Life with Newspaper* (Fig. 6-20) space was further denied by the strong flatness of the newspaper and the apparent fusion of the table top with the surface of the painting. The vestiges of projective drawing in the fruit bowl and glass are contradicted by the transparent intersection of planes of different colors. For the first time since the Middle Ages a pronounced spatial ambiguity is present. This ambiguity of two- and three-dimensionalism is one of the primary objectives of the painting. What in

the Gothic manuscript (Fig. 6-8) was a rather straightforward presentation of active figures in combination with the flatness of the decorated page, is here presented more in terms of conflict—that is, what is visibly present seems at the same time to be logically impossible. The five-hundred-year-old tradition of unified space in painting came to an end for one major branch of twentieth-century art when the Cubists eliminated the concepts of the station point and the picture plane.

7
The
Role
of
Illusion

Representation in art seems to work on at least three levels. The first, mentioned at the beginning of Chapter Five, is the level of *recognition:* we recognized the bull Picasso made from bicycle parts or the animals drawn on the vase from Susa. Young children draw stick figures, or they make recognizable houses from a few lines that read as sides, roof, and chimney. The second level is that of *representational consistency:* parts of an image relate to the total image by adherence to a single mode of representation in sculpture or painting. It can also be achieved by adherence to a consistent system of projection, as we saw in Chapter Six.

The third level on which representation seems to operate can be called *representational coherence.* It can bring about a stronger response from the viewer because it involves a stronger illusion of reality. The world of reality—*nature* is the term often used to mean reality as it is perceived visually—is replete with attributes which we perceive visually and which can be depicted, for instance, in the art of painting. Among these attributes are roundness, weightiness, smoothness, roughness, glitter, brilliance, vastness, and so forth. Dozens of such perceptual attributes can be represented in painting to produce images that go far beyond mere recognition. In order to make their paintings self-sufficient things, however, artists select those attributes, or qualities, that can provide the illusion essential to the feeling of coherence.

First we should make clear that the term *illusion* as applied to art does not mean *deceptive illusion.* No one who is watching a play, for instance, confuses the illusion on the stage with real life; we are not impelled to jump over the footlights and knock the villain down. Yet the force and the subtlety with which the evil character is portrayed have a lot to do with the success of the play as art. In drawing, painting, and sculpture there is an analogous search for means of bringing the convincingness of reality into the work of art. As with the play, the unity or self-sufficiency of the work of art—its very separateness from reality—can be enhanced by making use of the qualities of reality through illusion.

It is possible to demonstrate the force of illu-

sion with the help of a master of representation. Figure 7-1 is a detail from an etching by Rembrandt, chosen so that the lines are almost impossible to fit together into any meaningful relationship. But if we enlarge this section so that we can recognize a group of mourning women at the foot of the cross (Fig. 7-2) the previously unrelated lines are seen in a new context. Not only do we recognize the women as such but we also perceive them as space-occupying forms. More specifically, these figures seem to have real structure. The front woman with her leg extended, shoulder hunched, hand by her downward-turned face, is remarkably drawn. Rembrandt's grasp of her structure is thorough even though few lines are used. The limpness of the fainting Virgin at the left is also well expressed, and we read considerable three-dimensionality into her form through the modeling on her face and arms. Modeling is also present in the woman who attends the Virgin, increasing the sense of solidity in the group and helping to distinguish the overlapping planes of arms, hands, and heads.

The qualities of nature—that is, the visual world—that Rembrandt particularly calls forth here are structure, solidity, and space (through overlapping planes). If we now look at the complete etching of *The Three Crosses* (Fig. 7-3) we find that another quality has been dramatically added: light. The area containing the group of women is in a blaze of light compared with the foreground and sides of the picture. The whole scene also evokes a much richer and more complex sense of three-dimensional space than the small group did.

The four dominant qualities of nature that Rembrandt has embodied in his etching through the force of illusion, then, are *structure, solidity, space,* and *light.* As we apprehend these singly, or more likely in combination, his very complex picture attains a remarkable coherence. Of course the compositional organization enters in too, but here we are focusing on the unification through representational means.

A sense of structure in the organic forms is felt in single figures and in the superbly drawn horse. Solid forms, or masses, are felt in single figures

7-1 Detail of an etching by Rembrandt.

and in groups of figures. Space and light, as suggested, make themselves felt in the whole, though they often gain particular emphasis in parts, such as the space that separates the two walking men in the foreground from the figures at the foot of the cross.

7-2 Detail of an etching by Rembrandt.

7-3 Rembrandt, *The Three Crosses*, 1653. First-state etching, 15" x 18". Pierpont Morgan Library, New York.

There are many other qualities of nature suggested here: the movement and weight of figures or the textures of surfaces such as robes and armor. But these and others that could be cited, do not seem to have the capacity to gather together in perception a number of disparate elements and make them cohere. For this reason we shall emphasize the four qualities that do have this capacity and, concentrating on one at a time, suggest some ways in which they demonstrate the force of illusion in art.

Structure

If we compare the antelopes in Figures 7-4 and 7-5 we have a simple illustration of what is meant by structure in representation. Both are decorations applied to the insides of bowls and both are completely linear. But within this restricted range it is the Greek artist who has created a convincing organic structure. Without using foreshortening or modeling he has expressed the way in which the legs are related to the body, the neck joins the

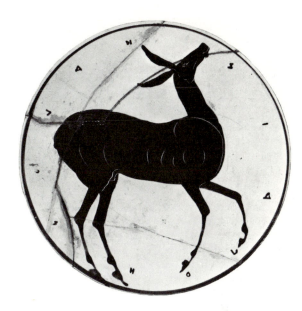

7-4 *Antelope,* Iran, thirteenth century A.D. Sultanabad bowl, underglaze decoration. Freer Gallery of Art, Washington, D.C.

7-5 *Antelope,* Greece, sixth century B.C. Kylix. British Museum, London.

shoulders, and even how the rearing pose of the head produces a taut curve in the spine. The Persian artist had few of these interests. His antelope is believable at a recognition level that differentiates between ears, horns, hooves, and the like, but not at a level suggestive of the interrelation among bones, muscle, and flesh, such as we find in the Greek antelope. In fact, by covering the body of the animal with a pattern of dots the Persian artist encourages the viewer to stop at a certain level and not search for a further degree of illusion. This decorative aim is just as valid as the representational aim of the Greek artist, but different.

The structural coherence we sense in the Greek antelope means that we see it all of a piece, all parts belonging to a larger whole because of their structural interrelation. The Persian drawing does not provide us with the particular cues that enable us to create a structural unity. Such cues in the Greek drawing include the sequence of subtle curves leading from throat to chest, the refined adjustments of contours on either side of the legs, and the probing quality of the white lines inside the silhouette shape.

Our next comparison brings out a distinctly

qualitative difference. While the Greek and Persian artists had such different objectives that we notice a difference in kind rather than quality, the details of paintings shown in Figures 7-6 and 7-7 are clearly similar in intent: one is believed to be a copy done by a pupil of Pieter Bruegel of one of the master's paintings. If we compare the central tree in both details we find that Bruegel (Fig. 7-6) is more responsive to the way in which a smaller branch springing from a large one affects the growth of the larger, creating slightly angular interruptions in its shape. In the copy (Fig. 7-7) the branches are unnaturally sinuous; this is especially evident in the upper left major branch of the central tree but may also be observed in other places. Bruegel also took note of the structural fact that the tapering of branches is not gradual, like the tapering of a snake, but rather makes more abrupt changes at the point of branching. In sum, the illusion of natural structure is present in Bruegel's trees and we consider them better drawn than those of the copyist.

When we come to the consideration of structure in the human figure, and particularly the nude, there is a temptation to think of it as identical to anatomy. While it is true that artists who

7-6 Pieter Bruegel, *Massacre of the Innocents* (detail). Hampton Court, Surrey, England.

7-7 Follower of Pieter Bruegel, *Massacre of the Innocents* (detail). Kunsthistorisches Museum, Vienna.

become involved with the expression of figure structure naturally turn to anatomical studies, the two are not identical. Anatomy is a set of facts about nature which can be comprehended, while structure is a quality of living form that can only be apprehended. Comprehension is an intellectual activity while apprehension is aesthetic.

The Greeks again provide us with a transparently clear development of interest in figure structure, which was to be the beginning of the whole Western tradition of the nude in art. In the same epoch in which we observed the evolution from linear to sculptural to pictorial modes of representation (in Chapter Five) we can watch a parallel change in the study of anatomical structure.

A standing youth, or *kouros*, was the typical male nude of Greek art. Our first example (Fig. 7-8), a bronze statue recently discovered in the harbor of Athens, shows the early stage of an interest in what exists beneath the skin. The tapering torso and swelling thighs reflects an observation of skeletal and muscular structure. The symmetry of the body is important and is modified only by a slight turn of the head and one advancing leg. Like the antelope on the vase painting, it belongs to the Archaic period of Greek art. The taut, bounding line of the antelope and the equally taut, bounding edges of the nude express the muscle and bone that make us recognize them as living creatures.

A bronze statuette of an athlete (Fig. 7-9) created a century later reveals how, by bringing

more movement into the figure, even more of the anatomical structure is evoked. This standing nude is statically posed, yet because of the multiple ways in which it breaks from symmetry, the pose seems a temporary stopping point in the

7-8 *Kouros*, Greece, *c.* 500 B.C. Bronze. National Museum, Athens.

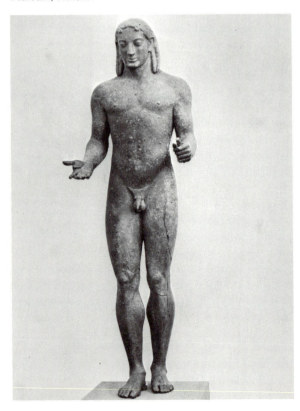

process of movement. First of all the weight of the upper body has been shifted so that it is nearly all carried by one leg. This results in the thrusting upward of the hip on the side of this "engaged leg." The relaxing of the other leg effects a dropping of the hip on that side and these movements produce the angled direction of the abdomen. At the chest level the lateral direction has returned to a horizontal, but a tilt in the opposite direction begins here and is intensified by the dropping of the head. This combination of thrusts and supports tells us a great deal about the figure's anatomy and particularly about those aspects of its structure which the artist regarded as most important: the poising of the body's weight; the curving of its axis (the line from neck to navel, more stressed than in reality, reflects the curve of the spine inside a real body); and the differentiation of rigid and flexible parts of the figure. These observations about the body, as well as many others, make for a much greater

differentiation of parts than in the *kouros* where the torso seems all one unit. In the later work we sense the collar bones, the bones defining the rib cage, and the precise location of the hip joints, one projecting and the other recessed. Differentiated from these are the swelling muscles of the chest and those above each hip, to mention the torso only. Thus, while rendering a more complex set of parts, the artist has organized them in an interrelating way so that they belong to a coherent structural system.

This exploration of the human body continued in the next century, and we find yet another solution in a third bronze statue (Fig. 7-10). While the sculptor of the fifth-century athlete had a great interest in the horizontal divisions of the body, marking them off with subdivisions of the chest, abdomen, and exaggerated edges above the hips, the fourth-century sculptor downplayed these. Instead, he emphasized the flowing S curve from foot to head—a vertical

7-9 *Statuette of an Athlete*, Greece, second half of the fifth century B.C. Bronze. Louvre, Paris.

7-10 *Youth from Marathon*, Greece, second half of the fourth century B.C. Bronze. National Museum, Athens.

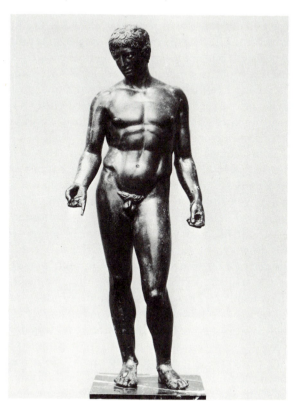

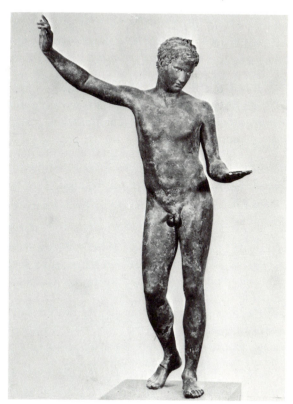

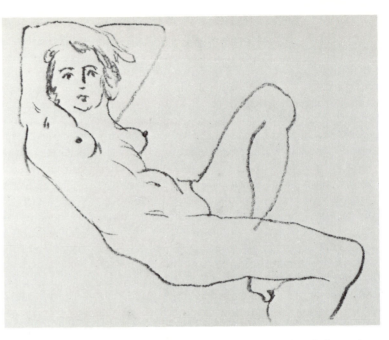

7-11 Antonio Pollaiuolo, *Hercules and the Hydra*. Pen drawing. British Museum.

7-12 Henri Matisse, *Reclining Figure*, 1924. Lithograph, 10⅝″ × 16¼″. Stanford University Museum of Art, Gift of Mrs. Michael Stein.

continuity. While returning to a surface simplicity reminiscent of the sixth-century youth, he implied a complex inner structure of the figure that has its external expression in a flowing continuity of surface form. In each of these periods of Greek art bodily structure was "seen" in a different way, but in all three the illusion of structure is of great importance.

Our examples of structural unification have so far been organic forms—animals, trees, and people. The reason that artists can communicate so much information and can express such subtleties of structure in these forms is that we ourselves have accumulated a good deal of knowledge about them. Often we don't know the extent of our knowledge until an artist teaches us to see. Antonio Pollaiuolo's pen drawing of Hercules and the Hydra (Fig. 7-11) shows the hero in a scanty lionskin costume putting all his physical energy into slaying the many-headed hydra, one head at a time. With a few rapidly drawn lines the artist expressed the complex action of chest, torso, shoulders, and hips. Henri Matisse, in a lithograph of a female nude (Fig. 7-12), expresses

the equally complex forces in a relaxed figure in which the effect of gravity on the skeleton is well concealed, but not lost, under the flesh, which is itself part of the structure. Edgar Degas once said, "Drawing is not what one sees but what one must make others see." We can see more structure in a real human figure after we have had it clarified for us in drawings like these.

Most things that we encounter in the real world possess a structure which can be expressed in a work of art. Drapery, for instance, played a major role in art for centuries. Often patterns produced in drapery were a source of great interest to artists, as they were to Albrecht Dürer in his drawing of the Holy Family (Fig. 7-13). But a source of even greater coherence in such a study is the structural character of the drapery itself. The intricate interlocking of folds produces a system that binds the whole together nearly as tightly as if it were an organic structure. It is not that drapery "looks like" what Dürer drew—for one thing, the effect of gravity on the cloth has been minimized. Neither does real cloth always fall into such purposeful relationships in which

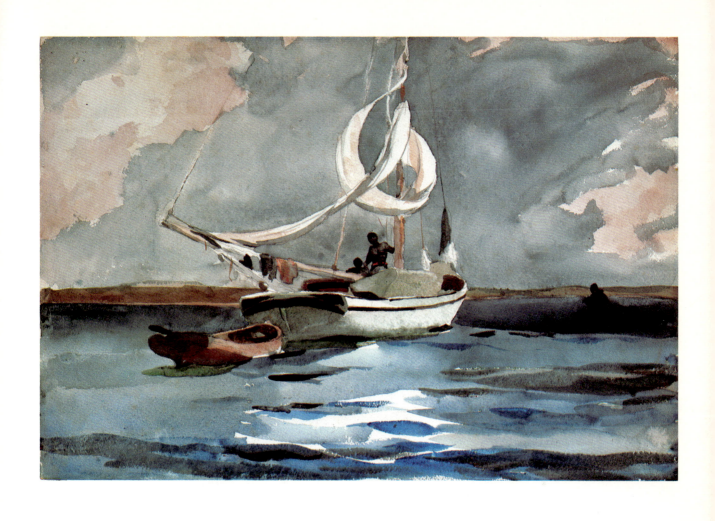

Plate 1 Winslow Homer, *Sloop, Bermuda*, 1899. Watercolor, 15″ × 21½″. Metropolitan Museum of Art, New York, Amelia B. Lazarus Fund, 1910.

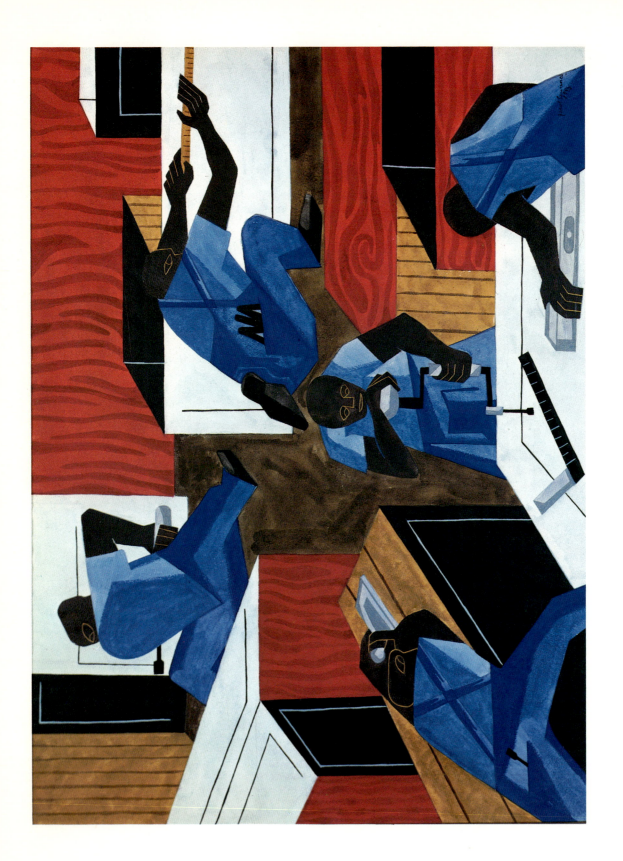

Plate 2 Jacob Lawrence, *Cabinet Makers*, 1946. Gouache with pencil on paper, 21¼″ × 30″. Hirshhorn Museum and Sculpture Garden, Smithsonian Institution.

Plate 3 Frank Stella, *Darabjerd III*, 1967. Synthetic polymer on canvas, 10′ × 15′. Hirshhorn Museum and Sculpture Garden, Smithsonian Institution.

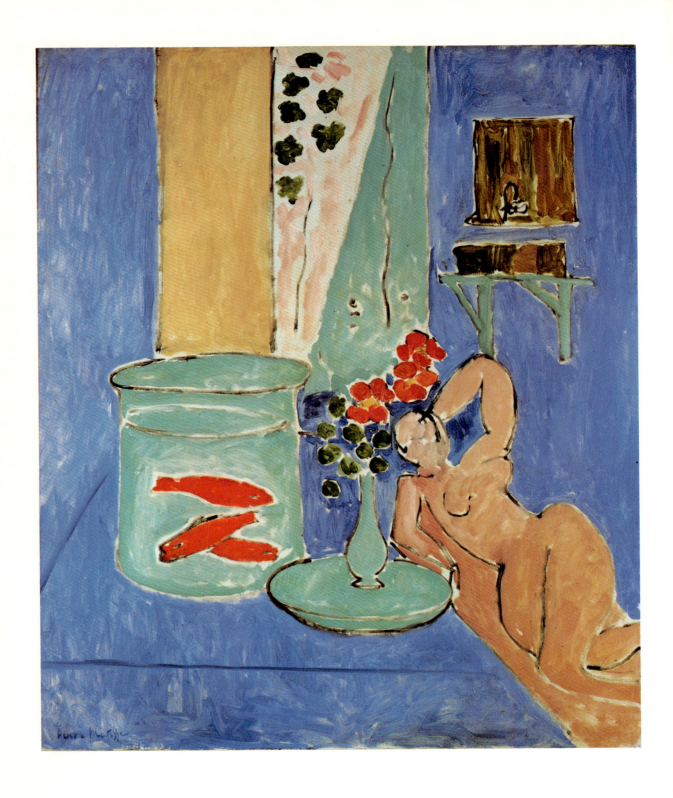

Plate 4 Henri Matisse, *Goldfish and Sculpture*, 1911. Oil on canvas, 46″ × 39⅝″. Museum of Modern Art, New York (Gift of Mr. and Mrs. John Hay Whitney).

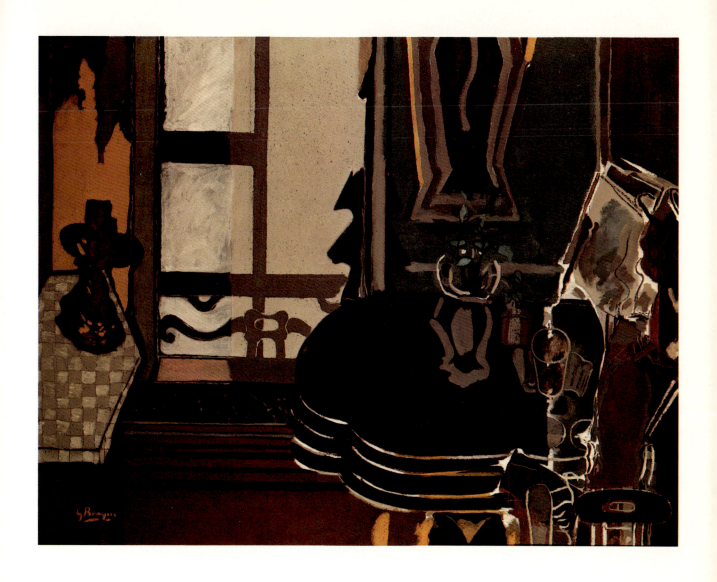

Plate 5 Georges Braque, *The Salon*, 1944. Oil on canvas, 47½″ × 58¾″. Musée National d'Art Moderne, Paris.

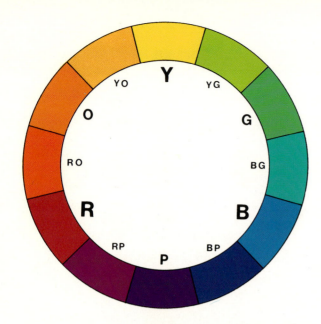

Plate 6 Color Chart I The Color Circle

Top: The traditional color circle, with all samples of high intensity.

Upper middle: The color circle cut at yellow and straightened horizontally (yellow repeated left and right).

Lower middle: The same, but with samples placed with height conforming to their value levels (neutrals shown at right).

Bottom: Corresponding samples, but all adjusted to middle value—with only red-orange and blue-green remaining at high intensity.

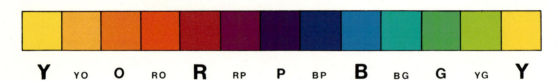

Y YO O RO **R** RP P BP **B** BG **G** YG Y

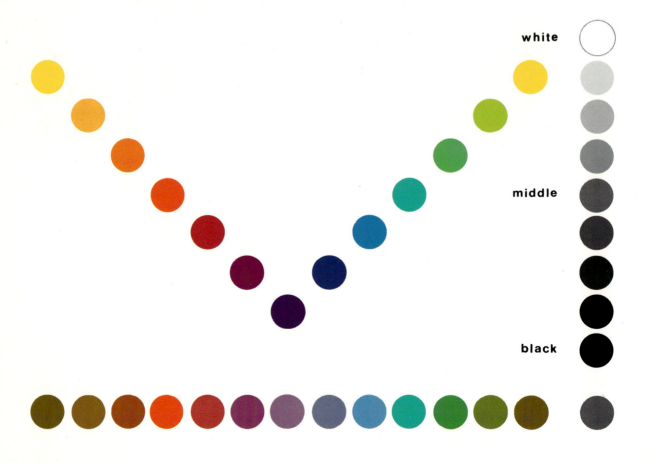

white

middle

black

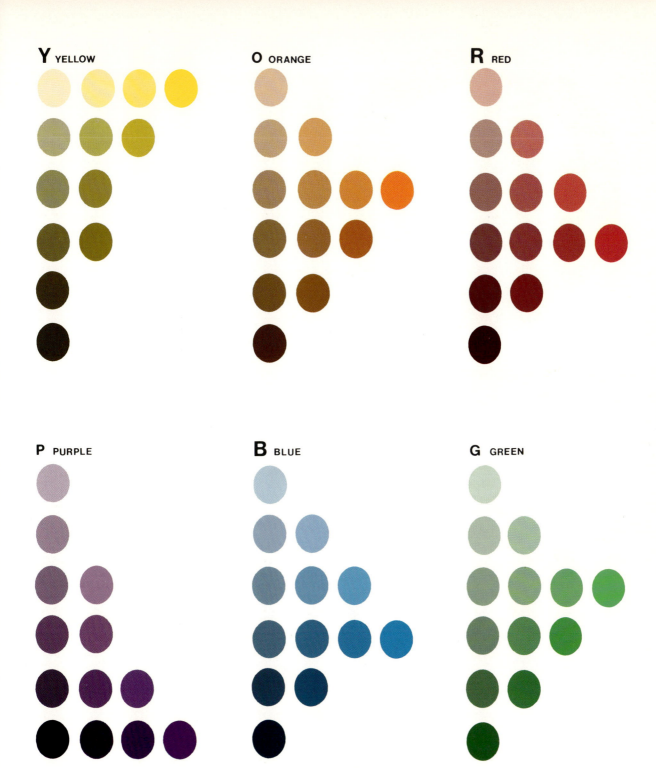

Plate 7 Color Chart II Hue Triangles

Neutrals omitted. Intensities increase from left to right, reaching full intensity at the extreme right.

Plate 8 Georgia O'Keeffe, *Abstraction*, 1926. Oil on canvas, 30″ × 18″. Whitney Museum of American Art, New York.

Plate 9 Vincent van Gogh, *The Zouave*, 1888. Oil on canvas, 31⅞″ × 25⅝″. The Lefevre Gallery, London.

Plate 10 "Infancy" window (upper section), Chartres Cathedral, mid-twelfth century.

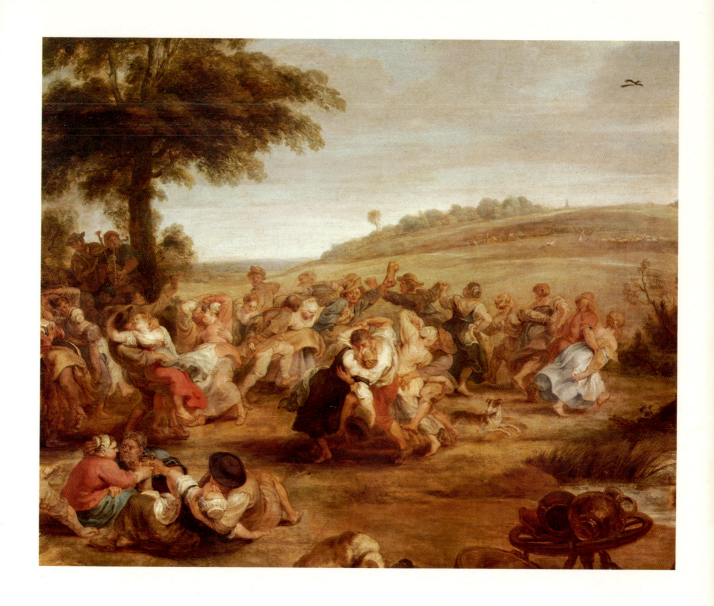

Plate 11 Peter Paul Rubens, detail of *Kermesse*, 1635–38. Louvre, Paris.

Plate 12 Richard Anuszkiewicz, *The Fourth of the Three*, 1963. Synthetic polymer on composition board, 4′ ½″ × 4′ ½″.
Whitney Museum of American Art (Gift of the Friends of the Whitney Museum of American Art).

Plate 13 Paul Cézanne, *Still Life with Geraniums, c.* 1888-90. Oil on canvas, 17¾″ × 21¼″. Courtauld Institute Galleries
(Courtauld Collection), London.

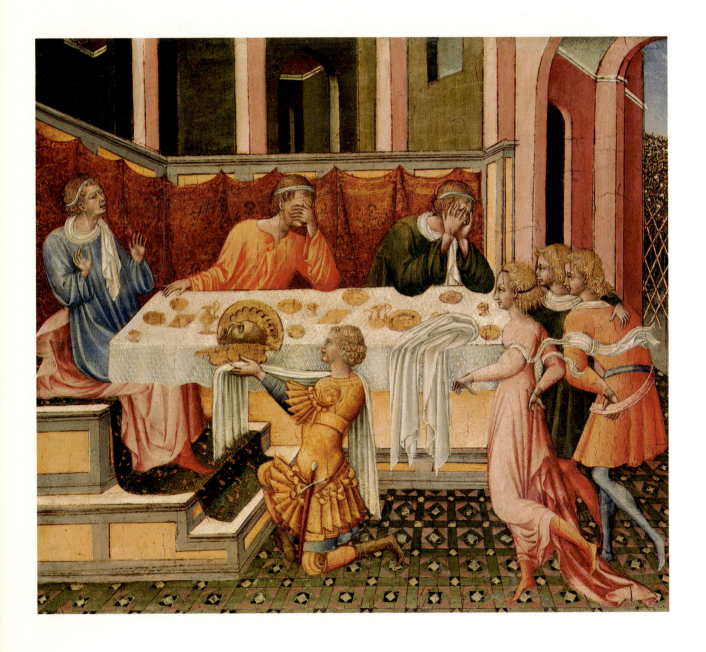

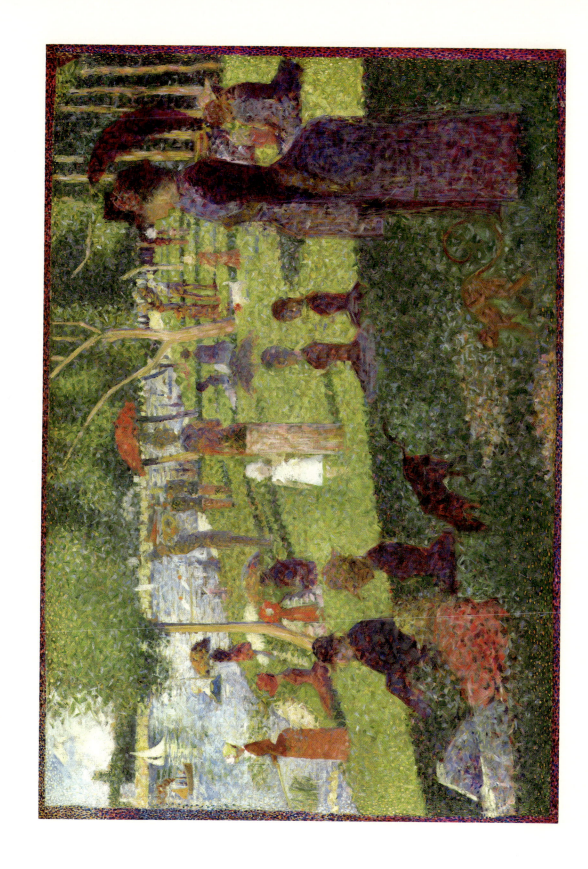

Plate 16 Giotto, *Presentation of the Virgin*, 1305-06. Fresco, Arena Chapel, Padua.

the effect of one force working on another is so clearly evident. The "weight" of the material is also made clear—every time a fold breaks, a little "hook" of light betrays the thickness of the cloth, which in turn determines the scale of the folds (note the smaller scale of the thinner material around the child). All these folds add up to produce a consistent effect of material being governed by the laws of drapery structure, and a strong coherence results from this illusion.

Solidity

With this example of structural unification we can make the transition into our next category: the three-dimensional existence of things. In addition to the structural interrelation there is also in Dürer's seated Virgin a unification by means of the volume of the whole, both figure and drapery. Despite the many folds and eye-catching de-

tails, a total form is achieved by a masterly control of the modeling. Our perception of the whole is stronger than our perception of the parts. In analyzing reasons for this we find the total form to be made up of a continuous sequence from light to shadow which can be simplified into planes of light, half-light, and shadow. Notice in the drapery around the knees how much paper is left white in the light plane, how the white is reduced mostly to the small ridges of the form in the half-light, and how it has been completely eliminated in the shadow plane, the area of deepest dark between Mary and Joseph. The lighter "hooks" are still there but they have been incorporated into the shadow by being darker than white.

Contrast this successful subordination of parts to the whole by comparing the drawing with another by Hans Schäufflein, a follower of Dürer who, though able, did not have the regard for solid forms that is present in Dürer's work (Fig. 7-14). Behind the forward arm a too-linear ren-

7-13 Albrecht Dürer, *Holy Family in a Landscape* (detail). Pen drawing. Staatliche Museum, Berlin.

7-14 Hans Schäufflein, *Lady Wearing a Headdress* (detail). Pen drawing. Staatliche Museum, Berlin.

7-15 Gaston Lachaise, *The Mountain*, c. 1913. Bronze, 8" × 17" × 5". Courtesy of the Oliver B. James Collection of American Art, University Art Collection, Arizona State University, Tempe.

dering prevents us from reading three dimensions into the folds, while in the portion of drapery just above the artist's monogram the planes do not clearly separate from each other. While Dürer always reinforced the contours of major plane distinctions with major light-dark contrasts Schäufflein did not, and solidity of form is lost by this lack of cooperation between lines and tones. Nor did Schäufflein respect the consistent weight of the material as Dürer had, and the result is a "mushy" character in the drapery covering the nearer hand.

These drawings may be used to clarify the difference between our concerns in Chapter Five and our concerns in this chapter. Both artists approached the representation of nature in a sculptural manner, or worked in a sculptural mode, our concern in Chapter Five. But the illusion of solidity and structure has been so much better realized by Dürer that we are now making a comparison in *quality* between the two drawings, as we did between Bruegel's painting and the copy.

In sculpture the problem of creating the illusion of three-dimensional form is different from that in painting inasmuch as this form actually exists in the round. But there are ways in which sculptors may enhance three-dimensionality so that we are more aware of it than we might oth-

erwise be. Gaston Lachaise in a bronze sculpture entitled *Mountain* (Fig. 7-15) accomplished this by exaggerating the torso region of the figure while diminishing the sizes of head and feet. This not only makes the composition extremely compact but also, by distorting the figure in relation to our concept of normality, emphasizes its three-dimensional massiveness. Three-dimensionalism is also intensified by the torsion in the figure between the shoulders and the hips, which continues on down to the feet. Such spiraling of forms in space tends to impel us around the figure, and even if we don't constantly move around it, the sense of fully rounded forms is conveyed.

Michelangelo invariably spiraled the forms in his sculptures. If we look at his marble group known as the *Medici Madonna* (Fig. 7-16) from any viewpoint we see more foreshortened forms than frontal ones. Each figure is in a spiral pose: the mother's is a long, slow spiral and the child's is small and tight. From the view shown, the arm of the child recedes back in space and the mother's hand thrusts forward. On the left, her hand and wrist disappear as we move down from the shoulder, and on the right the child's leg falls behind her knee. Even from the photograph we can sense that these receding forms would change as we moved around the group, always intensify-

86 THE ROLE OF ILLUSION

ing its full roundness. Interestingly, this movement stops just before we get to the back of the figure because the marble block was set against a background and was therefore visible from front and sides only.

The pose of the Madonna was derived from those that Michelangelo saw in ancient statues like those in Figures 7-9 and 7-10, poses that involve an opposition of movements—such as the body tilting to the right and the head tilting to the left. In her pose several actions counter each other; the dropped shoulder is on the same side as the upthrust hip and the upthrust shoulder is on the opposite side from the raised knee (the name we use for this is *contrapposto*). The point is that the constant disappearing of forms behind each other and the recurrent twisting and countertwisting emphasize the full three-dimensionality of the group.

This analysis will seem closely related to what we discussed earlier as a closed composition—and certainly everything here tends to turn inward to create the compactness we feel. But we are now focusing on representation rather than design, and our attention is therefore on the *turning* of the forms and how this emphasizes the solidity of the figure.

Space

Solidity and space are both aspects of three-dimensionality and cannot be completely separated. In the Dürer drawing, for example, we read pockets of space into the many shaded regions of the form. But in a drawing of a guitar player by Antoine Watteau (see Fig. 14-17) the role of space in three-dimensionality is far greater. Except for the head the figure is not strongly modeled, yet it is convincingly three-dimensional. The adept foreshortening is one reason for this, but the way in which Watteau suggests the space *between* things is what concerns us now. The forward hand is in front of the body and the further arm. Even the fingers in the fingering hand appear in front of the palm. These effects are produced by emphasizing continuity over discontinuity, by accenting the forward lines and

7-16 Michelangelo, *Medici Madonna, c.* 1520. Marble. San Lorenzo, Florence.

suppressing the lines in further planes. Often the further lines are completely eliminated; for instance, around the strumming hand. All these devices for separating planes create space in which the form of the figure can exist; there is an interaction of solids and spaces in producing the illusion of three-dimensionality.

A drawing by Pieter Bruegel done as a study for an engraving of peasants harvesting grain employs a variety of means to create the illusion of space (Fig. 7-17). In the first place, the artist used perspective with its vanishing point and its regular diminution of sizes going back. Next we note that, on the left, he emphasized disconnection in

7-17 Pieter Bruegel, *The Harvesters*, 1568. Pen drawing. Kunsthalle, Hamburg.

setting the foreground figures against the distant field, while on the right, he emphasized continuity: the four men with scythes and the edge of the uncut wheat provide a continuous recession. Besides the abrupt reduction in size of the four men there is an accompanying reduction in the details rendered: the nearest man has buckles and straps, and the knife at his belt even swings out to separate two stalks of wheat; the next three have none of these surface details, and the amount of modeling on their forms is diminished, the fourth having very little at all. The drinking peasant on the left has details and a degree of modeling to match the one at the right, while the wheat gath-

7-18 Francesco Guardi, *Piazza San Marco*. Pen and wash drawing. Phillips Collection, Washington, D.C.

erers in the center have already considerably less of both. Details suggestive of the texture of cut grain and stubble fill the foreground space but also diminish quickly with distance. So, the degree of modeling, the amount of detail, and the selective use of continuity or disconnection all work with perspective to create space. And in the end it is the realization of this total space that holds all parts of the drawing together.

A drawing by Francesco Guardi (Fig. 7-18) is entirely different from Bruegel's drawing in its degree of detail and finish but it also creates the sense of a total space. The most effective means in creating the illusion are the abrupt contrasts between the shadowed buildings in the left and right foreground and the sunlit courtyard beyond. To reinforce the shift from foreground to background the shadows in the courtyard are much paler and the lines more broken in their definition of architectural details. The surface is barely touched with the pen in areas where the artist wants to suggest both distance and the glare of sunlight. The strongest pen strokes and darkest areas of wash are found in the figures in the center foreground while a controlled reduction in such contrasts carries us back from figure to figure into the distance. Guardi's strict adherence in his perspective to an eye level just below the heads of the foreground figures helps achieve a firm spatial placement of the figures even though some are hardly more than a rippling line.

A comparable use of emphasis and de-emphasis to achieve space is often found in relief sculpture. The Early Renaissance artist Ghiberti did a series of reliefs depicting the life of Christ for a set of bronze doors. One of them showed Christ walking on the water and St. Peter failing to do the same (Fig. 7-19). These two figures are executed nearly in the round, especially the upper portions of their bodies. The middle group builds up to a quite high relief, around the figures' heads. The third group again has low-relief bodies and higher-relief heads, so that they appear to be in front of the two heads emerging partially behind them. Everything in the scene appears in front of the frame except the tip of the mast—even though this frame is in moderately high relief. The solution to the problem of rendering space is, then, not unlike what we ob-

served in the Watteau and the Guardi—a strong spatial separation in the regions in which one object comes in front of another. Space is rendered not simply by scaling off of the relief from higher in front to lower in back any more than the drawings made use of gradually weakening lines from front to back. It seems more important to clarify forms within limited regions of space than to apply a completely logical front-to-back reduction of accents or degrees of relief. Sensations of space seem to depend on major plane distinctions in these examples much as in nature they depend on changing focus of our eyes, our movement in relation to layers of depth, and our binocular vision in perceiving foreground objects and spaces. Artists simply do not have access to these three aids to space perception and must employ their own artistic language.

It is interesting that this language is similar

7-19 Lorenzo Ghiberti, *Christ Walking on the Water,* first quarter of the fifteenth century. Bronze. Panel of Baptistry door, Florence.

even when used in very different times and places. In a Chinese landscape painting like Ma Yuan's *Willows* (Fig. 7-20) the sense of space is largely due to the succession of planes achieved by darkening the tops of nearer ones and lightening the ones immediately behind. There is more detail near the tops of the planes as well. Both these devices are the same as those used by Western artists and are parallel to the means used by Ghiberti in sculpture. The lighter valleys seem to be filled with mist, which we recognize as a convenient means of achieving space by planar distinction.

Ch'en Jung's *Nine Dragon Scroll* (Fig. 7-21) depicts creatures emerging from a rushing stream and then nearly disappearing back into it. Their forms are mostly lights set off by dark backgrounds that come and go like the mists in the landscape. An illusion of space is certainly generated—and by means that are somewhat removed from nature. At many points in this chapter we are reminded that verisimilitude—literal likeness to nature—is not the most effective means of achieving a convincing illusion.

7-20 Ma Yuan, *Landscape with Willows*, thirteenth century. Ink on silk, 9⅜″ × 10″. Museum of Fine Arts, Boston.

Finally, we should take note of the ways in which color can enhance effects of space. We began to realize this in Chapter Four, where we found that Rubens used stronger color accents to bring forward the figures of his dancers in his painting *Kermesse* (Color Plate 11). The effect in nature which this parallels is the increasing neutralization of colors by overlaying with atmospheric tone: the further away objects are the grayer and lighter they get, until their local colors are lost in the tone of the atmosphere. This effect is frequently called *atmospheric* (or aerial) *perspective* and it is one of the landscape painter's, or the photographer's, most effective ways of giving an illusion of space. Ma Yuan made use of it in his fan painting while combining it with the selective emphasis on plane edges. And Claude Monet used the reduction of color contrasts produced by atmospheric tone in his scene of the beach at Trouville (Color Plate 18). But he did more than simply record this effect as a color photograph might. In the three receding blocks of buildings at the right (the beach hotels) the intensities of the red and yellow of brick and stucco diminish in each successive block. This is accompanied by a lessening of detail as well, similar to what we see in the Bruegel drawing. Here the lessening detail is noticeable particularly in the windows and the moldings around them. But the quickly diminished contrast between the red and yellow going from building to building is what especially concerns us and it is reinforced by a most effective placing of the red and yellow flag. This flag is brought clearly out in front of the building by having its red stripes seen against the weakened brick red and its yellow stripe against the weakened yellow stucco. These contrasts in color intensity convey a remarkable effect of space because of *where* they are placed as well as how controlled the color differences are. Equally effective is the color on the clothes of the standing man on the beach: his dark jacket is seen against the water while his light pants are placed against the even lighter sand. The two contrasts are similar enough in degree that they convey a precise location in space for the figure. Imagine interchanging these two colors and the disruption of the figure this would cause.

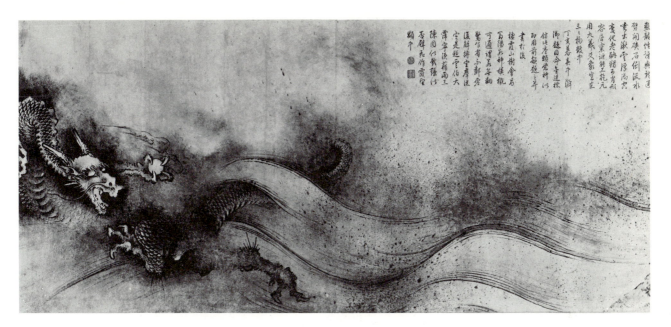

7-21 Ch'en Jung, *Nine Dragon Scroll* (detail), 1244. Ink and color on paper, 18¼″ high. Museum of Fine Arts, Boston. Francis Gardner Fund.

Light

We have analyzed Monet's painting from the point of view of space representation, but clearly it is equally convincing as a representation of light. This fourth and last of our major categories has many parallels to space: both fill the whole of a pictorial image and are not limited to a simple solid or structural form; both therefore have the broadest powers of unification. While space can be achieved in painting without necessarily involving light (see the Chinese scroll of Wen Ch'i, for instance, Fig. 6-5), it seems that light does require a certain amount of picture space. This is borne out by the fact that European artists did not begin their study of light until they had mastered the rendering of space. The fifteenth-century Flemish artist Jan van Eyck, as we saw in Chapter Five, was one of the first. But it was in the seventeenth century that the sophisticated analysis of light was first undertaken and the powerful unifying effects of light exploited. Led by Caravaggio (see Fig. 5-18), painters in Italy and elsewhere studied artificial illumination. Artemisia Gentileschi, in her painting *Judith and*

Maidservant with the Head of Holofernes (Fig. 7-22), employed the light of a single candle to reveal the nighttime event in the story of the Old Testament heroine. This not only enabled her to achieve a powerful dramatic force but, by treating the value relations in a special way, resulted in an effective illusion of light. The shadow side of each form and the shadows cast onto other forms (like the shadow thrown on Judith's face from her light-shielding hand) are made suddenly dark. Darkness fills most of the painting and the contrasts among darks are minimized. This can be called a *crowding of the darks* and its purpose is to emphasize the lights and to make contrasts among them more evident. The candle seems to burn with a light brighter than white. Landscape painters soon adopted similar means and directed them toward the illusion of daylight. Claude Lorraine was one of these. In his *Marriage of Isaac and Rebecca* (see Fig. 14-14) he created a sense of luminous sky and light-filled distant atmosphere by crowding darks in the foreground and middleground that provide a foil to the central areas of light.

Other painters practiced a *crowding of the*

7-22 Artemisia Gentileschi, *Judith and Maidservant with the Head of Holofernes*, c. 1625. Oil on canvas, 72″ × 56″. Detroit Institute of the Arts (Gift of Leslie H. Green).

lights, condensing the other end of the value scale to gain a feeling of luminous atmospheric tone throughout a painting. This is seen in Turner's watercolor *The Crook of the Lune* (see Fig. 15-5), in which the lights on the foreground trees and throughout the background are pushed together into the upper ranges of the value scale. Rembrandt crowded both lights and darks in his etching of *The Three Crosses* (Fig. 7-3).

The reason that artists crowd darks or lights is to approximate through exaggeration of contrasts the much greater value range in nature compared with the range between white and black paint. But the illusion of light can result from a proportional transcription of values from nature into painting if relations among hues and intensities are also taken into account. This was noted in Chapter Five when discussing the modeling of

forms by artists working in a visual mode, like van Eyck or Vermeer. A small painting by Vermeer will allow us to study this more closely (Color Plate 27). Here we see that the light coming from the upper right strikes the hat, face, and jacket, each of which loses intensity with the transition into shadow. Yet the distinctions among these colors are not lost, they are merely diminished; unlike those of Rembrandt, who sacrificed some local-color differences to the effect of light flowing over forms in his *Slaughtered Ox* (Color Plate 26). Vermeer achieved his effects of light by preserving such distinctions. Our attention is called to light and shadow contrasts by rather crisp brushstrokes that directly juxtapose such contrasts: note the folds of the jacket and the color planes in the half-hidden hand. Further, as noted in Chapter Five, reflected lights and highlights convey the multiple effects of light from a particular source falling on local colors.

It was this cause-and-effect phenomenon toward which the studies of Impressionists like Monet were directed. Looking again at *The Beach at Trouville* (Color Plate 18), we note that all the decisions about the color of shadows—in the green stairs or on the sandy beach—are similarly governed by a desire to preserve the local color while still keeping the overall light effect. Now something else has been added, however. In an outdoor subject in full sunlight the painter has observed that shadows receive their light from the blue sky and are therefore more blue than the lights. During the nineteenth century, landscape painters began to work outdoors for the first time, and discovered a number of facts of vision, such as the blueness of shadows in sunlight.

As the Impressionists became more involved in the recording of light, they began to explore entirely new realms of color. We can study these in a painting done by Monet about fifteen years later than *Trouville,* a work called *Torrent, Dauphine* (Color Plate 19). The most significant change that has taken place is the subordination of local color to the effect of light. Here hue differences such as those on the middle hill between the pink lights and the blue shadows are much more important than hue constancy of the sort seen in the green steps in *Trouville.* The hue differences in the light and shadow of the sand in the earlier painting are now exaggerated, with the result that our attention is directed to the light effect itself. Further, the color is not applied in large simplified areas as it was in Vermeer's *Girl with a Red Hat,* but in small, differentiated brushstrokes—that is, with *broken color,* as in Seurat's study (Color Plate 15). Another Impressionist, Camille Pissarro, characterized the effects of broken color as "stirring up luminosities more intense than those created by mixed pigments." Besides modified local colors and broken color, a third contributing factor to the creation of the illusion of light in Impressionism is the use of high intensity color, again as described in Chapter Four, and evident in *Torrent, Dauphine.*

The basic point concerning the various ways of achieving the illusion of light is that complex visual experiences of nature are brought under the control of the dominating effect of light. Coherence resides in the illusion, much as it did in the Greek antelope's structure, Dürer's solidity, or Bruegel's space. These qualities are not mutually exclusive: the *Medici Madonna* is structurally coherent and emphatically solid; Monet's paintings capture both the space and light of reality.

PART THREE

THE EXPRESSIVENESS OF ART

Up to this point our analyses have focused on the formal aspects of each work of art. We have been concerned mostly with how a work of art is put together, its organization in both abstract and representational terms. In studying representational art we have not become involved to any degree with the responses of artists to their subject matter nor what might have prompted them to choose particular subjects in the first place. In looking at buildings or works of abstract art we have considered them largely in isolation from their purposes, overlooking the very thing that set the designing process in motion to begin with. In emphasizing factors that make a work of art cohere or attain unity, we have not dealt with the equally important factors that threaten to disrupt this unity in order to achieve a more important goal. In short, in attempting to understand artistic form we have not considered the expressiveness of art.

This does not mean that we have not experienced the expressive side of art while looking at the pictures in the previous chapters. It would be impossible not to respond to the eloquent but restrained poses of the child Mary and her mother in Giotto's fresco (Color Plate 16), or not to be caught up in the excitement and action of Rubens' *Battle of the Amazons* (Fig. 14-1), or not to be thrilled by the virtual presence of sunlight in Monet's *Torrent, Dauphine* (Color Plate 19). It is rather that in order to establish the place of formal organization in works of art we have tried to examine them in a somewhat detached way. Having thus dissected them for purposes of analysis we now try to put them back together again.

We will begin in Chapter Eight by returning to a point that was made in the first chapter—that the tensions created between different aspects of a work of art are what give it life. There we concentrated on a few examples of one sort of tension; here we will explore some of the wealth of interactions between forces that artists find to be expressive of feelings and ideas.

In Chapter Nine we will compare the treatments of similar subjects by different artists to discover the varieties of interpretations that are possible. Even the same artist painting the same theme for a second time may find that very different ideas and feelings can be expressed.

And finally, in Chapter Ten, we will look at works of art in the context of the time and place in which they were created. We will see that no matter how unique an artist's style may seem, it is always related to the work of other artists of the same period and the same part of the world. How a sculptor shapes a block of stone or an architect arranges the solids and spaces in a building depends not only on individual genius but also on the needs and aspirations of the people whose world they are a part of.

8
The Interaction of Forces

In the introduction to this book we examined the uses of tension in art with the help of a sculpture by Jacques Lipchitz. We found that the artist had worked in ways that encouraged us to view the work of art both as object and as image—as the figure of a woman *and* as a solid block of stone. This contradiction between the image and the object we perceive is one of the most basic tensions to be found in works of representational art, but it is certainly not the only one. As we will begin to see in this chapter, there is a great variety of tensions that artists set up in their works to impart vitality to them.

Tension, we may say, is a primary medium of expressiveness. Without some kind of conflicting pulls upon our perceptions, a piece of sculpture or a drawing would be lifeless and uninteresting. This is the case with the average urban building, which serves only as a fairly efficient form of shelter and storage. Some attempt may be made to make it look "nice"—a few Greek columns on the outside or a glossy surface of glass and stone—but it is rarely enough to make us look twice, much less actually wish to go inside. What, we might ask, *can* be done to something as functional as a building to convert it into a work of art? What tensions comparable to that of the object/image are available to someone who must work in such abstract terms as architects do?

Contrasting Abstract Forces

Let us begin to examine this question not by looking at a functional modern building but by going back fourteen centuries to one of the great religious buildings of all time, Hagia Sophia in Istanbul (Fig. 8-1). Built as a Christian church in the sixth century, it was subsequently a mosque and is, at present, a museum. But regardless of the cultural backgrounds visitors may bring to it this Byzantine church expresses the spiritual qualities that its architects embodied in tension-filled contrasts. As we approach the building we are struck by the massiveness of the great blocks of material. But as we enter, the impression of massiveness begins to fade. The huge supporting piers seem less heavy than they really are because their surfaces are made of polished marble that is col-

8-1 Anthemius of Tralles and Isidorus of Miletus, Hagia Sophia, Istanbul, A.D. 532-537. 308' × 236'.

8-2 Interior of Hagia Sophia.

orful and delicately grained. Then, entering the large central area we experience an entirely different effect. Instead of mass and solidity, we find a huge domed space from which has been removed nearly all evidence of support (Fig. 8-2). Only when the logical mind tells us that all that stone over our heads must be held up somehow do we wonder where the supports are. The architect-engineers who designed Hagia Sophia took full advantage of the fact that vaults and domes transfer their weight outward as well as downward. The hemisphere of the central dome is set upon four spherical triangles in such a way that its weight, and theirs, is concentrated at the four points of a square (which can be seen on the plan in Fig. 8-3). In the transition from the circular dome to the square below, the actual weight has been directed to huge supports entirely outside the central area. This is what makes possible

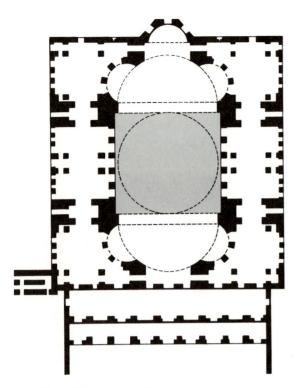

8-3 Plan of Hagia Sophia. (Shading shows the dome and triangles.)

the large interior space that is seemingly without weight or support. Moreover, the design has taken full advantage of the weight-directing characteristics of the circular set of arches that compose the dome to leave a ring of windows all along the base. And these, on a bright day, fill the edge with light and make the dome seem to float in the air—a gravity-defying sensation that is highly suitable for a religious building.

Another characteristic of the interior space of Hagia Sophia is that it is both centralized—by its square/circular plan—and has a longitudinal thrust from the entrance to the three semidomes at the opposite end. The effect of the long axis is reinforced by the two-story arcade on each side whose rows of columns parallel this axis. These contrasting effects relate to the religious function of the church: the central area reaches its climax in the dome, symbolic of heaven, while the long axis leads toward the high altar in the sanctuary beneath the central semidome at the end. Hence references to both the spiritual goal and the

means of approaching that goal are embodied in the architectural forms. Opposing perceptions, then, seem to characterize our experience here. Mass is opposed to void; the knowledge of weight to the sensation of weightlessness; a central emphasis to an axial emphasis; and a solid and logical structure to a colorful and luminous immateriality.

Now that we have seen what architects can do to make a building into a work of art, let us return to the present and to the question of tensions in urban buildings. The Seagram Building in New York City (Fig. 8-4) is the work of two of the most influential architects of this century, Mies van der Rohe and Philip Johnson. It was an early example of a vast generation of steel-and-glass skyscrapers, and is still generally considered to be the best of its kind. The purpose of the skyscraper is, of course, a very different one from that of a church, but the challenge of bringing into the structure some interest beyond that of making a shelter is still present.

The architects' answer once again involved finding tensions that would impart a sense of vitality to a simple boxlike shape, of making it seem "alive." It is essentially rectangular and sheer-sided, although the back of the rectangle has a projecting center section and smaller units on either side. But from the front, which is set as far back from the sidewalk as the width of the building, it is pure rectangle, the great mass of which is well revealed by the open space of the plaza with its reflecting pools. The building's thirty-eight stories impose a verticality that is repeated in the uninterrupted mullions running from bottom to top. These strong lines are set in opposition to the horizontal bands that mark off the floors. They are also set out from the building's surface (Fig. 8-5). Both the lines and the bands are sheathed with bronze, giving them a warm dark tone. The warm gray glass of the windows holds them visually in the same plane as the bands, except in those areas where reflections tend to destroy this surface. Different light effects on these surfaces, and particularly different reflections of sky, clouds, and surrounding buildings in the glass, introduce a great variety of colors. This is, however, tempered by the gray color of the

8-5 Detail of Seagram Building.

8-4 Ludwig Mies van der Rohe and Philip Johnson, Seagram Building, New York, 1956-58.

glass. From the exterior, then, a major tension is felt between the flat, regular grid of the surface and the transitory reflections with their hints of space and color. Another major tension is between the verticality of the mullions and the horizontality of the bands. Few other solutions to the problem of skyscraper design seem to have arrived at as refined an equilibrium as we find here: the linear verticals are uniformly spaced and set at closer intervals than the horizontals, which alternate between the wider windows and narrower bronze strips. The whole tower is strongly vertical, but almost any view of it from the streets yields the equal but opposing stresses on horizontal and vertical.

We also feel other tensions, such as those between the nonsupportive character of the sheathlike exterior and the supports we know to be there (and can partly see at the ground level), and between the geometric rigidity of the design and the flow and movement of life going on in and around (and reflected on the surface of) the building. Altogether, an expressive solution to the problem of the skyscraper.

Living Form vs. Abstract Form

Let us move now from the problem of tensions in the abstract forms of buildings back to representational art in which there is also a considerable emphasis on geometric form. We will look at two sculptural works in which the major tension is between geometry and the human figure. The first is a Renaissance portrait bust by Francesco Laurana (Fig. 8-6) that is believed to be of Isabella of Aragon. It seems quite wonderful that such a sensitive record of an individual could be embodied in such an abstract set of forms. Qualities of a living being, like the downward glance of the eyes or the implied mobility of the mouth, as well as the poising of the head on the neck, are surprisingly present in the shaped marble. Because the head constantly approaches a perfect ovoid form, and the neck is more of a cylinder than any real person's neck, we are drawn strongly to the sensing of geometric forms. We find it hard to believe that so much humanity and so much of an abstract-object quality can coexist without damaging each other. The fact is that our experience is an enlightening one concerning the nature of beauty—human and geometric—which, while seemingly in conflict, can so effectively be fused.

In the twentieth century the abstract has come to be even more valued. Brancusi's *Muse* (Fig. 8-7) consists of four quite clearly separable solids, standing for head, neck, upper torso and arm, which obviously read more strongly as abstract forms than do the parts that make up Laurana's bust. Therefore there is considerable tension in the pull between simplified masses and rather delicately rendered features, or between inorganic forms and human feeling conveyed by a pensive pose.

Solids vs. Voids

Prior to the twentieth century the forms of sculpture were largely determined by the solid volumes of the human figure. One of the most radical innovations of sculpture occurred when parts of these solid volumes were replaced with voids. In Henry Moore's *Reclining Figure* (Fig. 8-8) the upper torso is made up of strongly con-

8-6 Francesco Laurana, *Isabella of Aragon* (?), c. 1490. Marble, life-size. Museo Nazionale, Palermo.

8-7 Constantin Brancusi, *Muse*, 1912. Plaster, 18¼" high. The Solomon R. Guggenheim Museum, New York.

8-8 Henry Moore, *Reclining Figure*, 1935. Elmwood, 19″ × 35″ × 15″. Albright-Knox Art Gallery, Buffalo, N.Y. (Room of Contemporary Art Fund, 1939).

vex forms but below the breasts, where nature might provide a gently concave surface, the concavity becomes a hole passing through the figure. The effect on the viewer—the shock of seeing a hole instead of a surface—is felt by all observers, for even someone very familiar with Moore's work senses the tension between a real human form and the highly modified created form of the sculpture. About twenty-five years later the concern with the void in Moore's art had reached the stage we see in the *Lincoln Center Reclining Figure* (Fig. 8-9). Now the tension stems not so much from discovering a hole in a represented figure as from discovering a figure in two massive and separate pieces of bronze.

The expressiveness of Moore's art is due in part to the relationship he suggests between humanity and the natural environment. In the earlier work the flowing lines and shapes of the sculpture seem to relate to weathered natural forms, worn perhaps by wind or water, at the same time that they stand for humanity. In the later work the two solids look like ancient rock forms whose rugged massiveness is conveyed partly by the large scale of the work. Yet there is still a breath of humanity in them. The fusing of these ideas taken from the natural world with the tensions of solid and void is what raises Moore's work well above the level of most other artists who have taken an open and abstract approach to sculpture.

Expansion vs. Contraction

Michelangelo's sculpture imparts to everyone a sense of extraordinary vitality. His favorite subject matter, the male nude, often expresses great physical energy, owing to the ways in which the artist developed its structure and articulated its anatomical parts. The exceptional degree of tension he embodied in his figures comes from his combination of expanding and contracting energies. The marble figure of *Day* from the Medici Chapel in Florence illustrates this (Fig. 8-10). Many elements have an outward force: the outward gaze, the bulging muscles that seem to

8-9 Henry Moore, *Lincoln Center Reclining Figure*, 1961-65. Bronze. Lincoln Center, New York.

threaten to burst through the skin, and the twist of the back and the pull on the arm that suggest a spring about to unwind and release all that power. Yet the wound-up nature of the pose, with the arms wrapped around the torso, the exaggerated curve of the back, and the bent leg straining with pressure against the other binds the outward moving forces into a compact mass. So the centrifugal energies and the centripetal counterforces are played against each other as in a tug of war; no actual movement is shown but the potential for one movement or the other to win always seems to be present. This theme, with many variations, recurs constantly in Michelangelo's work; his figures are filled with movement though they have no power of locomotion. The resulting tension is responsible for a special and inimitable expressiveness in his art—one that involves both physical and psychological, or spiritual, aspects of humanity.

A twentieth-century artist, Umberto Boccioni, found expanding and contracting forces in the action of a soccer player and embodied them in the abstract forms of a painting (Color Plate 20). Boccioni was a member of a group of Italian artists who called themselves Futurists and whose primary concern was to express the dynamism of modern life. To them speed was the symbol of this dynamism, whether the speed of a machine or an athlete, and the challenge was to find ways of expressing speed in abstract terms. Here we cannot fix on any one part of the soccer player's

8-10 Michelangelo, *Day*, from the tomb of Giuliano de' Medici, 1520–34. Marble, over life-size. New Sacristy, San Lorenzo, Florence.

anatomy, but traces of his actions seem to be left all through the painting. Graded curves and color gradations create as much sense of movement as the static art of painting is able to express, much of it wheeling around the center of the picture—which also seems to be the core of the elusive figure. A concentration of reds in the center contributes to the contraction of movement while the rays of yellow, green, and blue seem to expand to the frame and beyond it. And the agitated effect of the broken strokes used in applying the paint helps to sustain the feeling of constant flux.

Nature vs. Medium

One of the most basic tensions in representational art is that between reality and the material or medium into which that reality has been translated. While this is related to the object-vs.-image tension mentioned earlier, the vast range of mediums or materials available to the artist suggests that we direct our attention more specifically to materials themselves rather than to the concept of an object. In speaking of the different forces in Michelangelo's *Day* we were in the realm of illusion; no real movement or muscles are present. We were actually looking at stone, and the fact that Michelangelo wanted us to think of his sculpture as stone is borne out by the unfinished character of it. The chisel marks on the head and elsewhere remind us constantly that it is made of marble.

Not many artists have used parts of a bicycle as a medium. Yet we saw Picasso do this in his *Bull* (see Fig. 5-1), where we were aware simultaneously of the bull and the bicycle. The difference between these two is extreme enough to be funny. Still in the realm of humor is Claes Oldenburg's *Soft Washstand* (Fig. 8-11) which represents an object of everyday life in a wholly inappropriate medium. The parts and their original relationships are recognizable enough and the slick surface of the plastic looks a good deal like porcelain, but everything that pertains to the original function of the washstand has been transformed. Like many of the objects which Oldenburg has "metamorphosed," a washstand is

8-11 Claes Oldenburg, *Soft Washstand*, 1965. Vinyl, plexiglass, and kapok, 55″ × 36″ × 28″. Collection Dr. Hubert Peeters, Bruges, Belgium.

something that we all have constant sensuous contact with—its faucet handles resist and then give way to the twist of a hand, its surface is cold and often wet, and above all it is hard and firmly fixed to the floor. These are precisely the qualities that the represented washstand does not have, so that the tension between reality and the medium in which it is re-created is extreme. It reminds us that humor in the visual arts (as in literature and music) can produce "serious" art.

Turning to painting, one of the common transformations is that of nature into paint. When Edouard Manet painted his *Oysters* (Fig. 8-12) he was interested in capturing the precise relationships among lights, shadows, and reflections in

8-12 Edouard Manet, *Still Life with Oysters*. Oil on canvas, 15¼″ × 18¼″. National Gallery, Washington, D.C. (Gift of the Adele R. Levy Fund, Inc.).

his subject. He was just as interested in the application of thick strokes of fluid paint which retain the scale and texture given them by a wide brush when the paint was wet. This painted surface vies equally for our attention with the illusion of visual reality. The subject would not hold our attention long by itself but the experience of seeing nature embodied in a medium so different from reality does.

A similar reaction comes from looking at Winslow Homer's *Sloop, Bermuda* (Color Plate 1) as we apprehend that the seeming casualness of the strokes of watercolor on a somewhat textured paper actually captures a great deal of nature. Sunlight, space, a reflective water surface, the

sense of moving waves and rocking boats, of wind whipping the sails and turbulence in the clouds—all these aspects of reality seem present. Many clever painters can apply oil paint fluidly like Manet or watercolor with the apparent ease of Homer, but it is only when the illusion of reality is simultaneously present that we feel this particular effect of tension between nature and the medium.

Space vs. Surface

Artists like Manet and Homer were interested in a high degree of naturalism but many artists in the generation following theirs began to retreat

from naturalism in favor of a greater emphasis on the flatness of the picture surface. Edouard Vuillard was one of these. A painter of quiet, middle-class subjects, he chose to deemphasize their three-dimensionality, as we see in his *Interior at l'Etang la Ville* (Fig. 8-13). The picture represents the artist's sister, busy at her dressmaking, and a painter named Roussel, who catches her attention as he peeks around a corner. The figures seem little more than silhouettes, though in the foreground there is some modeling and an effect of light and shadow on the materials at the right. But these and the limited use of perspective do little to create a three-dimensional interior. Rather, the flat areas of color and the patterned surfaces of walls and dresses all tend to merge into a single plane that is the surface of the painting itself. Some of the gentle intimacy that Vuillard captured here is surely due to bringing everything nearly into the same plane.

Paul Cézanne carried the tension between three-dimensional forms and the flatness of the surface to a new high in his late works like *Mont Sainte-Victoire Seen from Bibémus Quarry* (see Fig. 15-16). The warm colors of the rocks in the foreground make them appear to stand well in front of the grayish peak beyond, and the mountain's lower slopes have strongly modeled forms that seem to bring it forward to nearly the same plane. The huge mountain reads as far away because of its small size, yet the outlines that define it are of the same strength as those in the foreground, thus bringing it forward. The consistent scale of the brushstrokes unifies all the parts on the picture surface, but we carry away from our viewing of it a sense of space and the massiveness of the rocky forms. Such tension between opposites reflects the artist's feeling of restrained excitement that is the essence of Cézanne's expressiveness.

A third example of this important tension between more and less three-dimensionality in painting is Rogier van der Weyden's *The Descent from the Cross* (see Fig. 13-2). Rogier was one of the most sophisticated painters of fifteenth-century Flanders, and other works of his from the

8-13 Edouard Vuillard, *The Suitor* or *Interior at l'Etang la Ville*, 1893. Oil on panel, 12½″ × 14½″. Smith College Museum of Art, Northampton, Mass.

same time show that he was quite capable of constructing a readable perspective space. Here, nevertheless, he chose to place a group of figures in a space that seems too shallow to hold them. The fainting Virgin occupies the front plane, and located successively behind her are the body of Christ, the man holding him, the cross, the ladder and the boy assisting in the lowering of the body. Yet all these are fitted into a niche that, judging from the upper corners, is barely two figures deep. We know the origin of Rogier's idea; it is the traditional sculpture in a niche, found in many churches, in which the figures in front may be in the round but the further ones are in high relief, making it possible to fit them into a limited space. By combining this idea with the natural rendering in full color of fully modeled figures with detailed textures of clothes and flesh, Rogier creates a decided conflict between reality and an ideal concept. The solution of this conflict is to be found in reading the painting neither as straight reality nor as re-created sculpture in an ideal space, but as a coexistence of both, only resolvable in the painting itself.

Figure vs. Ground

A special case of the relation between two and three dimensions appears when the ground against which a figure is placed becomes important enough to assume the role of figure itself. If we look back to Chapter Two and the Greek vase painting of running men (see Fig. 2-7) the light areas between the men's legs and bodies are clearly background, or *negative* as compared with the *positive* areas of the men. When attention is focused on the light shapes, they temporarily become figures and the black shapes are seen as the ground. Soon, of course, our attention returns to the dominant reading of darks against light. This pull from one reading to another has an ambiguous effect of such a special character that it has been named a *figure-ground relationship*.

The tensions produced by the figure-ground phenomenon have attracted many modern artists. One of the first to experiment with it was the Frenchman Paul Gauguin, who recognized its value in woodcuts (Fig. 8-14). In *Women at the River* the dark woman is the figure seen against a light ground, but the light ground then merges with the light woman, hence becoming figure. The dark water which is her ground assumes positive shapes to her right and reads more as figure. At the upper left, light land and dark water seem equivalent in their figure-ground relationship. There is a third force at work here as well—the texture of the carved wood, which has been transferred to the paper in making the print and which belongs to both the light and dark

8-14 Paul Gauguin, *Auti te Pape—Women at the River*, 1891-93. Woodcut with color, 8⅛" × 14". The Museum of Modern Art, New York (Gift of Abby Aldrich Rockefeller).

shapes. These numerous ambiguities animate our viewing of this otherwise simple woodcut.

In the still life by Juan Gris illustrated in Figure 6-20, figure and ground are constantly being interchanged. Recognizable objects such as the fruit bowl tend to be seen as figures, but when shapes overlap them they become ground. A positive shape like the dark area in the lower left tends to read as figure, yet its upper right border seems to be the edge of a table top that must lie in front of it. The ambiguities that were hinted at in the Gauguin become dominant in this developed Cubist work.

Visual Metaphors

Finally, moving away from the somewhat technical concerns of the figure-ground problem, we turn to relationships that involve the ideas embodied in works of art. The *visual metaphor* relates two things that are very different in their references but similar visually, usually in their shapes. The French artist Honoré Daumier sometimes used visual metaphors to poke fun at the pretentious, like the *Ladies of the Demi-Monde* (Fig. 8-15). The central theme of this lithograph is the improbability of the two ladies with excessive skirts fitting into the tiny carriage, but there is also a visual metaphor of sorts to be seen in the similarities between one lady's profile and the horse's rump and tail.

Generally, however, visual metaphors are more subtle and more serious, as in El Greco's painting of Christ in the Garden of Gethsemane, (Color Plate 21). An angel appears at the left to offer the cup to Christ while the soldiers who will arrest him approach in the distance. He had been praying when the angel appeared, and his pose suggests the tension in his relationship to this world and to the world of the spirit. Behind him rises an unnatural hill that repeats his overall shape and seems energized by a similar emotion.

8-15 Honoré Daumier, *Ladies of the Demi-Monde*, c. 1850. Lithograph, 7½″ × 10″. Museum of Fine Arts, Boston (Babson Bequest).

The animation that El Greco infuses into this rock not only repeats that of Christ but also amplifies it, extending its force through the whole picture. Its formal repetition of his shape is a likeness grouping, but it goes beyond that in being so different—rock versus person—while at the same time echoing human emotions. Intense colors in Christ's robes reinforce the intensity of his emotion while the gray of the hill relates it to the lifeless ground.

In this chapter we have dealt with some of the oppositions in works of art which, when held in an appropriate state of tension, produce a response in the viewer. Some of these oppositions are primarily visual, like those in the Seagram building, others touch on the spiritual, like the painting by El Greco. There are other types of oppositions that could be explored in different works, but those studied here should be enough to establish the idea that tensions in works of art infuse them with a kind of vitality that heightens our own sense of being alive.

9
Interpretation

Our next step into the expressive realm will involve subject matter and how artists interpret it. We shall be concerned only with representational art and with particular ways in which meanings have been evoked from a subject or theme.

By this time readers will have realized that *interpretation* can have two meanings. We speak on the one hand of the artist interpreting the subject matter and on the other hand of the viewer or critic interpreting the artist's work (or interpreting the artist's interpretation). Ideally the two interpretations will turn out to be the same; in practice this is not always true, since different people in different periods will look at things differently. What is presented here is one interpretation of treatments of the same theme by the same or by other artists. The object of these comparisons is both to examine what an artist does when interpreting subject matter and to demonstrate that many different ideas can be embodied in the same theme.

One type of variation in interpretation occurs when an artist revises a work after a long interval of time. El Greco did this when he repeated the subject of the *Purification of the Temple* some thirty years after his first version of it (Fig. 9-1). His starting point for both was the account in the Gospels; here is John's version of Christ's actions in the temple that day:

> In the temple he found those who were selling oxen and sheep and pigeons, and the money-changers at their business. And making a whip of cords, he drove them all, with the sheep and oxen, out of the temple; and he poured out the coins of the money-changers and overturned their tables. And he told those who sold the pigeons, "Take those things away; you shall not make my father's house a house of trade."

Evidently El Greco was satisfied with many of the major figures in his first version when he did the second (Fig. 9-2). He kept the poses of Christ, three of the figures to the left, the two older men at the lower right, and three or four in the group of people above them. But otherwise a considerable simplification has taken place. The four portraits (of other artists) in the lower right corner are gone, and several figures from the left-hand group have been omitted. A most effective

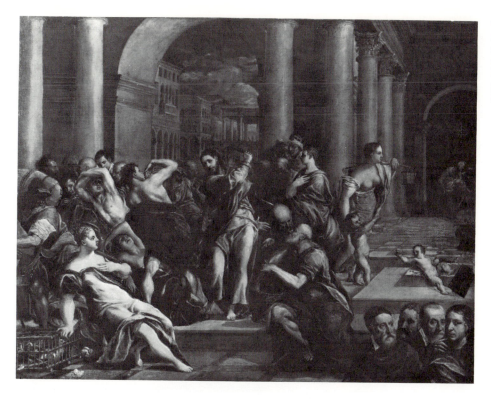

9-1　El Greco, *The Purification of the Temple,* c. 1570-75. Oil on canvas, 46⅜″ × 59⅜″. Minneapolis Institute of the Arts (The William Hood Dunwoody Fund).

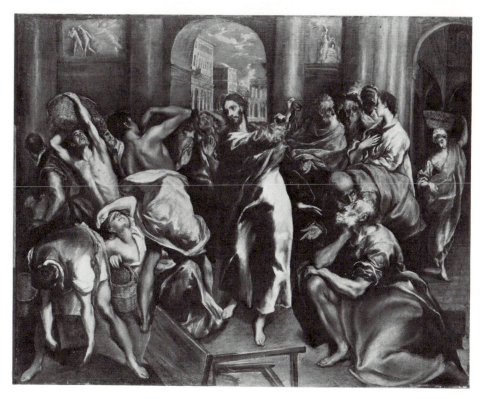

9-2　El Greco, *The Purification of the Temple,* c. 1600-05. Oil on canvas, 41¾″ × 51¼″. Reproduced by courtesy of the Trustees, The National Gallery, London.

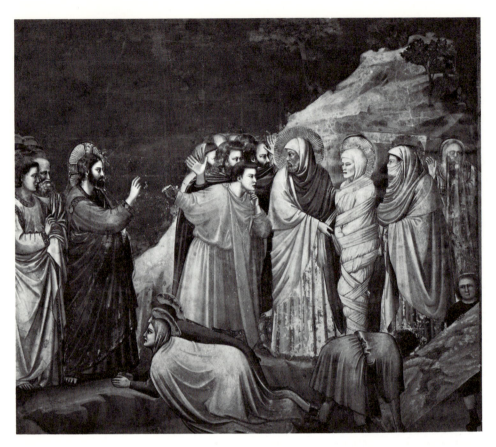

9-3 Giotto, *The Raising of Lazarus,* 1305-06. Fresco in the Arena Chapel, Padua.

change is the enlargement of the figures in relation to the whole and the subordination of the architecture in relation to them. Even the space has been simplified, with less in the foreground and a decided truncation of the depth behind the figures. And the perspective lines that articulated the space in the earlier version are gone.

The principal additions are the man leaning forward to pick up his money chest in the left foreground, the tipped-over table, and two sculptured reliefs on the wall on either side of the arch. These latter enlarge the scope of the subject matter by depicting events in the Old Testament which bear an analogy to the event of the angry Christ driving out the money-changers: on the left the angel of God drives Adam and Eve from the Garden of Eden, and on the right an angel stays the hand of Abraham as he is about to sacrifice his own son. One refers to the anger of God and the other to God's restraint; both were. found in Christ's actions as well.

What we notice in comparing these two paintings is the greater focus of emotion and energy and the greater intensity of the feelings expressed in the later version. Christ is a more dominating and arresting figure for several reasons: his actions are more sweeping (the curve from toe to waist is uninterrupted), the color of his robes, if we could see it, is more striking, and there is more emphasis on his face and eyes. The glances and gestures of the crowd direct us more strongly to Christ, and the narrowing of the archway also pulls our attention there. The actions of those he strikes out at are also more violent, the elongated heads and the upward stretching arm aiding in this effect.

There is so much visible evidence that El Greco has made the theme more forceful, more focused, and more dramatic—generally richer in emotional content—that we can be quite sure that we have not gone too far in our interpretation of the second version. El Greco clearly intended the

expressiveness and feelings that we have found there.

Let us now examine a situation that is slightly different—one in which two artists of unequal abilities depicted the same theme in almost identical ways. First we will see how Giotto evoked meaning from a subject by the way he presented and arranged the characters. The story is that of the *Raising of Lazarus* (Fig. 9-3), one of Christ's most impressive miracles. In response to the pleas of Mary and Martha, Christ revived their brother Lazarus, who had been dead for four days. A number of people were there when the lid of the tomb was removed and the unwrapping of the corpse was begun. Then Christ spoke the words, "Lazarus, come forth," and the flutter of Lazarus' eyelids signalled the return of life. This is the instant recorded by Giotto. He also chose to include the events just preceding and just following this moment. The boys are still shown removing the lid, the spectators express their amazement at the signs of life (those to Lazarus' right cover their noses against the smell of death), and Mary and Martha fall to their knees in gratitude. By thus telescoping the sequence of events,

Giotto enlarged the significance of the particular moment of the reawakening. (He also enlarged it by placing this scene directly above a scene in the same series of paintings showing Christ's own emergence from the tomb at his Resurrection.)

The extraordinary use of visual means to emphasize or suppress each event is what is so impressive about this painting. The foreground figures of the sisters and the boys are noticeable but are kept subordinate to Christ and to Lazarus. Christ's head, and particularly his hand, are isolated against the dark blue sky, clearly making him the central character. The two men in the center serve to call attention to both Christ and Lazarus. The haloed man turns sharply to Christ while his action connects him to Lazarus; the other gestures toward Christ while staring at the revived corpse. The heads of both these men avoid being on the horizontal line that connects the eyes of Christ and Lazarus—one is above and the other below it—hence they do not interfere with the compelling psychic connection between the two chief characters.

The effectiveness of Giotto's interpretation is revealed if we compare it with a version of this

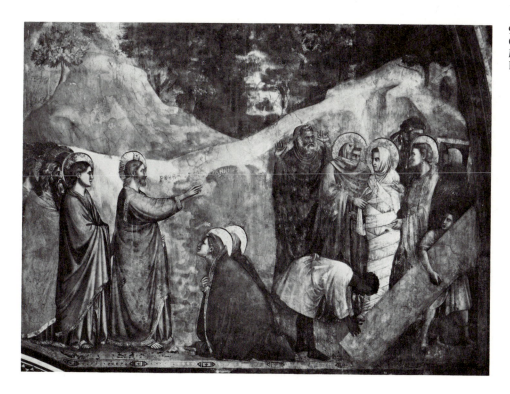

9-4 Follower of Giotto, *The Raising of Lazarus.* Fresco in San Francesco, Assisi.

subject by one of his followers (Fig. 9-4). In this version the powerful psychic tie between Christ and Lazarus is nearly lost because of the overlarge rift between them. Into this area the two sisters intrude so that they are no longer subordinate as they were in the other version. The boys with the grave slab also are too prominent. As a result of these changes the main theme is much weakened and Giotto's very successful control of dominant and subordinate themes has been lost.

From these examples of reworkings of themes we get a sense of the kinds of decision making that artists face as they try to find meaning in their subjects. A kind of critical activity is involved: some things are preserved from the earlier version, others are modified, eliminated, or added in the process of reworking. In El Greco's case the later version seems more successful in its dramatic realization of the subject, while the follower of Giotto came up with a decidedly weaker version.

Now let us consider an instance in which one

9-6 Michelangelo, *Virgin and Child (Bruges Madonna)*, c. 1504. Marble. Onze Lieve Vrouwe, Bruges, Belgium.

9-5 Michelangelo, *The Holy Family (Doni Madonna)*, c. 1504. Uffizi, Florence.

artist treated the same subject in very different ways at about the same time. Early in his career Michelangelo created two images of the Virgin and child: a painting, the *Doni Madonna* (Fig. 9-5), and a sculpture, the *Bruges Madonna* (Fig. 9-6). We immediately sense a difference in the approach to these two works that sets them apart as much as the difference in mediums. The painting is filled with a sensation of activity that arises from a twisting of arms and bodies and the full curves of drapery forms, both relating to the circular shape of the frame. Joseph is included in this group, supporting the child who seems about to step onto his mother's arm. She is turned toward the child in a pose as active as his own, and her attention seems entirely directed to him. In the sculpture the Virgin is contemplative and the child is quiet, so that the two are as similar in their thoughtfulness as they are in their activeness in the painting. The draperies again contribute to the effect, for even though their articulation is as marked as in the painting, they

hang in largely vertical patterns with a heaviness that reinforces the feeling of tranquility. If we compare these two versions with that of the *Medici Madonna* (see Fig. 7-16), done some twenty years later, we find, interestingly, that the third work combines elements of both of these. In the Medici version the two figures are set into opposition, the activity of the child serving as a foil to what in the end is the dominant feeling, the almost dreamy mood of contemplation in Mary's face. Her unfocused eyes seem to see beyond the present and the slight sadness in her face suggests that she is aware of the tragedy to come, while her busy son behaves like any other child.

Sometimes there is evidence that one artist's work played a part in the formation of ideas in the work of another artist, as in the case of Mantegna and Rembrandt. Among Rembrandt's possessions in the year 1656, when he went into bankruptcy and had to make an inventory, was what he recorded as "the precious book of Mantegna," a collection of engravings by an artist who preceded him by two hundred years. One of these was the *Entombment of Christ* (Fig. 9-7), which Rembrandt copied in a pen and wash drawing (Fig. 9-8). As we compare the two we see

9-7 Andrea Mantegna, *The Entombment of Christ,* second half of fifteenth century. Engraving. Reproduced by Courtesy of the Trustees of the British Museum.

how Rembrandt modified the earlier version. Besides leaving out the background and eliminating much of the detailed description of sculptural form, he removed some of the melodrama from the scene. At the left he eliminated the woman with out-flung arms and some of the

9-8 Rembrandt, copy after Mantegna's *The Entombment of Christ.* Pen and wash.

9-9 Rembrandt, *The Entombment, c.* 1645. Etching, 5″ × 4¼″. The Metropolitan Museum of Art, New York.

more flamboyant drapery folds. Christ and the central standing figure were changed very little, except for leaving out bits of floating drapery. The fainting Virgin and the woman supporting her have been moved toward the center and raised slightly to group them more closely with the central figure, while the apostle John, at the right, remains essentially the same. In all, there is more unity and a greater simplicity in Rembrandt's copy and the expression of grief is more restrained.

But it is in Rembrandt's own etching of this subject, unencumbered by the ideas of others, that his very different interpretation comes clearly forth (Fig. 9-9). All that remains to suggest that he knew Mantegna's print is the great rock with its opening that will be a tomb and the distant hill where the procession of mourners began. The greater simplicity and restraint noted in his copy now dominate all. Each figure in the procession is quietly grieving rather than outwardly expressing sorrow. Mantegna made each figure a separate symbol of grief as well as a sepa-

9-10 Giorgione and/or Titian, *Concert Champêtre, c.* 1510. Oil on canvas, approx. 43″ × 54″. Louvre, Paris.

rate sculptural form; Rembrandt brought his figures together into a solid block and created thereby a kind of monolithic grief, as all move together slowly toward the door of the tomb. As well as being quiet and restrained, the emotion here is unified and pervasive. It seems to be carried throughout the whole of this small print by the fluid darks that pass from rock to figure group, and lights that move from foreground into the burial procession and beyond. In its simplicity the quiet horizontal of the dead Christ sets the tone for the feeling of the whole. With these various means for emphasizing the whole there is little need to emphasize facial expression. The quiet poses of the figures and the ways in which they relate to each other are sufficient to convey meaning, something that we may lose sight of in this day of the close-up movie camera and its focus upon facial expression.

Sometimes a new version of a subject leads to a completely new interpretation. This occurred, for example, when the nineteenth-century French artist Edouard Manet decided to do a painting with figures in an outdoor setting based on an Italian Renaissance work. The painting that served as his starting point—we are not certain whether it was painted by Giorgione or Titian—was an idyllic scene of two women and two young men in a pastoral setting (Fig. 9-10). Since it is in the Louvre, it has for a long time been known by its French title, *Concert Champêtre*, and so far as we know it may have had no more definite subject than a simple evocation of the feelings associated with music and a pleasant environment. Because of the artist's ability to unify all parts of the painting through the breadth of his composition and his pictorial treatment, the mood generated by the four people pervades the whole. It is a mood of sensuous satisfaction, and one that exists more in the imagination than in reality. In reality there is always something to remind us of the specific and the temporal, while here all such elements have been removed and what remains belongs to an ideal world. We hardly give a second thought to the fact that the men are clothed and the women nude.

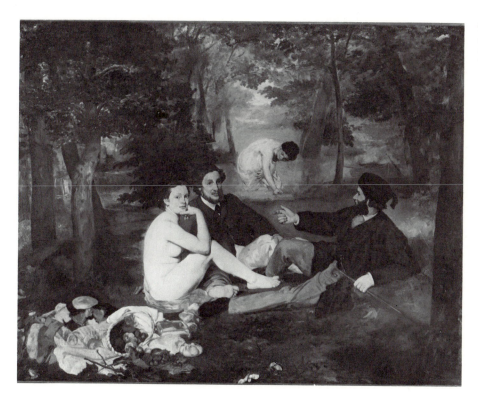

9-11 Edouard Manet, *Le déjeuner sur l'herbe*, 1863. Oil on canvas, approx. 7' × 8'10". Louvre, Paris.

9-12 Claude Monet, *Study for Le déjeuner sur l'herbe*, 1865-66. Oil on canvas, 52" × 72½". Moscow, Pushkin Museum.

When Edouard Manet borrowed the theme in 1863, he placed the clothed men and a nude woman in a park-like setting and gave it the title *Le déjeuner sur l'herbe* (Fig. 9-11). In many ways Manet tried to make his painting like a Renaissance work, but the interpretation of the subject is strikingly different—to his contemporaries shockingly different. Instead of a generalized and idealized mood of timeless reverie there is a sense here that we have walked into an unusual picnic. The luncheon is spread out at our feet together with the woman's garments. She is not only without clothes, she also looks at us frankly and without embarrassment or surprise. The men seem to be engaged in conversation, while the fourth person is wading in a pond. The emphasis on the specific—the contemporary clothes, the portrait-like figures, and the woman's relation to the spectator—removes from this painting the ideal content we feel in the Giorgione/Titian and gives it a quality of the real. So does the very specific lighting on the figures: a strong light from the front that produces large areas of rather flat color and small patches of cast shadow. These

matter-of-fact local colors convey a more factual reality than the arbitrary passages of shadow and light over the male figures, for instance, in the *Concert*. It is not surprising then to learn that Manet's painting was regarded as indecent by most of the public when it was first exhibited. Many paintings of nudes were exhibited in Paris at the time but most of them were somewhat generalized along Renaissance lines or represented nymphs or goddesses that would not be having lunch in the park with Parisian gentlemen.

A variation on the theme of this painting, almost amounting to a criticism of it, was painted by another artist of the time. Claude Monet was in his early twenties when Manet's *Déjeuner* was exhibited, and within two years the younger man was at work on a much larger painting with more figures, which he referred to as his *Déjeuner sur l'herbe*. Except for two fragments this painting does not now exist, but a study for it has been preserved (Fig. 9-12). What Monet set out to do was to portray a picnic that would actually have occurred among the upper-middle-class society with which he was familiar. He preferred to re-

place the subtle wittiness of Manet's version and its historical references to earlier art with straightforward realism. While he rendered clothing and faces in a factual way similar to Manet's, and used the same bold method of applying paint, Monet pushed realism further by placing the figures more believably within the wooded setting. Manet's setting seems almost like a stage backdrop compared with Monet's; the younger artist had been painting realistic landscapes and wished now to place large figures in an authentic natural setting (the painting was about twenty feet wide). Figures and setting were to be held together by being subjected to the same effect of sunlight and shadow—and not, as in the Manet, separated by a difference of effect. Altogether, the quality of the "here and now" is more strongly stated in Monet's version.

These last examples are different from the earlier ones in this chapter by not having such specific subject matter, for the characters are not well known and there are no stories to be familiar with—yet the artists convey their sense of the significant as much as if there were stories and characters. To follow this line of thought further let us look at a series of landscapes and the variations in interpretation of the world that they express. One day in the spring of 1877 Camille Pissarro and Paul Cézanne set up their easels side by side in an orchard and proceeded to notice very different things in the scene before them. Pissarro, like Monet, had been developing the Impressionist approach to the interpretation of landscape, and now in *Orchard* (Fig. 9-13) we see the full development of it. Impressionism was a way of looking at the world which placed the major emphasis on *appearance*—earlier, we recall, it was identified with the visual mode of representation. The logical conclusion of this approach is to render things as they appear at a particular moment of time, and that is what we see here: there is even the illusion of motion in these leaves and blossoms as the wind turns some to catch a glint of sunlight while others are tipped into shadow. The artist was faithful to the appearance of the scene from where he sat. He noted that the houses were partially hidden by foliage, that atmospheric tone strongly affects the colors of things, and that surfaces in sunlight are warmer in color than those in shadow. These momentary and atmospheric qualities are accompanied by luminous effects enhanced by broken color; "luminosities stirred up," as Pissarro has already been quoted as saying. To complete the sense of the real moment Pissarro avoided any evidence of conscious composing in his picture. The sense of casual rather than contrived seeing is maintained throughout.

How differently Cézanne interpreted the subject (Fig. 9-14). He diminished the atmospheric effect to the point where it seems to be a different kind of day. The sparkle of sunlight and the illusion of leaves moving in the wind no longer dominate. They are suppressed in favor of rather firm areas with linear edges and nearly geometric shapes. The houses seem to have been moved forward so that the surface composition is of greater importance than it was in Pissarro's work, and the trees have been stripped of much of their foliage to achieve a firm simplicity of composition. In describing these formal differences between the two landscapes many of the basic differences in interpretation are suggested. However, form is not expression, and as artists interpret reality so critics must address themselves to making this interpretation as available as possible to others. To suggest this, critical language has to move away from the more precise to the more suggestive and allusive.

Pissarro's painting suggests a benign world where people live in a close relationship with nature, enjoying the beauty and fragrance of fruit trees in flower while looking forward to the rewards of the harvest. An early planting of the foreground garden already shows promise. Houses settle into this rural environment as if they are at one with it, just as they share the same soft air and pervasive sunlight. This pleasant world is presented to the senses in a moment of time, which the artist could convey because he had mastered the means of momentary representation.

This was not the challenge felt by Cézanne. The expression of a passing moment was not as important as the suggestion of more permanent qualities he felt in the world. The firm horizon-

9-13 Camille Pissarro, *Orchard in Pontoise,* 1877. Oil on canvas, 25⅝″ × 31⅞″. Louvre, Paris.

9-14 Paul Cézanne, *Orchard in Pontoise,* 1877. Oil on canvas, 20″ × 24½″. Collection Mrs. Alexander Albert, San Francisco.

tals of the wall, hardly noticed by Pissarro, are there through all the changing seasons. The buildings and the hillside itself have a solidity which, to Cézanne, was more significant than the transitory leaves and blossoms. Crisp edges between buildings and sky are worthy of emphasis and their positive shapes give firmness to the whole composition, for it was by composing in a thoughtful way and by reading geometrically simple forms into the scene that permanence and stability could be expressed. Later in his life they would become even more important to him, as seen in his painting of *Mont Sainte-Victoire as Seen from Bibémus Quarry* (see Fig. 15-16).

An idea of the range of interpretation possible in art can be obtained by examining a series of paintings of the same subject matter. Perhaps none lends itself better than landscape, which has been treated to a surprising variety of visions over the centuries. Carrying on from the discussions of Pissarro and Cézanne, we will consider the approaches taken by a number of major artists and see how they expressed different emotions and ideas. The first artist we will look at was a younger contemporary of Pissarro and Cézanne. When Vincent van Gogh, a Dutch painter, moved to the south of France he became excited about new landscape forms that he had not known in the north. He wrote in a letter of 1889, "The cypresses are always occupying my thoughts, . . . it astonishes me that they have not yet been done as I see them." Looking at one of van Gogh's paintings of *Cypresses* (Fig. 9-15) we have a strong impression of how he saw them: as turbulent forms bound together by the flame-like motifs that he read into them. The natural forms themselves were his starting point, but he has gone beyond these by turning not only the trees but the sky and foreground as well into a closely woven set of curved brushstrokes. As if to give emphasis to the individuality of his brushstrokes he used an impasto paint. The brushstrokes, the insistence on the character of the paint itself (the artist's medium, not nature's), and the sense of emotional involvement, all combine to make us see nature through the artist's eyes and feelings. This is very different from either Pissarro or Cézanne, who also selected and emphasized but did not assert their personalities to the same de-

9-15 Vincent van Gogh, *Cypresses*, 1889. Oil on canvas, 36¾" × 29⅛". Metropolitan Museum of Art (Rogers Fund, 1949).

gree. Van Gogh's kind of painting is called *expressionistic*, a term that refers to the heightening of feeling by means of the exaggeration or distortion of visual elements. It usually requires that observers share the artist's feelings and that they become sympathetic participants rather than detached viewers. For instance, in order to accept the artist's turning of clouds and sky into curlicues of white and blue paint we have to merge our perceptions to some extent with those of van Gogh. The popularity of his art suggests that many people are able to do this.

About a half a century before van Gogh, Joseph Mallord William Turner was painting pictures which also had a high degree of emotionalism. His *Snowstorm in the Val d'Aosta* (Fig. 9-16) is representative of a movement called *Romanticism*, which was felt in all of the arts during the first half of the nineteenth century.

9-16 J. M. W. Turner, *Snowstorm, Avalanche, and Inundation in the Val d'Aosta*, 1837. Oil on canvas, 36¼″ × 48″. Courtesy of The Art Institute of Chicago (Frederick T. Haskell Collection).

Romantic artists often traveled great distances in order to find subjects as violent and inhospitable as this Alpine snowstorm and avalanche. While van Gogh's emotionalism seemed to be within the artist himself, it was in nature's "moods" that Turner found the kinds of forces that evoked or reflected human moods. These forces have an awesome power. The human beings at the lower right are overwhelmed by the scale of their surroundings and the energy of nature's destructive forces. Yet there is a certain grandeur to this cataclysm too; the sun shining through the snowstorm and striking the ice and rocks conveys a sense of natural beauty as well. Turner and other Romantic artists frequently combined emotions

associated with beauty and those akin to terror in the same painting.

Turner was capable of imbuing almost any landscape with heroic qualities. His *The Crook of the Lune* (see Fig. 15-5) creates a vastness of space as plane succeeds plane back into a distance that suggests infinity. The small figures are again dwarfed by these effects of luminous space. This is a far cry from the intimate backyard of Pissarro.

Interpretations of landscape similar to Turner's had appeared many centuries earlier in China. Fan K'uan was the probable author of *Travelers in Autumn Mountains* (Fig. 9-17), which also depicts tiny humans in an imposing setting of mountains and waterfalls. No two periods of

9-17 Fan K'uan, *Travelers in Autumn Mountains* (detail), c. 1000. Hanging scroll, ink and colors on silk. Collection of the National Palace Museum, Taipei, Taiwan, Republic of China.

painting reflect identical attitudes, however, and the Chinese artist's scene does not call forth the same degree of emotion in us as does the Englishman's with its shifting lights and darks. There is greater detachment from a particular effect of light and atmosphere and more emphasis on permanent characteristics of rocks and trees. So in spite of its grandeur, the term *romantic* is less applicable to this painting because our reaction involves less of an immediate sense-invading experience than with Turner's. Nevertheless, the contrast between a grand natural setting and the transitory passage of man through it is strongly felt.

A greater equality between nature and human beings is found in *The Return from the Field*, a painting by Rubens (Fig. 9-18). There is something almost triumphant about the peasant women returning with their harvest, the man with the cart waving to them as his dog hurries the sheep homeward. In the middle ground the horses, having been freed from their carts, turn to some late afternoon grazing. Rubens brought people and nature together in an optimistic celebration of country life. Trees and clouds share in the movement of people, animals, and birds. A richly pictorial treatment and powerful spatial recessions provide the setting for the expression of harmony existing between creatures and their environment. The world is a dynamic whole to which everything contributes its own vitality.

In using people and animals in a natural environment, Rubens was following a tradition begun only in the previous century by the great Flemish painter Pieter Bruegel, who had mostly painted scenes of the everyday lives of the peasants. In his *Hunters in the Snow* (Fig. 9-19) men are returning to the village with their dogs. They pass a house with a fire out front and they look down, as we do, on a pond that has been swept clean of snow for the skaters. In the distance are Alp-like mountains that Bruegel would not have

seen in his homeland but which he felt would add to the grandeur of his scene and suggest the range of the natural world. In including them he was unlike any of our other landscapists except Fan K'uan who also wanted to recognize aspects

of natural grandeur even though we can't be sure that his mountains actually existed in this setting either. So there is something of a conceptual interpretation in both of them. Perhaps this is also why they paid such attention to the structure of their trees and rocks, allowing the character of these structures' forms to be dominant rather than being subjected to the forces of light and wind, as Rubens and Turner had made them. Neither Cézanne nor Pissarro kept this separateness of the objects in their landscapes, and van Gogh subordinated them to his subjective interpretation. None of the other landscapists deliberately enlarged the range of references by including people at play as well as work, village life as well as open country. Rubens came closest to Bruegel in this, but he did not include the grandeur of mountain scenery. Pissarro's is the most limited in scope, deliberately, as he wanted to convey the naturalness of the moment.

Again we have no single word suggestive of Bruegel's interpretation. It is naturalistic in the sense that we feel the objective character of everything (note the particularity of the bush in the center foreground), and that the space is completely clear from the foreground to the horizon. But it is universalized as Pissarro's naturalism is not. The fact that it is so ordered compositionally, with everything contained within its boundaries instead of being a fragment of nature, lends it a quality of permanence that it shares with the Cézanne. All the details belong to the whole and yet are not so subjected to the whole as with Rubens. For instance, we can look closely at the various figures in the lower right part of the painting and accept them for themselves alone without feeling it essential to relate them always to the total painting. In short, none of the

9-18 Peter Paul Rubens, *Return from the Field*, c. 1635. Oil, 48½″ × 77½″. Pitti Palace, Florence.

9-19 Pieter Bruegel, *Hunters in the Snow*, 1565. Oil on panel, 46⅛″ × 63¾″. Kunsthistorisches Museum, Vienna.

other landscape artists combined the quality of the individual object or figure with the embracing quality of the whole, or the naturalness of a scene with a universality of reference in the same way that Bruegel did.

As we think back over the different works and artists considered in this chapter we note that they represent a variety of periods and countries. The differences between them can sometimes be traced to individual personalities but often they are in part the product of the different times and places in which they lived. This means that if we are to achieve an understanding of these works we must take adequate account of the relation between artists and the cultures to which they belong. To what extent are artists influenced by time and place and by the traditions and beliefs which surround them? In our search for answers to these questions we must examine the concept of style in art.

10
Civilization
and
Style

In the medieval galleries in the Museum of Fine Arts in Boston there is a life-size wooden statue of the Virgin Mary holding her child (Fig. 10-1). She wears a crown, indicating her role as heavenly queen, and the child holds an orb, symbolic of the universe, and once raised a hand in what must have been a gesture of blessing. Several things contribute to a sense of seriousness, serenity, and gentle sentiment conveyed by this mother and child: the frontality of the poses, the linear verticality of the drapery folds, and the simple elongated overall shape that is repeated in such long ovals as the Virgin's head and the drapery over her knees.

This description is not unlike the kind that has often been given in earlier chapters, but it is no longer sufficient for our purposes in this and future chapters. *The Virgin and Child* was not created to be placed in a room in a museum and become an aesthetic object simply to be contemplated. The museum is not the sculpture's cultural home. If we are to better understand this work, we must return to asking the kinds of questions that were raised in Chapter One. For whom was this gentle *Virgin and Child* created and for what reasons? The answer to the first part of this question is lost in the past and there is no single answer to the second part, but we can examine the civilization that produced it—that of northern France in the early part of the thirteenth century—with the aim of placing it in its original context. In doing this we shall also begin to understand why it looks the way it does.

The Style of the Year 1200

If we begin by looking at the subject matter, we will find that the Virgin Mary was an extremely popular figure in the art of that time and place. She had been prominent in the Christian hierarchy for centuries, but in the early thirteenth century very nearly took over the position of prime importance from her son. The great cathedrals of northern France—Chartres, Paris, Amiens, Reims, Rouen—were all dedicated to Our Lady (*Notre Dame*). Christ ruled in heaven, where he became virtually identified with God, but Mary, being closer to this world, was more

accessible to those seeking comfort. Christ had crowned her queen of heaven and therefore she could be a powerful intercessor in time of need. Further, she had an appeal to the people of this period because of a special regard for women that was also expressed by the growing emphasis on courtly love and on the rules of chivalry. (The French poet Chrétien de Troyes had recently written about King Arthur and the court of Camelot—the earliest accounts that have come down to us of this romantic period of the past.)

Nowhere was this cult of the Virgin more thoroughly developed than at Chartres. One of the reasons for her popularity there was that the cathedral owned an important relic, her tunic, and relics provided the people of the Middle

10-2 Central doorway, north portal of Chartres Cathedral, early thirteenth century.

10-1 *The Virgin and Child*, Ile-de France, early thirteenth century. Polychromed wood. Museum of Fine Arts, Boston.

Ages with strongly felt ties to the figures of their religion. This tunic survived a major fire in 1194 that destroyed most of the unfinished cathedral, and the grateful people of Chartres set about building a larger one in which they gave the Virgin a more important place.

The elaborate sculptural program of the north portal reflects the emphasis on Mary. The portal has three doorways and all of the hundreds of sculptures around them relate to some aspect of the Virgin's life. In the relief above the middle door is her triumph as she is being crowned by Christ in Heaven (Fig. 10-2). The portal to the left of the one illustrated treats her role as

mother—and thereby the means of Christ's incarnation on earth. The one to the right deals with ideas dear to the churchmen of the day, namely the union of Christ and the Church, and the triumph of the Church over dangers threatening it. These themes relate to Mary because she was frequently identified with the Church. In this middle doorway she appears as a child in her mother's arms (on the central pier) and in scenes from her death and her transportation to heaven by angels (immediately above the doors) as well as in the coronation scene above.

One of the things that impresses us as we look back on this period from a modern perspective is the degree to which the whole population par-

10-3 Jamb figures on the central doorway of the north portal of Chartres Cathedral, c. 1200-10.

ticipated in the planning, building, and use of a cathedral such as Chartres. The subject matter of the north portal sculpture was worked out by the churchmen of the day, following a very organized set of theological ideas. The immense cost of the portal was borne by the French royal family, who followed the progress of the work with interest. And the people themselves participated in bearing the cost of the entire cathedral and even in contributing their labor. One account, dating from the first building program, prior to the fire, tells how peasants and nobles labored together to pull the carts loaded with stone from the quarries to the site of the church. Evidence of the degree to which a cross-section of the population participated in the great task is provided by the stained-glass windows, most of which were done during the same period as the north portal. Forty-two of them were gifts of guilds and businesses, and among the guilds were those of the carpenters, weavers, bakers, watercarriers, armorers, shoemakers, silversmiths, and so on.

Concerning its use, the church itself was located in the heart of the city and was accessible (as it still is) to those who wished to stop in for private devotion as well as for attendance at masses or at the large services held on feast days. Four of the most important feast days each year were dedicated to the Virgin and, in connection with these, large fairs were held in the squares and streets around the church. These were the occasions on which hordes of pilgrims visited the cathedral, so that the economic as well as the religious life of the city became focused around them. The practical and the religious aspects of living were very closely interwoven in the fabric of medieval life.

We can now return to the Boston *Virgin and Child* with an awareness of the significance of this subject to the people for whom it was created and with a knowledge that the statue was a product of an extraordinarily unified society. In such a society the individual was less important than today and it is not surprising therefore that we don't know the names of the sculptors of any of these works. If we look more closely at the Old Testament figures which line the approach to the door itself (Fig. 10-3) we find that they resemble the statue so closely that they might have been

done by the same artist. The characteristics of the *Virgin and Child* mentioned earlier—frontal pose, linearism and vertical emphasis, combined with recurrent long ovals and flowing curves—are also to be seen in the portal figures. Not all are as frontally posed as the Virgin, though only their heads turn, not their bodies. If we look at Moses, who is in the center, we can note other particulars, such as the fanlike radiating lines in portions of the drapery, the falling curves of drapery that are partially, but not completely, responsive to gravity, and the subtle suppression of the depth dimension all through. Illustrating this point is the slight flattening of Moses's bent arm that is comparable to the flattening of the depth of the Virgin's legs from hips to knees. The faces of Mary and Moses seem to possess a similar degree of naturalism, although neither is strongly individualized. As for the expressive qualities of the Moses, we feel a quiet seriousness and a gentleness that is akin to the quiet sentiment felt in the *Virgin and Child*. Any pronounced expression of feeling is avoided in these or in any of the portal figures.

The name we give to such uniqueness of appearance is *style*, and this style is known as the Gothic. As we have seen, it is characterized by a certain linear abstraction and restrained movement. Combined with these is some attention to natural representation, as in the faces and in the way gravity is felt to be affecting the fall of the drapery. (Such naturalism is not to be found, for instance, in a comparable seated figure from Korea, shown in Figure 5-8, which however does employ linear abstraction and a minimum of movement.) But Gothic is a rather general term, applying to all of Europe, and it can be divided into substyles that reflect variations. We can separate French Gothic from that of other countries and, within that category, northern French Gothic of the late twelfth and early thirteenth centuries. This last division was the subject of a major exhibition called *The Year 1200* at the Metropolitan Museum in New York in 1972, thus providing us with a style name for the works we have just looked at.

We find similar forms and some of the feeling associated with them in all the visual art produced in northern France around the year 1200.

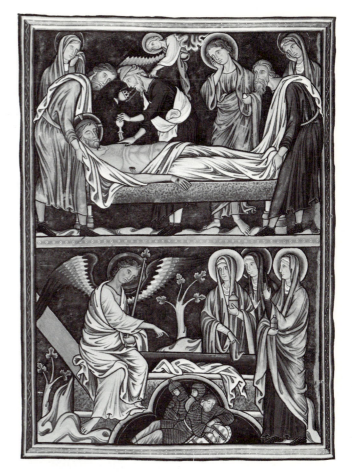

10-4 *Entombment* (top) and *Three Marys at the Tomb*, from the Psalter of Queen Ingeborg, *c.* 1200. Musée Condé, Chantilly.

Many of the stained-glass windows of the Cathedral of Chartres are filled with Christian stories painted on the glass, and these images clearly belong to the same style. So do many manuscript illustrations done at this time, as we can see in a page from a book made for Queen Ingeborg of France showing the *Entombment* and the *Three Marys at the Tomb* (Fig. 10-4). We have no trouble recognizing the style here. Long lines are drawn very much like those that we have seen crisply carved in stone or wood. There are the same oval shapes, a similar shallow third dimension suggested by modeling, and the same smooth rounding of drapery over shoulders and bent knees.

Even the architecture of Chartres Cathedral itself has qualities we can recognize as being akin to

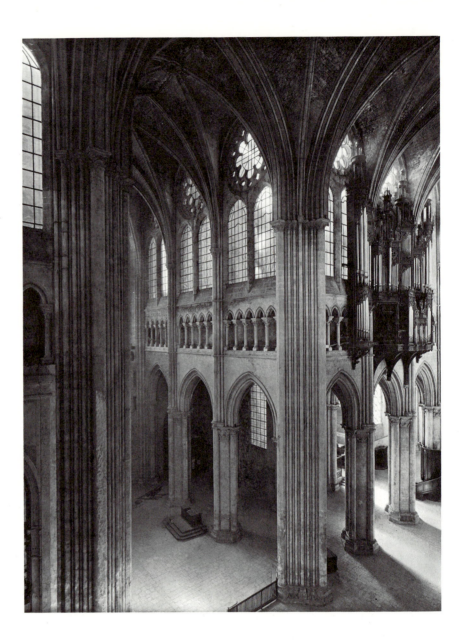

10-5 View into the choir of Chartres Cathedral.

the sculpture. If we go inside the cathedral (Fig. 10-5) we will find a high central space defined by piers with long, repeated lines like those in the sculpture. The tentlike shapes above our heads seem pulled taut, like drapery across a shoulder of one of the sculptures. Together with the sheer flatness of the walls these qualities make an architecture of lines and planes rather than masses. The verticality of the elongated bodies and heads in the sculptures is even more exaggerated in the vast height of the vaulted spaces and the uninterrupted lines that lend it emphasis.

Italian Baroque Style

From the above discussion we can conclude that the concept of style in the study of art enables us to relate the appearance of works of art to the time and place in which they were done. Style is linked to a cultural community, in fact, by being an actual creation of that community (or of a number of artists who belong to the community), rather than the creation of an individual. It is, thus, a vehicle for expressing the feelings of a society and reflects, to some extent, the values

that the society of the time considers to be important.

In order to apply the concept of style to a wholly different kind of art we turn now to the seventeenth century and the Baroque style of Italy. While the Style of the Year 1200 had a restricted geographic spread and was of fairly short duration, the Italian Baroque lasted for over a century and was carried by Italian-trained artists to other parts of Europe as well. It was immensely prolific—even today much of Rome feels like a Baroque city—and was, like the Gothic, inspired largely by the Catholic religion. Despite the great difference between the Europe of 1600 and the Europe of four hundred years earlier, the Catholic church was still a powerful force. During the intervening period of the Renaissance there had been a lessening of the faith among some, while others had engaged in the revolutionary Protestant Reformation. In reaction to the Reformation, the Catholic church itself had entered upon a program of reform and reaffirmation of its dogma that brought about a practice of religion that was more fervent than it was during the Gothic period. Music and art sought forms that would express the high feelings associated with religion, and church-building was carried on at a pace equaling that of Gothic France. While religion was not the only force affecting the evolution of the Baroque style, it was, in Italy, more influential than any other. This parallelism with similar circumstances in Gothic times makes the comparison between the two styles especially illuminating.

A typical Italian Baroque church differs in every regard from the cathedral of Chartres (Fig. 10-6). Instead of flat surfaces channeled with many long lines we see heavy forms and deep

10-6 Baldassare Longhena, Santa Maria della Salute, Venice, 1635-56.

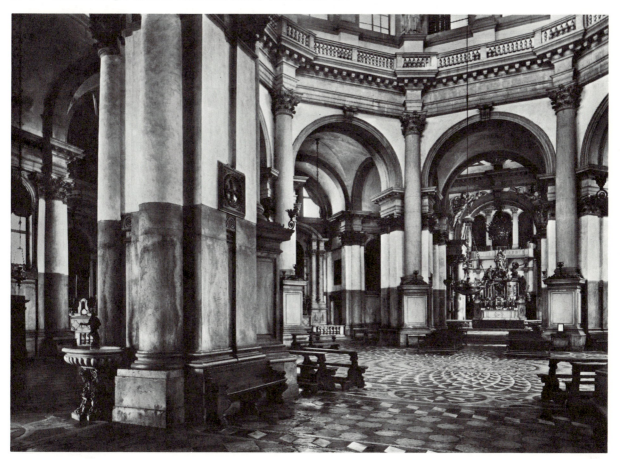

10-7 Detail of the columns and entablature, Santa Maria della Salute.

spaces. The openings under the arches of this church, Santa Maria della Salute in Venice, thrust back into space in varied directions while emphatic forms project forward from the walls. The columns, nearly detached from the surfaces behind them, support jutting portions of the horizontal sections above them, which in turn support stronger projections in the balustrade above. Repetitions of the same forms with a similarly plastic character are found in the spaces that branch out from this central area. A wholly different set of proportions is found here than in Gothic architecture; one based on recurring rectangles, semicircular arches, and a standard ratio of height to width in the columns, all deriving from the classical architecture of Greece and Rome.

The architect, Baldassare Longhena, seems to have taken every opportunity, while still employing a classical vocabulary, to avoid the static quality of right angles and has introduced the dynamic quality of acute and obtuse angles (Fig. 10-7). One result of this is that as people walk about in this church they are invited by the large openings, the diagonals, and the curves in the plan to wander around freely. Such "fluid" movements are encouraged by the way in which the spaces open into each other, uninhibited by rectangular planning; it is a very open architectural composition.

Another characteristic of this and other Baroque buildings is the important role played by light and shadow. The strong projections and recessions either catch or avoid the light that pours in from the windows on both levels. This can be seen in the photograph looking up at the capitals, where the overhanging parts produce darkened areas that are, in turn, animated by flecks of light caught by projecting details. The octagonal central space receives full light from the windows that surround it on the second level. From the central space the visitor passes through a relatively dark area and then comes to the main altar, at the right, which is again in full light. Such alternations of light and dark are common in Baroque architecture and are suggestive of theatrical lighting effects. It is not surprising to learn that Baroque architects often designed sets for theater productions.

10-8 Gianlorenzo Bernini, angel from the altar of the Capella del Santissimo, St. Peter's, Rome.

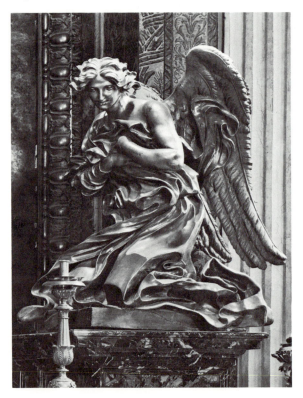

A number of characteristics of this style have emerged from this discussion. If we attempt to reduce them to their simplest terms, we can call the Baroque plastic, flowing, open, and luminous.

Baroque sculpture has many similar characteristics. A gilded bronze angel by Gianlorenzo Bernini is also emphatically plastic and flowing, and is made up of many light-catching surfaces (Fig. 10-8). Earlier the term *pictorial* was used to describe Bernini's way of interpreting nature in sculpture by means of the deep recessions and strong projections that make up his surfaces. Now we are associating this treatment of form with a similar way of employing the abstract forms of architecture. It, too, can be called *open*, for the angel's drapery seems to overflow the base on which he kneels, and his eyes stare downward. It is not an isolated piece of sculpture; along with another equally active angel it is placed above and to one side of an altar toward which the angel's eyes direct us.

If the Gothic Virgin seemed quiet, restrained, and a bit somber, Bernini's over-life-size angel is agitated, unrestrained, and nearly ecstatic. The rest of the altar has equally emphatic forms, so that the whole complex to which it belongs reflects the exuberant Catholic civilization centered in Rome between the years 1625 and 1675.

A similar intensity of feeling pervades a painting by Giovanni Liss, *The Vision of St. Jerome* (Fig. 10-9). Jerome was going through a period of penance in the desert when angels appeared to him, one directing his attention toward heaven and the other sounding the trumpet summoning him to judgment, while a child angel read from the word of God. There is a wide emotional range suggested in this work, from the ecstatic angels to the humble saint, who is dressed in sackcloth and has his faithful lion at his feet. To express such feelings, Liss made full use of Baroque stylistic qualities. The forms are emphatically plastic and they thrust back and forth in space. For instance, the saint's head and one of his arms are foreshortened away from us while his other arm and his leg angle toward us. These actions fuse with the flowing quality generated by the reversing curves that run throughout the picture. There is a pronounced luminosity, increasing from bottom to top and reaching points

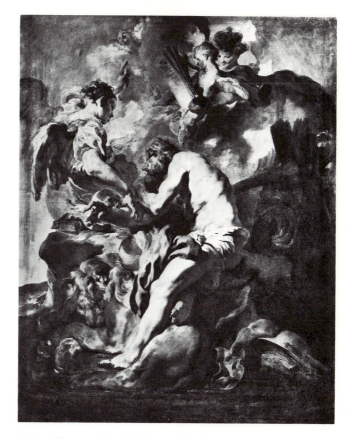

10-9 Giovanni Liss, *The Vision of St. Jerome*, 1629. Oil on canvas. S. Niccolò dei Tolentino, Venice.

of climax on the body of the saint, the shoulder of the angel at the left, and the heavenly glow above. And there is a funnel-like opening-up of the picture space that directs attention upward, even beyond the top border of the painting.

These three works represent two centers of artistic activity in Baroque Italy; Venice and Rome. While Rome was unquestionably the center, the style quickly spread to other cities. Giovanni (or Johann) Liss was a German who came to Venice, where he painted the *St. Jerome* before continuing to Rome. Other Baroque artists, like Rubens, carried the style from Italy to other countries, so that it was not unique to Italy but became part of an international style called the High Baroque. Wherever it appeared it embodied the characteristics we have found in these three examples: the plastic, the open, the flowing, and the luminous.

Style of Early Kamakura Japan

For all their contrasts, the two styles that have just been examined were linked by being part of European culture and inspired in large part by the same religion. There was even an evolutionary development that led from the Gothic to the Baroque (which we will study in later chapters). For the reflection of a completely different environment—one that involves both religious and secular aspects of a civilization—we now move away from the Western tradition to examine works from an Eastern culture: Japan.

The Japanese style we will study, that of early Kamakura art, developed at the same time as

10-10 Unkei, *Mujaku*, Kamakura period, thirteenth century.

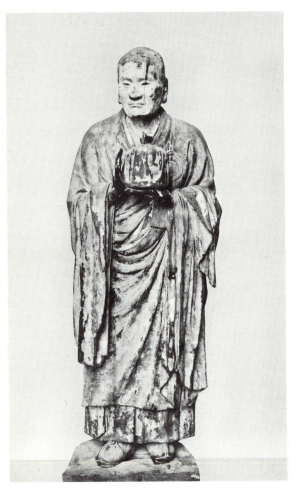

early Gothic art. In fact, a wooden figure of a Buddhist priest and teacher, by the sculptor Unkei (Fig. 10-10), was done in the first decade of the thirteenth century at the very same time that sculptors were carving the figures on the north portal at Chartres. This representation of a figure out of the history of Buddhism is carved in a very realistic style: the forms are plastic, the pose is natural and at ease, with the weight shifted slightly to one foot, and the face is like a portrait. Movement seems to play around the mouth and the eyes have a realistic sparkle achieved by inserting crystals between the lids. Such naturalism was new to Japanese art at this time, although the direct inspiration for it came from earlier Buddhist sculpture from the same religious site. The new style, however, placed more emphasis on movement and individuality.

Here again we can understand more about how a style comes to exist by looking beyond the individual works to the place and period in which they flourished. Among the important factors influencing Kamakura art were two changes in Japanese Buddhism. Previously, religious practices had been largely under the control of the aristocracy, but new popular sects made religion more accessible to the common people. At about the same time Zen, the Japanese name for the Chinese Ch'an sect, began to exert an intellectual and aesthetic influence on the military rulers of Japan. Zen rejects scripture, ritual, and orthodox learning, emphasizing instead the individual, everyday experience, and the discipline of meditation. The transmission of Zen teachings is based on the direct relationship between master and pupil, which led to changes in portrait painting and sculpture that are reflected in Unkei's interpretation of the Indian teacher Mujaku.

The newly established leaders of the state were members of the Minamoto family who had come into power after the military defeat of an opposing family during the war of 1180-85. Following this victory Yoritomo, the leader of the Minamoto, moved the seat of power from Kyoto to Kamakura on the eastern coast. Among the changes he brought about was the restoration of the great temples at Nara, dating from the eighth century, that had been damaged in the wars. The project included the commission of a large

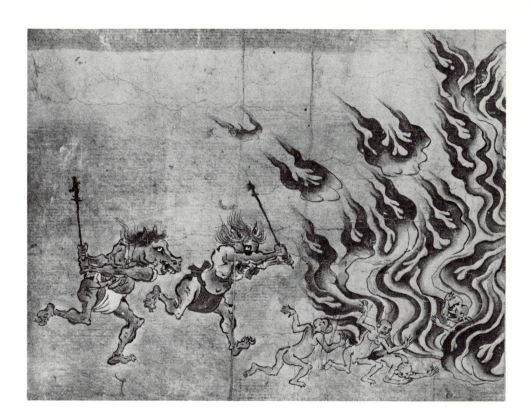

10-11 *Hell Scroll* (detail), Kamakura period, *c.* 1200. Ink and color on paper, 10¼" high. Seattle Art Museum (Eugene Fuller Memorial Collection).

number of new sculptures as well, and Unkei was one of the leading sculptors involved in it. He and other sculptors executed two gigantic figures, almost thirty feet tall, which combine the realistic technique of the Mujaku figure with the traditional demon/warrior types associated with the guardian image. One of these, Kongorikishi, was shown in Figure 5-9. When discussing it earlier, emphasis was placed on the pictorialism of this figure, an effect that was achieved by deep undercutting of the laminated wood of which the sculpture was made. In this regard, it resembles the bronze angel by Bernini but we would not confuse the two styles. Unkei's figure is a descendant of centuries of linear representation and, particularly because of its traditional temple setting, the artist chose to keep the sharp-edged drapery forms and the somewhat linear treatment of facial and other anatomical details. But the most impressive qualities of the work are obviously its energy and fearsome power, both of which are highly characteristic of Kamakura art.

The interest in the expression of dynamic movement and energy are a reflection of the new tastes in the early Kamakura period. The warrior class was dominant in this society that had come to power by the sword. (In fact the well-established art of making fine swords in Japan reached its peak during this period.) Realism and the expression of energy combine with the grotesque in a scroll painting of a scene in hell (Fig. 10-11). The horse-headed demons here are driving the miserable victims into the flames of hell for having beaten and tortured animals. Probably no artists in history have evolved a more expressive depiction of fire than the painters of Kamakura Japan. The billowing smoke and the swelling and tapering flames come as close as static art can to the movement of fire while the intense red-orange seems to vibrate with the heat. The demons embody an equivalent action. Close observation of the figure drawing shows a treatment of the form in the demons' legs that is very like the sculptured knee and calf of the guardian Kongorikishi. Both sculpture and painting have sharply accented details and an exaggeration of knobby and swelling forms that are suggestive of power and energy. In the painting, the abruptly

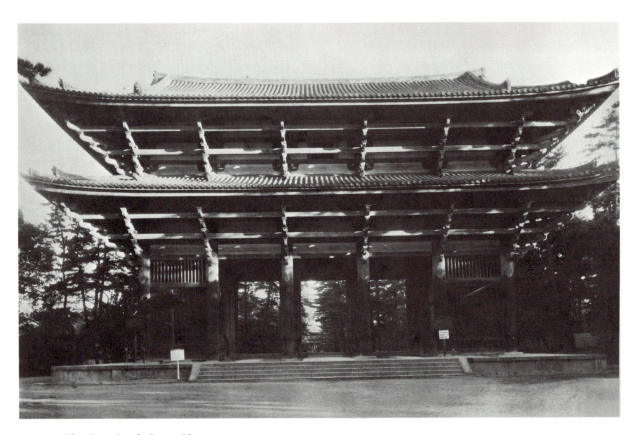

10-12 The Great South Gate at Nara.

10-13 Bracket system, Great South Gate.

tapered lines resulting from the variations in pressure on the brush are directly expressive of energy.

There is not the same degree of unity in the religious art of Kamakura Japan as there was in the early Gothic art of Chartres. We have seen an example of sculpture which emphasizes individuality (Mujaku) and an example of the less individualized, more traditional guardian figure related to the programmatic art of institutionalized Buddhism. Yet both kinds of art are strongly realistic and, even when linearism is present as it is in the guardian and demons, they share an interest in pictorialism. They can therefore be seen as belonging to the same style.

It is also possible to find elements in the style of temple architecture of the time that relate to the painting and sculpture, much as we saw in Gothic and Baroque architecture. The parallels

are not quite as direct, for a building like the Great South Gate at Nara (Fig. 10-12) was partly based on ideas imported from China. Like the realistic art of the time, the gate's architecture represents a brief departure from tradition. It is strong, heavy, and bold in comparison with the religious structures of the previous period—characteristics that seem to relate it to the forceful style of the early Kamakura period. One feature cannot be appreciated from the exterior view: the columns, which are trunks of trees, are sixty-five feet tall from the ground to the underside of the upper roof, and as one passes through the gateway the boldness of this scale is impressive. Another major feature is the bracket system designed to support the overhanging roofs and to terminate the long boards that connect two sides of the building (Fig. 10-13). This is more complex in its tiered structure than that found in comparable buildings of earlier times and it conveys a sense of daring and force as it thrusts outward from the supporting posts. The two long boards that intersect the brackets beneath each of the roofs contribute a feeling of linear tautness

to the design. Some of the brackets themselves pass through the posts and continue unbroken to the other side, so that as one walks through to the temple precinct they seem to strap the building together at the upper levels. All this expresses a kind of contained energy and is achieved without obscuring the linear openness of the wooden construction.

One of the major achievements of Kamakura artists was the development of narrative scroll painting that depicted popular Japanese subjects rather than traditional Buddhist themes. (The hell scene is a popular development of Buddhist subject matter.) Narrative scrolls frequently tell the stories of historic battles, or of events in the lives of members of important families or monks. One memorable scroll, originally eighty feet long, relates the adventures of an eighth-century Japanese ambassador to China, Kibi Daijin (Fig. 10-14). Kibi appears many times in the course of the unrolling of the scroll and is readily identifiable by his rotund, black-robed figure. Here he is shown escorted by his excited Chinese captors. Compared with the quiet narrative scrolls of

10-14 *The Adventures of Kibi-Daijin in China* (detail), Heian period, late twelfth century. Ink and color on paper, 12¾″ high. Museum of Fine Arts, Boston (William Sturgis Bigelow Collection by Exchange).

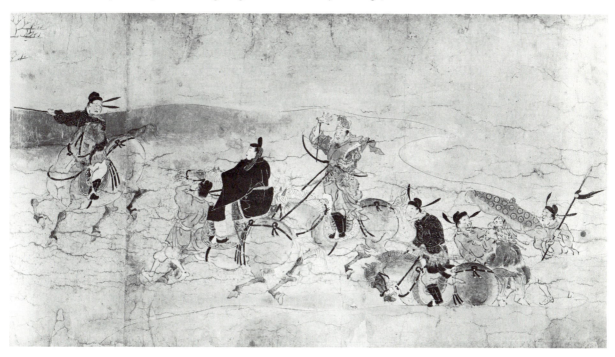

Chinese art (see Figs. 6-3 and 6-5) the Kamakura love of action is clearly evident here. While Kibi himself seems calm enough, the mounted warrior beside him stands in his saddle in his excitement and the footman violently reins in Kibi's horse. The twisted poses and flying tails of other horses echo the excitement of their riders. Facial expressions are equally animated and come close to being caricatures. Underlying this expressive drawing is a basic naturalism like that seen in the sculpture of Mujaku—although here it has been subjected to a systematic exaggeration to achieve the desired expression. In other scenes the action subsides but does not die, and periodically the pace is relieved by blank areas of paper, so that there is a kind of pulsating dramatic force in the telling of the whole story.

The early Kamakura period has a homogeneity comparable to that of northern France of the same period or Italy of the seventeenth century. The church played the major role in knitting together these European civilizations; in Japan the military and political forces were of major importance in achieving the homogeneity that seems to be essential to the creation of a style which permeates the visual arts. Later, in the thirteenth and fourteenth centuries, it was the strength of the military tradition that helped establish Zen taste as a major force in Japanese culture, and to make the martial arts, the tea ceremony, teahouse architecture, and landscape design so much a part of what we think of as Japanese today.

Style in Our Own Day

Art has always been an important source of clues to the attitudes of societies past and present. The ways in which the artists of any given time portray their world is often as rich a source of information about the beliefs and feelings of that world as can be found in any book. From the work of the sculptors who carved the north portal of Chartres we know that there was little place for individuality in their society. Not only was their work so similar as to make it impossible to distinguish between them, the people they portrayed were not individuals but merely human

10-15 Chuck Close, *Mark*, 1979. Acrylic on canvas, 9' high. Courtesy of The Pace Gallery, New York.

beings—their faces lack the degree of detail to make them recognizable as specific persons.

The sculptures on the cathedral were not intended to belong to the artists' world but to another level of existence; they are idealized images. If they seem strange to us today, perhaps it is because we are not accustomed to this type of idealization. In our society the individual is more visible than ever before, and therefore idealized representation is unlikely to appeal to its artists—who themselves are very concerned with the expression of individual values and developing highly personal styles.

Chuck Close's *Mark* (Fig. 10-15) is typical of one substyle or school, of representational painting today—*Photo-Realism*. It is an unidealized image based directly on a color photograph and rendered in extremely large scale (it is nine feet tall) so that it provides much more detail than we are accustomed to seeing. Every wart, hair, pore, and imperfection of the skin is visible. The

characteristics of this style are exactly what we might expect from the name. The techniques and qualities of photography have been adapted to painting, so that the picture even duplicates focus—details are sharpest at the plane of the eyes and fuzzy from the ears back and at the tip of the nose. At first glance (and particularly when it is reproduced in small size in a book) the painting seems to be the ultimate in accurate representation.

Mark is, indeed, an accurate representation of a photograph—but the photograph is not an accurate representation of Mark because it shows him as we could never see him in life. Our visual perception of the world works differently from the camera's mechanical recording of it. We cannot see one area out of focus the way a lens can because our eyes adapt as we direct our attention from one point to another. And because the pic-

ture was taken with a telephoto lens, his eyes are not focused on us—as they would be in a conversation or if the picture had been taken with a "normal" lens—but seem to look right through us.

Mark seems "real" to us because photography is so much a part of our daily lives—and our visual language—that it has become a criterion for what is real. But if we were able to take this painting back in history and show it to a Gothic artist in thirteenth-century France, we would most likely be told that it was a very *unrealistic* image of a human being. He would not be able to understand the phenomenon of focus, why the eyes looked beyond him (though he might possibly interpret this as a sign of spirituality), or the exaggerated emphasis on detail that seems to make this a *very* specific person. (It is ironic, of course, that Mark has been portrayed in this way, for he is otherwise treated as an anonymous being,

10-16 Louise Nevelson, Erol Beker Chapel of the Good Shepherd, 1977. (Center, *Cross of the Good Shepherd*).

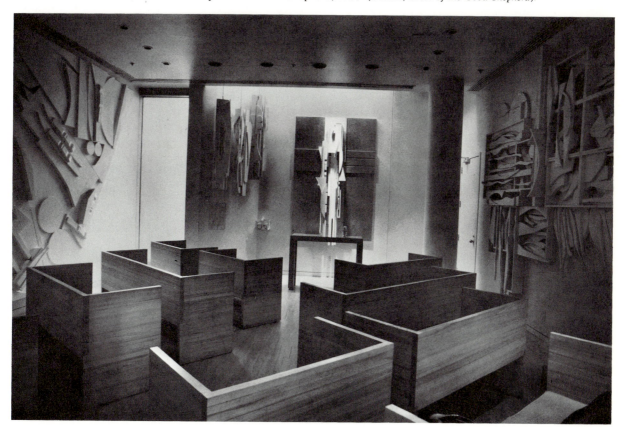

identified only by his first name. This is because Close is principally concerned, as he has often said in interviews, with "information" rather than the individual, with what is to be seen in each detail of the photograph and with how the photograph shows it rather than with who Mark is. (The supreme irony is that anyone acquainted with contemporary art will be able to identify the artist immediately but will probably never know who the model was.)

To continue the comparisons of the other sections of this chapter, let us now look at an example of religious sculpture in our own day and see what attitudes it may reflect. In the same city as *Mark* was painted, and at almost exactly the same time, the Lutheran church of St. Peter's was erected as part of the total design of the Citicorp building, a sleek, corporate skyscraper. The church is separate from the huge building, which literally hangs over it, but related to it by its proximity and design. Inside the church there are a larger room for group worship and a small chapel for prayer and meditation—the Erol Beker Chapel of the Good Shepherd, which contains several sculptures by Louise Nevelson (Fig. 10-16). Recalling the way in which the cathedral of Chartres dominates the city, we are struck by the contrast offered by this tiny chapel, part of a church which is itself dwarfed by the building towering above it with its hundreds of offices devoted to corporate business. Yet it too serves a religious purpose in our day, though by comparison a modest one for a tiny fraction of the population.

There are references to traditional Christianity in the six white wooden reliefs but no overt depiction of Christian figures or events. The closest is the *Cross of the Good Shepherd* over the plain altar. The cross form, conveying its traditional meaning, is clearly evident and the gold-leaf background is probably a passing reference to the many altarpieces with gold leaf found in Christian churches. The figure of Christ is only lightly hinted at by the vertical element of the cross. White, composed of thin strips and a few curving shapes, and lighted from almost directly overhead, it has a buoyancy and general upward movement that suggest triumph rather than suffering. This cool but generally optimistic tone is carried out on all the walls of the small room, leading the visitor in the direction of general meditation rather than focusing on specific events of Christian history.

The other particularly impressive relief in the chapel is one entitled *Sky Vestment—Trinity* (Fig. 10-17). *Sky* is a word that occurs often as part of the title of Nevelson's works; *vestment* refers to the overall shape, like a gown worn by a priest or

10-17 Louise Nevelson, *Sky Vestment—Trinity*, approx. 10′ high.

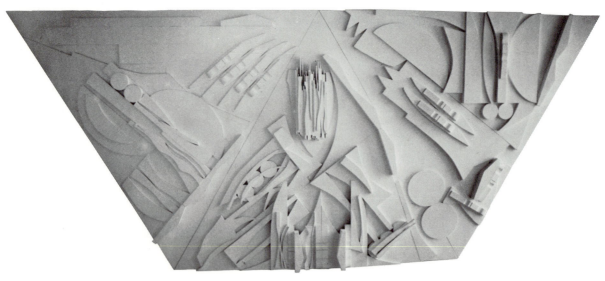

minister; and *trinity* connects the familiar Christian concept with the three triangles that determine the composition.

Nevelson's work belongs to a style of abstract art that has a longer history than Photo-Realism—it goes back to Cubist collage, which originated more than fifty years earlier in France. She has given it a personal interpretation by including "found objects" in her works (two pieces are derived from the shape of clothespins) and by unifying everything with the same white paint. (Other works by her are uniformly black, as seen in Fig. 3-8.) Of greater importance in the achievement of a personal style on her part is the exceptional quality of the design and the presence of tensions throughout the works. These are the means by which she achieved her stated purpose of creating "a place of purity." The environment inside the chapel encourages meditation without dictating its direction, and the restrained energy of the reliefs reminds one that spiritual experience is not merely a passive but an animated state of being.

For a third example of art in the years 1977-79 let us turn to a piece of public sculpture created for a very different audience than the other two. Rafael Ferrer's *Puerto Rican Sun* stands on the corner of a bleak vacant lot in a Hispanic neighborhood in the south Bronx (Color Plate 22). The image is simple—a pair of ragged palm trees joined by a sun, all roughly cut from a single piece of steel. On the other side the sun is a moon and the colors, instead of being warm, are cool. It is a tropical postcard cliché reproduced in a truthful scale (the trees are twenty-five feet high).

One can easily read this image as a bitter symbol of the dreams and memories of people who left their homes in order to improve their lot and who cannot afford to return there. But one can also read it as a symbol of hope, an exuberant, almost manic metal flower blooming in a weed-filled lot. It is difficult to imagine it in an elegant city plaza or a suburban cultural center, traditional locations for public sculpture, because here it seems to gain power from its site. The boldness of its shape and color is amplified by the contrast with the drab space and the boxlike apartment houses. One cannot help but wonder whether this work will be treated with the same respect

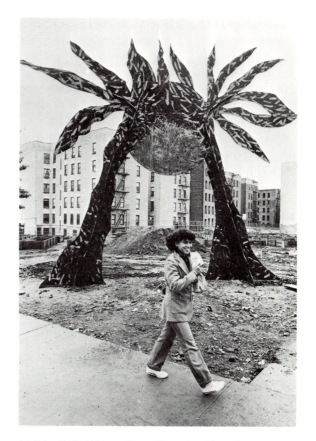

10-18 Rafael Ferrer, *Puerto Rican Sun* (day side).

over the centuries as the figures at Chartres have been. Chances are that as the paint wears off it will be repainted, perhaps even by the people of the area. Will the neighborhood develop a sense of pride in the work, and if so will the character of the neighborhood change for the better? These are unanswerable questions because of the mobility of so many urban societies and the experimental character of the work; its style is too new to be able to predict a future for it.

There are several elements in *Puerto Rican Sun* that relate it enough to other works so that it can be said to participate, if not in a style, in a group of works that exhibit sympathetic characteristics. Its obvious, almost childlike subject matter relates it to the Pop Art movement of the 1960s and its impulsive execution to the Abstract Expressionist movement of the 1950s. Nevertheless, it is clearly an outgrowth of these two

movements that have been partly affected by the artist's personal style and partly by changes in the temper of the age. The seventies had little of the characteristics of either of the two earlier decades, and the art of the seventies was also very different—its artists were more diverse in their interests and very much involved with a re-evaluation of past art and other sources. This can be seen to some degree in Ferrer's references to postcards, Pop Art and Abstract Expressionism, street graffiti, and the popular art of Puerto Rico.

If the works of these three artists seem too different to have been created at the same time, it is at least partly because they are in fact artists of different periods. Each found his or her personal style at a different time and has continued to work in a consistent way while the world and its art have changed. Nevelson is one of the principal sculptors of the Abstract Expressionist period, Close a founder of the Photo-Realist movement that was part of the as-yet-unnamed period of the sixties and early seventies, and Ferrer a very independent spirit in yet another period that may defy classification.

Perhaps life today is too varied to produce a single style, and art is a mirror of this variety. The profusion of styles is certainly no more excessive than the profusion of scientific discoveries or electronic gadgets. We cannot fault artists for variety and change when those are hallmarks of our civilization. Citizens of medieval Chartres led very quiet lives by comparison. They knew little of the world beyond their city gates, while today almost anyone who owns a television set can see virtually any event happening within seconds of the moment it takes place. The building of the cathedral went on for several lifetimes, while now buildings larger than any cathedral rise to absurd heights in a matter of months. The ratio of the number of artists active in their society and ours is probably about the same, but the diversity of personal style among artists in our time is much greater. Moreover, two new groups have expanded the ranks of artists—women and racial and ethnic minorities.

A hundred years from now art historians may be able to sort out a few styles that are most characteristic of our time, though probably not *a* style. It can never be an easy matter for any group to decipher what is happening around them. Not knowing where we are going or how we will get there, we cannot tell which of the many directions and ideas now unfolding are likely to prove the most valid.

PART FOUR

A SEQUENCE OF WESTERN ART

The concept of a unique style belonging to one time and place, which we discussed in the last chapter, is one key to understanding art history. Another key is the evolution from one style to the next. How, for instance, did Christian art ever get from early Gothic to Baroque? The four-century interval saw a series of gradual changes together with occasional sudden jumps that are usually traceable to one individual artist of genius. These gradual and sudden changes make up the fascinating development of art through time. The pace varies, but the process never ceases, and although art changes, it does not progress. That is, art is unlike science, which increases in value as more and more facts are ascertained and theories proven. An historian of science might accurately state that the science of the year 1600 was superior to that of the year 1200, but an art historian would not consider the art of the Baroque period to be superior to that of the Gothic—or vice versa. In every age art fulfills different purposes for different societies.

This part of the book will be a simplified overview of Western art in which works of art are considered in relation to the culture which nurtured them. The evolutionary changes that have been touched on occasionally in earlier chapters, particularly Chapters Five and Six, will now be seen in the light of evolving world views. Such a condensed history of art as this must be considered as the mere opening of the door on a field of study capable of sustaining a life-long interest. We will see only a tiny sampling of what artists actually produced during twenty-five centuries of Western art—rather like seeing some of the peaks of a vast mountain range as compared with the experience of climbing the foothills and making the ascent to a number of the peaks. It is through leisurely contacts with original works of art, approached with some knowledge of art history, that one gains more rewarding experiences than can be offered in a single book.

11
The Ancient World of Greece and Rome

What we call Western civilization began in Greece around the sixth century B.C. after a long period of wars and migrations. It was "Western" not only in its art (particularly the seeking of a more true-to-life system of representation) but also in its ideas, the most important of which was democratic rule. The Greeks of the Archaic, or old, period reflected their democratic leanings in the layout of their cities and their emphasis on public life. Because the climate was mild and dry and favorable to social activity outdoors, large architectural complexes for religious or commercial purposes became part of Greek cities, and sacred areas away from the cities were developed as religious sites. Virtually all the energy that the Greeks of the classical period put into building was directed to public structures; private houses apparently amounted to very little.

Greek Art

The most typical form of Greek public architecture was the rectangular temple, bounded by columns and capped with a flat gable roof (Fig. 11-1). Such architectural details as the triglyphs, the three-part rectangular blocks located just under the eaves, suggest that temples were originally of wood; this stone form resembles the end of a wooden beam. Columns were probably trunks of trees in the earliest temples. But by the time the Greek temple form became established, sometime in the sixth century B.C., stone had replaced wood in the construction of shrines for the gods.

A Greek temple has a very different function than, say, a Christian church. The interiors of Chartres or Santa Maria della Salute are large enough to hold numbers of people and were planned to accommodate religious services. The Temple of Hera at Paestum, like all Greek temples, had a relatively small interior defined by solid walls behind the exterior row of columns, as the plan shows (Fig. 11-2). This restricted space was further reduced by two superimposed rows of columns within it. So the interior was clearly not intended for crowds of worshippers. It was, rather, the location of a statue of the appropriate

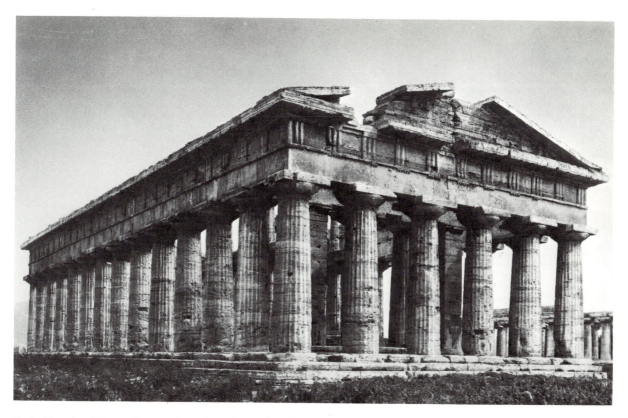

11-1　Temple of Hera at Paestum (view from the southeast), c. 460 B.C.

god or goddess, and the temple was a symbolic home for the deity. The ceremony connected with paying tribute to the god was held outdoors. The building itself, then, took the form of a monument, without a clearly defined front or back but equally interesting from any viewpoint. Its simplicity of form—rectangular, compact, and exhibiting uniform size and spacing of columns— makes it easy to take in as a whole. While the spaces between the columns lend some openness, the basic mass creates a sense of solidity. This, and the general emphasis on exterior form rather than interior function, gives it a sculptural quality, making it an object to be contemplated from the outside.

To encourage the contemplation of a Greek temple, the setting in which it was placed was carefully considered. Sometimes capping a hill, sometimes set in mountainous scenery and sometimes starkly isolated on a plain, the temple was in an environment that contributed much to the over-

all effect it had on the observer. Its impressive presence was a constant reminder that a chosen god or goddess was protecting the people of the region and that they, in turn, were paying their respects in an appropriate way.

Even though they looked to the gods for protection and support the Greeks believed firmly in the worthiness and dignity of humanity. Hence they did not hesitate to cast their gods in the

11-2　Plan of the Temple of Hera.

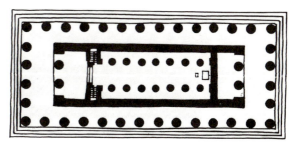

likeness of men and women and even to attribute to them many human shortcomings. But at the same time the gods were capable of representing the best in mankind and it was this that the dignified temple and its accompanying sculpture honored.

The style of the fifth-century temple is called *Doric,* named after the Dorians, one branch of the early invaders who established Greek civilization. The Doric temple consisted of similar parts combined always in the same relation to each other (Fig. 11-3). A low platform is the base for the columns, six or eight of them on the ends and about twice as many on the sides. The shaft of each column is tapered from bottom to top, has a slight swelling in the middle, called the entasis, and is grooved with shallow curves known as fluting. A square block and its cushion-like transitional piece comprise the capital. These columns (shaft and capital) support the big horizontal architrave and the frieze above it which consists of alternating triglyphs and metopes, the whole being capped by an overhanging cornice. On the two ends the flat triangles of the pediments support the low pitched roof.

We characterized the overall effect of the Doric temple as being "dignified," which seems an appropriate way of summing up the feeling conveyed by the firm horizontality above and below and the stabilizing verticality of the columns. No building ever invented makes such happy use of the simply stated horizontals, borrowed from the land, and verticals, borrowed from trees that grow and people who stand upright. The well-cushioned capital seems to pass the weight of the heavy stone of the architrave easily to the supporting columns while the entasis suggests a resiliency in those supports. The roundness of the columns is made more evident by the fluting that catches increasingly larger pockets of shadow as the column curves away from the sun.

During the fifth century a number of Doric temples were built in Greece itself and in southern Italy and Sicily, each of which is slightly different from any other. It was in the area of proportions, chiefly of height to width, or in the relation between solids and spaces, that a controlled experimentation took place, as we can see by comparing the temple at Paestum with the Parthenon in Athens (Fig. 11-4). The Parthenon,

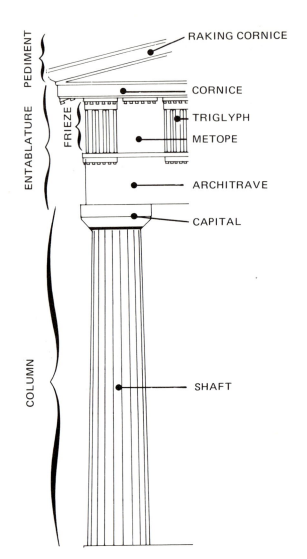

11-3　Parts of a Doric temple.

which occupies a crowning position on the rocky hill of the Acropolis in the center of Athens, is one of the later temples in the series and has the slimmest proportions. That is, the columns are taller in relation to their width and there is more space between them. In response to these thinner supports the *entablature* above them (the term for architrave, frieze and cornice together) is lighter, being about a third the height of the columns while at the Temple of Hera it is considerably less than a third their height. The pronounced projection of the cornice and capitals in the Temple of Hera has been lessened in the

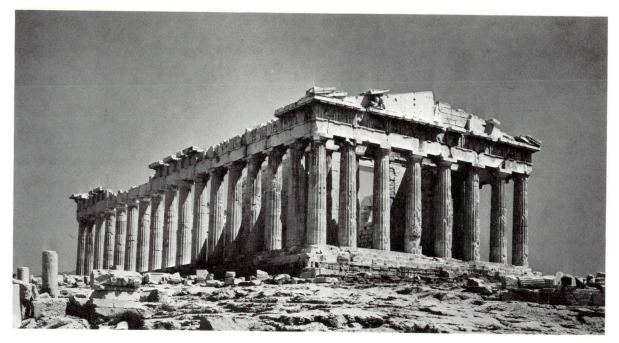

11-4 Ictinus and Callicrates, Parthenon, on the Acropolis in Athens, 447-432 B.C.

Parthenon in keeping with its more delicate proportions. Yet despite the change from weighty to less weighty solids the relation of weight to support has been maintained; i.e., more weight needs more support, less needs less. A review of a number of Doric temples would reveal that this adjustment of weight to support was a prime consideration of Greek architects and one that always seemed under control. In general, restraint and control are highly characteristic of Greek thought and feeling and seem naturally to find expression in their buildings.

Rational thought and mathematical order, in combination with restrained feeling, made Greek architecture a model for many later periods. Classical architecture prevailed throughout antiquity (that is, for about eight centuries after it was evolved by the Greeks) and was revived in the Renaissance of the fifteenth century to be continued with few interruptions into the twentieth century. The Doric order, as it is called, went through many variations but retained its essential relationships. Other more elaborate orders developed during the fifth century B.C.: the Ionic order and the Corinthian order became part of the vocabulary of classical architecture in

antiquity and during the Renaissance. One of the distinguishing characteristics of these orders is the presence of a frieze consisting not of triglyphs and metopes but of relief carving, either of a purely decorative sort or with represented figures. A section of the decorative frieze from the Erechtheum, an Ionic temple also located on the Acropolis, can be seen in Figure 2-9. Our analysis of its design there suggests the more elaborate organization of the elements of the Ionic order as compared with the Doric.

Architecture which employs the three Greek orders is often referred to as "classical," but the style which historians call *Classical* prevailed primarily during the fifth and fourth centuries B.C. It was a style that embraced all the arts and it reflects particular qualities of thought and feeling. The simple orderliness suggests the Greek love of geometry—in the Doric temple the spacing between triglyphs is exactly one half of the spacing between columns, for instance. Yet a subtle avoidance of mathematically straight lines shows up in the curving entasis and in the very slight upward curve toward the center of the long horizontals of the base of the Parthenon. Relationships that are partially based on number and

measurement and partially based on the subtle curves and resilient forms of living things are also characteristic of Greek sculpture in the Classical style. We have already seen a number of these (in Chapters Five and Seven) and we now return to several of them with our attention on the culture that produced them.

Humanity being "the measure of all things" to the Greeks, it is no surprise that their sculpture is almost entirely concerned with men and women. The well-developed male figure is shown nude from early times, apparently because warriors and athletes wore few or no clothes when engaged in war or sports. It was toward the end of the sixth century B.C. that artists became particularly concerned with natural proportions and early in the fifth century that they introduced the kind of movement and distribution of weight that we examined in Chapter Seven. At the same time that

the interest in anatomy and movement began to unify the figure as a structural whole the face also became more human. The style before this time is the Archaic: the head in Figure 5-3 or the body in Figure 7-8 are typically Archaic. Faces have the "Archaic smile" that seems to enliven them despite their rigid symmetry, and figure action, when present, has an abrupt character that again connotes animation. We see these characteristics in a figure from the temple at Aegina where the pediment sculpture depicts events from the Trojan War, as Homer recounted them in the *Iliad*. A warrior pulling his bow (Fig. 11-5) is made up of angular movements in a body in which every muscle seems tensed. Heroic action and athletic prowess were the recurrent themes in Archaic times, as seen in the black-figured vase of a foot race (see Fig. 2-7).

Another favorite subject was the mythical bat-

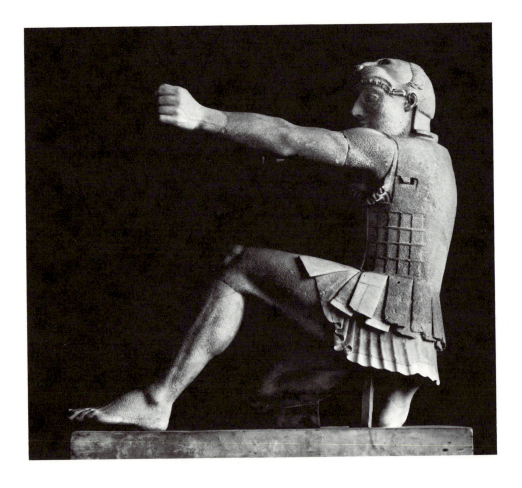

11-5 *Warrior*, pediment of the Temple at Aegina, c. 490 B.C. Marble, 31" high. Staatliche Antikensammlungen, Munich.

tle of the Lapiths and Centaurs, a combat that occurred when the Centaurs, who were invited to a wedding by the Greek Lapiths, drank too much wine and started carrying off the women. This is depicted in the sculpture from the west pediment of the Temple of Zeus at Olympia, in which such scenes as that shown in Figure 11-6 are combined with other incidents of Centaurs either engaged in battle with the Lapiths or attempting to abduct the women. As might be expected the Greeks won and drove away the bestial Centaurs, a triumph of the "civilized" Greeks against the less-than-human Centaurs. Greek artists seemed to enjoy depicting the energy of Centaurs and Satyrs as much as that of heroes even though they relegated their actions to the realm of the baser senses. There was a specific purpose in the choice of this subject for one of the pediments at the important Temple of

Zeus at Olympia. The Olympic games were held there every four years. Contestants came from all parts of Greece and, while there, suspended local rivalries. A rule of hospitality prevailed and the story of Lapiths and Centaurs was always visible on the pediment of the chief temple to remind visitors of one unfortunate occasion at which this rule was broken.

Standing in the center of this pediment and seeming to direct the Greeks to their victory was the god Apollo, whose head is shown in Figure 5-4. In the discussion of this head it was noted that it differed from an Archaic head by being more plastic and sculptural. It also seems to be more capable of thought. The smile, which in Archaic art seemed to echo the tenseness of the body, has disappeared and the face has become impassive, a hallmark of the Classical style. Both Apollo and the Lapith woman illustrate this

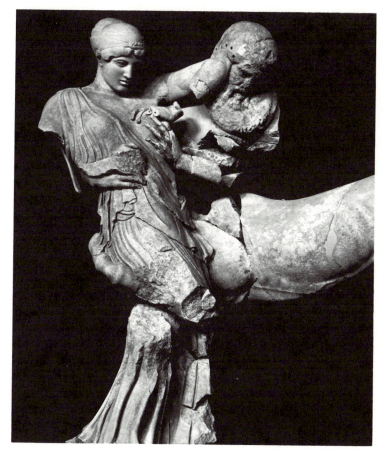

11-6 *Lapith Woman and Centaur,* pediment of the Temple of Zeus at Olympia, c. 460 B.C. Marble, over life-size. Museum, Olympia.

quality of facial expression that seems to remove them from the passions that one might expect to be their reactions to the event. The Centaurs, by contrast, do exhibit their base feelings in their faces.

These sculptures from Olympia were done about 460 B.C. and they mark the early phase of the Classical style, which would continue to dominate Greek art for about 150 years. Those qualities of a face that seem both to conform to an idealized concept of beauty and to be suggestive of human intelligence were somehow discovered by Greek sculptors and painters. Beginning in this Early Classical phase and increasing in the High Classical phase emphasis shifted away from the purely physical and active to the contemplative side of life.

At the same time as this happened a change occurred in the relationship between the head and the body. The bronze statuette in Figure 7-9, which was made in the second half of the fifth century, possesses a psychological dimension lacking in the Archaic standing nude shown in Figure 7-8. The head of the later figure exhibits a greater interdependence with the body by completing the *contrapposto* pose: its tilt opposes the tilt of the torso. Physical and psychological qualities are bound into a larger unity in Classical, as opposed to Archaic, Greek art. In this High Classical period we find the fullest expressions of the thoughtful aspect of human life. The relief of Hegeso (see Fig. 3-7) depicts a moment in the life of the woman when she sits quietly in the presence of a servant, contemplating a jewel which has been removed from her jewel box. Of all the events in her life it was this contemplative act which was chosen to memorialize Hegeso. A quiet dignity pervades the scene, as it does the architecture of the Parthenon.

So the second half of the fifth century was the period of Greek art in which feeling and contemplative thought were added to the expression of physical being that dominated the previous one hundred years. It is no coincidence that it is also the period in which Socrates was so concerned with the values of thought and the nature of virtue. Greek playwrights too were exploring the subtleties of character and human emotions at this time.

In the visual arts the most complete expression is the Parthenon and its sculpture, dating from the years 447-432 B.C. The sculpture was under the general direction of Phidias who, we assume, carved many of the large figures that originally were placed in the two pediments. There were three locations for the sculptural program: the mi topes, done in very high relief, the pediments, with figures in the full round, and the frieze, carved in low relief. This frieze was wrapped around the outside of the *cella*, or main body of the temple, and could be seen as one looked past the outer row of columns to the upper part of the wall enclosing this central space. The metopes, which were the first sculptures done on the Parthenon, emphasize physical action in the battle between Lapiths and Centaurs. The pediments celebrate Athena's birth and her triumph over Poseidon for guardianship of the city of Athens. Both events are witnessed by groups of gods and goddesses like the reclining figure that may represent Dionysus (Fig. 11-7). In contrast with the warrior from Aegina this figure is in a relaxed pose; apparently the Greeks had to master the body in action before they could render it in relaxation, to learn to depict tensed muscles before they could depict them in repose. The figure's inaction in combination with the thoughtful expression which we seem to find in the face (despite its damaged condition) produce the total impression of a powerful physique controlled by a cool will. The mind masters the body in the fullest expression of Greek art.

The triangular overall shape of this reclining figure is adapted to the elongated triangle of the shape of the pediment itself. We can see from the remaining fragment still on the west pediment (Fig. 11-3) how this reclining god from the east pediment would have been placed (he would have been in approximately the same position within the pediment that the fragment occupies).

The Parthenon frieze records the Panathenaic procession which took place every four years on the Acropolis, surrounding the Parthenon. Riders mounted on vigorous horses make up portions of the frieze and a quiet group of gods and goddesses brings the procession to a close (Fig. 11-8). A few types of persons serve to represent the human race, or the gods who resem-

11-7 *Dionysus,*
pediment of the
Parthenon, 448–432
B.C. Marble, over
life-size. British
Museum, London.

bled them: an older bearded man, a youth, and a young but mature woman. Each had perfectly formed features and a figure to match, for one of the purposes of sculpture for the Greeks was to present images of men and women of ideal beauty for all to contemplate. It is as if beauty as well as virtue might be emulated by all of mankind, or at least that an awareness of its existence could be an ennobling experience.

The High Classic style as typified in this portion of the frieze and this figure from the pediment of the Parthenon, has been admired and emulated by many subsequent civilizations. Classical clarity and restraint are shown in the detail of the frieze by the clear separation of figures from background and the parallelism of the figures and the benches to the background, often appearing as pure profile views. The actions of the figures in their varied contrapposto poses are also restrained. In the Dionysus the slow forward turn of the torso is countered by the easy turning of the head away from us. These gentle actions are enough to unify the whole pose, while the large subdivisions of the torso into chest, lower ribcage, and abdomen clarify this most complex portion of the body.

In their composition and grouping, the gods and goddess from the frieze accomplish the same kind of easy linking of figure to figure that we noted in the relief of Hegeso. In the fully round figures of the pediments the interconnection of figures through both feelings and actions is suggested by Dionysus' attention to the activity on the left while the backward thrust of his shoulder and elbow lead to the right where other figures were located. Unlike the clearly separate figures from Aegina, the Parthenon figures interact with their neighbors and relate to the ground itself by the effect of gravity on their bodies and garments.

Classicism (with a capital *c*) is the style-name of Greek art; no other style reflective of a civiliza-

11-8 *Group of Gods and Godesses,* frieze of the Parthenon, 447-432 B.C. Marble, 43″ high. British Museum, London.

tion has had such a pervasive influence. Even when there is no sign of a "classical order" in architecture or no interest in gods and goddesses, or the nude, there still may be a classical feeling in a work of art because it contains qualities that the Greeks combined for the first time but which many others have found to be expressive of their basic feelings as well. An example of such latter-day classicism (with a small *c*) is Georges Seurat's *Sunday Afternoon on the Grande Jatte* (see Fig. 15-17). Here clarity and restraint, as well as a compositional linking of figure to figure, seem to play a role similar to their role in the sculpture and the architecture of the Parthenon.

Hellenistic and Roman Art

The High Classic style lasted for a period of roughly fifty years; then the elements which comprised it began to show signs of change. The trend we noted in the pediment sculpture of the Parthenon—an interaction among the figures—soon led to an increased narrative interest that

brought in more specific actions. We notice this in the fourth-century bronze *Youth from Marathon* (see Fig. 7-10), who is engaged in a specific activity involving his hands—perhaps he is pouring a liquid from one container into another. This activity takes some of his attention, though hardly enough to affect the graceful stance of his body. But during the next century an interest in specific action and purposeful gesture definitely exceeds in importance the display of the noble human body. *A Scythian Sharpening His Knife* (Fig. 11-9), done in Pergamon in the third century B.C., represents this new interest. Originally there were three figures in the group to which he belongs and they told the story of a musical contest between the god Apollo and the satyr Marsyas. The penalty for losing the contest was that Marsyas was to be skinned alive. A Scythian (a barbarian to the Greeks) was to do the job. This coarse-faced and heavily muscled man looks up to Marsyas as he sharpens his knife. Shown in a momentary pose (as opposed to Classical repose), he has specific features (as opposed to the generalized types of Classical art) even to the wisps of

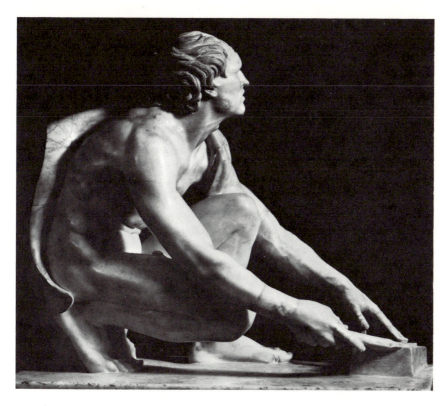

11-9 *A Scythian Sharpening His Knife*, Pergamon, second half of the third century B.C. Uffizi Gallery, Florence.

hair on his chin. His body is that of a bully-boy and he is about to perform a barbaric act. So even though the subject is from a Greek myth and the knowledge of the human figure a Greek inheritance, the essential qualities of Classicism are absent. This is Hellenistic as opposed to Classical Greek, or Hellenic, art.

The Hellenistic period, when Greek influence in the arts was spread over a wide territory, followed the conquests of Alexander the Great (336-323 B.C.). For the next three centuries art clearly deriving from Greece, but different in ways suggested in the preceding paragraph, was produced in Asia Minor, Egypt, and in areas soon to be dominated by Rome. Pergamon in Asia Minor was the site of a huge complex of temples and palaces that satisfied the Hellenistic taste for the grandiose. A generation or two after the group with the Scythian was carved a Pergamese emperor named Eumenes built a large altar to Zeus, in which the Hellenistic love of the flamboyant and the emotional found expression. A portion of the frieze of this altar (Fig. 11-10) combines the heroic concept appropriate to the

11-10 *Battle of Gods and Giants*, portion of the Altar of Zeus, Pergamon, c. 180 B.C. Marble; height of frieze, 7'6". Pergamon Museum, Berlin.

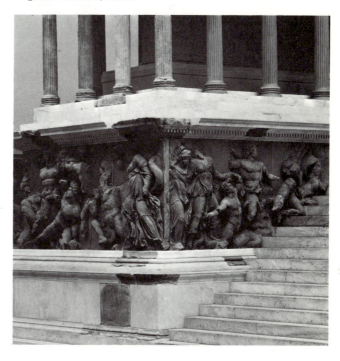

subject matter, the gods' victory over the giants, with the realism found in the Scythian. In this high-relief sculpture, frequently emerging into the full round, the realism stems partly from the way in which the heavily modeled figures actually spill out onto the stairs that lead up to the elevated altar. In Classical times sculpture obeyed the rules of the architecture, as in the Parthenon frieze (Fig. 11-8), where the forms are all contained within the shallow block of space alloted to them—unlike those at Pergamon, which overlap the moldings above and the base of the relief below. The frieze is located under the columns rather than above them, to bring it closer to our own level. The result is a feeling that the characters belong as much to our space as to the architectural space and are, therefore, no longer as unapproachable as those on the Parthenon—hence they impress us as being more real.

An even more striking characteristic of the re-lief at Pergamon is its rich pictorialism. It seems that everything possible has been done to catch light on the protruding forms and to create pockets of shadow in the hollows. The great variation in degrees of relief is also in striking contrast to the Parthenon frieze: the front forms are in the full round while the furthest ones are barely raised off the background. Violent action, intense emotion, heightened plasticity, and pictorialism all contribute to the effect of excitement as gods battle giants.

At the time when Hellenistic rulers were erecting these monuments in the eastern Mediterranean a new political center was evolving in Rome on the Italian peninsula. The republic of Rome expanded far beyond the city of its beginnings and by the time of the birth of Christ had become a vast empire. The Romans have gone down in history as masters of practical social living: they governed a large sprawling empire so

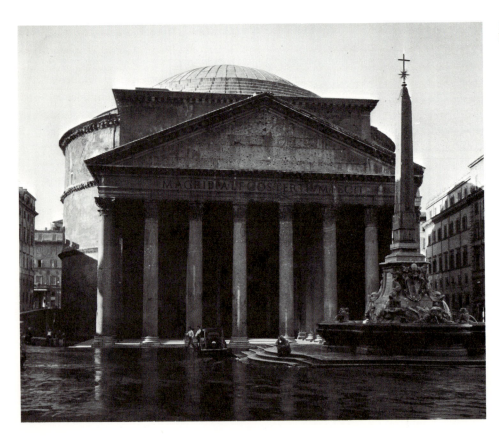

11-11 Pantheon, Rome, A.D. 118-125.

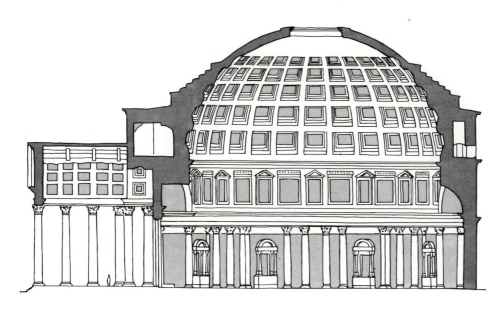

11-12 Cross-section of the Pantheon.

that it didn't collapse for several centuries; they organized cities so that large numbers of people lived and worked together successfully; and they accommodated a number of religions without, for a while anyway, suppressing or favoring any particular one. In their art the first practical thing they did was to borrow whatever was useful to them from Greek and Hellenistic art. Hence Greek architectural orders are to be found throughout five centuries of Roman architecture, and though they are somewhat modified they are never changed in fundamental proportions, such as the ratio of height to width of a column or of size of entablature to size of column. But the variety of types and functions of Roman buildings far exceeds that of Greece. For instance, by the second century A.D. the Romans had transformed the simple Greek temple into a large domed structure with a vast interior space (Figs. 11-11, 11-12). Because this temple was dedicated to a number of gods it was known as the Pantheon (from the Greek words meaning *all* and *god*). While it is unique among Roman temples for the size of its interior, it is typical of Roman architecture in its inventiveness and practicality. The portico is clearly an adaptation of a Greek temple; originally it was more impressive by being several steps above the pavement (the level of cities

tends to rise as new building is done upon the rubble of the old). Passing through the portico the visitor entered (as one does today) a single space of great simplicity: circular in plan and hemispherical above, where the huge dome arches over the whole interior. This space so completely surrounds the visitor that it cannot be well photographed. The cross-section shown here records the whole better than any single photograph and makes clear that the measurements of height and width are equal: if the circle of the dome were completed it would touch the floor. Behind the paired columns are niches that allow shrines for seven gods. The dome is distinctive for two reasons besides its impressive scale: a coffered surface treatment that repeats its circularity and articulates its upward curving shape by means of graded sizes, and a circular opening to the sky at the top, 144 feet above the floor. This opening provides the sole lighting for the interior and is, again, a unique solution.

The Pantheon has a grandeur of scale that was not found in Greek architecture, though it was anticipated by Hellenistic buildings. At the same time it continued the classical tradition of clarity and restraint in the simple geometry of its interior space. The Greeks had never attempted to make a large interior space—in fact, would not have

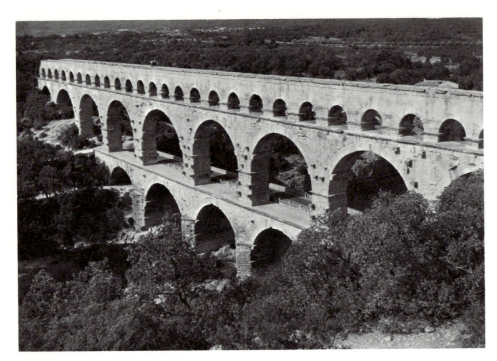

11-13 Pont du Gard, near Nîmes, France, first century B.C.

11-14 Reconstruction of the Basilica of Constantine, Rome, fourth century A.D.

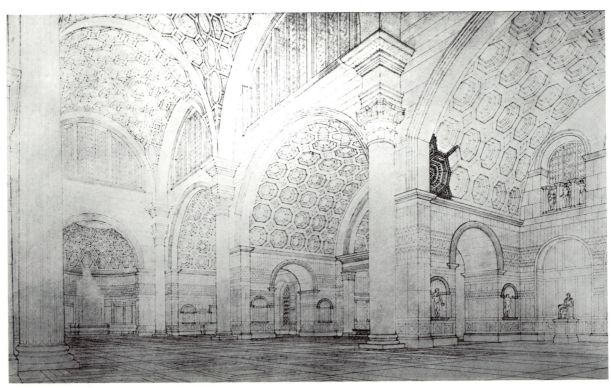

been able to, since they had not explored the principles of arch construction. The inventiveness of the Romans in this area opened up a tradition of interior spatial design that has been unbroken ever since.

The simplest use of the arch is to produce an elevated level in one direction, as was required of a Roman aqueduct. The beautifully simple and efficient aqueduct designed to bridge a valley and bring water to the city of Nîmes in South France is such a project (Fig. 11-13). No one before the Romans had exploited the potential of the arch to bridge spaces and create interiors. They noted that the weight of stone, when deflected by the locked-in curve of an arch, became a sideward thrust. Without some kind of counterthrust an arch would collapse, but if one arch abutted another each would absorb the other's thrust. In the Pont du Gard, as the Nîmes aqueduct is called, this system of mutual support continues across the valley until the final thrusts are absorbed by the hills themselves. A dome is a hemisphere based on the principle of arch construction, though the building of it is not quite so simple. The outward thrusts of the dome of the Pantheon are absorbed by massive masonry which transforms them into dead weight that is passed vertically to the ground, as seen in the cross-section.

The third use of arch construction is to produce vaults (curved ceilings), which were widely employed in medieval and later architecture, as we saw in the last chapter. Again the Romans were responsible for varied uses of the round *barrel vault* and the intersecting or *groined vault*, both of which are seen in the drawing of the Basilica of Constantine, built in the early fourth century (Fig. 11-14). Barrel vaults cover the side spaces while in the higher central section the long barrel vault is intersected by shorter vaults at right angles to it. The latter allow for large windows at the higher level, while at the same time the cross-pattern of their groins is both visually satisfying and revealing of their structure. All the vaults are decorated with octagonal coffers. The building itself provided large interior spaces for civic functions and is still impressive in its ruined state in the Roman Forum, even though stripped

of its original marble veneer and bronze decoration. These and other ruins reveal the building materials of brick, concrete, and rubble that were standard in Roman construction. As builders, as engineers, and as artists notable for the creation of architectural spaces for public use, the Romans made a lasting contribution to the world's architecture.

Roman sculptors had Greek and Hellenistic achievements to work with, but from the beginning their overriding interest was in portraiture. We know what people of the Roman world looked like because from the second century B.C.

11-15 *Boy*, Roman, c. 10 B.C.–A.D. 12. Bronze. Metropolitan Museum, New York (Rogers Fund, 1914).

12
The
Middle
Ages

It is difficult to say when the period known as the Middle Ages began, or when it came to an end. We can say that it was a period of approximately ten centuries dominated by Christian belief that found expression in religious thought and art. A natural beginning for the separation of the Early Christian period from Roman times would be when this dominance begins to be felt; and that happened during the fifth and sixth centuries. It coincided with the political demise of the Roman Empire, the outward signs of which were the sack of Rome by the Visigoths in 410 and the abdication of the last Western Roman Emperor in 476. The so-called fathers of the church, particularly St. Augustine, were laying the foundations of Medieval Christian dogma and the seeds of the new faith were being planted as far away as Ireland (by St. Patrick). In the sixth century the first monastery was established by the Benedictine order; soon, and for several centuries to follow, Christian learning and art were to be centered in such monasteries.

Early Christian and Byzantine Art

Long before these clear signs indicated the dominance of Christianity over all other religions there had been Christian art. Christian subjects showed up on objects such as carved marble sarcophagi (coffins) back in the third century. Favorite subjects were those which emphasized salvation or showed persons engaged in prayer. Symbols that are still in use today appeared. Christ is shown as a good shepherd and grapes signified the symbolic wine of the Eucharist (Christ's blood). The growing popularity of symbols coincided with the turning away from naturalistic representation that we have already noted in later Roman art. By the early sixth century the new, highly symbolic subject matter became joined with the new nonnaturalistic representation to result in such works as the ivory carving of *The Archangel Michael* (Fig. 12-1). The figure of the angel, with his rounded cheeks and legs that swell beneath the drapery, is descended from

11-17 *Eutropios*, c. A.D. 450.
Marble, 12½″ high.
Kunsthistorisches Museum, Vienna.

tion, presumably because it is in the eyes that inner feeling finds expression. A spiritual as well as a psychological human being is presented to us. This notion corresponds with what we know about the late Roman world: that many people were affected by a great spiritual hunger, that they tried many religions which differed from the traditional religions of Greece and earlier Rome by having elements of mystery in them, and that they settled on one of these new religions, Christianity, as the one which best satisfied their needs.

12
The
Middle
Ages

It is difficult to say when the period known as the Middle Ages began, or when it came to an end. We can say that it was a period of approximately ten centuries dominated by Christian belief that found expression in religious thought and art. A natural beginning for the separation of the Early Christian period from Roman times would be when this dominance begins to be felt; and that happened during the fifth and sixth centuries. It coincided with the political demise of the Roman Empire, the outward signs of which were the sack of Rome by the Visigoths in 410 and the abdication of the last Western Roman Emperor in 476. The so-called fathers of the church, particularly St. Augustine, were laying the foundations of Medieval Christian dogma and the seeds of the new faith were being planted as far away as Ireland (by St. Patrick). In the sixth century the first monastery was established by the Benedictine order; soon, and for several centuries to follow, Christian learning and art were to be centered in such monasteries.

Early Christian and Byzantine Art

Long before these clear signs indicated the dominance of Christianity over all other religions there had been Christian art. Christian subjects showed up on objects such as carved marble sarcophagi (coffins) back in the third century. Favorite subjects were those which emphasized salvation or showed persons engaged in prayer. Symbols that are still in use today appeared. Christ is shown as a good shepherd and grapes signified the symbolic wine of the Eucharist (Christ's blood). The growing popularity of symbols coincided with the turning away from naturalistic representation that we have already noted in later Roman art. By the early sixth century the new, highly symbolic subject matter became joined with the new nonnaturalistic representation to result in such works as the ivory carving of *The Archangel Michael* (Fig. 12-1). The figure of the angel, with his rounded cheeks and legs that swell beneath the drapery, is descended from

been able to, since they had not explored the principles of arch construction. The inventiveness of the Romans in this area opened up a tradition of interior spatial design that has been unbroken ever since.

The simplest use of the arch is to produce an elevated level in one direction, as was required of a Roman aqueduct. The beautifully simple and efficient aqueduct designed to bridge a valley and bring water to the city of Nîmes in South France is such a project (Fig. 11-13). No one before the Romans had exploited the potential of the arch to bridge spaces and create interiors. They noted that the weight of stone, when deflected by the locked-in curve of an arch, became a sideward thrust. Without some kind of counterthrust an arch would collapse, but if one arch abutted another each would absorb the other's thrust. In the Pont du Gard, as the Nîmes aqueduct is called, this system of mutual support continues across the valley until the final thrusts are absorbed by the hills themselves. A dome is a hemisphere based on the principle of arch construction, though the building of it is not quite so simple. The outward thrusts of the dome of the Pantheon are absorbed by massive masonry which transforms them into dead weight that is passed vertically to the ground, as seen in the cross-section.

The third use of arch construction is to produce vaults (curved ceilings), which were widely employed in medieval and later architecture, as we saw in the last chapter. Again the Romans were responsible for varied uses of the round *barrel vault* and the intersecting or *groined vault*, both of which are seen in the drawing of the Basilica of Constantine, built in the early fourth century (Fig. 11-14). Barrel vaults cover the side spaces while in the higher central section the long barrel vault is intersected by shorter vaults at right angles to it. The latter allow for large windows at the higher level, while at the same time the cross-pattern of their groins is both visually satisfying and revealing of their structure. All the vaults are decorated with octagonal coffers. The building itself provided large interior spaces for civic functions and is still impressive in its ruined state in the Roman Forum, even though stripped

of its original marble veneer and bronze decoration. These and other ruins reveal the building materials of brick, concrete, and rubble that were standard in Roman construction. As builders, as engineers, and as artists notable for the creation of architectural spaces for public use, the Romans made a lasting contribution to the world's architecture.

Roman sculptors had Greek and Hellenistic achievements to work with, but from the beginning their overriding interest was in portraiture. We know what people of the Roman world looked like because from the second century B.C.

11-15 *Boy*, Roman, *c*. 10 B.C.-A.D. 12. Bronze. Metropolitan Museum, New York (Rogers Fund, 1914).

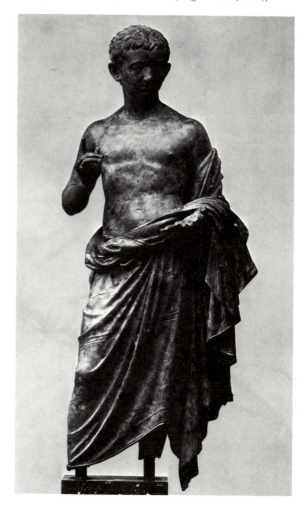

to the fifth century of the Christian era we have records in sculpture or in painting of hundreds of individual likenesses. Figure 11-15 is a bronze portrait of a boy—probably a member of the family of the emperor Augustus—done around the beginning of the first century A.D. The pose was taken from Greek art and the action has a specific quality similar to that of Hellenistic art, but the extreme sensitivity to the individual character of the face is Roman. This successful fusion of some idealism, as in the graceful pose, with the straightforward realism found in the head and upper body is typical of Roman sculpture. Frequently their portraits were busts only, in which realism clearly dominates.

Portrait painting in Rome is also characterized by realism. One active center of painting near the edge of the Empire was in Egypt, at a place called Faiyum, where many mummy cases were provided with realistic portraits of the deceased. A Faiyum portrait from the second century A.D. is shown in Figure 11-16. Not only are we convinced of the accuracy of the likeness but we also have a convincing sense of a head existing in space and light. In a way that we have previously characterized as pictorial the luminous face emerges from a darkish background. Highlights and cast shadows (as beneath the front lock of hair) aid in the illusion. We examined earlier (see Fig. 6-12) an even more pictorial landscape from Pompeii, in which an illusion of space was present as well (though we noted that the concept of a totally unified space was never quite achieved by the Romans). Roman paintings, building on the precedent of Greek paintings (which are now entirely lost) had arrived at a high degree of naturalistic representation and a strongly pictorial style during the period from the first century B.C. through the second century A.D. Then, in the next two or three centuries there occurred one of the greatest cultural revolutions in history. At the same time that the Roman Empire was crumbling politically, spiritual and other values were being radically altered. In art the changes were equally profound.

If we compare the portrait sculpture of Eutropius (Fig. 11-17) with the head of the Augustan boy, these changes are apparent. From a world in

11-16 *Portrait of a Man*, Faiyum, A.D. 160-170. Encaustic painting on wood, 13¾″ × 8″. Albright-Knox Art Gallery, Buffalo (Charles Clifton Fund).

which forms are naturally proportioned, and are capable of motion (as in the down-turned eyes), we have moved into a world in which these physical properties are unimportant and have been replaced by what may best be called inner feelings. The chief dimension now is psychological rather than physical, and the change is expressed in a radical shift from a plastic to a linear mode of representation. In the later sculpture, planes quickly shift from front to side surfaces, as in the forehead. The eyes move forward, as it were, to a plane closer to those of forehead and nose, and stripes and lines also appear in the forehead, eyes, hair, and beard. The eyes have become larger and demand more of our atten-

12-1 *The Archangel Michael*, early sixth century. Ivory (one wing of a diptych), 17″ × 5½″. British Museum, London.

a classical figure, but the impression we carry away from this delicately carved relief is less of a physical than of a spiritual being. The spiritual quality derives from the eyes and from the patterned animation of the details, both of drapery and of architectural ornament. The two crosses refer to Christ while the angel's large wings suggest the supernatural. Qualities of this world are diminished in importance: the uncertainty of the way in which the feet are placed upon the steps, and the questionable relation of the columns to the bases on which they seem to stand, suggest a lack of concern with logical representation. There is a denial of space beyond the figure or under the arch. From this point until the close of the Middle Ages there was no clear three-dimensional representation, and "reality" was sought in a spiritual rather than in a physical realm.

The same three centuries that saw the bringing together of symbolic image and less natural representation, also saw the development of new architectural forms in Christian church building. A simple longitudinal building, or basilica, deriving from Roman structures but without their elaborate vaulting, proved to be the most useful for Christian worship (Fig. 12-2). Churches from the Early Christian period essentially consist of a long *nave,* defined by rows of columns, which directs the worshipper's attention to the *altar* at the east end (most Christian churches were oriented in this way, with the sanctuary pointing toward Jerusalem). Light enters the nave from the *clerestory* windows above as well as from the lower windows in the aisles. The semidome of the *apse* also calls attention to the altar beneath because of its rich mosaic decoration. In the church of Sant' Apollinare in Classe in Ravenna, Italy (Fig. 12-3), the mosaic shows St. Apollinare in a gesture of prayer with upraised arms beneath the cross while the twelve sheep beside him stand for the twelve apostles. The exterior of the church is quite plain; it is on the interior that the richly colored marble work and mosaics are concentrated. In comparison with the weightiness

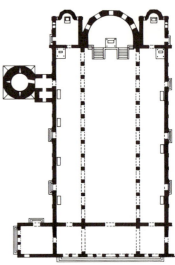

12-2 Plan of Sant' Apollinare.

12-3 Nave of Sant' Apollinare in Classe, Ravenna, A.D. 530-549.

and plasticity of Roman interiors like the Pantheon and the Basilica of Constantine, the walls here consist of flat or curved planes and the wooden ceiling appears relatively light. The architecture of this period, like the sculpture, lost its heaviness and its concern with the expression of weight and support.

In the sixth century, when the church of Sant' Apollinare was built, Early Christian art was merging with Byzantine art. The emperor Justinian, who was from Constantinople, maintained a court in Ravenna on the eastern coast of the Italian peninsula and erected an imperial chapel dedicated to a local saint, San Vitale. The mosaics in the richly finished interior of San Vitale are the fullest expression of the first period of Byzantine art. The section depicting the emperor with the bishop Maximianus and their retinue of churchmen and soldiers is part of the mosaic decoration of the apse of the church (Color Plate 23). The color is used to maintain the feeling of two-dimensional surfaces as well as to embellish them with the richness of gold and colored stones. We have already studied the way in which different types of contrasts—some in value and some in hue—result in an equality of visual attraction in

this mosaic. Now we can understand that the enrichment of the wall surfaces by means of decorative color fulfills an architectural purpose. We can sense also the expressive significance of this flatness: to aid in revealing the nonmaterial or spiritual nature of the event as Justinian presents his offering to Christ. Even more than the ivory of the Archangel Michael, the emphasis on the eyes of the participants in this ceremony suggests that the greatest reality is in the realm of the spirit. The climax of the mosaics of San Vitale is in the semidome of the apse itself, where Christ is enthroned on a globe of the universe attended by archangels.

Justinian's empire was based in Constantinople, originally Byzantium until renamed by Constantine in the fourth century (and now Istanbul). Following the political division between eastern and western empires, the churches separated too; henceforth the Eastern or Orthodox church was to be centered in Constantinople, and later Russia, while the Western or Roman church retained its center in Rome. As well as the church of San Vitale, Justinian had built the church of Hagia Sophia (Holy Wisdom) in Constantinople. We have already seen this large and most original

building in Chapter Eight, where we observed some of its expressive effects. Now, with more knowledge of the period, we can relate the richness of its mosaic-covered walls, its treatment of space, and the refinement of its marble surfaces to the urge to make the house of God more grand than anything Roman or pagan.

By the tenth century Byzantine art had developed a particular expressiveness that can be seen in the mosaic depicting the Virgin enthroned between Constantine and Justinian (see Fig. 6-7). A dignified aloofness characterizes the three figures, shown as static or restrained in movement. Emotions are absent, almost as in Greek art. The slight modeling gives a hint of three-dimensionality to the forms, but flat, near-geometric shapes set against an abstract background of gold mosaic tend to dominate. The effect of unreality is entirely consistent with the image presented. Mary, Queen of Heaven, and her Child are receiving two symbolic gifts: on the right the fourth-century emperor, Constantine, offers the city of Constantinople; on the left the sixth-century emperor, Justinian, offers the church of Hagia Sophia. How could such a timeless, spaceless concept be better rendered than in a style which itself incorporates timelessness and spacelessness?

As we move further into the Middle Ages we can take note of certain characteristics of Christian art that continued to show up even though particular styles changed according to time and place. Among these characteristics are the use of symbols to communicate ideas; a favoring of the abstract over the representational; a love of the precious (gold, jewels, rich patterns, and color); and refined craftsmanship in the working of the materials. One or another of these might dominate at different times but all are present in some degree in nearly all medieval art.

Pre-Romanesque Art of Western Europe

Classical art of the Mediterranean basin was not the only art practiced on the European continent in the centuries we have been studying. The groups of largely nomadic people to the north also had their artists. They produced small works

that could be easily carried from place to place, usually objects that had a practical as well as an aesthetic purpose. These were either completely abstract in form or combined abstract elements with depictions of animals and birds. A Visigothic brooch in the form of an eagle is typical (Fig. 12-4). Gold or copper-gilt bands form the pattern and colored enamel fills the spaces—a technique known as *cloisonné*. These objects already exhibited the characteristics of preciousness, fine craftsmanship, and a high degree of abstraction in the images; they only needed the addition of Christian subject matter and symbolism to join the growing stream of beautiful objects that comprised early medieval art. We watched late Roman art gradually lose its representational qualities and become more linear and decorative at the same time that it entered the

12-4 Eagle fibula, Visigothic, second half of the sixth century. Cloisonné (metal and enamel). Walters Art Gallery, Baltimore.

service of Christianity in southern and eastern Europe. Now we will see how an originally abstract and decorative art gained new subjects and symbolic references as it entered the service of Christianity in northwestern Europe. This process began in the seventh and eighth centuries.

One of the finest books produced by the monks working in centers in Ireland and coastal England was the Lindisfarne Gospel, a page from which was shown in Figure 2-15. Its abstract, compartmented forms reveal the influence of cloisonné objects like the eagle fibula. Here, however, these elements have been translated into ink lines and paint and become part of the embellishment of a book. The book was of particular importance to these enthusiastic Christians because it contained divine messages carried by the written word. The initial pages of the gospels (the first four books of the New Testament) were occasions for the greatest elaboration of words and patterns. The results are among the richest abstract designs ever made; colorful pigments—sometimes ground semiprecious stones—were worked with incredible skill to make visible the significance of the words. The leading motifs of the spiral and the interlace had been used for the decoration of Celtic objects for some centuries, but only when they became infused with new Christian content did they develop such a richness of design as we see here.

When we looked at another page from one of these early Irish books, the *Book of Kells* (see Fig. 5-11), we observed the complete absence of foreshortening in the image of St. John. This indicates that there was almost no dependence on late classic or early Christian models, which had some modeling and some foreshortening. Instead this is pure concept-drawing, the concept of a person being conveyed simply by frontality and symmetry. The evangelist holding his book owes his effectiveness to the lively shapes and colors worked into flat areas bounded by wirelike lines—and, if it weren't for the Christian subject, could almost be a refined product of the Celtic tribes. But by this time the Christianized Irish had established monasteries not only in Ireland and England but on the continent as well, and these were among the most civilized centers in all Europe.

Other centers of civilization in the late eighth and ninth centuries were those established by Charlemagne in northeastern France. With his ambition to become the successor to the Roman emperors (he was crowned emperor in Rome in the year 800) Charlemagne gave scholars and artists the task of copying ancient texts and their illustrations. Many of these craftsmen were original artists who infused as high a degree of energy into their figure drawings as the Irish monks brought to their more abstract art (Fig. 12-5).

12-5 School of Reims, Psalm III from the *Utrecht Psalter, c.* A.D. 820. University Library, Utrecht.

The Psalm illustrated on this page of the *Utrecht Psalter* reads: "The Lord is gracious and merciful. He provides food for those who fear him. . . . He has shown his people the power of his works, in giving them the heritage of the nations." The Lord's hand emerges from a cloud at the upper right, blessing the generous persons who pass out food to the poor. The trio of women with children at the right who receive the gifts are rendered in a most convincing way; actions and expressions indicate that the artist was observing the real world as well as referring to an ancient model in drawing the figure. The psalm is interpreted in very concrete terms as opposed to the abstract terms of the Irish works, yet both convey an excited and sincere response to the words of the Bible.

Romanesque Art

In the next century or so these two types of response, one abstract, the other concerned with representation, came together in the formation of a new style of painting and sculpture known as Romanesque. This style, dominant in the West from about 1050 to 1200, paralleled Byzantine art in the East and borrowed freely from it. But while Byzantine art is dignified and somewhat aloof, creating a detached and timeless realm, Romanesque art is active, concretely involved in the illustration of religious stories, and ready to use strong colors and active abstract patterns to enhance the expression of feeling. An example is the painting of the evangelist St. Mark in a gospel book of the eleventh century (Fig. 12-6). The patterned gradations and repetitions join with the activated pose to create a convincing feeling of the evangelist being inspired by his mystical symbol, the lion. Our response is one that involves feeling or emotion, so that the term *expressionistic* seems appropriate to designate the interpretation we find here.

Expressionistic also is the relief sculpture of the prophet Isaiah on the door jamb of a church at Souillac in southern France (Fig. 12-7). He seems as excited about calling our attention to a scroll bearing his prophecy as St. Mark was about receiving his inspiration. Crossed legs, hunched

12-6 *St. Mark,* from the *Gospel Book of Corbie,* northern France, c. 1025-50. Municipal Library, Amiens.

shoulders, and a tilted head are found in both. So are billowing curves and linear drapery patterns; and in both the tension is enhanced by confining the movement within borders which seem to restrict the figures' actions. The Souillac figure has a crisp quality of carved stone that enhances its linearism just as the sharp pen line does in the manuscript illumination.

As well as being a spiritualized figure it is also frankly made of stone, which serves to fuse it with the material of the church itself. Romanesque sculpture is also filled with shapes which relate to those of the architecture. The capitals of columns, either inside churches or in the open cloisters adjacent to them, were favorite loca-

12-7 *Isaiah,* c. 1120. Jamb figure from
Sainte Marie, Souillac. Stone, 5'9" high.

12-8 *Sacrifice of Cain and Abel,* twelfth century. Stone
capital from Moutier-Saint-Jean. Fogg Art Museum,
Cambridge, Massachusetts.

tions for figure sculpture. Our illustration is of a
capital that once was part of a twelfth-century
French church at Moutier-Saint-Jean (Fig. 12-8).
Abel is shown offering a lamb to God (whose
hand emerges from a cloud) while Cain presents a
sheaf of wheat. The figures are nicely adapted to
the form of the capital with its transformation
from square top to round bottom. Linearism and
abstract patterning are strong and, while not so
ecstatic as the prophet Isaiah, the sons of Adam
and Eve seem intensely involved in the religious
rite.

As we turn to the architecture of this period
one of our strongest impressions, as with the
sculpture, will be that of the stone itself. Except
for occasional use of paint, little was done to
"finish" the often rough surface of the stone.
Roman architects frequently covered their
rougher stone with marble veneer, and this was
done in some Italian Romanesque churches. In

France, however, Romanesque sculptors and ar-
chitects liked the appearance of stone and their
frank use of it still holds a strong appeal for us
today.

Like painting and sculpture the architecture of
the Romanesque period became an international
style. All over Europe a great surge of church
building produced structures that were fre-
quently large and designed to be as permanent as
possible. Earlier churches, with wooden roofs,
had often been destroyed by fire, so most of the
new ones were made entirely of stone. Both the
number and the size of Romanesque churches
reflect the confidence and the faith of the people
who built them. These are also the qualities that
inspired Western Europeans at this time to con-
duct a series of crusades against the Moslem
Turks to drive them from the Holy Land.

As they had been for some centuries, many of
the major churches were located in monasteries

where monks, dedicated to the principles of poverty, chastity, and obedience, lived lives of hard work and devotion. Their lives gave form to their buildings, as we can see from the aerial view of the now ruined Fountains Abbey in England, a Cistercian monastery (Fig. 12-9). The church, its apse directed to the east, is flanked by a belltower on the north while on the sunny south side is the cloister. Here members of the brotherhood could spend time in meditation, outdoors in good weather and under cover of the roofed passageway, separated from the open court by an arcade, in bad weather. A dormitory bordered the cloister on the west with a smaller one on the east. On the south side of the cloister was the refectory, or dining hall, connected to the dormitory by the kitchen. On the east was the chapter house where the abbot met for business with the members. Further east was the infirmary. Flowing past it and the kitchen, dormitories, and latrines was a swift stream for drainage. And surrounding the complex were fields for cultivation by the monks.

Such functional groups of buildings were the centers of learning and art all over Europe. But the church building dominated, just as religion dominated the lives of the monks. Not all Romanesque churches were monastic churches headed by abbots; those that bear the name *ca-thedral* were the domains of bishops. The basic plans of Romanesque churches derive from the Early Christian basilica, with its long nave leading to the apse and with aisles on both sides. This plan is clearly seen in an aerial view of the Italian Cathedral of Pisa with its baptistry and famous belltower (Fig. 12-10). The simplicity of the major forms in the cathedral is also like an Early Christian church; the exterior of Sant' Apollinare in Ravenna consists of a raised central portion where the clerestory windows are located and of shed roofs over the aisles. Here, however, following the model of other Early Christian churches, there is a *transept* intersecting the main body of the church at right angles. The intersection of nave and transept is called the *crossing* and it is here covered with a dome. All large Romanesque churches have transepts. Differing from the plain exteriors of Early Christian churches the exteriors of the cathedral and belltower at Pisa are decorated with marble arcades, those on the ground story having attached columns *(blind arcades)* and those above set away from the wall to produce shallow balconies. Bits of colorful mosaic set into the marble combine with the pattern of light and shadow to create a lively exterior appearance. In other churches sculpture is used to enhance the exteriors.

12-9 Fountains Abbey monastery (ruins), begun 1132. Yorkshire, England.

12-10 Cathedral of Pisa, 1053-1272. (At left, the baptistry; at right, the belltower.)

12-11 Nave of Sainte-Foy, Conques, c. 1050-1120.

We turn now to France, where in two churches from the late eleventh and early twelfth centuries we can study the all-important system of vaulting characteristic of this style. The first is the church of Sainte-Foy at Conques in southern France. The interior (Fig. 12-11) suggests why the name *Romanesque* was applied to this period—the round arches and vaults were clearly derived from Roman architecture. The many repetitions of the semicircle and the ever-present stone give a visual unity to the interior. All the structural elements work together in an organic manner: each attached column extends from the floor to the transverse arch in the vault, which meets the corresponding half-column on the other side of the nave. A slight, alternating rhythm is given by making every other projection a square pilaster instead of a round half-column. Shorter half-columns meet the arches of the nave arcade in a similar way, and in the second-story arcade, called the *gallery*, two smaller arches are supported by smaller columns and half-columns. The capitals of these columns were sculptured and looked very much like the capital of Cain and Abel we have just seen. The same rounded forms as well as the same stone are found in both architecture and sculpture. Another quality

shared by sculpture and architecture is the preference for crisp edges. In the architecture the right-angle corners that occur whenever surfaces meet each other are as important as the round arches in unifying the whole.

The interior spaces of Saint-Foy, made up of rectangular blocks with rounded tops, have the same decisive character as the solids do. The tall nave directs us toward the altar and the crossing is strongly marked by the light coming down through the windows. If one looks at the exterior from above, which can readily be done since the church is built on a steep hill (Fig. 12-12), one sees the clearly separable blocks which compose it. On the left the intersection of nave and transept is marked by the tall lantern, and on this side of it are the *choir* and apse. Aisles around nave and transept are covered by separate roofs and twin towers flank the main entrance.

The second church is in Normandy in northwest France. Saint-Etienne at Caen (Fig. 12-13) also has round arches and right-angle junctures but the vaulting is more complex. The intersecting vaults depend for their support on a system of *ribs*, which are located where the sections of the

vaults join. They concentrate the weight of the stone on points between the windows where some of it is borne by the heavy piers and the rest becomes a lateral thrust that is met by the masonry under the aisle roof. These intersecting vaults allow clerestory windows to light the nave, unlike Conques, where the nave had no direct lighting. The tentlike forms of the vaulting also impart an energy to the organic system that was not present in Conques. Such innovations by Norman Romanesque architects made possible the art of the Gothic cathedral.

Gothic Art

About the middle of the twelfth century, there began a series of changes that transformed the solid horizontality of the Romanesque into the soaring litheness of the Gothic. We see the results of these changes in the nave of Chartres Cathedral, built between 1194 and 1220 (Fig. 12-14). Compared with the Romanesque of Saint-Etienne, the High Gothic of Chartres is taller in relation to its width and more unified in feeling.

12-12 Sainte-Foy, Conques.

12-13 Nave of Saint-Etienne, Caen, early twelfth century.

to make the eye move faster down the nave than does the alternating system of Saint-Etienne.

The arches are all pointed in Gothic architecture, and since pointed arches are not restricted to one width in relation to their height (as round arches are) they range from the broad points of those spanning the nave and choir to the sharp points of those at the end of the choir. The many different points, and particularly the numerous linear shafts seen in the crossing, assure the dominance of the vertical over the horizontal.

Everything in the Gothic is lighter in feeling. The walls are thinner in relation to their height and have less area because the openings and windows are larger. There is no longer a dominance of weighty solidity and square-edged stone blocks. The angled placement of the piers, and the softening of their corners by rounded shafts make for easy transitions between the central

12-14 Nave of Chartres Cathedral, early thirteenth century.

This latter effect comes from the strong vertical lift of a higher nave arcade and a taller clerestory together with less emphasis on the gallery between them. The vaults reach halfway down the clerestory windows to meet the upward thrust of the slender cluster of columns. So, despite the great height, there is a knitting together of the ground level and the vault region in the nave of Chartres. And in the crossing and east end with its lancet windows the vertical emphasis becomes even greater (see Fig. 10-5).

The vaulting is simpler than that of Saint-Etienne. There each *bay* (the unit whose repetition forms the nave) is bounded by clustered colonettes with a single one in the center, and it embraces two arches of the nave. At Chartres each bay includes just one of the nave arches and the clustered colonettes are all the same. In Saint-Etienne a six-part vault covers the larger bay while at Chartres each bay is capped with a four-part vault (Fig. 12-15). The regular repetition of vertical elements and vaulting tends

12-15 Left, six-part vaults (Saint-Etienne); right, four-part vaults (Chartres).

space and the side spaces. And all the tonnage of masonry seems to be carried lightly by the supports. In fact, the logical mind might be unsatisfied by the interior of this cathedral, wondering how the weight is borne, but outside the answer is given in the flying buttresses that reach over from their massive bases to support the wall at just those points where the vaults exert their thrusts (Fig. 12-16).

We can speak of this kind of construction as *skeletal* as opposed to the *solid-wall* construction of the Romanesque. The thin architectural members are like bones over which the skin of the walls is stretched. So much of the wall is made of colored glass that there is a rather dramatic contrast between the working parts that are made of stone and the decorative feeling in the

12-17 Plan of Chartres Cathedral. (Shaded area approximates view in Fig. 12-14.)

windows (see Color Plate 10). But in fact it would be easy to overemphasize the separation of these two. The structural parts with their repetitions, groupings, alternations, and so on, are themselves decorative, and the windows with their purposeful use of color give a kind of visual strength to the plane of the wall even though they are not physically supportive.

This discussion of Chartres began by calling attention to the interior of the building. The aerial view of it suggests that the exterior form is also unified in comparison with Pisa (Fig. 12-10) or Conques (Fig. 12-12), in both of which the Romanesque preference for blocky forms added on to each other is apparent. At Chartres, even though the exterior has become more complex,

12-16 Chartres Cathedral, begun 1194.

with its high western spires, its buttresses and flying buttresses, and its exterior sculptural enrichment, the overall envelope is quite compact. The plan (Fig. 12–17) shows how the transept has been shortened in relation to the nave in order to achieve this compactness and how, in the later eastern end in particular, the skeleton system has enabled the designer to focus all the weight on a minimum amount of masonry.

This brings us to a major difference between the social functions of Gothic and of Romanesque churches. Romanesque churches were frequently in the country and belonged to sprawling monastic complexes. They were religious centers for the monks, presided over by an abbot, and often the lay people who visited them were on pilgrimages to a series of religious shrines. We feel an intensely religious emphasis in such images as that of Isaiah from Souillac, and quite often it was a representation of the Last Judgment over the main door that greeted the visitor. Gothic churches, usually larger than the Romanesque buildings, were built in the cities and visited more frequently by the average citizen. Presided over by a bishop, among whose charges were the parish priests who had daily contact with the populace, these cathedrals were closely related to the life of the people. The cities had grown rapidly during the twelfth and thirteenth centuries as commerce developed and the number of tradespeople and artisans increased. The sculpture and stained glass addressed a wider range of subjects than those of the previous period and had an enlarged realm of human interest. This is strongly evident in the portal sculpture of French cathedrals of the thirteenth century.

Chartres Cathedral has portals on the west, south, and north sides, each with rows of sculptured figures lining the splayed entrances and filling the area above the doors. If we compare the statue of Moses, seen in the center of Figure 10–3, with the figure of Isaiah from Souillac (Fig. 12–7), we will see that changes took place between the Romanesque and Gothic in sculpture as radical as the changes in the architecture. There is, for example, the formal difference between the abstract shapes and geometric patterns in the Isaiah and the more natural curves and fuller forms of the Moses. While still quite linear the Moses has lines that are less sharp-edged (as the corners of Gothic architecture were in comparison with Romanesque). We are encouraged to read some natural forms of the body beneath the drapery as well. The difference in expression is even greater. Isaiah seems animated by a mysterious energy that makes him assume a nearly frenetic pose, while Moses is calm and serene—any emotional content resides in his slightly tense facial expression. Isaiah's face, with its flying beard and bulging eyes, is anything but calm.

The same humanizing process affected Gothic manuscript paintings. The artist of the *Ingeborg Psalter* (see Fig. 10–4) gave the figures a suggestion of modeling and sought to express a gentle human sentiment. Compare this to the supernatural trance in which the Romanesque *St. Mark* is depicted (Fig. 12–6). A bit further into the thirteenth century is the manuscript which includes a page telling the story of David and Goliath (see Fig. 6–8). Here the action is very convincing: with his shepherd's crook in one hand and the upswinging sling in the other, David aims at Goliath, who stands firmly and draws his sword. In the groups of figures below, where David brings the giant's head to King Saul and then trades cloaks with Jonathan (a token of friendship and therefore a very human touch), there seem to be conversational exchanges. The speakers are often identified by hand gestures, as seen also in the speaking angel in the *Three Marys at the Tomb* from the Ingeborg Psalter. Yet despite their vivid story-telling, Gothic miniatures cannot be described as very naturalistic. The figures rely more on lines than modeling for their definition. And, as we saw in Chapter Six, there is very little space-rendering. Figures are all in the same scale and are related spatially only by overlapping. They also overlap the frame, which means that the artist did not think of the frame as a window through which we look at the scene, as later artists did. The flatness which dominated earlier medieval painting is still felt, though the figures move quite freely within this "abstract space."

The next generation or two of artists brought about significant changes, especially in Italy, where they were responding to different conditions than those we have seen in the north of

Europe. For one thing, the Byzantine style was currently in favor for panel paintings and mosaics. The mosaic from Hagia Sophia seen in Figure 6-7 dating from about A.D. 1000, is typical of the dignified and aloof religious images that spread from Greece and Constantinople into Italy, particularly through Venice and Sicily. Changes were relatively slight during the next two hundred years, especially in comparison with the radical changes we have seen in western Europe. So in the late thirteenth century, the most important artist of Siena in north central Italy was still using compositions and figure-types that look Byzantine. This leader among Sienese artists was Duccio, whose painting of *The Temptation of Christ* is illustrated in Figure 5-13. His Christ has the same features and the same gold-edged dark blue robe that had been used by the preceding generations of Byzantine mosaic artists. The figures in this scene are all the same size, as in both Byzantine and French Gothic painting. A gold background prevents us from reading natural distance into it, but the buildings, even though they belong to a different scale from the figures, do provide us with readable areas of local spaces, an interest not found in the work of Duccio's predecessors or his French contemporaries.

Duccio's *Temptation* is a small painting on a wooden panel. Though it is similar to many *independent pictures* (i.e., not painted on walls or pages of books) of its time, it happens to be one of a series of narrative paintings that once belonged to a large altarpiece by Duccio which was set up in the Cathedral of Siena in the year 1311. In addition to the dozens of small panels making up the altarpiece, its front presented a large image of the Virgin and Child enthroned, flanked by groups of angels, saints, and apostles (Fig. 12-18). From this scene of the Virgin enthroned in majesty the altarpiece gets its name, the *Maestà*. Its bold symmetrical design faced the congregation from the high altar of the cathedral. Although quite Byzantine-looking, the enthroned Madonna and Child appear more human than those of the mosaic from Hagia Sophia of three hundred years earlier (see Fig. 6-7): the mother leans toward her child and touches him gently; he looks more his age; and the angels relate in an affectionate way to the pair. The figures and their draperies have gained in volume, and continuous modeling rounds their forms gently, providing a kind of counterinterest to the linearism that is still strong in the edges of folds and the pattern on the throne. There is still a sense of the

12-18 Duccio, *Madonna Enthroned with Angels*, Maestà Altarpiece, 1308-11. 6'10½" high. Cathedral Museum, Siena.

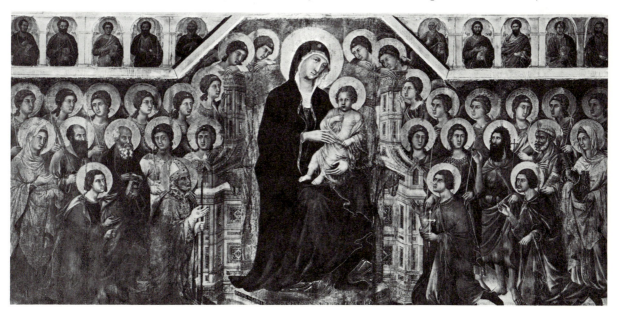

other-worldly in the gold leaf seen in the circles of the halos with their elaborate incised patterns, the robe behind Mary, and the edging of her gown, but signs of a new naturalism are beginning to be evident.

Besides paintings like Duccio's, done on wooden panels with tempera paint, artists of fourteenth-century Italy produced numerous mural paintings. There were more flat wall-surfaces in Italian churches than in the French and the dry climate favored painting directly on plaster walls in a fresco technique. Both tempera and fresco had been used earlier, but now they became especially important due to the great upsurge in painting that began to take the place of mosaics, manuscript painting, and painting on glass.

In the city of Florence a younger contemporary of Duccio, Giotto, made a break with the past that was so radical that its qualities hardly seem to belong to the Middle Ages. Giotto took naturally to painting in a large scale on walls. At the height of his career, in the years 1305–1306, he was given the commission to paint the entire interior of a small, separate chapel in Padua, called the Arena Chapel, with scenes from the life of the Virgin and the life of Christ (Fig. 12–19). The story begins on the upper right-hand wall above the altar. For example, scenes relating to the Virgin's birth, youth, and marriage are in the top band of paintings, and the scene of the Annunciation, occurring on both sides of the arch, leads to the middle band and the life of Christ. The program of pictures is worked out as logically as it was on the north portal of Chartres: the Resurrection of Christ is related ideologically to the Resurrection of Lazarus, so it is placed directly under it, and so on. Visually, the interior of the chapel is unified by increasing areas of blue sky moving upward to the entirely blue vaulted ceiling with its regular pattern of stars and bust-length figures.

But it is not so much in the area of planning and decorative unity that Giotto's innovations are felt. It is rather in the way in which, for the first time since antiquity, he represented forms as fully three-dimensional and space-filling, and the way in which he interpreted events as happening at a moment in time and with a dramatic interac-

tion of the participants. His creation of three-dimensional forms was discussed in Chapter Five, where the *Presentation of the Virgin* was used to define a sculptural mode of representation (see Color Plate 16). Compared with the medieval paintings we have seen so far there is in both of these a convincing sense of reality based on solid figures existing in space beyond the plane of the picture. Giotto's interest in the third dimension was limited to the stagelike space in which the figure action occurs. For example, the small crowd of figures beyond the central group in the *Presentation of the Virgin* does not have much room. But the main actors in this drama have a clear and readable space in which to relate to each other, as they might if they were on a stage.

So the stage is set and the characters convincingly real and it remains for Giotto to relate them in a dramatic way. We saw how well he did this in his *Raising of Lazarus* when we compared his interpretation with that of one of his pupils (see Figs. 9–3 and 9–4). In the *Presentation of the Virgin* our attention soon goes to the child, who is being gently urged by her mother, Anne, to go to the high priest. The movement of figures from the left border of the painting, through Anne, directs us to Mary, while the priest with hands outstretched and head tilted brings this movement to a close. Being centrally located he might dominate the central group except that he is neatly cancelled out by the colonette in front of him. From the right border the gesture of the figure whose back is toward us (an unmedieval method of representation) leads us also to the center and, aided by the receding building, back into the picture space. Movement is slow in a painting by Giotto, and everything else is restrained as well, yet there is an undeniable centering of attention on the young virgin who seems by her dignified yet shy attitude to accept the great responsibility that has been conferred on her.

Giotto was unique in the late Gothic period in achieving a unity of time and place in his scenes. It is only in the Renaissance, a hundred years later, that we find his true followers in this realm. But other artists belonging to the two or three generations between Giotto and the Renaissance added different elements to the growing natural-

12-19 Giotto and pupils, frescoes in the Arena Chapel, Padua, 1305-06.

ism of the time. A love of detail in the depiction of the visible world was one of these and it was strong in northern France and Flanders. At the end of the fourteenth and in the very early fifteenth centuries three brothers named Limbourg were among the finest of these painters. Like most northern artists of the time they continued the miniature tradition of manuscript painting. A page from the most splendid of the books by Pol de Limbourg and his brothers done for the Duke of Berry is illustrated in Figure 6-13. This *Book of Hours* includes a calendar of the months. Our illustration shows a June haying scene taking place in Paris with a castle and the thirteenth-century Sainte-Chapelle in the background. It is interesting to note that everyday life had by now become important enough to deserve a page in an aristocrat's book of prayers. Not only details of nature but a very adequate rendering of space and atmosphere had become part of the repertory of the painter. The world about us had begun to merit equal attention with the world of religious characters and events. The Renaissance was about to arrive.

13
The Renaissance: Fifteenth and Sixteenth Centuries

Shortly after the year 1400 changes of a revolutionary sort were seen in the visual arts in both northern and southern Europe. These changes reflected an inquiring and exploratory point of view and a confidence in individual action that were found also in the great geographical discoveries later in the century. Because of the creativity of the fifteenth and sixteenth centuries the French word *renaissance*, which literally means *rebirth*, has come to mean any vital upsurge of human energy and imagination. The rebirth itself was at first limited to Italy, where an awakened admiration for things Greek and Roman gave an impetus to the work of artists and men of letters. The Greek language was avidly studied, and Latin, for centuries the universal language of the church, was thought of as the language of ancient pagan authors as well. The most obvious imitation of antiquity occurred in architecture where classical "orders" and the proportions of Roman buildings were employed quite directly by Renaissance architects. Yet, as we shall see later, there was much originality and individual variation even in their use.

Northern Europe in the Fifteenth Century

If the major artistic activity of the fifteenth century had been limited to Italy the term *Renaissance* would be quite accurate, but it happens that a great school of painting emerged in northern Europe without classical inspiration. Revolutionary as it was, its evolution out of Late Gothic painting is evident and it is, therefore, a good point at which to begin a discussion of fifteenth-century art.

It was the Netherlands which nurtured the new art. The region known as Flanders, now a part of modern Belgium, produced a series of artists who were active from about 1420 to the end of the century and who recorded the visual world in a new and penetrating way. We have already been introduced to the greatest of the innovators of this period, Jan van Eyck: Chapter Five included an analysis of some of his means for producing an effect of light on forms in space in the portrait of *Arnolfini and his Wife* (Color Plate

17). While this portrait is quite different from Italian paintings of the period, it shares some characteristics with them. Comparing the Arnolfini portrait with an Italian painting, the *Trinity* by Masaccio (Fig. 13-7), we find that both have an interest in rendering the *specific* and both give a new importance to the *larger effects* of nature: space, form, and light. Concerning the specific, portraiture itself had just been reintroduced: the first portraits of living people since late Roman times had been done in the previous century. Van Eyck and his contemporaries were among the first Western artists in a thousand years to study the faces of people closely with the purpose of making visual records of them. Concerning nature's larger effects, Masaccio and other Italians emphasized the solidity of forms and the precise treatment of perspective while the Flemish chose light effects and the very particular rendering of details to create their illusion of reality. The Arnolfini portrait is the most complete realization of these interests.

In Chapter Seven some of the methods by which the larger effects of nature have been achieved were analyzed and the term *coherence* was employed to suggest the unification of the whole through illusion. We get the feeling of wholeness in van Eyck's paintings because the illusion of space beyond the picture plane was one of his primary concerns. In another of his paintings, the Rolin *Virgin and Child* (Fig. 13-1), we find the perspective effects convincing, if not entirely accurate. The resultant sense of space, together with the closely studied light effect and the faithful recording of textures and near-microscopic details, produces a most satisfying illusion of visual reality. Yet it is far from the naturalism of an Impressionist like Monet (see Color Plate

13-1 Jan van Eyck, *Virgin and Child with Chancellor Rolin, c.* 1433. Oil on panel, 26″ × 24½″. Louvre, Paris.

18), whose visual mode of representation catches the moment in time. We are definitely not looking at a passing moment in the real world—quite the opposite, in fact, because a real person, Nicholas Rolin, is depicted in the presence of Mary, Jesus, and an angel in an imaginary room overlooking an unidentifiable city. Even the two light effects are kept somewhat separate, though each is itself convincing: the figures and interior are lighted from a direct source to the right, and the landscape by a glow from the lower part of the sky, as if it were shortly before sunrise. What we see, then, is a unique combination of the real world and an abstract idea. Mary, with her jewel-edged robe, is being crowned by a tiny angel with an elaborate golden crown. The child holds a precious-looking cross and orb, symbolic of the universe, and blesses Rolin with a gesture. The painting is quite medieval in feeling, employing symbols and precious materials, and displaying superb craftsmanship, much as we have seen in earlier medieval works. Yet except for the floating angel and the child's gesture it seems a faithful representation of reality—which is unlike most medieval work. The Chancellor is entirely of this world, his face portrayed in a thoroughly naturalistic way down to the small blemishes on his skin.

The quiet scene is set in a room built in a Romanesque style. Judging from other occurrences of this convention, the use of this architecture from a few centuries earlier than van Eyck's time symbolized the old dispensation, the era before Christ's appearance. Above the heads of Rolin and Mary are sculptured reliefs with Old Testament subjects. The story of Cain slaying Abel, for instance, suggests the sorry state of man before the coming of Christ. The city with its many Gothic spires seems to refer to the new order, a concept of the New Jerusalem that embodies the hope of the future. Other symbols such as the lilies that signify Mary's purity reach back into the Middle Ages. The uniqueness of fifteenth-century Flemish painting and of van Eyck in particular is the combination of the real and the ideal in such a way that they do not seem at odds with each other—rather, each seems to enhance the other. Reality gains sanctity by being incorporated into a religious idea, and religion is brought closer to life by being linked to everyday

visual experience. And in Flemish painting it was not just the form and idea that were combined in a new way; the technique as well was innovative. For the first time pigments were mixed with a thick oil which, when dry, locked them into an enamel-like film. Without the new oil technique van Eyck would not have been able to get the rich colors of the deeper shadows mentioned in Chapter Five.

It was only about fifteen years earlier that other Flemish artists, the Limbourg brothers, had pointed the direction that Northern art was to take. In the illustrations of the months done for the Duke of Berry (see Fig. 6-13) we see the concern for particular details and for people engaged in everyday activities. But without van Eyck's firmer sense of perspective and strongly modeled forms, without his thorough grasp of light as it models forms and affects colors, and without his oil technique, these miniatures fall short of van Eyck's achievement.

Flemish painters followed van Eyck into this new naturalism, but not many of them made as complete a commitment to it. Most retreated from it somewhat in order to attain the kind of religious expression that was still their primary aim. Rogier van der Weyden was such an artist, as we can see by looking again at his *Descent from the Cross* (Fig. 13-2). A detail of the figure of Mary Magdalen (Fig. 13-3) shows him to have been a close student of nature's forms and surfaces. The head and neck are as refined in modeling as anything found in van Eyck's painting, even though there is less interest in a direct, specific light source and a greater interest in a sculptural rendering of form. The textures of the cloth of the headdress, the flesh, and the teardrops are almost as perfect reproductions of reality as are van Eyck's. But in this very formalized pose, Rogier seems to have taken a step back from reality in order to embody the idea of grief in a more permanent form. The arms, hands, and shoulders of the weeping woman frame the pure profile of her face in such a way that a kind of timeless symbol of grief is created.

The whole painting seems to have a similar quality of timelessness. The confining of the group in a niche produces a less-than-real feeling of space (as discussed in Chapter Eight). The near-geometry of John on the left and Mary

13-2 Rogier van der Weyden, *The Descent from the Cross*, c. 1435. Tempera on panel, 7'3" × 8'7". Prado, Madrid.

13-3 Detail from *The Descent from the Cross* (Mary Magdalen).

Magdalen on the right creates a parenthesis-like closure and the whole group is capped by a low archlike shape. The lines of the bodies of Christ and the fainting Virgin are nearly the same. Certainly the *idea* of the tragic event overrides its actuality. Yet the grim reality of the scene is recorded in the blood from Christ's wounds, which dried while he was still on the cross.

The basically religious content of early Flemish art prevailed for another fifty years as, for example, in this *Adoration of the Shepherds* by Hugo van der Goes (Fig. 13-4). It is the central

13-4 Hugo van der Goes, *The Adoration of the Shepherds* (center panel of the Portinari Altarpiece), c. 1476. Oil on panel, approx. 8'3" × 10'. Uffizi, Florence.

section of a large triptych (a three-part painting), the side panels of which contain portraits of the donors and their patron saints. Again we find a great attention to visual reality combined with a kind of timelessness, as tiny, unreal angels, some kneeling and some floating, are seen alongside very real shepherds. There are symbolic references, such as the foreground flowers, iris and columbine, which were traditionally associated with the sorrows of the Virgin and therefore hint at tragedy in this otherwise joyous event. Like van Eyck, van der Goes studied specific light effects; note the lighting from beneath on the floating angel nearest to Mary and on Joseph's hands, where it reveals the texture of the skin. This naturalism reaches its height in the shepherds, whose individualized faces and clothes indicate a growing interest in genre art. This interest, which we saw earlier in the work of the Limbourg brothers, would continue to grow for a century and a half in the art of the Lowlands.

The strong religious faith that made possible the coexistence of idea and reality began to break down by the end of the fifteenth century. This change appeared in various ways, one of which is seen in a triptych entitled *The Hay Wain,* painted by Hieronymus Bosch (Fig. 13-5). Few of Bosch's subjects are entirely explainable today, though the general content is clear enough. A moralizing tone and occasional anticlerical references suggest a radical break with previous art. The visual arts are often barometers of change; within two or three decades the Protestant Reformation would be initiated by Martin Luther.

What is it that Bosch was trying to convey in this and similar paintings? On the left panel we find the Garden of Eden and its brief state of bliss: God, at the very top, directs a band of good angels to drive out the rebel angels. Then comes a sequence of the creation of Eve, the temptation, and the expulsion of Adam and Eve from the garden. The temptations and evils of the world are the subject of the central panel, followed by the tortures of Hell in the right wing. The hay wain itself is the symbol of worldly goods and pleasures. Lovers sit on top of it, blissfully igno-

rant of the evil demon at the right. Below them people try to grab some hay and in the process they become embroiled in fights. Clergy are involved as well as members of all classes: a tonsured monk is in a scrap at the center while the fat priest at the lower right is enjoying the good life. A pope and a king behind the load still manage to maintain their dignity. The intention is clearly to convey a moral message: the world, which was perfect until the sin of Adam and Eve, is filled with temptations of the flesh and material goods which most people are unable to resist—and they are doomed to go to Hell.

Bosch's small figures are more broadly painted and contain fewer details than those of van Eyck or van der Goes. They are kept from appearing chaotic by a more pictorial treatment: broad light and dark tones set them off and help organize the picture space into a series of planes. Fantastic creatures and the vision of Hell give a nightmarish tone to the picture and add humor to the moralistic content.

Flemish painting of the fifteenth century, together with the painting of Germany, Spain, and France which it influenced, cannot correctly be called Renaissance, as was suggested at the beginning of this chapter. Lacking any very specific style-name, it has been referred to as "Late Gothic," even though it is as different from the late Gothic art of the fourteenth century in its grasp of reality as is Renaissance Italian art. We have to be satisfied with such designations as "Late Gothic Flemish painting," or simply "fifteenth-century Flemish painting." For the Renaissance proper we must turn our attention to Italy.

13-5 Hieronymus Bosch, *The Hay Wain*, c. 1490. Oil on panel, 4'5" × 6'3". Prado, Madrid.

The Early Renaissance in Italy

The period of the Early Renaissance in Italy conforms neatly to the 1400s, for which reason it is also known by the Italian word for that century—the *Quattrocento*. The principal center of activity was Florence. Around 1420, just about the time van Eyck became active as a painter, three Florentines were virtually creating the Italian Renaissance. The architect Brunelleschi had just begun the great dome of the Gothic Cathedral of Florence which still dominates the city; the sculptor Donatello had completed his statue of St. George; and the painter Masaccio, a precocious nineteen, was preparing for the revolutionary kind of painting he was to do before his death at twenty-seven. All exemplify the sense of individual adventure that characterized this period.

13-6 Filippo Brunelleschi, interior of the Pazzi Chapel, begun *c.* 1440. Santa Croce, Florence.

Filippo Brunelleschi had studied in Rome itself, and his buildings clearly show their source. A feeling for measured relationships was as important to him as it was to the Greeks and Romans. Like the Pantheon, the interior of Brunelleschi's Pazzi Chapel (Fig. 13-6) is essentially a single space capped by a dome. As we step into this small chapel, directly opposite the altar (visible at the lower right) we immediately see the whole interior. We are already under the central dome and are looking across the short dimension of a rectangular space to the altar, which is slightly raised and placed in a smaller domed space. The barrel-vaulted extensions of the central space produce the rectangular plan. Such simple and geometrically ordered architecture is a decided break from anything we saw in the Middle Ages. The circles, semicircles, and rectangles, emphasized by being of gray stone against the white wall, provide the motifs for the highly organized design of the wall surfaces that, like the spaces, are simple. The final touches are given by the refined carving of the Corinthian capitals, the delicate ceramic sculpture within the circles, and the blue ceramic frieze with Christian symbols that runs around the whole interior. These images of saints and angels remind us that though the architectural forms are new the purpose of the chapel is still religious—in fact, there is ample evidence to establish that Brunelleschi and other Florentine thinkers identified the perfected forms of geometry with the order that God impressed upon the universe. In comparison with the architecture of the Middle Ages, we are now dealing with an interpretation which gives greater importance to the intellect of man in the quest for a contact with the Creator.

Every Florentine painter who experienced such an interior as this wished to incorporate the illusion of simple geometric space into his paintings—which the new perspective projection made possible. In fact, Brunelleschi was one of the first to analyze perspective construction, which he did by inventing an optical machine to observe the geometric convergence of the lines of a building as seen through a peephole.

Masaccio's *Holy Trinity*, painted on a wall of the church of Santa Maria Novella in Florence (Fig. 13-7), may be the first large-scale use of perspective projection in painting. This painting

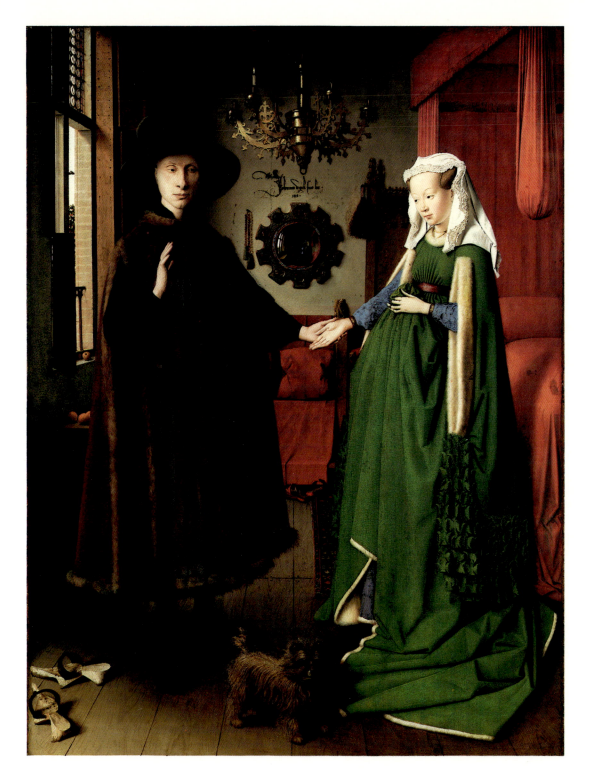

Plate 17 Jan van Eyck, *Giovanni Arnolfini and His Bride*, 1434. Tempera and oil on wood panel, approx. 32″ × 22″. Reproduced by Courtesy of the Trustees, The National Gallery, London.

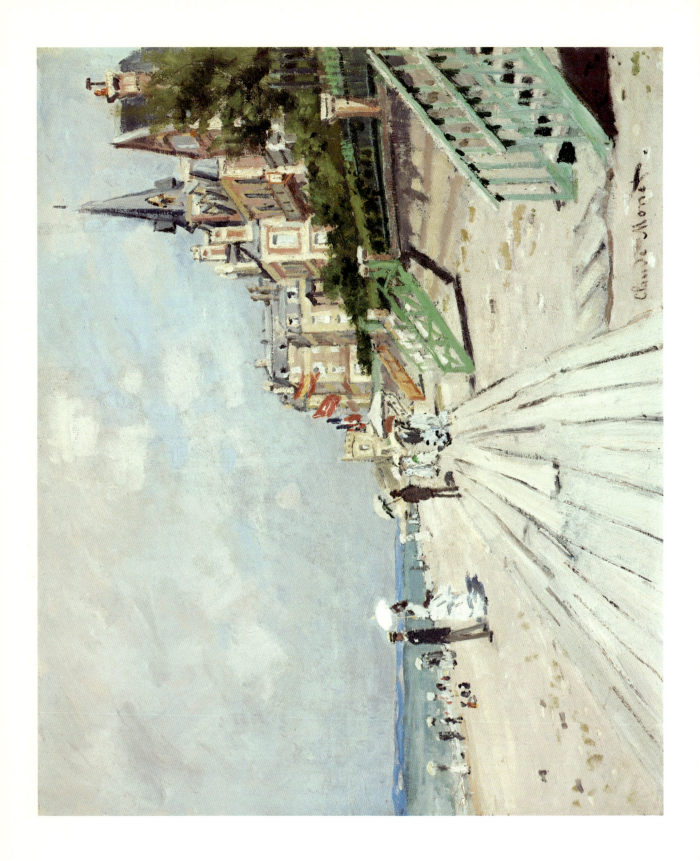

Plate 18 Claude Monet, *The Beach at Trouville (Hotel des Roches Noires)*, 1870. Oil on canvas, 21½″ × 23¾″. Wadsworth Atheneum, Hartford (Ella Gallup Sumner and Mary Catlin Sumner Collection).

Plate 19 Claude Monet, *Torrent, Dauphine*, 1888–89. Oil on canvas, 25½″ × 36½″. Art Institute of Chicago (Palmer Collection).

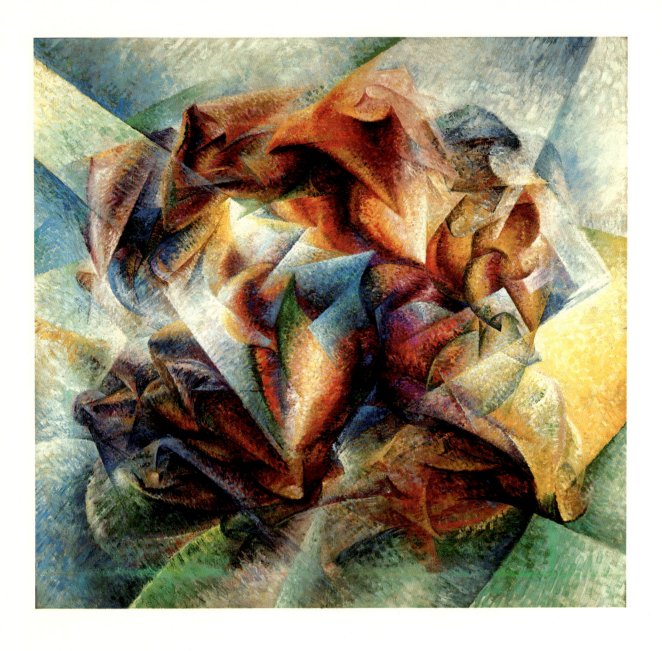

Plate 20 Umberto Boccioni, *Dynamism of a Soccer Player*, 1913. Oil on canvas, 6′ 4⅛″ × 6′ 7⅛″. Museum of Modern Art, New York (The Sidney and Harriet Janis Collection, gift to The Museum of Modern Art).

Plate 21 El Greco, *Agony in the Garden of Gethsemane*, c. 1590–95. Oil on canvas, 40″ × 51½″. Reproduced by Courtesy of the Trustees, The National Gallery, London.

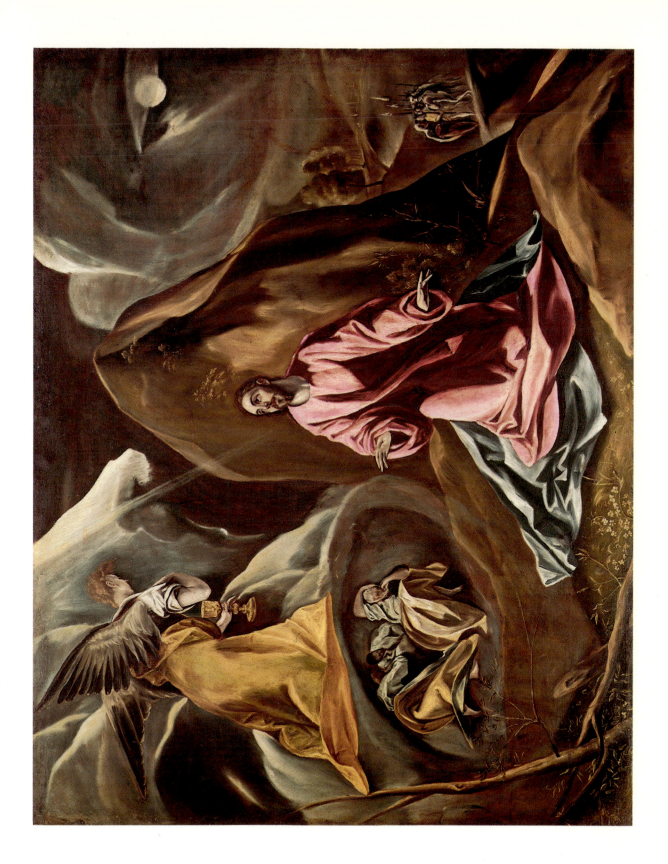

Plate 22 Rafael Ferrer, *Puerto Rican Sun* (night side), 1979. Painted steel, 25′ high. Collection City of New York.

Plate 23 *Justinian and His Retinue, c.* A.D. 547. Apse mosaic from the church of San Vitale, Ravenna, Italy.

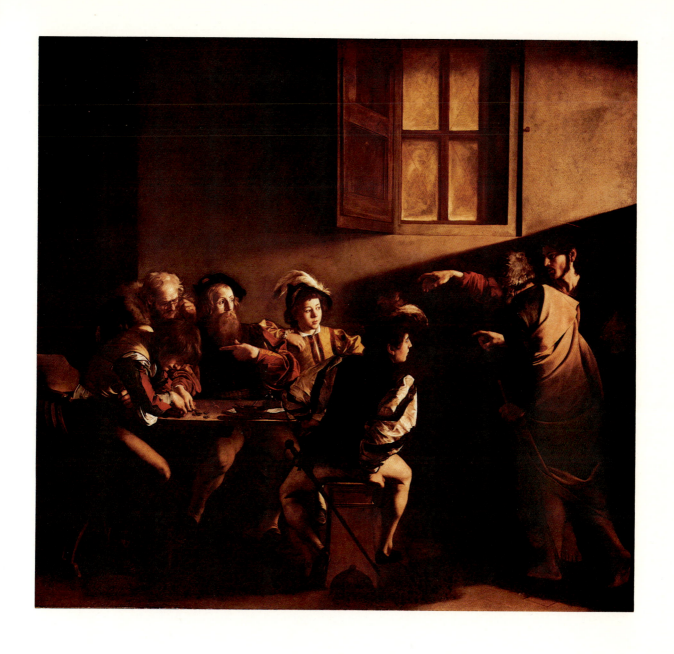

Plate 25 Caravaggio, *The Calling of Matthew, c.* 1597–98. Oil on canvas, 11′ 1″ × 11′ 5″. San Luigi dei Francesi, Rome.

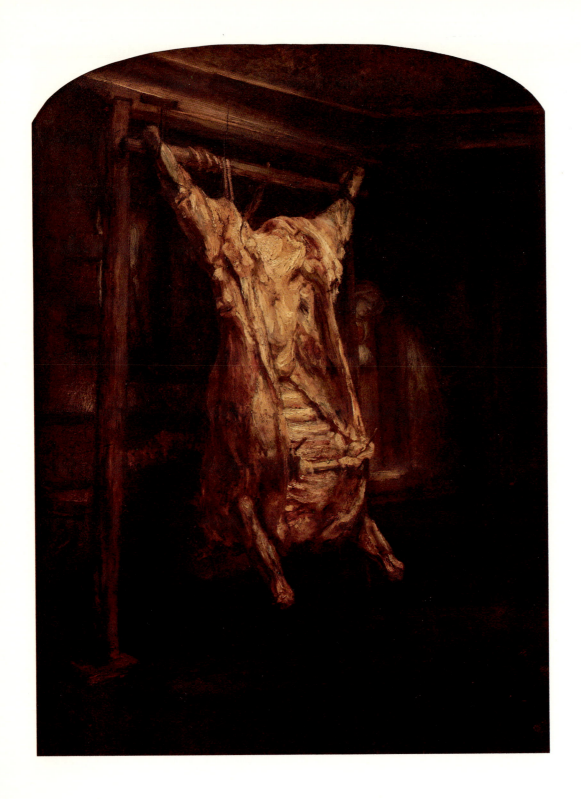

Plate 26 Rembrandt, *The Slaughtered Ox*, 1655. Oil on panel, 37″ × 26½″. Louvre, Paris.

Plate 27 Jan Vermeer, *The Girl with a Red Hat, c.* 1660. Oil on panel, 9⅛″ × 7⅛″. National Gallery of Art, Washington, D.C. (Andrew W. Mellon Collection).

Plate 28 Diego Velázquez, detail of *The Maids of Honor*, 1656. Prado, Madrid.

Plate 29 Giovanni Battista Tiepolo, *Apotheosis of Aeneas*, mid-eighteenth century. Oil on canvas, 28⅞" × 20⅛". Courtesy of the Fogg Museum of Art, Harvard University, Cambridge, Massachusetts (Purchase—Allston Burr Bequest Fund).

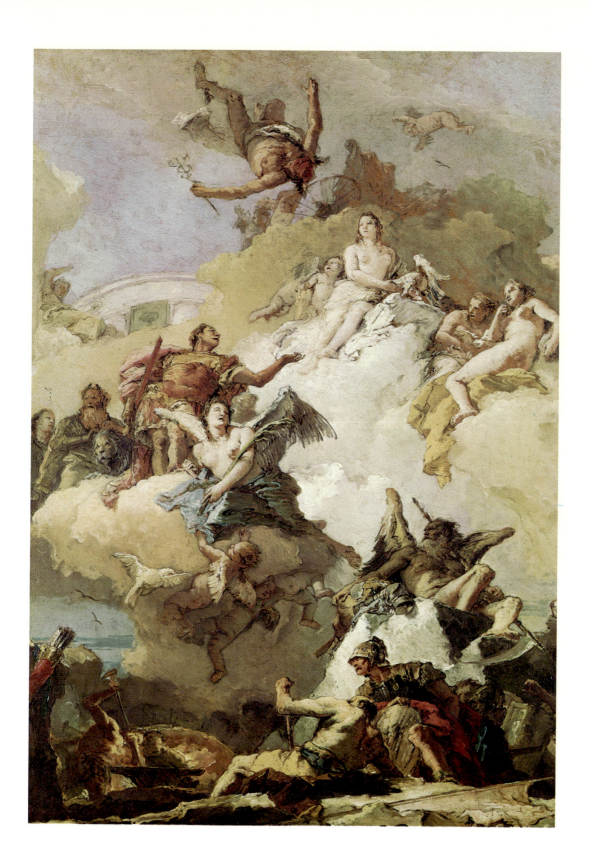

Plate 30 Eugène Delacroix, *The Abduction of Rebecca,* 1846. Oil on canvas, 39½″ × 32¼″. Metropolitan Museum of Art, New York (Wolfe Fund, 1903, Catharine Lorillard Wolfe Collection).

Plate 31 Edgar Degas, *The Dancers,* 1899. Pastel on paper, 24½″ × 25½″. The Toledo Museum of Art, Toledo, Ohio (Gift of Edward Drummond Libbey).

Plate 32 Henri de Toulouse-Lautrec, *Marcelle Lender, Bowing*, 1895. Lithograph, 14¾″ × 11¼″. Colby College Museum of Art, Waterville, Maine.

and van Eyck's Rolin Madonna (Fig. 13-1) were done within a few years of each other, and a further comparison of them reveals similarities and differences in the styles of north and south. Both are basically symmetrical and combine imagined and symbolic figures (such works are sometimes called *devotional* to distinguish them from *narrative* subject matter). Masaccio placed God above the crucified Christ with the dove of the Holy Spirit between them. Mary and John add to the narrative content of the Crucifixion, while the donors are separated from the scene by being placed in front of the architectural niche (unlike van Eyck's intimate mingling of real and ideal). The architecture in the painting, which is like Brunelleschi's, is set into perspective in relation to a vanishing point near the bottom, at the eye level of an observer standing on the floor of the church. A geometric construction clearly preceded Masaccio's painting, while in van Eyck's picture an acceptable visual effect was sufficient.

Throughout Italian Renaissance art we find an analytical approach to problems of representation: books were written about perspective from the 1430s on and, later in the century, analytical diagrams of anatomy based on the dissection of corpses aided in establishing a theoretical knowledge of this subject. In fact, Italian artists of this century can be considered among the first scientists, inasmuch as they sought to find principles of operation in observed phenomena of the natural world. The Flemish were content to observe and record with great accuracy, and so neither wrote books nor made anatomical drawings.

Both Masaccio and van Eyck sought spatial coherence through the illusion of an existence beyond the picture plane, but while van Eyck achieved it largely through light and detail, Masaccio emphasized the bulk of simple and unornamented forms. This new attention to the weightiness of forms and the distribution of weight within the figure is seen best in St. John. All suggestion of medieval richness in color and execution had been left behind by Masaccio, whose large, static figures have the dignified presence of the most memorable works of classical antiquity.

Donatello, like Brunelleschi, got many ideas from direct contact with ancient works of art in Rome, yet his art is very different from that of the

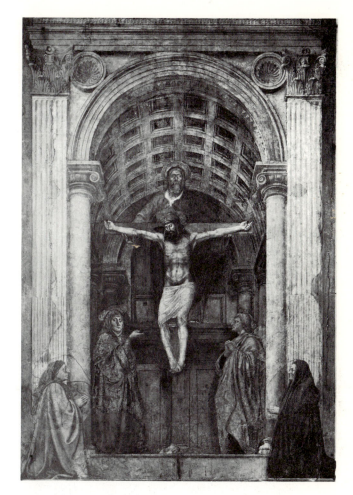

13-7 Masaccio, *The Holy Trinity*, c. 1425. Fresco. Santa Maria Novella, Florence.

Romans, and in good part because of its Christian content. His *St. George* (Fig. 13-8), now removed from its original position outdoors to a museum, combines the firm stance of the young hero with a sensitive face that reveals a less self-assured person than the pose would seem to suggest. There is still some kinship in this face to the Old Testament figures seen at the north portal at Chartres (see Fig. 10-3), if only because they seem somewhat dependent on a power greater than the individual. But St. George seems to take more responsibility on himself—if we read his rather concerned frown correctly. The vast difference between the Middle Ages and the Renaissance shows in the physical vitality in the saint's stance, realized by means of Donatello's

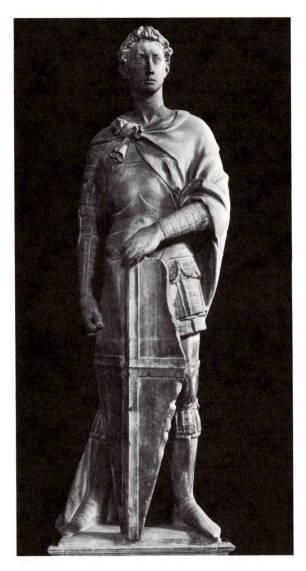

13-8 Donatello, *St. George*, c. 1415. Marble, 6′ 10″ high. Museo Nazionale, Florence.

understanding of the anatomy of the body beneath the cloak and armor.

Later in the century, Florentine Humanists (the Renaissance designation for a scholar of Greek and Latin) defined man as the "connecting link between God and the world" or as the "center of the universe." In all serious Renaissance religious art we feel this combination of subservience to God on the one hand, and a high level of individual responsibility on the other. In Chapter Nine, for example, Michelangelo was seen to

have dealt with the relationship between the Virgin and Child in terms of her psychological independence from him—an idea that would not have arisen in the Middle Ages.

Fifteenth-century sculpture had many lines of development other than the traditionally religious. Portrait sculpture in the hands of artists like Desiderio da Settignano and Francesco Laurana combined the new love of geometric simplicity with an enthusiasm for depicting specific individuals. The result was a new ideal of beauty, both in nature and in art (see Figs. 5-6 and 8-6). Another direction was the intense study of anatomy and physical action, at which Antonio Pollaiuolo excelled. In his drawing of Hercules and the Hydra (see Fig. 7-11) and in his sculpture of Hercules and Antaeus (see Fig. 3-12) we encounter the most thoroughgoing study of male anatomy to that date. Pollaiuolo's researches yielded a new understanding of the differentiation of functions in bones, muscles, and tendons. This understanding in turn made possible the expression of strain and compression, in short, physical exertion, of a wholly new order.

In our brief survey of Flemish art of this period the importance of individual styles as well as the style of a period and place was implied—for instance, in the differences between Jan van Eyck and Rogier van der Weyden. This is even more true of Italian artists, who felt the need for individual expression more than ever before. The styles of Laurana and Pollaiuolo, one favoring serenity of expression and abstract form and the other an intensity of expression and a nearly scientific interest in anatomy, are personal styles. A new sense of individuality had evolved that was destined to continue to the present day.

Yet there is a period style as well which is primarily characterized by the rendering of naturally proportioned figures in a sculptural mode and within a clearly articulated picture space. We have just seen this in the painting by Masaccio, which exemplified such clarity of form and space and rendered figure action even beneath drapery. And in Chapter Five we saw that Andrea del Castagno's interest in the sculptural mode was so strong that no cast shadows were allowed to interfere with the separate plastic forms in his *Last Supper* (see Fig. 5-14). The *Annunciation* attrib-

uted to Antoniazzo Romano is a painting of the period in which the interest in sculptural form was not as strong but the interest in clear rendering of three-dimensional space was paramount (see Fig. 6-14).

One of the major painters active during the middle years of the fifteenth century, Piero della Francesca, painted a fresco cycle telling the story of the True Cross (Fig. 13-9). This portion shows the Queen of Sheba kneeling to the left of center as she recognizes the sacred nature of the wood later to be used in the cross. Right of center, in an open-sided temple, the Queen is again seen meeting King Solomon. Even though separated in time the two events are included within the same picture space, clearly evoked by means of perspective. With the eye level placed at the mid-section of the figures, the heads descend as they recede, while the feet are set higher on the plane of the floor. Piero displayed a minimum of movement in his figures and seems to have had a kinship with Francesco Laurana in his love of geometric simplicity. Even more, he reminds us of the serene dignity found in Greek sculpture of the early Classical period. He was apprenticed to Domenico Veneziano, and we can notice many

similarities with that artist's *Annunciation* and *St. Lucy Altarpiece* (see Figs. 1-1 and 3-1), such as spatial clarity and the lighting of the figures. In the compact grouping of his figures, however, Piero links up with the tradition of monumental wall painting to which Giotto and Masaccio belong and which we will find fifty years later in the frescoes of Raphael.

A different feeling permeates the work of a Florentine painter active in the second half of the fifteenth century, Sandro Botticelli. At the time he painted his *Allegory of Spring* (Fig. 13-10) his chief patrons were members of the Medici family, which had produced both civic leaders and patrons of art for three generations. The Medici favored mythological themes approached in the rather sophisticated manner we find here. The story goes from right to left, as the spring wind, Zephyr, pursues a nymph who runs toward Flora and Venus. The blindfolded cupid above Venus aims his arrow at the three Graces, carrying out the theme of the fertility of Spring. Mercury, messenger of the gods, stands at the far side. In contrast with the seriousness of the work of Piero and Masaccio, this painting has a light and almost melodic quality, developing as it does across the

13-9 Piero della Francesca, *Discovery of the True Cross: Meeting of Solomon and the Queen of Sheba,* c. 1455. Fresco, San Francesco, Arezzo.

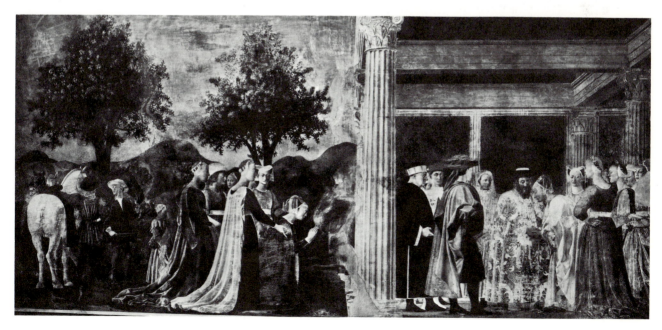

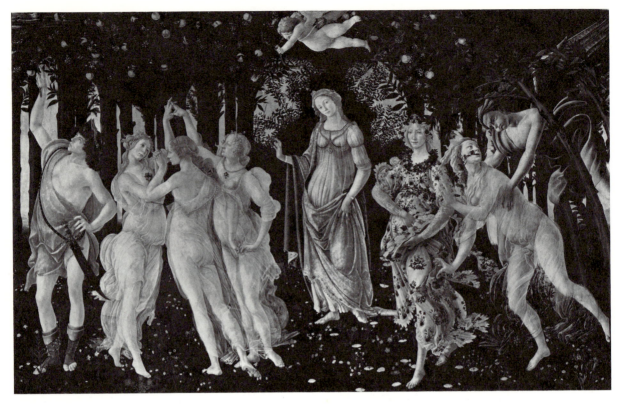

13-10 Sandro Botticelli, *Allegory of Spring*, c. 1478. Tempera on panel, 6'8" × 10'3¼". Uffizi, Florence.

surface rather than into the picture space. Lines (as delineators of form and pattern) take precedence over masses. There is almost a recall of Gothic linearism in the very different mood sought by Botticelli. The style of the Early Renaissance allowed much room for individual variation.

The High Renaissance in Florence and Rome

Italian art next turned away from linearism and again favored large forms and deep spaces; this monumental tradition is the foundation on which the art of the High Renaissance was built. Leonardo da Vinci was the oldest of this generation of artists whose work reached its culmination in the first three decades of the sixteenth century. He loved line, as we saw in his drawing of plants (see Fig. 2-8), but made his linear details add up to a voluminous overall form with a strong three-dimensional illusion. This is even more obvious in his large cartoon in charcoal for a group of Mary, her mother Anne, and the children Jesus and John (see Fig. 5-16). By massing the figures into a large, three-dimensional unit and throwing more than half of the group into shadow (thus shifting the emphasis toward a pictorial approach to representation, as noted in Chapter Five) Leonardo directed our attention to the largest forms. The first thing we are aware of is the whole. Perhaps the best general word for this is *breadth*, a dominant characteristic of High Renaissance art.

This strong emphasis on wholeness is seen also in his best-known portrait, the *Mona Lisa* (Fig. 13-11). With this painting, Leonardo created a new form for the portrait that was to provide a model for innumerable portraits to come. The head, upper body, and arms belong to a closed

form that fills the forward space and angles back into it. The sitter's supporting arm leans on a surface parallel to the picture plane, while the other arm is strongly foreshortened to enhance three-dimensionality and assist in providing space for the body. The foreshortened curve of the bodice enhances the fullness of form around the body, while the drapery curving diagonally over the near shoulder helps to evoke the mass of the figure from front to back. Other aspects of this portrait are unique to Leonardo: the *sfumato* effect (mentioned in Chapter Five) which produces subtle half-lights at the corners of eyes and mouth, thus suggesting mobility at these points; the linear byplay as the small folds in each sleeve repeat the shape and scale of fingers in the adjacent hand; and the misty background with its natural forms bordering on the fantastic and the

13-11 Leonardo da Vinci, *Mona Lisa*, 1503-05. Oil on panel, 30″ × 21″. Louvre, Paris.

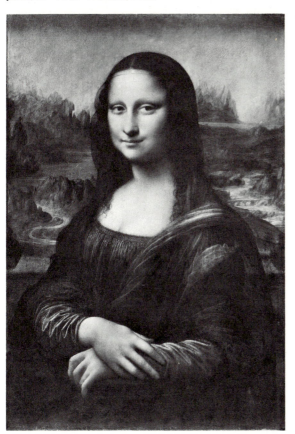

unexplained ambiguity of horizon, to the left and right of the head. Besides his great inventiveness and scientific curiosity, Leonardo had an irrational side to his nature, a mind intrigued by qualities of the world that transcend reason and suggest the mysterious. Generations of critics have noted the ambiguity of Mona Lisa's smile.

The new breadth introduced by Leonardo was seen almost immediately in all art forms. In the architecture of the church of Santa Maria della Consolazione in Todi (Fig. 13-12), the great compact mass of the exterior easily dominates the parts. The larger parts are simple solids: four half-domed half-cylinders adhere to a square, central block which is capped by a cylinder and dome. A comparison with Brunelleschi's Pazzi Chapel (Fig. 13-6) makes clear the large three-dimensionalism of the sixteenth century compared with fifteenth-century linearism. The details are also more plastic, particularly the cornices and the balustrade. The heavy second-story cornice relates, in its scale, to both lower stories, not just the upper one, thus emphasizing a larger part over a smaller one. Inside, the four major corner pilasters (flat, squared-off columns) pass through the same two stories with a similar result (Fig. 13-13). This so-called *colossal order* was seldom used before the High Renaissance. By keeping the same proportion of height to width in the colossal order as in the single-storied pilasters, a largeness of scale is felt in the whole interior. The High Renaissance may lose some of the intimacy of the Early Renaissance but it gains in grandeur.

The grandest of all Renaissance churches is St. Peter's in Rome. It was Pope Julius II who decided to raze the old St. Peter's, an early Christian church, and build a modern church that would be suitably impressive in size and beauty to serve as the church of the popes. High Renaissance patrons, like their artists, tended to think big. In 1506 Julius commissioned the leading architect of the day, Bramante, to design the new structure and begin its building. Bramante was influenced by drawings and plans made by Leonardo, but Leonardo's churches were never built. A central plan with four equal arms like those at Todi (which reflected Bramante's designing) was to provide the new church with a similar strong

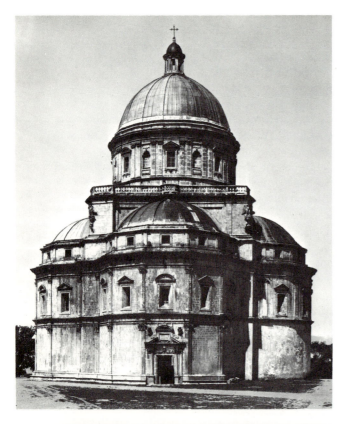

unity. After Bramante's death and a succession of architects who more or less carried on with his plan, Michelangelo, in his later years, became the architect of St. Peter's. His design is seen in the present building, especially if viewed from the back, where his scheme of a large mass dominated by a dome can be best appreciated (Fig. 13-14). The lower stories consist of faceted surfaces that wrap around the symmetrical form of the whole as seen in the plan (Fig. 13-15). Paired colossal pilasters enrich these surfaces. The dome and its drum are also enriched, and the soaring quality of the dome articulated, by the strongly projecting paired columns and the ribs ascending to the *lantern* (the decorative crown of a dome). In the lower stories and in the drum, the windows are crowded between pilasters or columns so as to oppose such voids directly to the projecting solids. As in his sculpture, an energetic forcefulness is the result of such designing.

It is impossible to discuss the range of Michelangelo's achievement in a few pages. He epitomized the individualism of the Renaissance in that anything he touched bore the impress of his personality. He appeared at the right moment to receive the acquired knowledge of the previous century, particularly knowledge about the structure and anatomy of the human body, and he reached artistic maturity at the moment when Leonardo had arrived at the new forms of the High Renaissance. There was never any doubt that the nude was his chief vehicle of expression and, at least at the beginning of his career, that sculpture was his chosen medium.

When we examined Michelangelo's reclining male figure *Day* (Fig. 8-10) we saw that a tension between expanding and contracting forces was the vehicle for the expression of a spiritual restlessness. Nearly all Michelangelo's figures are physically active, and their power, held within,

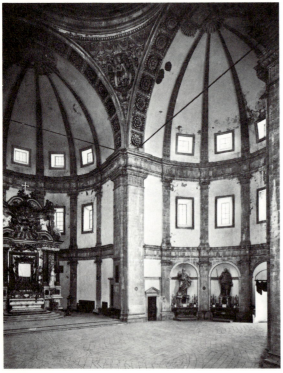

13-13 Santa Maria della Consolazione (interior).

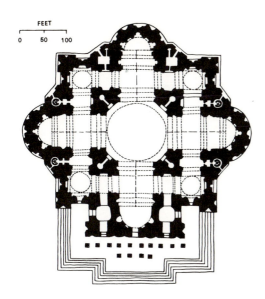

13-15 Plan of St. Peter's.

13-14 Michelangelo, St. Peter's, Rome, 1546-64 (view from the west).

often suggests a psychological meaning, sometimes emphatic, as here, and sometimes quiet and restrained as in the *Medici Madonna* (see Fig. 7-16). It is difficult to become very specific about the underlying content of a tortured figure like the *Day*. We know that at the simplest level of meaning the four figures in the Medici Chapel (two male and two female) signified day and night, dawn and twilight, and that their presence in a chamber for the dead referred to the passing of time leading to death. This much the artist himself has told us in a written passage. At another level the four figures are cast in the tragic role of time as the destroyer of life—all exhibit tortured poses and expressions, even the sleeping *Night*. But the most basic feeling we get from them is of fruitless struggle, of restlessness without respite, as if an irresolvable inner conflict were silently taking place before us. This feeling probably stems from Michelangelo's own inner struggle, the source of which we do not know. Perhaps the most acceptable guess is that there

existed in his life and art an equally strong commitment to a pagan love of physical beauty on the one hand and, on the other, to a Christian spiritual life that is independent of the body. A medieval religious intensity fills his work—but in the Middle Ages there was no cult of physical beauty to come into conflict with it. The clash of these two forces could only come at this particular time, and apparently only in this particular artist, for we do not feel it in any degree in another.

Though he always preferred to think of himself as a sculptor, Michelangelo was the author of one of the most famous paintings in the world— the ceiling of the Sistine Chapel in the Vatican. The Old Testament figures and scenes painted in fresco on the flat vault allude to the future coming of Christ. Prophets and sibyls who foresaw the future are placed beside nine scenes taken from the book of Genesis, most of which deal with the Creation. One of these is the *Creation of the Sun and Moon* (Fig. 13-16). Most previous

13-16 Michelangelo, *Creation of the Sun and Moon* (detail from the Sistine Chapel ceiling), 1508–12. Fresco, 9'2" × 18'8".

artists who depicted this subject didn't attempt to present it as a dramatic cosmic event; they usually showed God mildly placing two balls in the sky. But Michelangelo presents it as an overwhelming act of creation. With two far-flung gestures God creates the sun before him and the moon behind him, then moves on to the next project, creating the plants of the earth. (Michelangelo does not hesitate to use the medieval device of continuous narration: showing God twice in the same scene.) Typically High Renaissance is the emphasis on the whole in the group of the creating God. His heavy form and the forms of his attendants are embraced by large swirls of drapery that produce a compact whole, despite the out-flung gestures. The sculpturally painted masses are emphatic but, in comparison with his earlier Doni Madonna (see Fig. 9-5), the artist had learned how to suppress individual forms in favor of larger units. The subordinate figures are incorporated in areas of dark. Even the back-flung arm of God is flattened into a near-silhouette because the artist felt that painting required the patterning of areas. Yet his superb drawing of the contours of this arm

preserves its structural qualities while the heavy drapery seems to amplify its mass. Michelangelo successfully adapted his sculptural inclinations to the pictorial demands of the decoration of a large ceiling. God's actions in the Creation series are more purposeful than those of the sculptured *Day*, for instance, although the conflicting thrusts of the forward and backward gestures have a similar effect of creating opposing tensions and ultimately expressing the artist's own restless energy.

The youngest of the great trio of High Renaissance artists was Raphael, who died in 1520 at the age of thirty-seven. Fortunately he began producing major works like the *Madonna of the Meadow* (Fig. 13-17) in his early twenties. This Madonna serves well to introduce us to the prevailing content of Raphael's art—serenity expressed through physical grace. At the same time it illustrates the role of geometric order in High Renaissance composition. The three compactly grouped figures are fitted into a rather strict triangular shape, though there is resiliency in having the right side more concave and the left more

convex. In its humanized sense of order this picture reminds us again of Greek art: the order of near-symmetry and balanced actions, which is combined with perfection of human types and a spiritual tranquillity. And the Greeks did not have the concept of the virgin mother of the savior of mankind to work with. The Renaissance, for all its worldly preoccupations, was still able to hold to Christian idealism, at least in the work of some of its artists.

Another dimension of Raphael's art is found in his ability to compose groups of figures in deep picture space, which reached its fullest expression in a series of fresco paintings in the Vatican done for Pope Julius II in 1509-11. These paintings cover the walls and ceiling of a small room, the Stanza della Segnatura, where papal documents were given their official seal. The range of subject matter is imposing. One wall deals with the doctrine of Christianity and presents visually the

13-17 Raphael Sanzio, *Madonna of the Meadow, c.* 1505. Oil on panel, 44½″ × 34¾″. Kunsthistorisches Museum, Vienna.

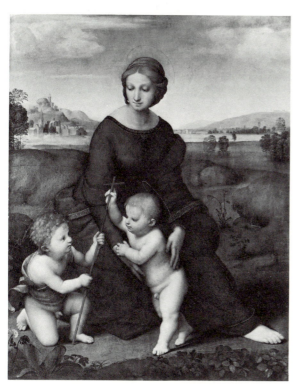

Holy Trinity, Old Testament antecedents of Christ, and numerous persons connected with the Church. It is known as the *Disputà;* we saw a drawing for part of it in Fig. 5-15.

Two other walls deal with *Poetry and the Arts* and the *Judicial Virtues.* The painting on the fourth wall is devoted to ancient philosophy and is known as *The School of Athens* (Fig. 13-18). This grandly conceived work illustrates best of all Raphael's mastery of spatial composition. It is as if the breadth we found in the figures painted by Leonardo or Michelangelo were translated into large, three-dimensional voids. Or, a closer parallel, as if the architectural spaces of Bramante's St. Peter's (barely begun in 1510) were created through the illusion of painting—and then filled with figures.

A large (painted) arch defines the top of the picture plane while below, two rows of large square tiles define the horizontal plane that leads into the picture space. On this floor plane are two groups of figures examining books and diagrams, and seemingly in animated conversation. Beyond the foreground the steps recede in measured units to the main floor plane, which is raised so that its many figures are seen clearly. Then come the Roman-like walls with sculptures in the niches and coffered vaults above, providing an extremely symmetrical setting for the scene. Indeed, the symmetry of the architecture is reinforced by the impression that many of the verticals of the architecture travel down through the light-dark contrasts of the figures in the foreground.

Despite the absolute symmetry of the architecture there is a good deal of variety in the composition. The two foreground groups are off-center to the right as if to take account of the door that cuts into the lower left corner of the painting. We do not linger in the foreground because the open space between the groups and the diagonals, principally those formed by the heavy man at the left of center and the sprawling figure on the steps, lead us back to two figures. They are located at the center of the symmetrical composition, enframed by the vaults and intersected by a strong horizontal line of figures. These are the chief persons in this august company, the Greek philosophers Plato and Aristotle. In the row of figures on the left side an outward movement is

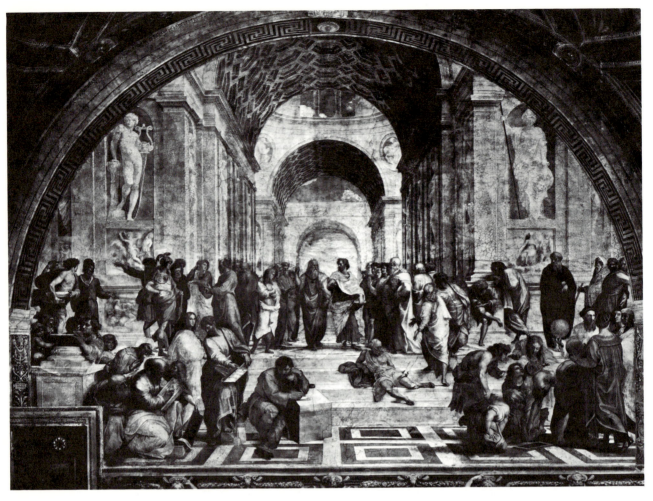

13-18 Raphael Sanzio, *The School of Athens*, 1509-11. Fresco. Stanza della Segnatura, Vatican Palace, Rome.

propelled by the position of several of the men and by the pointing figure. This thrust tends to balance the foreground groups that are placed off-center to the right. A final achievement of this composition is Raphael's decision to place the two major figures well into the picture space, forcing us to enter and experience it. This was an innovative decision that would be followed by innumerable artists to come.

If we could spend time on the organization of the ideas in *The School of Athens*, we would find it to be as rational and as intricate as the formal organization. Briefly, the left foreground group is comprised of arithmeticians, or thinkers who rely on numbers. Since music is based on numbers too, Apollo, god of music and poetry, appears in the niche above. In the left center, Plato gestures toward the heavens as if referring to the mystical "idea" that infuses his thought. Aristotle, just right of center, stretches his arm out horizontally, possibly in reference to his greater dependence on the earth as the source of his thought. Appropriately, the people in the right foreground group are geometricians (*geo* = earth) who discuss their demonstrable science with the aid of diagrams, and the goddess of wisdom and rational thought, Athena, appears in the right-hand niche.

Renaissance Painting in Venice

The kind of complex ideas favored by Michelangelo and Raphael in Rome had little appeal to the artists of Venice. Yet the two major Venetian artists of the time, Giorgione and Titian, moved as easily into a High Renaissance style as their Roman contemporaries. We see this if we look again at a painting done by one of these men (we are not sure which), the *Concert Champêtre* (see Fig. 9-10). A High Renaissance breadth is felt in the large forms of the nudes and in the simple and closed masses of the central group of figures and the trees behind them. In the landscape, large divisions of light and dark alternate as we move back into space; even the distant buildings are seen as light against dark and dark against light.

Although the Venetians did not invent pictorial paintings they certainly demonstrated many of the possibilities inherent in this approach to representation. So Venice became the home of a new synthesis of High Renaissance breadth and a rich pictorialism. The resulting style proved to be a most effective medium for the expression of a "Venetian attitude" toward life.

One aspect of this attitude was suggested when we examined the *Concert Champêtre* and found it to be expressive of sensuous satisfaction occurring in an idyllic environment. Venice itself is a city filled with color that is made more luxuriant by reflection in lagoons and canals. Its traditions have had much to do with music and relatively little to do with the kinds of intellectual achievements that emerged from Florence from the time of Dante to the time of Galileo. Music and color, then, are inherent in its civilization. Titian was the artist who, more than any other, developed such sensuous inclinations into an art that rivaled that of Florence and Rome in its range of expression. His *Bacchanal* (see Fig. 5-17) continued the theme of sensuous pleasure with the inclusion of activity bordering on abandon as the followers of Bacchus celebrate the properties of wine. Painted about ten years later than Raphael's *School of Athens*, it is its opposite in mood as well as in form. While the composition in the Raphael is calm and spacious, here it seems crowded and confused. Yet the order emerges as we continue to look: a diagonal slants from lower left to upper right, where the drunken Silenus lies; a nearly

13-19 Titian, *The Entombment*, c. 1525. Oil on canvas, 4'10" × 7' ½". Louvre, Paris.

13-20 Titian, *The Rape of Europa, c.* 1560. Oil on canvas, 5'10⅛" × 6'8¼". The Isabella Stewart Gardner Museum, Boston.

hidden triangle builds up in the center through the girl with extended arm on the left and the little boy on the right, to the shadowed man with upraised arm in the center. With the invention of such compositions as this, Titian was to have an influence on many painters to come, for he demonstrated how compositional order could be achieved without sacrificing natural action.

Titian's *Entombment* (Fig. 13-19) reveals his abilities as an interpreter of the tragic. The three men and the two women express their grief by different poses and facial expressions, and the feeling of tragedy is deepened by the heavy shadow that falls across Christ's body. Within a basically simple composition there are a surprising number of relationships. The three men arch over the body, the one on the right, in a light robe, in front of it, and the one on the left, in a dark robe, behind it. The center man, tipped to the right, with his silhouetted garment directing us to Christ, looks upward in the opposite direc-

tion. The triangular group of men is slightly off-center to the right, while the figures of the Virgin and Mary Magdalen direct our attention to the left, resulting in a less symmetrical composition than we find in most Florentine or Roman compositions of the time. Yet the *contrapposto* poses of many of the figures, the compactness of the grouping, and the parallelism of the main group to the picture plane are all typical of High Renaissance style.

The Venetians did not use fresco because their climate was unfavorably damp for a technique dependent upon plaster. But they did expand the oil medium into a rich and flexible technique that became the basis for most subsequent oil painting. Canvas was by then the accepted support, and the oil film could be thick or thin, transparent or opaque, depending on the wishes of the painter. Much more improvisation occurred during the process of the painting, so that the artist was no longer so dependent on detailed planning

and numerous preparatory drawings. A painter working in a Flemish oil method, or in tempera or fresco, had to plan nearly every detail before the paint could be applied to a surface, while Titian drew with his brush in a spontaneous manner as he worked on the final version. A detail from his finest painting to be seen in this country, *The Rape of Europa*, reveals his range of textures from canvas surface to thick touches of *impasto* paint that directly express the locks of hair on the bull's forehead (Fig. 13-20 and Color Plate 24). The use of glazes is also characteristic of the Venetian oil technique, in Europa's red scarf a special quality of color comes from passing a thin semitransparent glaze (red pigment suspended in the oil medium) over the thicker paint beneath. Freely handled oil paint on canvas has been used by painters ever since, though seldom with such effective use of glazing.

The subject of *The Rape of Europa* is from the myths concerned with the loves of Jupiter. Europa was a maiden whom Jupiter courted in the guise of a white bull; after enticing her to climb upon his back he swam away with her to an island. Cupids, one riding on a fish, follow while Europa's companions call out to her from the shore. The whole canvas resembles a tapestry, with its richly textured surface and bold color areas; the sky behind the flying cupids is a deep blue, a color chosen more for its rich surface effect rather than to create the illusion of distance. The flying cupids take our attention from the distance and bring it back to the foreground plane where the other figures are located. The composition is based on a large diagonal which separates the foreground figures from the background, while also repeating the diagonals of Europa's arm and the red drapery. This bold composition, combined with the tapestry-like appearance and the rich color, made this painting most effective as decoration in a large, high-ceilinged Renaissance room.

Mannerism

Many changes followed the great works of the High Renaissance in Rome and they often took the form of reactions to the stability and balance of the previous period. The result was a kind of counter-Renaissance rather like the Counter-Reformation that activated the Catholic church in the second half of the sixteenth century. The name used to designate the different feelings and the different ways of expressing these feelings is *Mannerism,* a term that reflects the use of mannered and self-conscious poses by some painters and sculptors beginning as early as the 1520s. An affected stylishness was part of their aim, but by discovering that a certain amount of distortion (which would have been unacceptable to High Renaissance artists) made possible the expression of emotions not otherwise expressible, they opened up new avenues of feeling. One of the most important Mannerist artists was also one of the last major painters of Venice in the sixteenth century, Jacopo Tintoretto. His *Annunciation* (Fig. 13-21) combines the pictorialism and bold composition he learned from Titian with a highly dramatic interpretation of the story that reflects both the new age and the personality of the artist. Compared with the excitement felt here, the action in Titian's *Baccanal* or *Europa* is restrained. The angel flies through the door of a ruined building toward the Virgin. He points, rather unnecessarily, to the glowing dove of the Holy Spirit at the head of a flock of child-angels. Light from the dove floods the Virgin's face as she starts back in surprise and wonder. We seem to be witnessing a supernatural event, an effect that many artists of the period of the Counter-Reformation attempted to achieve.

Some of the decisions made by Mannerist artists tend toward the irrational. Here, for instance, the ruined pier and column and the evident wreckage of a building at the left have a prominence we would scarcely find at any other time. They have symbolic meaning, referring to the sorry state of affairs under the old dispensation (which necessitated the coming of Christ and the new dispensation), but their forceful presence in the same scene with the supernatural event creates a nearly disrupting tension in the picture.

The other Mannerist painter to be discussed here carried irrationality even further. The art of El Greco was formed in Italy, chiefly Venice, where he worked for a time under Titian. Originally a Greek from the island of Crete, he settled

13-21 Jacopo Tintoretto, *The Annunciation*, 1583-87. Oil on canvas, 13'10" × 17'10". Scuola di San Rocco, Venice.

in Toledo, Spain, after his Italian apprenticeship. The Spaniards shortened his name from Domenikos Theotocopoulos to "the Greek." Just before he moved to Spain he painted an early version of the *Purification of the Temple* (see Figure 9-1), which has some of Titian's dramatic action and a typically Venetian emphasis on pictorial lights and shadows. There are some rather distracting elements that Titian would not have introduced—among them the off-center perspective, the strangely isolated baby, and the four portrait heads in the lower right (Titian himself is the head furthest left and Michelangelo is next to him)—all of which illustrate a Mannerist fascination with the unexpected and unusual. But it is a reasonable re-creation of the event. A later version (see Fig. 9-2) pushed reason further aside in favor of an exaggeration of feeling. The means used to arrive at the new interpretation amount to a catalog of Mannerist devices: a willful distortion of proportions, seen in the elongation of the figures of Christ and the kneeling man at the right; a confusion of spatial clarity caused by pro-

viding too little space for groups of figures or by inventing uncertain perspective constructions; an arrestingly nonnatural use of color, as if draperies were seen in a flash of lightning; and an exaggeration of gestures to express emotions. All these can be found in other Mannerist works, but no other artist combined them to achieve the expression of spiritualized anger that we find here. To appreciate the radical shift that has occurred since the High Renaissance, with its reasoned control, compare this painting to Raphael's *School of Athens* (Fig. 13-18).

El Greco was a deeply religious man who found a perfect setting for his religious expression in sixteenth-century Spain. It was here even more than in Italy that the revival of Catholic faith was both extremely intense and militant. Its intensity was to be found in the lives and work of the great mystics who inspired so much of the Counter-Reformation: St. Theresa and St. Ignatius Loyola, founder of the Jesuit order. Its militancy was expressed unfortunately through the Inquisition and its cruel treatment of nonbelievers. On

El Greco it had the effect of releasing an artistic spirit of the highest order. It is doubtful, for instance, that any artist has produced such an intensely expressive interpretation of the *Agony in the Garden* as that seen in Color Plate 21. All the elements of the story are here. In a nighttime setting the angel miraculously appears to offer the cup that signifies the sacrifice of Christ's life. The apostles who came up the hill with him are sleeping at the left, while the soldiers led by Judas approach in the right distance. It is the tortuous moment when Christ realizes that his death must come, and the viewer is left in no doubt as to the supernatural nature of the event.

The Sixteenth Century in Northern Europe

This treatment of Italian art and its Spanish offshoot in the person of El Greco has followed a continuous evolution from the Early into the High Renaissance and then on to the Mannerist art of the Counter-Reformation. But as yet we have not met the Protestant Reformation itself, which occurred in northern Europe under the leadership of Martin Luther. This German theologian felt, among other things, that the Catholic hierarchy of priests, bishops, and pope had too large a control over people's religious lives, that the intercession of saints was unnecessary to salvation, and that the individual should have readier access to the words of Christ. In the northern countries these ideas were to have a devastating effect on the religious imagery that had been so important to artists for centuries. But the greatest artist of the German Renaissance, Albrecht Dürer of Nuremberg, was himself an admirer of Martin Luther. Dürer was in his forties when Luther's public actions against the Roman church were taken (in 1517-20), so that his art was not fundamentally affected by the new beliefs. An early work like the pen drawing of the *Holy Family* (see Fig. 7-13), is traditional enough in its subject matter, though the down-to-earth treatment of the sleeping Joseph marks it as a product of the genre tradition of northern Europe, like the shepherds painted by Hugo van der Goes. The elaborate drapery in this drawing

is distinctively northern and, given how completely the bodies seem to be concealed by the drapery forms, it is late Gothic as well. When he did this drawing, at about the age of twenty, he was already a superb draftsman but, as yet, had learned very little about the developments of the Italian Renaissance. Only later was he to understand the principles of perspective he recorded in the woodcut illustration for the book on *The Teaching of Measurements* published in 1525 (see Fig. 6-9). To see the degree to which Dürer had become an artist of the High Renaissance let us look at an engraving of 1514, the *Melencolia I* (Fig. 13-22). More like Michelangelo's figures than Dürer's own pen drawing of twenty-three years earlier, the winged, allegorical female has a heavy body that is evident beneath her clothes. The strong modeling and weight-expressing pose give her a monumental strength. The intensity of

13-22 Albrecht Dürer, *Melencolia I*, 1514. Engraving, 9½″ × 7½″. Fogg Museum of Art, Harvard University, Cambridge, Massachusetts (Bequest of Francis Calley Gray).

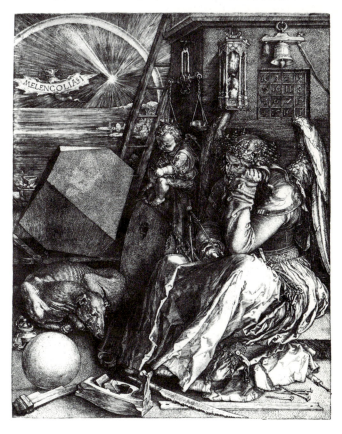

feeling in her face recalls the force of will in the face of Michelangelo's God (Fig. 13-16), but here a willful being seems to be frustrated and a resulting feeling of deep melancholy prevails. We know from many of the objects in this cluttered space that Dürer chose a maker of things and a thinker for his personification of melancholy. She is, however, earthbound and inactive as she waits for the ideal essential to creation. It is the depression of the intellectual and the artist (which we also find expressed in the poems of Michelangelo) that Dürer is expressing here.

While the fullness and breadth of forms are of the High Renaissance, the *Melencolia I* is clearly not an Italian work. The richness of detail and the multiplicity of textures are part of the northern tradition of artists like Jan van Eyck and Rogier van der Weyden. So are the hidden meanings and references found in the many objects that clutter the scene. And the incredible craftsmanship which enabled Dürer to build a rich array of forms and textures out of the fleck and line produced on metal by a graver is a product of the medieval love of craft that still persisted north of the Alps.

Several major artists were responsible for making the first half of the sixteenth century a high point in the history of German art. We include but one more, Hans Holbein the Younger. Born in Augsburg, he moved early to the Swiss city of Basel, where the humanist scholar Erasmus discovered his talents. It was Erasmus who recommended him to the Englishman Thomas More, and Holbein spent the later part of his career in England. His portrait of Thomas More (Fig. 13-23) has the same composition as that evolved by Leonardo for his *Mona Lisa*—a large form angling into the picture space, the hands closing the oval below, and the chain, fur collar, and receding arm reinforcing the illusion of volume. It is these embracing forms that are distinctively of the High Renaissance, while the detail found in all parts continues the northern tradition of close observation of nature. One can almost tell how long it has been since More was last shaved. Yet there is no suggestion of the momentary here: the form and structure of the head, for instance, have been realized above all else. We know that Holbein worked not from nature but from a drawing done

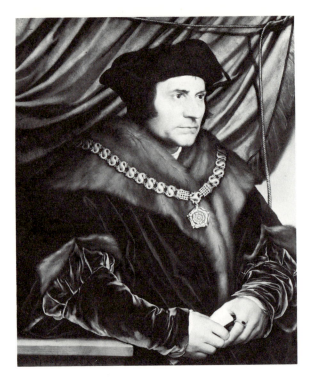

13-23 Hans Holbein the Younger, *Sir Thomas More*, 1527. Oil on oak panel, 29½" × 23¾". The Frick Collection, New York.

from nature, and between drawing and painting there was time to grasp intellectually the underlying structural qualities before recording them in paint. Renaissance Humanists spoke of the dignity of man, as had the Greeks, and it was through such devices as have been noted that Thomas More's portrait expresses this dignity.

The last northern artist of the sixteenth century to be considered here was not very interested in expressing man's dignity. Pieter Bruegel the Elder had spent some time in Italy in the 1550s and yet came home to his native Flanders to paint pictures which in no way imitated Italian or High Renaissance art. His rejection of the whole tradition of expressing man's dignity, of idealizing his appearance, or of creating large, formal compositions like those he must have seen in Rome makes him one of the most original artists of the period. It was in his own Flemish tradition that he found his roots, and in turning to it he went against the fashionable Italianate art of his time—to be new he turned away from the

present and looked especially to an artist who had died about ten years before he was born, Hieronymus Bosch (Fig. 13-5). From Bosch he learned some of the possibilities in the theme of the peasant and his environment, but Bruegel was less interested in drawing moral lessons from the life of the common man than Bosch had been. And after some Bosch-like experiments in fantasy, Bruegel, in the paintings of his maturity, chose to stay with everyday situations of people in their world. These people are always generalized by being types rather than individuals, or by having their faces turned away from us, as we can see in his drawing of *Harvesters* (see Fig. 7-17) or his painting *Hunters in the Snow* (see Fig. 9-19). Bruegel approached human beings with a sense of humor and with an appreciation of their earthiness. While he doesn't come as close to caricature as Bosch did we find a sympathetic humor in his barrel-bellied man drinking from a huge jug in the *Harvesters*. And in the *Hunters* the curly-tailed dogs amount to a commentary on the whimsical shapes to be found in that species. Along with the men and women they suffer a deflation of dignity. A French contemporary of Bruegel, Michel de Montaigne, recorded some comparable thoughts in his *Essays*. Of man he says,

> Who has persuaded him that this marvelous march of the vault of heaven, that the eternal light of these lamps rolling in majesty over his head, that the awful tides of this cosmic sea, were established and kept in motion through untold ages for his convenience and use? Can one imagine anything so ridiculous as this miserable and puny creature, who is not so much as the master of himself but is the butt of all things, and yet who dares to call himself the emperor of the universe?

Even though Bruegel turned away from Renaissance ideals and looked to fifteenth-century artists like Bosch, his art was still of its time. His husky peasants are powerfully sculptural like High Renaissance figures and his compositions do have a sixteenth-century breadth. It was his ability to compose a landscape in this broad, embracing way that led to his being considered the first great landscapist in European art. Prior to Bruegel, except for small paintings by a few Germans, landscape had always been a setting or a backdrop for subject-matter pictures. Following him, every generation down to our own day has produced landscape artists of significance. In particular, Bruegel opened possibilities soon to be exploited by Flemish and Dutch artists of the seventeenth century. For the first time, he painted landscapes with a continuous spatial recession from foreground to horizon instead of the plane by plane recession seen in other Renaissance landscapes like that in the background of Raphael's *Madonna* (Fig. 13-17). And accompanying the perspective recession is a correspondingly continuous gradation of color contrasts from separate local colors in the foreground to a unified gray blue atmospheric tone in the far distance—all of which anticipated the exploration of space and atmosphere that brought about the next major development in landscape painting.

The Renaissance had brought into European art a new consciousness of human life and revolutionary methods for representing the natural world. It saw the development of oil painting and created a new architecture based on the classical past. While these accomplishments were to be incorporated into the art of the next two centuries, there were also new attitudes which brought about a significant change in style that made its first appearance around the year 1600.

14
The Baroque and Rococo: Seventeenth and Eighteenth Centuries

Artistically, as well as politically, the seventeenth and eighteenth centuries were complex periods. As we examine them we will find that they include a very diverse group of works of art, and yet we will also discover that they share common qualities of style. These are not as closely knit as the works discussed in Chapter Ten under the Baroque style of Italy, but they are related enough to justify our separating these two centuries from those before and after. We will find as well that the Baroque soon became an international style, affecting the art of all Europe. In this regard it is unlike the Renaissance, which took a century to cross the Alps.

The Seventeenth Century: The Baroque

The beginnings of the Baroque were first felt in Italy, where the stage seems to have been set for the appearance of something new. The last of the great Venetian artists of the Renaissance and their Mannerist successors had died in the 1580s and 90s (except for El Greco, who had moved to Spain). The Mannerist cult of exaggerated actions and emotions had also lost a good deal of prestige. Some artists looked back to the High Renaissance for ideas, but it was a young man who had moved to Rome from northern Italy who came up with the combination of ideas that set a new style of painting in motion. His name was Michelangelo da Caravaggio, and we were introduced earlier to one of his paintings (see Fig. 5-18). When discussing the *Supper at Emmaus* our concern was with the rendering of light and the illusion of reality created in this way. It was the consistency of the effect of a single source of light and the particular force deriving from the "crowding of the darks" that interested us then. Now we can place these concerns with light in a historical context: at the beginning of the Baroque period, when a new interest in luminosity was emerging and when a new realism was entering religious painting. Caravaggio was caught up in the religious fervor of the Counter-Reformation just as El Greco had been, but his expression of this feeling was very down to earth in contrast with the mysticism that permeated El Greco's art.

What proved to be especially significant in the formation of the Baroque style of painting was Caravaggio's combination of naturalism and realism. *Naturalism* is the term used for the faithful depiction of nature, as in the visual mode of representation, and it is evident in the treatment of light and texture in *Supper at Emmaus*. The connotations of the term have to do with seeing. *Realism* has to do with subject matter—not so much *how* one sees as *what* one sees. Realism in the *Supper at Emmaus* is found in the everyday appearance of the pilgrims with their ragged garments and the prominence of the chicken and fruit on the table.

These qualities, along with his sense of the dramatic, made Caravaggio one of the most original painters of any age. They are seen in his *Calling of Matthew* (Color Plate 25), in which the artist chose the moment when the saint, engaged in a gambling game with some young soldiers, expresses his surprise in being called to be a follower of Christ. All the figures, and particularly Christ at the extreme right, are largely hidden in shadow, with the abrupt light picking out faces and parts of their clothes. Instantaneous poses convey the drama of the event. Everyday people in contemporary dress complete the realistic effect while the bareness of the room prevents our attention from straying from the figures. We are especially attracted by the intense reds which group the arm of Christ with the cluster of reds around the bearded Matthew, linking the two major figures of the story.

Within a decade or two Caravaggio's combination of genre-like religious art and dramatic naturalism spread throughout Italy and to France, Spain, and the Netherlands, encouraging numerous artists to represent the visible world of reality instead of using the stylized images of Mannerism. For the first time it became common to paint directly from nature. (Since no drawings exist from the hand of Caravaggio, it is likely that he preferred painting from live models.)

Among the Italian artists strongly influenced by Caravaggio was Artemisia Gentileschi, whose *Judith and Maidservant with the Head of Holofernes* (see Fig. 7-22) uses similar strong value contrasts for dramatic effect. Another characteristic of Baroque art is evident here: a fascination with scenes of physical torture or death, chiefly those associated with religious subject matter like this biblical scene. Saints were frequently shown at the moment of martyrdom and the presence of blood was common. Baroque religious artists found that their audiences were fascinated by scenes of horror and that the emotional stimulation such scenes produced became part of the religious response. Visions of the saints, like that of St. Jerome painted by Giovanni Liss (see Fig. 10-9), were equally effective in inspiring religious feeling. The Catholic church, recognizing the power of art in this way, intensified its patronage during the seventeenth century, not only in Italy but in Spain, France, southern Germany, and Flanders as well, and Baroque quickly became an international style.

High Baroque Art

The qualities of the Italian Baroque style which emerged from the discussion of this period in Chapter Ten belonged as well to the international High Baroque, which also can be described as *plastic, luminous, open,* and *flowing.* Caravaggio's early Baroque style is plastic and luminous but the fully fluid and open High Baroque art emerged in the second decade of the century, particularly in the work of Peter Paul Rubens. A Flemish artist who got his first training in Antwerp before going to Italy for a period of eight years, Rubens was attracted to the art of the High Renaissance, particularly to the heroic figures of Michelangelo and the composition and pictorialism of Titian and Tintoretto. He was also a student of the language and the art of ancient Rome. We see a combination of these interests in the works he did during a period of intense productivity after returning to Antwerp at the age of thirty-one. In the *Rape of the Daughters of Leucippus* (see Fig. 3-3) we find a more naturalistic version of Michelangelo's heroic figures and a compact composition of a more dynamic sort than those seen in the Renaissance. In the *Battle of the Amazons* (Fig. 14-1) the pictorial mode of representation learned from the Venetians was employed in an effortless way to unify a very complex painting. The diverse sources of his art

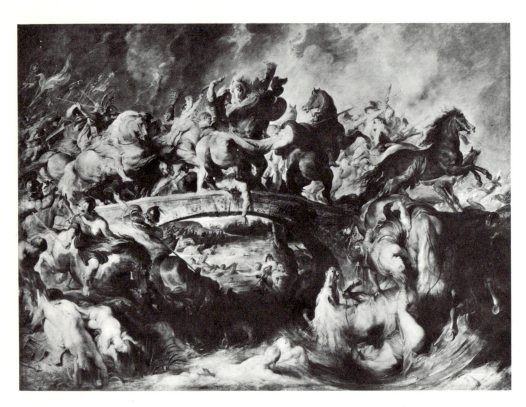

14-1 Peter Paul Rubens, *Battle of the Amazons, c.* 1619. Oil on panel, 47¾″ × 65¼″. Alte Pinakothek, Munich.

were by this time no longer separable, but fused into a unified style of his own. Like all his early important works this one is expressive of great energy, physical action, and drama. While this subject from Greek mythology may be hard for us to appreciate at first, we should understand that it stems from Rubens' great enthusiasm for classical antiquity. Then, rather like Caravaggio, he envisioned the event in the most realistic and vivid manner, so that even today we experience the illusion of the battle's violent action. The strong light effect found in Caravaggio—but with more colorful shadows—is joined with the sure drawing of physical bodies in action to produce this illusion. Astonishing foreshortenings like those of the horses on the bridge or the horse whose rear hooves show in the lower right create thrusts in and out of space. In the second decade of the seventeenth century, space evocation became another of the hallmarks of the new style, and its use, like much else in High Baroque art, was often unrestrained.

If not restraint, there is control here and it is largely of a compositional sort, with the figures on the bridge building up to a central point and those below converging on a lower one. While keeping their broad function in relation to the enframement, the light and dark areas have gained a new fluidity compared with Venetian art. The movement of Amazons and horses in the lower right joins with a downward flow of light, from dark horse above to light horse below, while the countermovement headed under the bridge at the lower left fuses with a curved wedge of increasing darkness; the luminous and flowing qualities of the Baroque are fully realized in this work.

Rubens' career was an international one. His patrons included the monarchs of France, Spain, and England, and in his travels connected with these commissions he found time as well to represent his country as a diplomat. The large paintings that were required by such patrons, and by the numerous churches for which he executed altarpieces, called for a big studio and many assistants. These assistants were not always able to achieve the effects the master intended and, as a result, many of the large paintings are dull, com-

pared with the works Rubens executed himself. The latter were often done for his more discriminating patrons and for them he would point out that the work was done "by my own hand." One of the large altarpieces done for a church in Antwerp, which has much of his own hand in it, is the *Marriage of St. Catherine* (Fig. 14-2). The event that gives the painting its name takes place in the upper center where the enthroned Virgin holds the Christ Child, who leans forward to place a ring on the finger of St. Catherine—a mystic marriage that was revealed to the saint in a vision. Surrounding these central figures are numerous saints: on their level are Peter and Paul at the left, Joseph and John the Baptist at the right. Below, in the foreground, are St. Augustine on the right and, on the left, St. George (with dragon) and St. Sebastian with a symbol of his martyrdom, a quiver of arrows. A group of female saints leads back and up to the main event. Compared with the *Amazons,* the composition of this picture is more three-dimensional. A spiral in space begins with St. Augustine and moves leftward, upward, and into depth, turning back with the four female saints until it reaches the Virgin. This curving spatial recession is aided by the spiraling motion of the figures themselves: St. Sebastian, for instance, does not assume a contrapposto pose as he might have in a Renaissance work but turns continuously, more like a corkscrew, as does St. John at the upper right. Thus the movement is passed from figure to figure and is inseparable from the space it defines.

With such movement in space the full Baroque quality of openness was realized in painting. It would dominate Rubens' later art, as can be seen in two works illustrated earlier, the *Kermesse* (see Fig. 4-6), and the *Return from the Field* (see Fig. 9-18). Both were done during the last decade of the artist's life, when he was spending considerable time in his country house and was less occupied with large commissions. While he had not given up his mythological and religious paintings he seemed to prefer painting scenes of country folk and the landscape around his house. The energetic action that had previously helped tell the stories of heroes and saints now was applied to peasants returning from work or reveling at a country dance. In any type of painting he under-

took he exploited the qualities of Baroque art to the fullest. Just as the High Renaissance could hardly be illustrated without the example of Raphael, so the High Baroque is more completely represented by Rubens than by any other painter.

Rubens was also the first artist to effectively fuse the artistic traditions of northern and southern Europe. We saw how different were the interests of the Flemish and the Italian painters of the fifteenth century, and how, in the sixteenth century, Dürer and Holbein mastered Italian Renaissance principles but kept their allegiance to northern factualism. None of the artists of the century of High Renaissance and Mannerism brought together southern humanism and north-

14-2 Peter Paul Rubens, *Marriage of St. Catherine,* 1628. Oil on canvas, 18'7" × 13'3". Royal Museum, Antwerp.

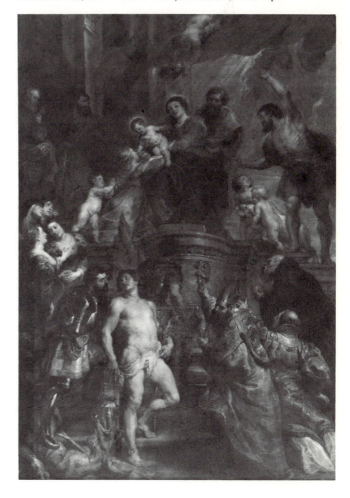

ern empiricism without sacrificing one to the other, or incorporating in their work the awkwardness of a disturbing compromise. It seemed to require the unifying power of a new style to bridge the gap of centuries of separate traditions.

The Italian sculptor Gianlorenzo Bernini was to the southern Baroque what Rubens was to that of the north. His work was exuberant in feeling and as High Baroque in its flowing, open forms, freely moving in space, as that of the great Flemish painter. His *Habakkuk and the Angel* (see Fig. 5-10) illustrates his tremendous technical skill. But it is not as an end in itself that he cut deep hollows into the marble and brought its surfaces to a high finish. By these means he created the sharp contrasts of light and shadow that provide the visual equivalent of the drama he felt in the subject. Everything was done to make the group appear as real as possible: the

anatomical rendering is faultless, and the differentiation of textures, such as those of the hair, rock, basket, and angel's wings add to the sense of reality. But the subject is quite unreal: the angel is about to pick up the prophet by a lock of his hair in order to transport him and his basket of food to his fellow prophet Daniel (who occupies a similar niche across the room). As this miracle is about to begin the angel gestures outward, into the viewers' own space and toward the unfortunate Daniel in the lion's den. Everything is very real except for the divine nature of the event.

Baroque sculpture seems to "stir up" the space in which the figures exist, creating the pockets of shadow that produce the pictorial effects discussed in Chapter Five. *Habakkuk* suggests that it also extends its spatial influence beyond the physical confines of the sculpture proper, or its niche or base, into the surrounding space. This

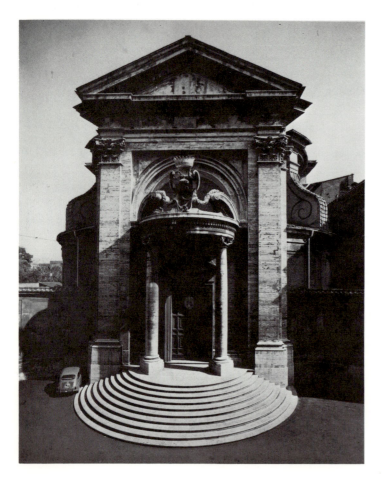

14-3 Gianlorenzo Bernini, Sant' Andrea al Quirinale, Rome, 1658-70.

14-4 Plan of Sant' Andrea al Quirinale.

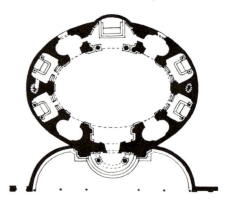

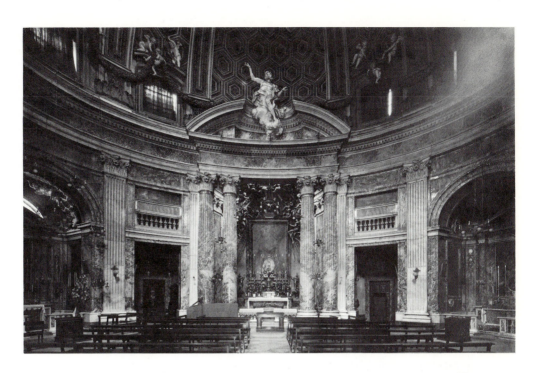

14-5 Interior of Sant'
Andrea al Quirinale.

was felt also in Bernini's kneeling bronze angel (see Fig. 10-8), which hardly seems complete in itself because its forms flow outward, suggesting its connection with other parts of the altar, including a similar angel on the other side. It is quite understandable then that Bernini was also an architect, shaping and controlling the space not only around his sculpture but in whole plazas and churches.

The facade of his small church of Sant' Andrea al Quirinale is made up of forms that are as emphatically worked in three dimensions as the forms in the sculpture (Fig. 14-3). From the main plane of the front of the building there curves outward a semicircular canopy, the shape of which is repeated in the curves of the steps. Reversing these outward curves are the concave wall surfaces that extend the space activated by the building out to the sidewalk of the street itself, welcoming passers-by and extending the light and shadow patterns of the portico proper. On entering, visitors find themselves looking across the short dimension of a simple oval space to the high altar (Fig. 14-4). Since an oval is a shape bounded by graded curves and a circle is bounded by a uniform curve, ovals are relatively more dynamic than circles. In examining another

Baroque church, Santa Maria della Salute (see Fig. 10-6), it was noted that the use of acute and obtuse angles rather than right angles lent a dynamic quality to the plan. The circles and right angles of Renaissance architecture are relatively static by comparison, much as the paintings of Raphael are more static than those of Rubens.

Another characteristic of High Baroque art is the participation of different art forms in a total complex, as in Sant' Andrea. The focal point of this interior is clearly the region of the altar, accented by the paired columns supporting an entablature and by the pediment that breaks forward from the smooth oval of the rest of the room (Fig. 14-5). The climactic point of this tabernacle is occupied by a marble sculpture of St. Andrew ascending heavenward on clouds as the upper cornice of the pediment curves inward to allow his passage. Above the gilded altar itself is a painting of the martyrdom of the saint, and providing a transition from this event to his ascent into heaven are a flight of gilded bronze angels. Hence architecture, sculpture, and painting all participate in this theatrical glorification of the saint. As one might suspect even from a black-and-white photograph, color plays an important role in this complex. Warm-grained mar-

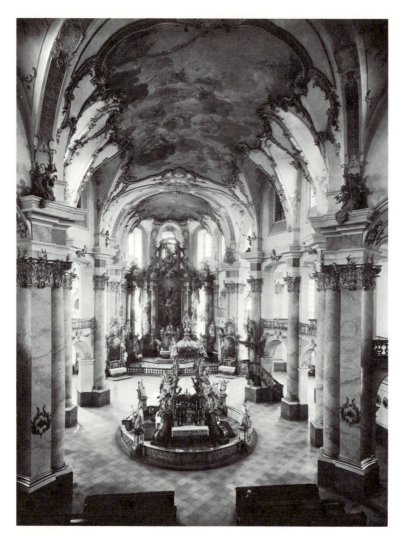

14-7 Plan of the church of Vierzehnheiligen.

14-6 Balthasar Neumann, church of Vierzehnheiligen, Franconia, Germany, 1743-72.

ble of wall surfaces and columns is set off by cool white marble cornices and intricately carved capitals. The saint too is of white marble, which reveals the subtle carving and suggests his ethereal passage into the next world. By contrast the painting of his martyrdom (not by Bernini) is richly colored and placed in a gilded setting.

In many other Baroque churches, ceiling paintings provided the climax—as seen in Andrea Pozzo's *Entrance of St. Ignatius into Paradise* in the church of S. Ignazio, Rome (see Fig. 6-15). Making use of his considerable technical and mathematical skill, the artist continued the perspective effect of the architecture of the real windows—as we see them when we stand in the center of the floor—into the painted architecture

above them. The illusion of real space breaking through the vault of the ceiling is remarkably convincing, and it represents an extreme in the use of theatrical means to convey a religious message in this age of religious fervor.

In architecture itself the most theatrical churches were built in southern Germany and Austria during the following century. Typical of these is the church of Vierzehnheiligen (Fourteen Saints) by Balthasar Neumann (Fig. 14-6). Here the mingling of sculpture and painting with the architectural forms has produced a final burst of Baroque exuberance greater than that of any Italian building. Everything except the floor seems to flow and undulate. As can be seen in the plan (Fig. 14-7), the piers and columns separate from

the general rectangle of the overall shape to create the intersecting ovals of the floor plan and the ceiling vaults. Adding to the florid character of the whole are the vinelike gilded decorations that frame the ceiling painting and edge the intersections of the vaults.

The Baroque in Holland

A surprising difference existed between the art and culture of the northern and southern Netherlands in this period. Separated by a small geographical distance, in matters of religious preference and political structure they had become very different during the sixteenth century. The southern part, which later became Belgium, was Catholic and under the Spanish monarchy. Its greatest artist, Rubens, was employed by church and state and, as we have seen, was a major representative of High Baroque art. The northern part, Holland, emerged as a separate nation when it successfully resisted Spanish attempts at domination during the last part of the sixteenth century. By the mid-seventeenth century it was a wholly independent republic, Protestant for the most part but tolerant of Catholics, English Separatists, and Jews. It was a center of a free economy and by midcentury one of the most prosperous regions in Europe. Since there was no aristocracy and the church bought little art, artists sold their paintings to the members of the middle class. The types of paintings they bought for their homes were portraits, landscapes, genre subjects, and still lifes. Naturalism dominated the manner of painting and again Caravaggio provided a starting point for many artists.

Though there were dozens of excellent painters at work in this great age of Dutch painting, from about 1620 to 1680, we must limit ourselves to a discussion of only a few. Frans Hals, the master of a strikingly new manner of portraiture, was the first major figure to step forward. His *Merry Drinker* (Fig. 14-8) combines portraiture with genre painting. It is certainly a specific individual and at the same time the depiction of an everyday event caught at a particular moment. The latter is superbly done: the pose, the gesture of the hands—one precariously holding a wine

glass—and the fleeting expression of eyes and mouth represent a further step in the Baroque pursuit of reality. Because our eyes see something different in every instant of time, the logical end of visual naturalism must be the rendering of momentary appearance. Hals' particular achievement was discovering how to do this without "freezing" the moment. He was able to suggest the transitoriness of what is seen by avoiding smaller details and specific contours. The impression of the lace collar or of the edge bounding the shoulder and arm on the right is given, though we cannot see either clearly. Boundaries are made up of a series of hatched strokes that depict a general edge but not a specific one. This impressionistic handling also adapts to the rendering of light since, instead of defining a tactile surface, it renders the sheen of light reflected from a surface. This is just the opposite of Holbein's portrait of Thomas More, where surface was more important than light (see Fig. 13-23). The way in which Hals makes us see the whole is by leaving out the parts; when we approach closer to the

14-8 Franz Hals, *The Merry Drinker*, 1627-30. Oil on canvas, 32″ × 26″. Rijksmuseum, Amsterdam.

painting we see no more details but are only conscious of the brushstrokes. The Impressionists of the nineteenth century were to exploit the same means when they also aimed at capturing the momentary.

A hearty good humor radiates from the picture, perfectly expressing the confidence of this society of bourgeoisie. Besides being interested in themselves, the men and women of Holland were fascinated with their environment: their own houses, the neat towns built largely of brick, the flat, moist countryside, and the sea that nearly surrounded them. The best of their landscape painters were able to go beyond mere description and express the larger qualities of nature, as we can see in a painting by Jan van Goyen (Fig. 14-9). It was the new range of perceptions opened by the Baroque vision which made these larger qualities of space and light available to an artist like van Goyen; and he, like Hals and other Dutch artists, contributed in turn to the maturing of this Baroque vision. The luminous, the open, and the flowing are all most evident in a cloud-filled sky, so Dutch landscapists characteristically devoted two-thirds to three-fourths of their

paintings to skies. Their skies, further, seem to suggest all the rest of the sky not shown. The diagonals of the cloud masses tend to carry our attention to the outer boundaries, and beyond. The big gradations which build toward darkness at the top do the same. By crowding the darks in the foreground, van Goyen provided for the widest possible range of values in the sky, hence allowing it to be developed as an important part of the scene. The size of the sky area enhances the illusion of deep horizontal space as well. To experience this, cover the top half of the van Goyen landscape with one hand while focusing on the distant buildings; then remove your hand and sense the apparent increase in the distance to the horizon.

Another characteristic of this and other Dutch landscapes is its restricted color range. The total range of hues and intensities lies within a warm yellow, a brown, and a blue, all of which are of relatively low intensities. The cool colors particularly are close to gray. Such a limitation enhances the unity of feeling one gets from this unimposing bit of countryside and encourages our attention to focus on the suggestion of mov-

14-9 Jan van Goyen, A Windmill by a River, 1642. Oil on panel, 11¾" × 14½". Reproduced by Courtesy of the Trustees of the National Gallery, London.

sixty painted self-portraits and half again as many etchings. If we compare two of these—one painted when he was about twenty-three and the other near the end of his life, at about age sixty—we gain some insight into his development as a person and as an artist. The early one (Fig. 14-10) shows a confident youth wearing an armored breastplate and a white lace-edged collar. The pose and the alert gaze suggest an active engagement with the observer and what seems to be an interest in the world around him. This was in fact true, for during his twenties Rembrandt made hundreds of drawings that testify to the sharpness of his powers of observation. The strongly modeled forms suggest the influence of Caravaggio but the light-to-shadow gradations are more subtle. There is less emphasis on the passing mo-

14-11 Rembrandt, *Self-Portrait, c.* 1660. Oil on canvas, 45" × 37". Kenwood House, London (Iveagh Bequest).

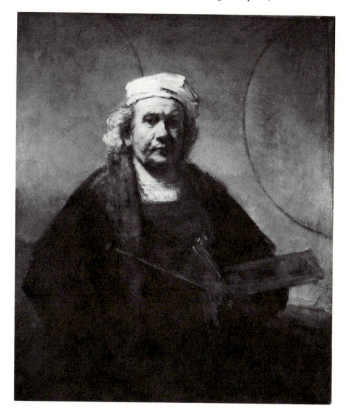

ing air and changing light rather than on separate objects possessing separate local colors.

Dutch painters tended to be specialists: Hals was a portraitist, van Goyen a landscapist, and others did middle-class interiors, or tavern scenes, or ship paintings, or still lifes; but the greatest among Dutch artists was not a specialist at all. Rembrandt van Rijn first became well known as a portrait painter in Amsterdam, but throughout his career he made drawings, etchings, and paintings of people in relation to other people, often of dramatic scenes and always with an extraordinary sense of their interactions. He was exceptional also in that many of these subjects were from the Bible at a time when few other Dutch painters undertook religious subjects. And as a landscapist his drawings, paintings, and etchings are compelling evocations of light and air, of the structure of natural forms and the vastness of spaces.

Rembrandt's portraits are records not only of the appearance of his sitters but of a wide range of psychological states—no other artist has gone so far in suggesting people's inner lives. As he was his own most available model, there are about

ment than in Hals' portrait; Rembrandt's greater interest in personality led him to focus attention on a single luminous area of the face and the adjacent collar and lock of hair. Such singleness of emphasis was common in his art, as it was in other Baroque art. In general this early work captures the artist's personality at this time in life: confident, energetic, alert, and curious about the world.

The later self-portrait (Fig. 14-11) is similarly lighted but the description of surfaces and details has been suppressed in favor of the light itself. The broadly handled paint enhances the tension between the still strong illusion of reality and the physical surface of the picture. But the most striking difference between the early and late work is in the interpretive realm. Instead of the assurance of youth and a pride in material things (armor and lace) the painter now sees himself as a rather saddened man, perhaps slightly quizzical, wearing rough clothes and a painter's cap. Yet there is a simple dignity about the large triangular figure. Our attention turns frequently to his eyes, not because they are emphasized by contrasts but because the play of light and shadow around them is rather indeterminate. The small touches of lights and half-lights intrigue us and we linger over the eyes, attempting to penetrate the shadows to these most expressive of features.

In his drawings and etchings of landscapes Rembrandt was less likely to employ the rather dramatic value contrasts seen in these portraits and more likely to emphasize an all-pervading light. We see this in his drawing, *A House Among Trees on a Canal* (Fig. 14-12). Luminous air exists in and around the trees as the light from the sky seems to enter every area, even the darker shadows. The white paper is left untouched in the foreground where it is the luminous equivalent of the dark foreground of van Goyen's *Windmill by a River*. In both instances there is a foreground of suppressed interest so that we may more easily step into the middle distance where the main subject is located. This threshold into the picture space was common in seventeenth- and eighteenth-century drawing and painting, but most artists used a dark rather than a light foreground. Having entered Rembrandt's picture space, we are held in the relatively closed area of trees and buildings and find ourselves responding to their relation to the ground and, in the trees, to the structure of branches and foliage as they thrust outward and upward. Even the effect of the prevailing wind upon branches constantly swept from the right side of the scene is taken into account. Finally the force of gravity is recorded at the far left where a lower branch succumbs to it, despite the counterforces of growth and wind.

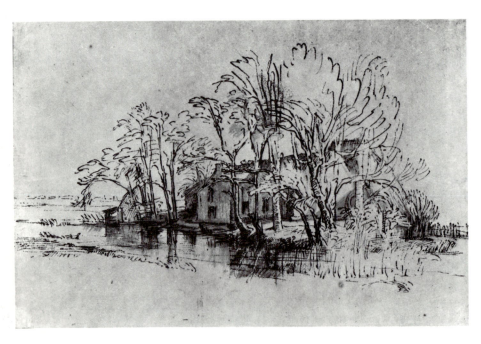

14-12 Rembrandt, *A House Among Trees on a Canal*, 1646. Pen and wash, 6¼″ × 9⅛″. British Museum, London.

The Slaughtered Ox (Color Plate 26) reflects the underlying realism in Rembrandt's art. Bruegel might have represented such a subject but certainly not an Italian artist of the Renaissance or even Rubens. Rembrandt and other Dutch artists made up the most substantial group of realists in the history of art since Roman times. No subject was too humble or too rough for them, and Rembrandt was able to see the beauty in the colors and plastic forms of even a bloody carcass.

Rembrandt was also a highly accomplished graphic artist. During the Renaissance most prints were done by engraving, like Dürer's *Melencolia* (see Fig. 13-22), but by the seventeenth century the newer and easier technique of etching had largely taken its place. Since one can draw on an etching plate with nearly the same freedom as on a piece of paper, it was naturally favored by artists who, like Rembrandt, drew with ease. The range of his contributions to that art can be seen in a comparison of two religious works. His *Entombment* (see Fig. 9-9), with its quiet sentiment and simple lines, reveals a close observation of actual people; these could be Dutch peasants at a country funeral. *The Three Crosses* (see Fig. 7-3) is a re-creation of the crucifixion that makes dramatic use of lights and darks rendered largely with stark patterns of straight lines. He has captured the "darkness over the whole land" and the turmoil among the soldiers and priests as "the earth did quake and the rocks rent" in the moment following Christ's death.

It is clear from these and other examples of his religious art that Rembrandt approached traditional subjects in a fresh manner, based on his own reading of the Bible and with a minimum of dependence on traditional Catholic versions of such scenes. He is the first religious artist we have encountered in this historical section whose background was Protestant.

Jan Vermeer was a more typical Dutch artist than Rembrandt in that his subjects were limited almost entirely to scenes from everyday life. But the dignified quality of domestic life his art evoked is as special as Rembrandt's, if less wide in scope. If we look at his *Girl with a Red Hat* (Color Plate 27), we notice a resemblance to both Hals and Rembrandt: the alert pose of the head and the engagement of the spectator's eyes are characteristic of the work of all three. The half-opened mouth recalls Hals, and the centralized massing of the light as it passes from cloak to collar to cheek is similar to Rembrandt's early self-portrait. Yet there is something about the way Vermeer presents this largely shaded face in the midst of a visual environment of colored areas and rather clear and positive shapes (the background is not simply neutral as the others are) that invites us to view all of the painting and not just the dramatic center. In Chapter Seven there was a reference to the way in which the colorful shadow areas of hat and face and cloak help produce the illusion of light; these same areas help also to make the shadows something to look *at,* so that they become part of a coherent picture surface. In this regard, Vermeer's color is more decorative than Rembrandt's. The background here is a tapestry, seen mostly in shadow with the edges of its pattern slightly fused. While keeping its place in the further plane it still participates in the overall visual interest.

It was earlier observed that the simplification of detail results in a more direct juxtaposition of light and shadow that enhances the illusion of light. Now we can observe Vermeer's method of forming small areas of light into little "beads," such as those in the half-light of the hat and especially on the carved lion heads of the chair. These add to the illusion of light by seeming to bounce off the surface of the chair, hence making the light effect separate from the surface of a form—visible rather than tactile. (One can observe this in nature by looking at a highlight reflecting from a shiny object; we can often feel our eyes having to change focus as we look first at the surface and than at the highlight. Sunlight reflecting off water seems also to detach itself from the water surface.) In Vermeer's case the roundness of these lights no doubt derives from the experiments of the time with light passing through a pinhole into a darkened box which produced effects of little "discs" of light. This so-called "camera obscura" was the ancestor of the photographic camera.

It is tempting to linger over Vermeer's solutions to formal problems because they lend themselves to analysis, but his achievements in the expressive realm are no less noteworthy. "Nothing in excess" could apply as easily to Vermeer as to the Greeks or Raphael. The admirable

thing is that Vermeer expresses the dignity of human beings without resorting to ideal subjects or settings. By and large, upper middle-class Dutch homes are his settings and Dutch housewives his protagonists. In *Lady Writing a Letter* (see Fig. 2-12) the maid who waits for her mistress to finish a letter is dignified by her quiet pose and simple rounded forms. She is detached from the central theme, the woman writing, and yet connected with it, just as she is formally grouped with both the window and the letter writer. The mistress of the house is given emphasis by the act of writing and by the strength of the light striking her. One feels that she is responsible for the domestic order in the house, the visible symbol of which is the formal order of the picture space and the objects it contains.

In comparison with works of the early part of the century Vermeer's scenes are quiet indeed. The period of the High Baroque had run its course in most of Europe by the second half of the seventeenth century, and art had entered a more classical phase—of which Vermeer is a prime representative. Yet the broad style-name Baroque still applies. Certainly there is the concern with naturalism and the illusion of space beyond the picture plane; notice how Vermeer uses the foreground foil of a dark curtain to introduce us into the picture space. And there is the window to the outside world which provides an openness, particularly as our attention tends to follow that of the maid. While the forms have lost the flowing quality of earlier Baroque, the light itself flows across them and, as in the *Girl with a Red Hat,* penetrates the deepest shadows.

The Baroque in Spain

When the philosopher A. N. Whitehead called the seventeenth century "the century of genius" he had in mind men like the scientists Galileo, Newton, and Harvey; the philosophers Descartes and Spinoza; the writers Milton and Molière; and, among painters, those we have been considering plus at least one more: Diego Velázquez. The career of Velázquez is closely identified with his patron, King Philip IV of Spain, whom he served for more than thirty-five years as court portrait-

ist. Among the numerous portraits of the king and his family, the most famous, and justly so, is the one known as *The Maids of Honor* (Fig. 14-13). It is rather similar to paintings by Vermeer in that it presents people in an interior lighted by a single window. But the work is more than ten feet high, while Vermeer always did small pictures. Velázquez's subject is the royal family assembled in a room in the palace. It is an informal grouping of people: apparently the youngest daughter of the king and queen, the Infanta Margarita, has entered the room in which the painter, Velázquez himself, is engaged in painting a portrait of the king and queen, who are seen in the mirror at the back of the room. The infanta is accompanied by two maids of honor, two dwarfs who are her companions, and a dog. The cast of eleven is completed by two figures in the shadows and a man, possibly the major-domo of the palace, seen against the light of the doorway. All the poses are transitory, conveying a sense of the moment, and the details are handled in a highly impressionistic manner (Color Plate 28). There is even less of a form-defining function in Velázquez's amorphous brushstrokes than in those of Hals—we are not even able to count the buttons on the infanta's dress—so that our attention is diverted even more toward light as the real "stuff" of which the image is composed. The sense of space relies upon such decisions as the light-shadow-light alternation from front plane to back; the size of the emptiness in the upper part of the room (compare van Goyen's empty sky); and in the control of color contrast and intensities which we can see, in part, in our color plate. The red bows in the foreground are more intense than those further back, and the hands-in-light hold their place clearly in front of the hands-in-shadow.

In this casual incident from everyday life Velázquez avoided the more geometric composing favored by his chief mentors, Titian and Rubens. His one concession is the symmetrical placing of the rectangles of mirror and doorway either side of the central axis. A nice tension is set up between the intriguing mistiness of the royal faces in the mirror and the sharp visual contrast of the man in the doorway. Besides being different but equal in visual attraction, the two rectangles juxtapose spatial extremes either

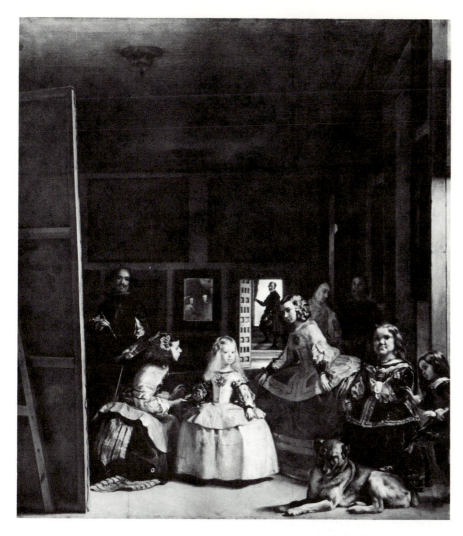

14-13 Diego Velázquez, *The Maids of Honor*, 1656. Oil on canvas, 10'5" × 9'. Prado, Madrid.

side of the picture plane: the doorway is the deepest point within the picture space while the mirror images refer us back to our own position on this side of the imagined picture plane. While the psychological realm is wholly different from that of a High Baroque artist like Bernini, both artists managed to incorporate the spectator into the work of art.

Baroque Classicism in France

We have seen that the composition and quiet mood of Vermeer's art generate a kind of classical feeling, and that classical subjects were important to Rubens and a number of other Baroque paint-

ers. It was in the work of two French artists, however, that the subjects and mood of classicism were most strongly united: Nicholas Poussin and Claude Lorraine. Both took up residence in Rome, where they were influenced by ancient art as well as by the serenity of the surrounding countryside. We can see that the self-contained poses of the figures in Poussin's painting, *The Inspiration of the Poet* (see Fig. 3-2), are akin to those of Raphael and that the lighting owes more to Titian than to Caravaggio. The ideal world definitely wins out over the real. It takes rather conscious observation to recognize a somewhat Baroque character in the large shadow area that connects the muse to Apollo and Apollo in turn to the poet. The painting belongs to the seven-

teenth century almost by default—the continuity of shadow and some naturalistic light on the muse and on the poet's face do not quite belong in the Renaissance. Because of the strength of Poussin's personality as an artist his classicism took hold, particularly in France. His classical principles of composition and of drawing (idealized figures in contrapposto poses) were eminently teachable at a time when the strongly centralized French monarchy was discovering the propaganda power of art. A follower of Poussin, Charles Le Brun, actually codified facial expressions to match the rigid formal "requirements" of good painting and organized a small army of artists to work for the young king, Louis XIV. In 1648 he established the Royal Academy of Painting and Sculpture, with the result that only those artists trained in the academic tradition were able to receive major commissions. A dictatorship of art parallel to Louis' political dictatorship prevailed in the last third of the seventeenth century in France.

Yet not all painters accepted the principles of classicism. At the end of the seventeenth century a number of French artists preferred the greater sensuous richness of Rubens to the academic classicism of Poussin. The rallying cry of the so-called "Rubénistes" was *color*, while that of the "Poussinistes" was *drawing*. The opposition between these two recalls the differences in the Renaissance between a Florentine emphasis on drawing and a Venetian emphasis on color. Usually a preference for drawing is combined with a classical ordering of the composition as well, while a preference for color tends to mean a favoring of a pictorial approach to representation. We shall find parallel oppositions in French art of the early nineteenth century.

A contemporary of Poussin, Claude Lorraine was the major representative of landscape painting in the classical vein. His imaginary scenes, a typical example of which is the *Marriage of Isaac and Rebecca* (Fig. 14-14), provided landscape painters of the next century and a half with an alternate model to northern landscape. While Dutch landscape art of the time was based on the more dynamic aspects of nature—dramatic sunlight, and wind-driven clouds, as in van Goyen—Claude's landscapes are serene and placid, an ideal physical setting for humanity. There are always people in his scenes, usually out of the classical or biblical past, as here, but the main theme is a benign nature's grand expanse. It is in this expansiveness, or openness, that the Baroque

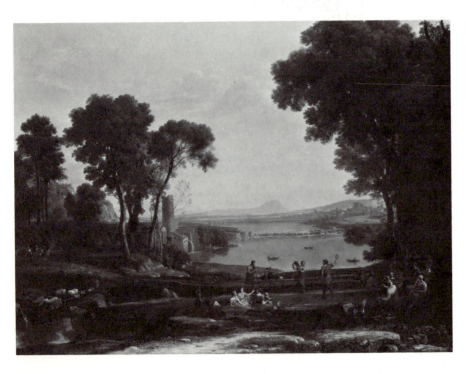

14-14 Claude Lorraine, *The Marriage of Isaac and Rebecca*, 1642. Oil on canvas, approx. 59″ × 77″. Reproduced by Courtesy of the Trustees of the National Gallery, London.

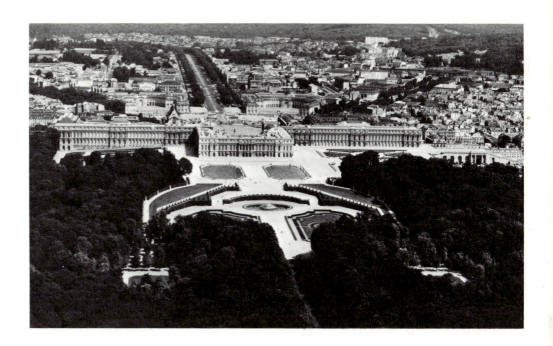

14-15 Louis Le Vau, Jules Hardouin-Mansart, and André Le Nôtre, palace and gardens of Versailles, 1669-85.

character of his art is felt. We move into this picture space toward an infinite distance. A classical order governs how we move into space: insistent parallels to the picture plane occur in foreground, middle ground, and distance; a large-scale alternation or zigzag leads from right foreground to the left middle ground to right distance; and the sweeping curve of the river unites all planes in a single, emphasized recession.

The other Baroque characteristic of Claude's art is its luminosity. As was noted earlier, his crowding of the darks helps the illusion of light in the sky. Looking closely, we can see that this light diffuses through the atmosphere, not only filling the distance with luminous air but affecting the nearer planes as well. The middle distance with its waterfalls, buildings, tower, and round classical temple (there is almost always a classical temple in his landscapes) is still in the misty glow, which is incidentally tinted by warm sunlight. The mist extends as far forward as the smaller tree in the right-hand clump and even lightens the edges of the foliage of the large, foreground tree. So the atmosphere acts to unify the space coloristically as the sweep of the river does in its more measurable terms.

Claude's foliage masses have little of the disorder of nature. They are assembled in hierarchies of large, medium, and small, in an orderly,

yet varied way. The units of which they are composed are brushstrokes, which we readily accept as individual leaves, ordered into regular sequences. This was a vocabulary of foliage forms taken over by Claude from Titian, among others, and incorporated into his total vision of nature. In the *Concert Champêtre* (see Fig. 9-10) similar regular foliage masses are built up from "scalloped" strokes, but they are composed into more closed Renaissance forms. Nor are their edges invaded by a pervasive mist as those of Claude's are.

Followers of Claude in France, England, and even Holland employed all the means outlined here, with modifications resulting from either different subjects or different temperaments. They were usually identified as "Italianate" to differentiate them from followers of the Dutch tradition.

Within the seventeenth century it remains for us briefly to suggest a kind of classicism in architecture parallel to classical painting. Again France was the center of this tradition, which developed as an alternative to the High Baroque during the second half of the century. In the environment of the court of Louis XIV, building had to be on a large scale, not unusual in Baroque times, but it also had to satisfy the growing taste for the classical. At the palace and gardens of Versailles both

demands were met in the architectural design of Louis Le Vau and the landscape design of André Le Nôtre. An aerial view conveys some sense of the gigantic scale and the geometric order of this complex (Fig. 14-15). The form of the building is governed by large, rectangular blocks and long, continuous horizontals. A closer view would reveal strong projections, a clustering of columns and pilasters, and a skyline broken by statues, all Baroque characteristics. But most typical of the Baroque is the bold design of the space, especially in the gardens, only a portion of which is visible here. Alleys of trees create large axes that pattern the space (the central one extends in a straight line for more than two miles). Such a breathtaking layout and the elaborate display of gardens it incorporates were intended, of course, to add to the glory of Louis, the self-styled Sun King. It has remained as the most grandiose design of architectural spaces in an age in which this was a specialty.

The Eighteenth Century: The Rococo

Bigness began to wear thin among many people of taste toward the end of Louis' reign (he died in 1715). The aristocracy no longer flocked to the large, cold rooms of Versailles but preferred instead to assemble for intimate social occasions in Parisian houses and apartments. As often, it was a major artist who first gave expression to the new taste for the intimate: Antoine Watteau. Most of his paintings are small in size and gentle in feeling. His favorite subjects were young couples, amorous in mood, who would wander rather aimlessly in informal parklike settings, engage in conversation, or listen to music; we see them in his *Fête d'Amour* (Fig. 14-16). They are less serious and classical than Poussin's allegorical figures, not so lusty as those of Rubens. They wear fashionable contemporary costumes and they seem at home in a natural environment in which the trees are slender and swaying, like the girls, and the foliage is drawn with the same deftness of touch found in satin dresses. The world of courtship, music, and refined manners which

Watteau created had an immediate appeal to the Parisians of his day.

The style that evolved out of Watteau's art in the early eighteenth century came to be called Rococo, partly a play on the word Baroque. It is commonly thought of as a style primarily of decoration, but Watteau's paintings are far more than that. They are spatially rich and filled with convincing air and light derived from his study of Rubens as well as of nature. He did many drawings from Rubens' paintings, but Rubens' figures are more robust and the modeling is stronger—they are emphatically Baroque—while Watteau's figures are more lithe and modeled with staccato touches of color. One could say the same of the trees here as compared with Rubens' trees in the *Return from the Field* (see Fig. 9-18). Watteau suppressed the heavy power of the Baroque in order to attain feelings of refinement that had moved into a new position of importance.

Yet there is nothing weak about Watteau's drawing. In the animated drawing of a guitar player (Fig. 14-17) we find an unsurpassed surety and firmness of touch as well as the convincing feeling of space noted in Chapter Seven. The deftness of execution and the rather exhilarating foreshortening, such as in the guitarist's hands, is also found in the work of other Rococo masters—though none accomplished so much with such economy of means. A kind of effortless performance is evident not only among painters and sculptors in the eighteenth century but among the craftsmen as well. A section of wooden paneling from the period of Louis XV (Fig. 14-18) points up the quality of craftsmanship at this time. The artisan followed the designer's directions, not only for the two-dimensional patterns of shapes but also for the three-dimensional swelling of the surface of the panel and the variations from flatter to fuller relief of the carvings on this surface. It is no wonder that the graceful, animated shapes of Rococo art are often compared with the grace and animation felt in the music of Mozart. However, not many artists of the period possessed the genius of Watteau or Mozart that enabled them to inject a serious (but not somber) content into such ingratiating forms.

Rococo taste continued into the last quarter of the century, as can be seen in a terra cotta sculp-

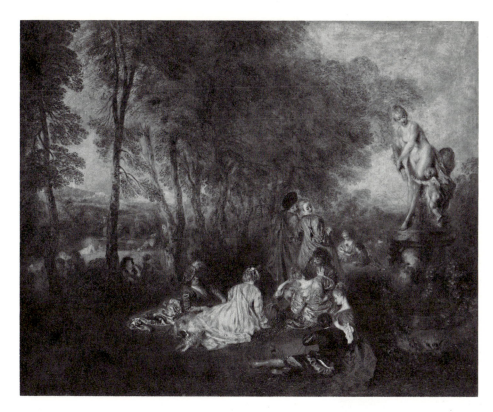

14-16 Antoine Watteau,
La Fête d'Amour, c. 1609.
Oil on canvas, 24″ × 29½″.
Dresden Museum.

14-17 Antoine Watteau, *Studies of a Guitar Player*, c. 1609.
Three-color chalk drawing, 9⅞″ × 15⅛″. British Museum, London.

14-18 Panel from the Louis XV period, designed by Nicolas Pineau.
Sauvage Collection, France.

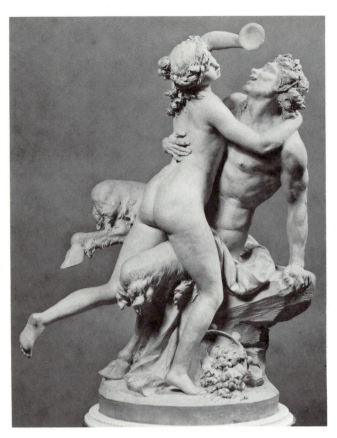

14-19 Clodion, *Satyr and Bacchante*, c. 1775. Terra cotta, 23″ high. The Metropolitan Museum of Art, New York (Bequest of Benjamin Altman, 1913).

The Eighteenth Century in Venice

In Italy during the eighteenth century the most ambitious decorative paintings were being done on ceilings. In viewing Andrea Pozzo's work of the previous century, the observer was supposed to stand in the middle of the floor and look directly up, but in viewing the ceiling paintings of the Venetian eighteenth-century master, Giambattista Tiepolo, the observer is given a better break. In the church of the Gesuati in Venice (Fig. 14-20), the observer is already at the station point upon entering the church and thus sees the correct perspective effect with much less strain on the neck. The subject is St. Dominic instituting the rosary, which is held in his hand and is the center of attention. The staging of the event is planned for this angle of viewing, for as heretics tumble out of the bottom our attention moves upward and into the picture space.

For such large-scale fresco paintings Tiepolo made oil studies like Color Plate 29. This is a study for a fresco that decorates a room in the Royal Palace, Madrid. It depicts the *Apotheosis of Aeneas,* the story of which was outlined in Chapter Three. As in *St. Dominic,* the clustering of figures near the lower part of the picture makes it unnecessary to look sharply upward, since the upper sections, more directly overhead, are largely sky and demand less attention. Observing Tiepolo's work in the context of the period and its style we notice that he has retained more of the vigor of Baroque art than his French contemporaries. In the *Aeneas* the lower figures that symbolize war are angular and heavily modeled with shadows that approach black. After passing the figure of Time in our progression upward, the shadows become lighter and more colorful. In the next plane, where Venus and her company are shown, the shadows are much paler and quite intense in color. So with his color the artist has suggested not only that a recession up and back into space is occurring, but that we are moving from a terrestrial to an ethereal realm as the hero takes his place among the gods.

While there are more Baroque qualities in Tiepolo's art than in that of the French Rococo, both share a preference for a stagelike recession of rather flattened planes as opposed to the diag-

ture by Clodion (Fig. 14-19). This erotic sculpture, designed for an intimate Rococo setting, is small in scale, like most of the paintings. Executed in a medium that requires finishing with the fingers, it conveys a sense of the artist's direct contact that adds to the feeling of intimacy. Such manipulation also increases the pictorial effect by the rippling surfaces it produces, not only in the details of hair and the grapes on the base of the sculpture but on the larger passages of flesh as well. The strong sensuality evident here is common in developed Rococo art and reveals, by contrast, the refinement in Watteau's treatment of sexual love. It was the relatively shallow character of Rococo subject matter that hastened the reaction against it, much as the pleasure-loving behavior of the aristocracy hastened its demise in the revolution that occurred at the end of the century.

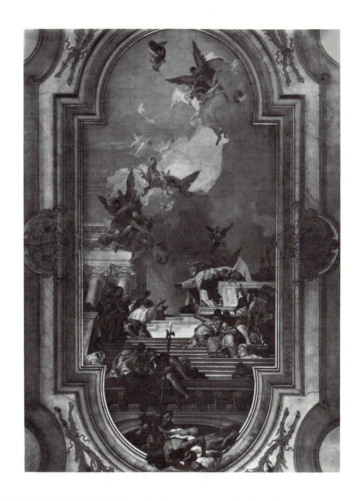

14-20 Giambattista Tiepolo, *St. Dominic Instituting the Rosary*, 1737-39. Ceiling fresco, church of the Gesuati, Venice.

onal thrusts into space found in Baroque art. One senses a kind of thinning out of the formal richness of Baroque art, and of the richness of the content as well. Tiepolo's people have the same rather limited emotional range whether they are enacting a religious or a mythological drama. The imagination involved presents more that is "fanciful" than what is real. In the reality of emotional life there are many nuances of feeling that are simply not incorporated in the paintings of Tiepolo or the sculpture of Clodion, where mythology seems to replace reality.

Among the other artists at work in Venice, Giovanni Battista Piranesi explored a new imaginary realm in a series of etchings of immense interiors of prisons (see Fig. 6-16). The few figures in these are also devoid of recognizable emotions although their extravagant poses and gestures link them in feeling with the extravagant architecture. Again it is an imagination directed by fancy. Based more on nature are the views of Venice that were produced in quantity by artists like Francesco Guardi. The light in his *View of the Dogana, Venice* (Fig. 14-21), as it reflects from

14-21 Francesco Guardi, *View of the Dogana, Venice, c.* 1750. Oil on canvas. Wallace Collection, London.

sails, boatmen, and water, has some of the same scintillating quality that we saw in Watteau's highlighted dresses. Space is effectively expressed by the distribution of boats across the water surface and by departures from literalism in the perspective. Deft touches of the brush add up to a sparkling and animated effect which links Guardi with the decorative spirit of Rococo. The way in which his rendering of light and space incorporates a decorative touch can be seen even more clearly in one of his drawings (see Fig. 7-18). No wonder he occasionally broke away from painting "views" to produce small and purely imaginative landscapes.

The Rational in Eighteenth-Century Art

There was a phase of eighteenth-century painting and sculpture that was dedicated more to fact than to fancy. At the height of the Rococo in France a painter named Jean Siméon Chardin chose not to paint fashionable people or mythologies but rather simple domestic subjects. His still-life paintings were among his most important

works (Fig. 14-22). The Dutch had painted still lifes frequently, but they usually preferred to study quite elaborate objects such as dead game birds that invited a display of the artist's skill in reproducing textures. Chardin also painted dead game but some of his most appealing works to modern viewers are like the one illustrated here. Simple kitchen objects, suggestive of the middle-class families that might have used them, are grouped in such a way that the dominant mass of the copper kettle, bowl, and onions is set into a subtly balanced relationship with the mortar and pestle at the left and the knife on the right. The table edge establishes the front plane of a spatial design that is equally orderly. What artists of later periods (right up to the present) particularly admired in Chardin's work was the importance of the very quality of the paint. Its richly textured "matter" is felt in every part of the picture, contradicting the strong illusion of forms in space by the undeniable object-nature of the painting itself. Somehow the simplicity and the consistency of the whole invite a contemplative attitude on the part of the viewer.

The sculptor Jean Antoine Houdon carried the concern with fact rather than fancy into portrait

14-22 Jean Siméon Chardin, *Still Life with Mortar and Pestle*, c. 1760. Oil on panel, 6¾″ × 8″. Musée Cognacq-Jay, Paris.

sculpture. His French and American patrons were wise enough to commission him to do such important figures of the later eighteenth century as Voltaire, Jefferson, Washington, and Lafayette. The plaster bust of Lafayette (see Fig. 5-7) has already been discussed as a characteristic example of pictorial sculpture. Particularly effective in giving emphasis to light are the slurred-over surfaces that fuse parts together, such as in the passage from hair to brow. Some of the animation of Rococo art is felt in the pose and the seemingly active ruffled shirt front, but a respect for fact, for truth of likeness, links Houdon even more with the rational side of eighteenth-century art. Reason exerted its appeal in almost every realm of human endeavor during this period, which came to be known as the Enlightenment. Enlightened thinking led to further scientific advances, to the questioning of superstition and of traditional religion, and to a belief that a more perfect world could be achieved through reason. In the political realm it was held unreasonable for the French monarchy to have so much control over people's lives or for Britain to repress the freedom of its citizens in the American colonies. Hence enlightenment led to revolution in order to throw off such an "artificial" social order. Nature, on the other hand, was linked with reason and with freedom. In the first sentence of the American Declaration of Independence Jefferson wrote of the necessity of one people assuming "the separate and equal station to which the Laws of Nature and of Nature's God entitle them." To the artists of the time the naturalism of Chardin's compositions and Houdon's likenesses seemed reasonable. It was appropriate that some of Houdon's best portraits are of men like Lafayette, who devoted so much of their lives to the fight for freedom.

In America itself a native art of significance was beginning to appear and it too was marked by a strong sense of fact. In the first place it was an art of portraiture, based on European models in general but, in the hands of the finest American painter of pre-Revolutionary times, John Singleton Copley, it had already acquired a no-non-

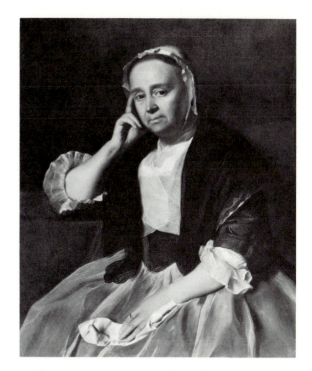

14-23 John Singleton Copley, *Mrs. Nathaniel Appleton*, 1763. Oil on canvas, 35⅝″ × 29⅛″. Harvard University, Portrait Collection, Cambridge, Massachusetts.

sense naturalism. Mrs. Nathaniel Appleton (Fig. 14-23) looks out of the picture at us matter-of-factly, seeming a bit dubious of the value of spending her time posing for her picture instead of doing more practical things. Copley defined every surface so that its tactile quality is perceived, whereas any eighteenth-century European painter would have given more attention to the handling of his brush. Yet the pictorial liveliness of the edges of the bonnet or the sleeves indicates his relation to the European tradition we have been considering. Much American painting from this time forward was derived closely from the European and, like Copley's, incorporated an attention to fact that seems to reflect a pragmatic outlook. One is tempted to relate this to the great American political experiment in which ideas generated in Europe were given their first pragmatic test in the American republic.

15
The Modern World: The Nineteenth Century

The modern world was ushered in by revolutions. The American Revolution was followed after fourteen years by the French Revolution, and both were brought about by the desire of the people to govern themselves. As noted in the previous chapter, it was considered natural and reasonable that this should be so, but nature and reality did not accomplish this automatically; acts of will and sacrifice were required.

Artists were striving for new ways to express ideas called forth by the seriousness of the times, and their decisions required strong acts of will. A break from the immediate past was the first requirement. This meant turning away from the more elegant ideas and forms of the Rococo and also from the quiet naturalism of artists like Chardin and Houdon, who showed a limited interest in challenging ideas. Largely because of its associations with courts and kings, the Rococo style was universally disdained by those artists who reached artistic maturity in the last quarter of the eighteenth century.

No artist illustrates better the sharpness of the break from the past in this period than Francisco Goya, who was born in Spain in 1746. If we were to follow Goya's career all the way from his early Rococo-like work (which was strongly influenced by Tiepolo, who lived in Spain in the 1770s) to his late works, we would witness the evolution of an artist whose work still seems quite modern. His art grew more serious and became less decorative as he came to express his ideas and feelings more directly. One reason for his increasing seriousness was that Spain became involved in a war with Napoleon in the year 1808. The Spanish people resisted the tyranny of Bonaparte's brother (the weak king having already submitted to it) and fought the French mercenaries in the streets of Madrid and in the countryside, before suffering the fate that Goya has commemorated in his painting entitled *May 3, 1808* (Fig. 15–1). In this large painting Spanish guerrillas are shown being executed at night on the outskirts of Madrid. The inhumanity of the executioners is expressed by the mechanical shapes of their hats and their leveled guns. The seventeenth century had tended to glorify war; the eighteenth century either ignored it or referred to it in the remote allegorical way seen in Tiepolo's *Aeneas;* Goya

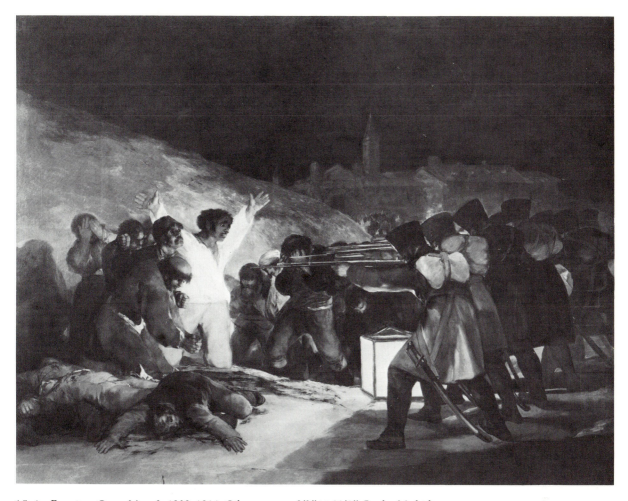

15–1 Francisco Goya, *May, 3, 1808,* 1814. Oil on canvas, 8′9″ × 11′4″. Prado, Madrid.

15–2 Francisco Goya, *Nor This Time* [*Does One Know Why?*], from *The Disasters of War* series, c. 1810–14. Etching and aquatint, trial proof, 6″ × 8⅛″. Courtesy, Museum of Fine Arts, Boston.

was the first to see it for the horror that it is and to depict it in its full inhumanity and without heroes. Goya made drawings during the actual fighting, so that there is a topical immediacy about this painting even though it was not done until a decade later. The same reality is also felt in the many etchings Goya published later under the title *The Disasters of War* (Fig. 15-2).

In *May 3, 1808* Goya not only left the Rococo far behind, he also turned away from Renaissance and Baroque devices. Many of the forms—particularly the executioners—are treated as

nearly flat shapes. The poses of the victims are presented in an almost summary way, without the articulated joints that Tiepolo or any other immediate predecessor would have given them. This simplified directness, like the stark shapes of the executioners, focuses our attention on the grim message itself. As if to record his responses to the event with an appropriate immediacy he painted in a broad manner—for instance, slurring over details in the clothing of the victims. This enhances the feeling of glaring light thrown by the square lantern on the ground—an adaptation of the impressionistic handling he had learned from studying and copying the work of Velázquez.

Neoclassicism

Jacques Louis David led a very different kind of struggle against the Rococo in France. Unlike Goya, he inspired numerous followers who found his style convenient to imitate. David encouraged this because he believed that the new approach was capable of expressing important truths. When he achieved a position of political power in the 1790s, he officially killed off the old Royal Academy and founded one of his own, the Institute of Fine Arts, that was soon to be put to the service of the state much as the old one had been.

David's stern style, known as Neoclassicism, had two sources: his conviction that painting had serious tasks to perform (that artists should address the moral issues of the day) and his adoption of the forms of classicism and subjects from ancient Greece and Rome. In the years leading up to the outbreak of the French Revolution in 1789 David executed several paintings dealing with great moral decisions in antiquity. Each had a tragic theme—people dying for a cause—and the relevance of these themes to the imminent fight for freedom was not lost on the French public. In one of these strong moral statements, *The Death of Socrates* (Fig. 15-3), the Greek philosopher is about to be executed with poison. As he accepts the cup from an anguished disciple, he declares, rather melodramatically, his faith in truth and the rightness of his cause: namely, to teach the truth. Other of David's paintings at this time proclaimed such themes as the necessity of combat and death in the fight for one's country. It is therefore not surprising to learn that David himself was a revolutionary and even a member of the Convention that voted for the beheading of the king and queen.

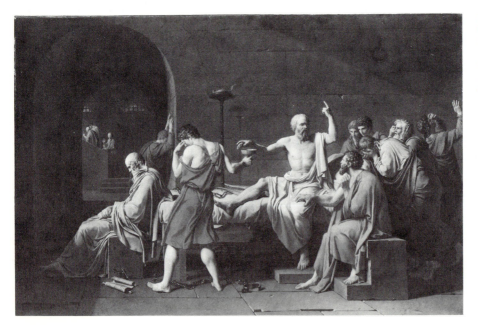

15-3 Jacques Louis David, *The Death of Socrates*, 1787. Oil on canvas, 51″ × 77¼″. Metropolitan Museum of Art, New York (Wolfe Fund, 1931).

Neoclassicism is different from the classicism of earlier artists—the Greeks themselves, Raphael, or Poussin—largely because the vision is basically naturalistic. Beneath the careful ordering of parts in *The Death of Socrates* is a very literal rendering of each figure and his drapery. In looking at Raphael's *Madonna of the Meadow* group (see Fig. 13-17) we do not have the sense of observing models posed in a studio light that we do here. When the young David was in Rome, he looked closely at the work of Caravaggio as well as that of the ancients (see Color Plate 25). Perhaps sensing the living presence of the figures was in David's mind essential to conveying the idea of the relevance of his themes to the here and now. Whether or not this was a conscious intent, the fact is that fidelity to natural vision was to be one of the strongest generative ideas of nineteenth-century art; and David was of his time. Raphael's representation leaned toward the sculptural while David's, despite the clear modeling of separate forms, was basically visual.

The principles of classical composition are very successfully followed here, with a sensitivity to relationships that raises David to a level above any other Neoclassic artist. In the space of the *Socrates* the planes of the furniture and the walls step firmly back with a strict parallelism that is echoed in the several profile figures and the frontally posed Socrates. The swiveling figure of the young man handing the poison to Socrates focuses attention on this key act. Groups of figures form into interlocking triangles and rectangles so that we are directed from part to part in a controlled way. And yet the essence of classicism, the suppression of the particular in favor of the general and the serene and restrained interpretation of human feeling, which was so perfectly embodied in the Greek relief of Hegeso (see Fig. 3-7), is in the end missing from David's art. This is because his commitment to the specific, the momentary, and the unrestrained expression of emotion, which are all antipathetic to true classicism, is too strong.

It is important to recognize the degree to which Neoclassicism dominated art and taste in the late eighteenth and early nineteenth century. In sculpture, the grip of classicism lasted to the middle of the century, possibly because so many

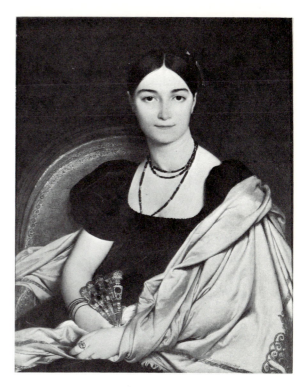

15-4 Jean-Auguste-Dominique Ingres, *Madame Devauçay*, 1807. Oil on canvas, 30″ × 23¼″. Musée Condé, Chantilly.

models remained from the ancient world. Because of the same problem noted with David—the incompatibility of classical feeling and an interest in the specific, the naturalistic, and the sentimental—most of this white marble sculpture has held little interest for us since it fell from favor.

A pupil of David, the painter Jean-Auguste-Dominique Ingres, continued the Neoclassical tradition in France and took over his teacher's role as the leading representative of the Institute and its Academy of Fine Arts. In the latter role he had a profound influence on the training of young artists, who were made to spend long hours copying casts from antique sculpture in order to learn about the perfection of the human form as the ancients saw it. Ingres himself was one of the most gifted draftsmen of the century; his fine pencil drawings combine ideal classical forms with intensely observed details. This combination was transferred to his painted portraits such as that of Madame Devauçay (Fig. 15-4). Literal rendering of textures of cloth and flesh

suggests the Neoclassical conflict between the ideal and the real, but the order of the symmetrical face and the dominance of the perfected curves, as seen in the continuation of the circular arc of the chair in her shoulder, give a strong stamp of ideal beauty to this portrait. The preference for a near pattern-like linearism in many places is Ingres' own.

Romanticism

A cult of ideal beauty did not remain dominant for long in French painting. An opposing trend soon began to rival Neoclassicism—Romanticism, the cult of feeling. While Neoclassicism maintained that the contemplation of perfected form was a purifying and elevating experience, Romanticism held that the most rewarding moments of life were those of vivid emotional experiences. Discipline, control, and order were replaced in the Romantic scheme of values by stimulation, excitement, and even abandon. The two movements had something in common besides their rejection of Rococo values; both went outside their own culture to find sources for the kinds of ideas espoused—the Neoclassicists to ancient Greece and Rome and the Romantics to the Middle Ages and the exotic civilizations of the Near East.

No painter illustrates better the Romantic dedication to feeling and emotion than Eugène Delacroix, the archrival of Ingres. Paralleling the conflict at the end of the seventeenth century between the Poussinistes and the Rubénistes, these two artists represented opposing aesthetic camps. Ingres was for precision in drawing and for classical order and clarity in all aspects of design, and favored subjects taken from antiquity. Delacroix was for freedom of execution and for pictorial and coloristic richness, and favored subjects from the Middle Ages. He also got many ideas from his older contemporaries among Romantic writers, particularly from the poems of Lord Byron and the novels of Sir Walter Scott. It was from *Ivanhoe* that he took the subject of *The Abduction of Rebecca* (Color Plate 30). The event is depicted at the height of the excitement and action. Against the background of a burning castle the Knight Templar in a white robe rushes up the hill and directs his henchmen in the abduction of the fainting Rebecca. Each incident in the painting is a separate climax. The poses of the two Saracens who lift Rebecca are so contorted that they are hardly credible. Compared to the discrete actions of each figure in David's *Socrates* these figures can hardly be separated from each other. Flowing movement passes from one to the other and back into the heaving landscape and curling smoke and flames. All this reminds us of Rubens, and the Baroque artist was indeed one of Delacroix's chief sources of ideas. He also copied Venetian paintings, as we might guess from the pictorial interplay of light, dark, and color. But if we follow the ribbons of whites and reds in this painting we sense that Delacroix, like Goya, was more concerned with a two-dimensional flattening of form than his predecessors; certainly we do not find the spatial thrusts of Baroque art here. Even in his *Lion Hunt* (see Fig. 3-6) there is relatively little depth evoked in comparison with a painting by Rubens. Delacroix's innovations consist partly in this surface emphasis and partly in the use of broken color (seen particularly on the horse's flank). These were qualities that artists of the Impressionist generation were to admire in him.

Another quality that non-academic artists admired was Delacroix's independence from the Academy and its limited vision of what art should be. In the minds of the independent artists of the next two generations, academic art, with its emphasis on literal naturalism, detailed finish, and "noble" subject matter, was the enemy. For his generation Delacroix was the one who stood up against this enemy and gave heart to those who were to do the same later in the century.

Not all Romantic painters relied on the distant past or exotic lands for stimulation. This was also a period in which artists discovered that significant emotional experiences were to be found in landscape and the moods of nature. The English artist J.M.W. Turner combined such a Romantic approach to landscape with an intense study of the natural world. He sought out breath-taking aspects of nature—vast spaces and a grandeur of terrain, intense lights and gloomy darks, storms

15-5 Joseph M. W. Turner, *The Crook of the Lune*, 1816-18. Watercolor, 11″ × 16¼″. Courtauld Institute Galleries, London.

and high seas, and many other extreme states in the world of nature which produce wonder or fear in the observer.

One of the things that distinguished Turner from the many other Romatic artists was his understanding of the structure of natural forms. *The Crook of the Lune* (Fig. 15-5) is—among many other things—an analytical study of hills; the painting uncovers for us their geologic structure. This understanding so impressed the leading English art critic of the day, John Ruskin, that he devoted a whole volume of his five-volume *Modern Painters* to Turner's understanding of rocks and mountains. A good portion of another volume deals with Turner's ability to capture the varieties of natural light. He clearly learned a great deal from the artists of earlier centuries, particularly the Baroque masters of Holland and the Frenchman Claude Lorraine. The crowding of darks and lights that we saw in the works of

Claude and Rembrandt in Chapter Seven were carried to even greater extremes in Turner's works. *The Crook of the Lune* is dominated by light, the contrast among light values being minimized and the dark foreground used to make more evident the crowded lights of the atmospheric distance. In the *Snowstorm in the Val D'Aosta* (see Fig. 9-16) the darks are crowded to create the frightening effect of an Alpine storm and the avalanche it caused. By having few transitional values between the dominant darks and the few areas of glinting sunlight Turner suggested the wide range of nature's contrasts—and their appalling effect on the observer.

Baroque means of spatial illusion are also evident in both these paintings in their sweeping curves and thrusting diagonals; so is Baroque pictorialism. But in the Romantic painter we find a greater subjectivism, or relating of the scene or event to the emotions of the observer, than in

15-6 Camille Corot, *The Bridge at Narni*, 1826. Oil on canvas, 14⅛″ × 19⅝″. Louvre, Paris.

the Baroque painters. This can be achieved not only by the multiplication of climaxes, as with Delacroix, but by placing the observer at a uniquely elevated viewpoint as in *The Crook of the Lune,* or by virtually engulfing the viewpoint in the fury of the storm and the falling rocks as in the *Val d'Aosta.*

Realism

In the discussion of Caravaggio in the last chapter a distinction was made between realism and naturalism as descriptive terms. Realism was said to apply to subjects or themes of art, in particular to those from everyday life or to unpleasant but real events. Naturalism was said to refer to the fidelity with which the visual world was represented. These distinctions are useful in discussing nineteenth-century art as well. Goya was a realist when he depicted war the way it really was while Turner was naturalistic in his description of nature in *The Crook of the Lune,* even though his underlying attitude was romantic.

The movement that came to be known as Realism attracted many artists who reacted against the unreality of Neoclassicism and Romanticism.

These usually dealt with events from the past, while Realism focused on the present. Realism is the opposite of idealism, and both classicism and romanticism preferred ideal situations—even Turner's depiction of nature in its exceptional rather than its everyday moods suggests an ideated, or ideal, condition. This is particularly obvious if we compare his work to that of Camille Corot, a French painter who had been producing gentle, naturalistic landscapes as early as the late 1820s. His small pictures were done out-of-doors, a novel manner of working at that time. *The Bridge at Narni* (Fig. 15-6) avoids Romantic subjectivism and dispenses with such devices as a darkened foreground or an uninterrupted recession into the distance that were important to Turner. While the diagonal of the stream leads into the picture space, it is stopped by the parallel of the ruined aqueduct, and from then on depth is defined by a series of parallels to the final ridge of the hills. This is more of a classical ordering of space, influenced partly by the Italian landscape and partly by the work of earlier classical landscapists like Claude Lorraine. But Corot did not use Claude's arbitrary shadows to provide steps into the distance; he relied more on crisply differentiated edges of planes and on refined color

distinctions based on reduced contrasts from foreground on back. The foreground is slurred over to allow our attention to move to subsequent planes. Instead of details there is the sense of the paint itself and of brushstrokes left boldly unfinished, a treatment that looks forward to modern practice. Like Vermeer before him, Corot's visual mode of painting crowds neither lights nor darks but transcribes in a proportional way the values of nature into paint. Light is his chief medium; it divides forms such as those of the foreground bushes or the aqueduct into blocky lights and shadows, and it produces an interaction of cast shadows and reflections in the stream. Corot's cool detachment enabled him to achieve an objective clarity in the visual study of nature.

Perhaps the most important of the artists who launched Realism as a movement was Gustave Courbet, a self-assured believer in the importance of the present and the real. Having been rejected by the Salon exhibition of 1855 in Paris, he set up his own exhibition, calling it *The Pavilion of Realism*. Courbet initiated a type of subject matter that would recur frequently in the next century: social realism, which concentrates on the Common Man and often carries the implication that its subjects are victims of the society in which they live. He once saw two men laboring beside the road and decided to paint them simply

because they seemed to him "the most complete expression of poverty." The result was an impressive painting with life-sized figures called *The Stone Breakers* (Fig. 15-7). In it Courbet stressed the heavy solidity of their forms by using dark shadows and by applying his paint thickly, often with a palette knife, so that it became expressive of the weightiness of the bodies it represented.

Another important French Realist has always been better known as a political cartoonist. Honoré Daumier was endowed with an exceptional sense of humor; we have already seen one of his commentaries on the bourgeois ladies of the day who tried, not always successfully, to live in the grand manner (see Fig. 8-15). This lithograph was one of several thousand that were published in periodicals during his lifetime. (The newly developed technique of lithography made possible the rapid printing of large quantities of pictures of every kind, and was widely used as a commercial printing method during the nineteenth century.) Very few cartoonists of the time achieved the high quality that Daumier did, and none is still held in such esteem. At the beginning and at the end of his career Daumier's cartoons were largely political commentaries aimed at failures of the government, but during his middle years he made many cartoons—and paintings—that dealt with human situations he encountered around Paris. Everything he saw took on the

15-7 Gustave Courbet, *The Stone Breakers*, 1849. Oil on canvas, 65″ × 94″. (Formerly in the Dresden Museum, lost during World War II.)

quality of a dramatic event in his rendering of it. In a painting of a collector shuffling through prints in a shop our attention is focused on the dramatic center between the man's head and the print he examines (Fig. 15-8). His complete absorption in the act is expressed by the tense arc of his back and the turn of his neck, while a Baroque-like interlocking of the strongest lights and darks keeps our attention centered. It is characteristic of Daumier that he finished his paintings only as much as the subject required. Here the idea is realized with broad and fluid brushwork that has the freshness of a drawing.

For all the movements that existed and the changes that took place during the first half of the nineteenth century, academic art continued to be the norm. It was, after all, supported by an official organization that ran the major exhibitions and influenced the government and other patrons of the arts. Even private collectors tended to prefer the safe and easy-to-understand

15-8 Honoré Daumier, *The Print Lover,* c. 1860. Oil on panel, 13⅜″ × 10¼″. Philadelphia Museum of Art (W. P. Wilstach Collection).

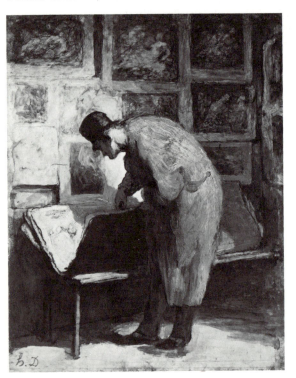

products of the academy. Academic painters had moved away from a primary concern with classical subjects, but they still regarded "history-paintings" as the right subjects for serious artists. A leading history-painter of the period was Ernest Meissonier and a typical painting is the *Battle of Friedland* (Fig. 15-9). In it Napoleon, with an appropriate sense of self-importance, is shown inspiring his attacking troops. The literal rendering of nearly every detail may satisfy a factual mind, but so far as creating a sense of movement or real emotion appropriate to the event, it is not very successful, particularly in comparison with an artist like Rubens. The cast shadows under the running horses seem frozen forever as literal dark shapes. A good deal of fussy detail clutters the scene and the surfaces are flecked with highlights that are made more important than the forms they belong to. Degas, a younger contemporary, aptly said that Meissonier "made everything look like metal except the armor." Little wonder that the younger artists of the day preferred to risk their careers by refusing to follow the academic line.

In 1863 the works of a number of independent artists—those we would call avant garde—were refused admission to the official Salon, and in response to their protests the authorities were persuaded to set up a *"Salon des Refusés"* (Exhibition of the Rejected). The most notorious picture in the exhibition was Manet's *Le déjeuner sur l'herbe* (see Fig. 9-11). In the discussion of this painting in Chapter Nine it was noted that Manet chose sixteenth-century precedents for the subject and for the figure grouping. In doing so he deliberately bypassed academic conventions in figure painting to rejoin, as it were, a deeper tradition that went back to Renaissance times. He was a realist in that the people and the picnic details were from his time (the naked woman is a person who appears in several other of his paintings), but he was not interested in the social relevance of the subject matter, as Courbet was. Nor did he model his forms heavily like Courbet; in fact, he deliberately arrived at a kind of flatness in the representation by reducing his shadows to near-stripes bounding the forms and by modeling forms with subtle half-lights. The frontal lighting that produced this effect also brought into prom-

15-9 Ernest Meissonier, *Battle of Friedland, 1807*, 1875. Oil on canvas, 4'5½" × 7'11½". Metropolitan Museum of Art, New York (Gift of Henry Hilton, 1887).

inence a striking pattern of local colors: the lights of table cloth, flesh, and pants are opposed to the darks of the men's jackets and heads of all four figures. The background extends the broad pattern in a less naturalistic way to the edges of the canvas. Flatness of forms and broad painting of the details joins with the patterning of the whole picture to create a strong sense of the surface itself.

Although the work appears skillful and well-conceived today, it was badly received in 1863. The boldness of execution and absence of modeling seem to have been as offensive to the people who came to the exhibition as the subject matter itself was, and Manet, though he was by nature rather aloof and averse to anything resembling publicity, became the object of considerable notoriety. A number of the young independent artists recognized the quality in Manet's art and responded favorably to the newness of his ideas. A few critics did also, though the great majority rejected the painting for either moral or artistic reasons, or both. In the year of the *Salon des Refusés,* a perceptive critic named Castagnary wrote of the new naturalism of Manet

and others: "For the first time in three centuries, French society is on its way to producing a French painting that may be made in its own image, and no longer in that of long dead peoples; that describes its own appearances and customs and no longer those of vanished civilizations; that finally in all its aspects, bears the imprint of its own luminous grace, and lucid, penetrating, clear spirit." This statement was indeed prophetic.

As part of Manet's revolt against the academy he made still-life paintings that deliberately avoided not only the literal rendering of detail but "significant" subject matter. Nothing could be further from the approved themes of the academy than his *Still Life with Oysters* (see Fig. 8-12), which was cited earlier as an example of the tension between the illusion of the real and the flatness of the painted surface. From the 1860s into the 1900s artists actively sought new ways of combining convincing images of reality with the equally compelling object-quality of flat painted surfaces.

Manet was also an interpreter of life in his time, though he did not see it in terms of social problems, as Courbet did, or depict it with dra-

matic overtones as Daumier had. One of his later works takes as its subject a barmaid at the Folies-Bergère (Fig. 15-10). She is seen in front of a mirror which reflects the marble bar and a balcony crowded with people. It also reflects the back of the girl and a customer with a tall hat, though these reflections are moved to one side enough so that we do not confuse his reflection with our own—since she is facing us as well. The mirror introduces an image within an image and also presents another plane, parallel to the picture plane, on which colored patches of paint simulate reality just as they do in the figure, bottles, and fruit on this side of the mirror.

Now more than in the *Déjeuner* Manet presents a surface enlivened by color that has something to catch our interest in every part: still-life elements, figure, balcony, and animated crowd (even the feet of a trapeze performer appear in the upper left corner). Our attention always returns to the quiet, detached figure of the barmaid in the center—but because her gaze avoids ours, we are never permitted to get close to her psychologically. As a result, we perceive her as a lonely person in the midst of a crowd—one of the first images of the isolated individual in a city environment that has become such a common

subject of art and literature since the 1880s. Yet for all its coolness the painting captures the lively atmosphere of a night club and even to us today seems expressive of contemporaneity.

Impressionism

In the eighteen years between the *Déjeuner sur l'herbe* and *The Bar at the Folies-Bergère* Impressionism had been born and reached its maturity. The *Bar* is an Impressionist painting—unlike the *Déjeuner*—for the following reasons: its subject is unequivocally contemporary; it records a passing moment in time; the palette has been lightened to express the overall luminosity of the scene; and, to enhance this, the paint was applied in separate strokes so that a partial fusion of these strokes produces the perceived color. This latter effect varies according to our distance from the canvas, hence producing the varieties of perceptions the viewer receives from an Impressionist painting. These qualities of color and resultant illusion of light were discussed in Chapter Four and Chapter Seven.

The development of Impressionism can best be studied in the work of Claude Monet, who, being

15-10 Edouard Manet, *The Bar at the Folies-Bergère*, 1882. Oil on canvas, approx. 37" × 51". Courtauld Institute Galleries, London.

15-11 Claude Monet, *The Seine at Bougival, c.* 1870. Oil on canvas, 25¾" × 36⅜". The Currier Gallery of Art, Manchester, N.H. (Mabel Putney Folsom Fund).

eight years younger than Manet, built on Manet's achievement and then in turn influenced him to move into Impressionism. The artistic rivalry between the two men was suggested in the account in Chapter Nine of Monet's undertaking a *Déjeuner sur l'herbe* of his own which would be closer to real life and more analytical in its study of color in nature than Manet's.

Monet continued his pursuit of visual representation primarily in landscape painting. In 1869 he painted *The Seine at Bougival,* in which he directed his attention to a very particular effect of light (Fig. 15-11). The scene recalls Corot's *Bridge at Narni* of more than forty years earlier, but a few changes are significant: it is more of a passing scene, with the suggestion of moving clouds in the sky and figures caught in momentary positions on the bridge; a more casual composition that juxtaposes the foreshortened road and the sparkling river; and especially a more specific light effect. The sun is in front of us, just above the top of the picture so that we do not see it, but the effects of this position are apparent all through. Almost no local colors of the objects are seen as such; they are either in shadow or in the glare of reflected sunlight, as in the case of the figures or the surface of the road.

Yet such is the accuracy of Monet's eye that local colors are read into all objects even though they are not actually seen. This cause-and-effect relationship between sunlight and local colors was cited in Chapter Seven in relation to Monet's *The Beach at Trouville,* where another position of the sun in relation to the objects was studied (see Color Plate 18). By the time of the Trouville picture the most typical subject matter of Impressionism had emerged: middle-class people frequently engaged in leisure-time activities and often in an outdoor environment.

High Impressionism is illustrated by Monet's *Torrent, Dauphine* (see Color Plate 19). The discussion of this in Chapter Seven suggested the growing emphasis on light itself, which seems to detach itself from the surfaces of the hills and the water. Most of the neutral colors had been eliminated from this palette in a search for the equivalent of light in pigments. Monet developed the internal organization of the color itself at the same time that he was developing color as a medium of light. In the *Torrent* two kinds of gradation occur from the foreground to the back: the lights on the first hill are red; on the second they are pink; and on the third nearly white. The shadows meanwhile are moving from a dark pur-

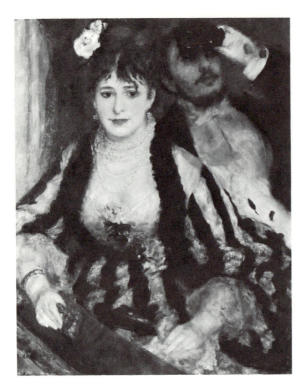

15-12 Auguste Renoir, *The Loge*, 1874. Oil on canvas, 32″ × 25″. Courtauld Institute Galleries, London.

plish hue, to a lighter purple blue, to a paler blue. While these changes are suggested by real light and atmospheric effects, Monet's color organization has an abstract development that goes beyond the aims of earlier Impressionism.

Camille Pissarro and Auguste Renoir both worked with Monet in evolving the principles and the techniques of Impressionism. Pissarro was a landscape painter especially interested in rural scenes that reflected life in the French villages and farms, as can be seen in his *Orchard at Pontoise* (see Fig. 9-13). Renoir preferred painting people to landscapes, perhaps because of his feeling for women and children as embodying the aspects of life that he most enjoyed. In his painting *The Loge* (Fig. 15-12), depicting a woman and a man at the opera, he characteristically subordinated the man to his companion by placing him in a half-shadow and concealing his eyes behind opera glasses. By placing the figures off-center—the man's head and hand are in the upper right corner of the rectangle—he captured the sense of immediacy, of nearly random seeing, that is part

of the Impressionist point of view. Then he stabilized the composition with a tension-creating equilibrium between the psychological center near the top and the sheer visual attraction of the black and white stripes in the woman's dress below. (Renoir would eventually eliminate black from his palette altogether.) His application of paint is in thin, wispy strokes that render delicate nuances of light and color.

The other major figure painter of Impressionism was Edgar Degas. Rather conservative in nature, like Manet, he was a devotee of Renaissance art and yet he was a bitter opponent of contemporary academic art. In the 1870s he moved away from his earlier interest in history painting and portraiture and became caught up in certain aspects of the world around him, in particular race horses and ballet dancers. His pictures are replete with new solutions to the problems of composing and grouping (see Fig. 3-5). Often these drew upon Japanese woodcuts, which had recently come to the attention of Western artists. Harunobu's *Mother and Child by a Mosquito Net* (Fig. 15-13) is typical of these in its choice of subject matter from everyday life. These popular prints were produced by a series of woodblocks, one for the lines and one for each color, which translated the artists' drawings into a technique that produced multiple copies. Manet, and later van Gogh, got ideas about using flat local colors from them, and Degas was attracted by the striking asymmetries, the oppositions of crowded and empty areas, and the diagonals that often governed their compositions.

Before the Race (see Fig. 1-4) is typical of Degas' race course pictures and typical also of the way in which his carefully thought-out compositions seem casual and accidental. The horses have not yet fallen into the regular formation of the race itself, just as his ballet dancers are seen in rehearsal or before a performance when the girls are stretching or practicing in a spontaneous manner. A late example of a ballet subject is a pastel called *The Dancers* (Color Plate 31). Degas' choice of pastel as a medium reflects again the experimental nature of his art. While not a new technique, it had never been used with the rich complexity we find here: layer after layer of varied hues to produce luminous effects similar to

those of the Impressionist landscapists. Rather like the later works of Monet (such as *The Torrent*) this pastel is as much concerned with the organization of the color itself as with problems of representation. Intensely colored shapes pattern the surface, reflecting Degas' growing interest in painting as a two-dimensional art-form in these later years.

The Impressionists were bound together not only by being involved in similar artistic ventures but also by their common endeavor of bringing their work to public attention despite their exclusion from the official salons. The first of their eight group exhibitions was in 1874 (on which occasion a hostile critic gave them the name "Impressionists") and the last was in 1886. There were naturally disagreements among the artists about who should be admitted to these showings, which led to the withdrawal of some artists from certain of the exhibitions. Pissarro, always

15-13 Harunobu, *Mother and Child by a Mosquito Net, c.* 1768. Color woodcut, 10½" × 7⅞". Philadelphia Museum of Art.

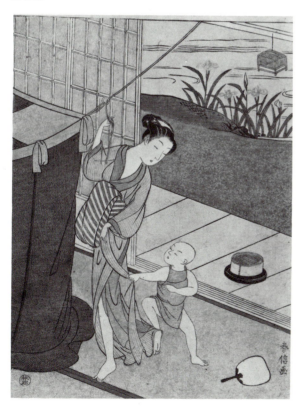

open-minded, showed in all eight while Degas and Berthe Morisot (see Fig. 5-19), were next, showing in seven. The American painter Mary Cassatt, also a member of the group, interested a number of American collectors in owning Impressionist paintings. Such encouragement was rare, because for the most part the critics remained less than enthusiastic during the years when the Impressionists were struggling for recognition.

Degas and Renoir were the only Impressionists to work in sculpture. With his growing interest in the nude form, Degas created a number of works, modeled in plasticene and cast in bronze after his death, of women bathing or assuming dancers' poses (see Fig. 2-14). To study them with the greatest degree of objectivity he slurred over faces, and to concentrate on the essential action and balance he also eliminated details of fingers and toes. They are the equivalents in sculpture of quickly painted sketches.

Sculptors had taken some time to break away from the Neoclassicism of the first half of the century, and had passed through Romantic and Realistic phases following that, but among sculptors of the Impressionist generation only one was able to match Degas' ability to see in the human body new dispositions of forms and previously unseen actions. Auguste Rodin executed a series of major sculptural monuments in the late nineteenth and early twentieth century which often embodied extremes of emotional feeling that seem more characteristic of the Romantic age than of the period of Impressionism. His *Prodigal Son* (see Fig. 3-13) was originally conceived as one figure of the many that were included in such a project. While it played a part in the whole, it is also self-sufficient as a statement about human anguish—the title was an afterthought, but an appropriate one. Such generalized embodiments of emotion are typical of the Romantic temperament but rare among Impressionists. One of his major commissions was done for the French city of Calais in commemoration of an event that took place in the fourteenth century—when six of its citizens gave themselves up to the English enemy to save the city (Fig. 15-14). Each of the figures in *The Burghers of Calais* is a highly individualized person created by Rodin to fill the

role of one of the voluntary victims of the hang-man. Rodin's realism incorporates a kind of earth-bound heaviness—expressed especially by the feet and the hands—and a complete break from the contrapposto pose that had dominated most sculpture in the earlier nineteenth century. The emphatic modeling that creates deep pockets of shadow is combined with a slurring over of details in the reliefs of the form. These means are an intensification of those found in other pictorial sculpture, but the forceful, hand-manipulated lumps and hollows are different enough to suggest a change in kind as well as degree. A restless treatment of surfaces throughout is characteristic of Rodin's art and it parallels the Impressionists' bold paint surfaces.

Painting in the United States in the late nineteenth century was similar in its basic naturalism to that in France, but there are qualities that clearly distinguish it from French painting. The broken color of Impressionism did not affect the work of two major American painters of the period, Thomas Eakins and Winslow Homer. Eakins, a Philadelphia painter, adhered to a factual realism combined with a stable composition, both of which are apparent in his *Portrait of Amelia Van Buren* (Fig. 15-15). The strong light and shadow that define the firm planes of the face are in striking contrast with Renoir's modeling of a face which, as we can see in *The Loge*, is done almost entirely with half-lights rather than full shadows. The solid forms of Eakins' figure and chair make up a composition of carefully balanced opposing directions, both on the surface and in space. This is also very different from Renoir's sophisticated off-center composition. There is a matter-of-fact quality in Eakins' portrait that is similar to Copley's portrait of a colonial matron (see Fig. 14-23), suggesting that such straightforward naturalism could be an American characteristic.

Another difference between American and French attitudes shows up in their treatments of groups of people. While the Impressionists usually selected subjects of leisure-time activity, painters like Eakins and Homer preferred to paint people engaged in purposeful occupations. Homer, for instance, painted men fishing in the Adirondacks, off the Maine coast, and in the southern Atlantic. *Sloop, Bermuda* (Color Plate 1) was done during winter months spent away from his home in Maine. Homer found that water-

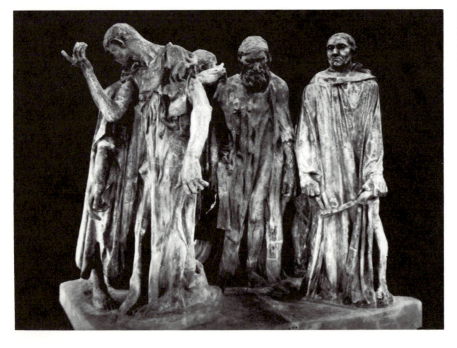

15-14 Auguste Rodin, *The Burghers of Calais*, 1886. Bronze, 6'10½" high. Hirshhorn Museum and Sculpture Garden, Smithsonian Institution.

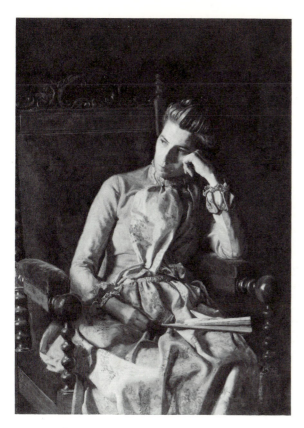

15-15 Thomas Eakins, *Portrait of Amelia Van Buren, c.* 1889-91. Oil on canvas, 44½" × 32". The Phillips Collection, Washington, D.C.

color, handled freely and transparently, enabled him to achieve luminous effects which were the equivalent of those achieved through the broken color of Impressionism. His use of the medium in his later years was the basis of a new tradition of watercolor painting in this country.

Post-Impressionism

All of the younger progressive artists active in France during the 1880s and 90s tend to be grouped under Post-Impressionism, a term which is of necessity very general because of the diveristy among them. They moved in different directions away from the naturalism that dominated Impressionism, even challenging the whole

tradition of single-viewpoint perspective. The first artist to move decisively away from a visual approach to representation was Paul Cézanne. Even though he was a contemporary of the Impressionists he had never shared their enthusiasm for representing the momentary, as we saw in the comparison of two landscapes by Pissarro and Cézanne (see Figs. 9-13, 9-14). Cézanne was more interested in discovering the decisive forms and shapes of the landscape, which he depicted with a degree of geometric order. This direction in his art can be seen in the work *Still Life with Geraniums* (Color Plate 13), in which the forms of the fruit have a geometric simplicity and their firmly modeled shapes are bounded by distinct lines. Since bounding lines do not occur in nature, the Impressionists consistently avoided them, as can be seen in Manet's *Oysters* (see Fig. 8-12). Manet also observed every cast shadow and highlight while Cézanne's shadows and highlights come and go at the painter's will. Although the general source of light is from the left there seem to be cast shadows both in front of and behind the pear in the foreground. The rim of the flower pot, located in a region we would expect to be in shadow, is in full light. In his departure from visual representation Cézanne moved toward a pictorial mode; no wonder that the artists he particularly admired were the sixteenth-century Venetians. And yet his technique of painting in broken color and the resulting richness of his color are very much of his time.

In many ways Cézanne was ahead of his time. *Mont Sainte-Victoire as Seen from the Bibémus Quarry* (Fig. 15-16) was done in his later years and shows how far the artist went in abstracting the forms of nature. This mountain, visible from his studio in the south of France, appeared in many of his paintings; in this one the simplified shape of the mountain and the chunky masses in the foreground quarry create a nearly geometric order. In some places the abstract order nearly conceals the natural forms, a direction that was to be the basis of the Cubist style that would be launched early in the following century.

Cézanne is one of the Post-Impressionists whose art is linked with the classical tradition. In the *Mont Sainte-Victoire* we can sense his detach-

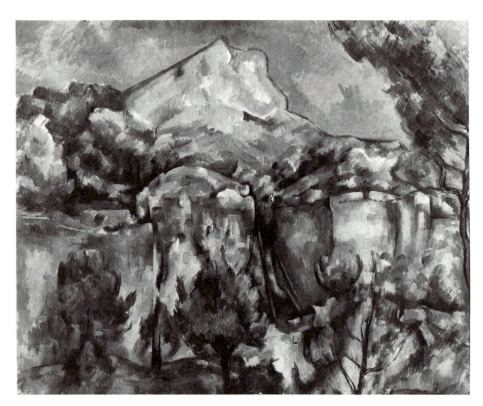

15-16 Paul Cézanne, *Mont Sainte-Victoire as Seen from Bibémus Quarry*, c. 1898. Oil on canvas, 25½″ × 32″. Baltimore Museum of Art (The Cone Collection).

ment from the real world, as if it were to be contemplated rather than to be lived in. We are not invited to enter the picture space here, as we are in paintings by Bruegel and Monet, since the space does not begin anywhere near us, and this, combined with the non-natural lighting and the absence of any people, seems to make it a very different realm from our own.

A younger contemporary of Cézanne was also developing a strongly classical style at this time. Georges Seurat's *Sunday Afternoon on the Island of La Grande Jatte* (Fig. 15-17) retains the subject matter of Impressionism—Parisians relaxing in a park—but breaks from the Impressionists' concern with the accidental and the momentary. Here everything seems filtered through the artist's mind, and we sense a kinship with the classical tradition of stability and permanence.

Seurat was the founder of a movement known as Neo-Impressionism, a development and refinement of Impressionist technique of broken color (see Color Plate 15). In the final version of *La Grande Jatte* he changed from the application of

paint by flecks to an application by dots (a technique called Pointillism) so that the optical mixture of color could be more carefully controlled. Even the border around this painting is made up of myriad dots of hues and values which produce simultaneous contrast with adjacent tones in the painting. Seurat spoke of painting as a science and described it as "the art of hollowing out a surface," a phrase that suggests the concern of painters of this time with the paradoxical two- and three-dimensionalism of their art.

Cézanne and Seurat began a tradition of formal experimentation that has continued in the twentieth century; they are the "formalists" among the Post-Impressionists. Van Gogh, Gauguin, and Toulouse-Lautrec were more interested in the ideas expressible in their art, each taking an individual direction: van Gogh concentrating on emotional expression, Gauguin on symbolism, and Toulouse-Lautrec on an incisive interpretation of Parisian night life. The art of all three is inseparable from the life-styles they chose. The identification of life and art is not uncommon

among modern artists, particularly those to whom the expression of ideas and feelings is important.

Vincent van Gogh's art focused on the people and the environment that touched his life directly—first in his native Holland, where he began his career as a social worker, then in Paris, then in the south of France, where he spent his most productive two years before taking his own life at the age of thirty-seven. A *Self-Portrait* (Fig. 15-18) reveals a good deal of his moody and emotional personality. The intensity with which he cultivated friendships often ended in his repelling those who meant so much to him, as he did Gauguin when they worked together in the south of France. He was in Paris when he painted this picture, attempting to absorb the influences of the high palette of Impressionism and the vibrancy of color resulting from the Pointillist technique (which became strokes rather than dots in his work). He brought these under the dominance of his own style by the strength of his drawing: the surfaces of forehead, nose, and cheeks are defined not only by modeling but by the directions of the strokes themselves, a kind of execution that seems expressive of his own feelings as well as descriptive of the subject. This degree of involvement is the opposite of the detachment of such classicists as Cézanne and Seurat.

Another influence that affected Van Gogh's art was that of the Japanese print. *The Zouave* (see Color Plate 9) has large areas of flat tone bounded by lines, an interest in pattern in the uniform, and a treatment of the tiles in the floor that derives from diagonal projection—all of which we can see in Harunobu's woodcut. The portrait itself is personalized much like his own

15-17 Georges Seurat, *Sunday Afternoon on the Island of La Grande Jatte*, 1884–86. Approx. 6'9" × 10'. Art Institute of Chicago (Helen Birch Bartlett Memorial Collection).

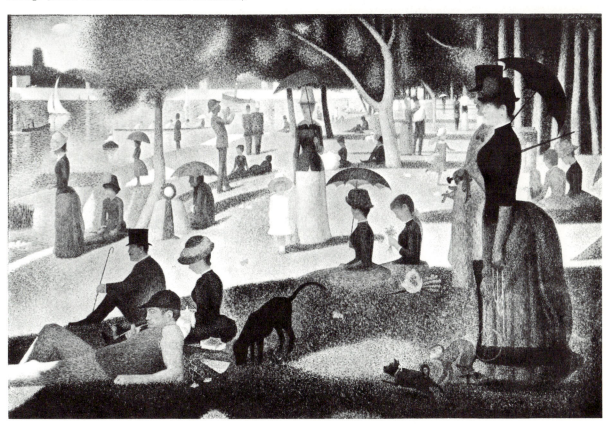

portrait; van Gogh asked people to sit for him because he had a personal relationship with them, and we are also asked to respond to them as individuals. Perhaps exaggeration—such as the awkwardness of the pose, the type of shoes the soldier wears, or the treatment of the braid on his uniform—is necessary to make this clear. Even a room may be considered to have the personality of the one who lives in it, which may be why van Gogh found the objects in his own room important enough to focus upon individually and to characterize so sharply (see Fig. 6-18). Such personalized statements became part of the language of expressionism from this time forward.

Paul Gauguin was a successful stockbroker when he decided to take leave of both his conventional life and his family in order to devote himself to painting. Beginning as an Impressionist under Pissarro's tutelage, he soon turned away from naturalism toward a more linear style with areas of intense local color. *The Yellow Christ* (Fig. 15-19) was done in Brittany where he and other painters, who soon became his disciples, worked out the principles of their Symbolist movement, like the preference for a "primitive"

15-18 Vincent van Gogh, *Self-Portrait*, 1887. Oil on canvas, 17″ × 15″. Stedelijk Museum, Amsterdam.

approach, made up of simplified forms with a minimum of modeling, and a general flattening of the picture space. The title suggests that the colors are non-natural as well: the modeling on the Christ figure is done in green, the women's clothes have flat areas of red, blue and white, and the trees are orange and red. The symbolism is found in the subject: Gauguin was not himself religious but was fascinated by religion as an idea and by the primitive forms, such as the wooden crucifix, employed by those who expressed religious ideas directly.

In his pursuit of more Symbolist themes and in search of a less expensive place to live, Gauguin moved to Tahiti. The paintings he did there were sent back to Paris, where they did not sell any better than those by van Gogh and Cézanne but did continue to hold the attention of those interested in the new ideas. Some of his most innovative works are his woodcuts, in which he exploited the design possibilities of the abrupt shapes that are produced by cutting into wood with a knife (see Fig. 8-14). His drawing of the forms minimized foreshortening, presenting images in a conceptual way based on telling silhouettes and strongly patterned shapes.

In taking the unsophisticated life of Tahiti as the subject matter of his art and stylizing his forms in ways learned from the art of other cultures Gauguin began the practice in modern art of seeking stimulation from other traditions. When Delacroix went to the Near East it was for subject matter only; when the Impressionists and van Gogh borrowed from Japanese prints it was for new formal solutions only; but when Gauguin borrowed exotic themes and non-Western figure-styles it was to declare a new freedom from the main line of European tradition. Symbols, more or less wrenched from their original contexts, were used because the overtones of symbolic meaning they conveyed could be incorporated into the modern work. Among other things the viewer is made aware that cultures other than our own have values from which we can learn—but perhaps the most important lesson is that the stimulation of the creativity of an artist is itself a value, whatever its source. Following Post-Impressionism, creativity was elevated to a position of greater importance than ever before.

15-19 Paul Gauguin, *The Yellow Christ*, 1889. Oil on canvas, 36¼″ × 26¾″. Albright-Knox Art Gallery, Buffalo (General Purchase Fund).

(Color Plate 32) is a lithograph of the red-haired singer in her stage make-up and with the ridiculous pompons in her hair. Everything about the lithograph is expressive of the singer's lively presence, caught as she is recognizing the applause of the audience. The shapes and colors that make up the strongly two-dimensional composition are tightly fitted to the border. In the technique of color lithography, which was beginning to be used by major artists, the lines and tones are applied with brush and crayons. About eight lithographic stones were needed for this print: one for the basic drawing and one for each color. The artist supervised the mixing of the colors, then turned over the complex process of printing to a craftsman.

Another series of drawings, prints, and paintings by Toulouse-Lautrec dealt with the circus. *Cirque Fernando* (Fig. 15-20) reveals his debt to Degas in both the drawing of the horses and the strikingly asymmetrical composition. But the difference in generations between the two men shows in Lautrec's use of flat tones and in his lack of interest in the illusion of light. And the comic element here would not be found in the objective art of Impressionism.

Henri de Toulouse-Lautrec got ideas for many of his paintings and lithographs from the nightclubs of Montmartre where he spent a good deal of his time. He was particularly fascinated by the singers and dancers who performed in the dance halls and his sharp characterizations of them border on caricatures. *Marcelle Lender, Bowing*

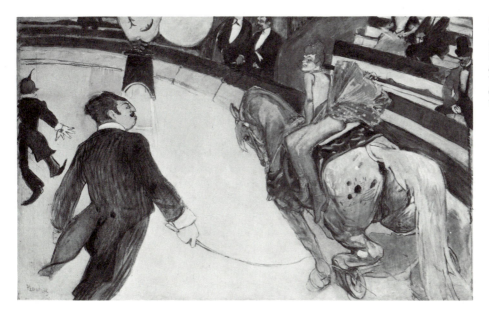

15-20 Henri de Toulouse-Lautrec, *In the Circus Fernando: The Ring Master*, 1888. Oil on canvas, 38¾″ × 63½″. The Art Institute of Chicago (Joseph Winterbotham Collection).

15-21 Thomas Jefferson, University of Virginia, Charlottesville, 1817-26. Lithograph.

Nineteenth-Century Architecture

Styles in architecture paralleled those in painting to a certain degree during the nineteenth century, but for the most part remained closer to models taken from the past. Greek and Roman buildings were naturally the models referred to by Neoclassic architects and, looking back on their buildings today, we find that those which hold our interest are by designers who used the old forms in inventive ways. One such designer was Thomas Jefferson. Before the turn of the century and his presidency, Jefferson had designed his own home, Monticello, and the Virginia State Capitol. In 1817-26 the University of Virginia at Charlottesville was built after his design. His buildings are still the center of the university but to see the overall scheme best we illustrate it with a lithograph of the last century (Fig. 15-21). The main building is modeled on the Pantheon (see Fig. 11-11), as Jefferson particularly admired the cubic, cylindrical, and hemispherical forms of Roman temples. The pavilions placed regularly on either side of the mall are connected by a one-story covered colonnade in front of the stu-

dents' living quarters. The pavilions themselves house the faculty and serve as classrooms. The whole complex is simple and practical, in the American manner, but in its choice of architectural style it embodies references to the Roman virtues so much admired by Jefferson and others at this time.

By the second quarter of the century, an alternative model was often chosen by architects: the Gothic style. Delacroix was only one of the many artists of the Romantic period to turn to the Middle Ages for subject matter; architects found that the soaring, open Gothic buildings provided a similar kind of inspiration. In the case of the architects, the very style, not just the subject matter, embodied an admiration for the medieval. Hence, Gothic Revival buildings followed closely on those of the classical revival throughout western Europe and America. Both showed imaginative uses of the borrowed forms; for instance, buildings that would have been of stone in Europe were conceived as wooden structures in New England. In 1837 a local architect designed a Greek Revival Baptist church in the village of Sedgwick, Maine (Fig. 15-22). Its crisp, cubical forms make a nice gradation from the

horizontal body of the church to the vertical tower, and its portico echoes the dignity felt in a Greek temple. The flat boards used in its construction readily adapt to the pilasters and metopes of the Doric order. A few years later an outside architect designed a wooden Gothic Revival church in Brunswick, Maine (Fig. 15-23). Richard Upjohn's First Parish Church has walls of "board-and-batten" construction. The vertical battens maintain the linear verticality of Gothic buildings while translating it into the lightness of wood. The plan has more complexity than the classical church, while the "picturesque" pinnacles and the pointed-arched window recall the admired qualities of Gothic architecture. The fact that sensitive adaptations of the Greek and Gothic styles should occur in rural New England suggests the pervasiveness of the influence of past civilizations and the feelings they evoked.

There was no Realist style of architecture as such, but about the time that Realism was maturing, industrial technology was beginning to enter the art of architecture. Iron arches had been used in the building of bridges in England and France even before the nineteenth century, and while some concealed iron was used by architects as they continued to build in revival

15-22 Benjamin S. Deane, Baptist church, Sedgwick, Maine, 1837.

15-23 Richard Upjohn, First Parish Church, Brunswick, Maine, 1845.

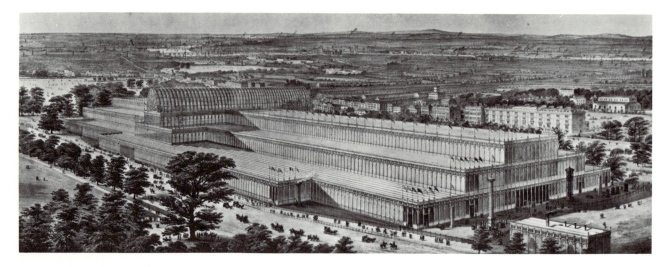

15-24 Joseph Paxton and others, Crystal Palace, London, 1850-51. Lithograph from the Victoria and Albert Museum, London.

15-25 Victor Horta, staircase of 6 rue Paul-Emile Janson, Brussels, 1892-93.

styles—including Renaissance, Baroque, and Romanesque—it was only in buildings in which engineers were given a significant role that such construction was allowed to show. The first major example of what could be done was created at mid-century (the year after Courbet's *Stone Breakers*), when a huge exhibition hall was built near London almost entirely out of iron and glass (Fig. 15-24). The Crystal Palace, as it was called, had been prefabricated, and was actually dismantled and rebuilt in another location before its accidental destruction. The Eiffel Tower of Paris, also designed for an exhibition, still stands as a tribute to the engineering daring of the nineteenth century and to the new aesthetic of openness and linearism in architectural design. It is not surprising that these two influential structures were designed by non-architects: the engineer, Gustave Eiffel, and the greenhouse designer, Joseph Paxton.

With such antecedents, architects soon moved to the point of complete independence from revival styles. Victor Horta, a Belgian architect, combined the strength of iron supports with the new feeling for fluid, linear design in his staircase for a building in Brussels, 1892-93 (Fig. 15-25). He ignored the traditional solutions to the problem of designing a capital for columns and created

new forms that suggest living plants and the energy of growth. Both structural and spatial problems are solved here, but in other work of the time there was a tendency to settle for decorative two-dimensional solutions. In America, where architecture had always tended to stress the practical, architects like Louis Sullivan and his pupil Frank Lloyd Wright dealt with basic structural problems. Several other architects in Chicago during the 1880s were involved with designing high-rise office buildings, but it was Sullivan's solutions that anticipated the future of urban architecture. The elevator had recently made such buildings feasible and the method of building over a skeleton of steel made construction of them possible. Sullivan's Carson Pirie Scott store in Chicago was based on a simple horizontal-vertical grid that is frankly stated in its design, while his taste for organic patterning was allowed full rein only in the border patterns of the lower two stories (Fig. 15-26). Interest is added to the repeated design of the walls (which are more window than wall), by having the rounded corner pavilion dominantly vertical in contrast to the dominant horizontality of the sides. Buildings like this held great promise for the architecture of the new century.

15-26 Louis Sullivan, Carson Pirie Scott Building, Chicago, 1899-1904.

16
The
Modern
World:
The
Twentieth
Century

The term *modernism* is loosely applied to the movement that grew out of Post-Impressionism and was eventually responsible for the radical break with nearly all earlier traditions in the visual arts. In the representational arts it has signified pronounced distortions of the forms and colors of nature, and, in extreme abstract art, it led to the elimination of any reference to nature. In architecture, the term refers to the abandonment of all revival styles and all references to the classical "orders" and to the planning of a building in such a way that the form grows out of the building's function ("Form follows function," in the words of Louis Sullivan).

Modernism is also associated with a drive for freedom of expression on the part of artists who participated in its movements. Both the Impressionists and Post-Impressionists had given direction to these attitudes; they had been experimental in their methods, bold in their departures from the past, and persistent in their creative endeavors despite discouragements. Their successors, right down to the present, have followed these principles of artistic freedom. But since these principles are predicated on a free society, modernism has flourished only in countries which have been relatively free of political restraints.

Painting in Europe: 1900–1940

As it had been for much of the nineteenth century, Paris was the artistic center of the movements of the new century. In this section we shall examine works by artists of several nationalities—Spanish, German, Italian, and Dutch, as well as French; nearly all of these artists spent some time in Paris during the first two decades of the century. Even those who did not were directly influenced by works coming out of Paris.

Fauvism At the turn of the century, the thirty-year-old Henri Matisse had systematically experimented with Impressionist and Neo-Impressionist techniques of painting and with a broad, flat use of intense color deriving from the work of Gauguin and van Gogh. He was also a

thorough student of form, having made use of both drawing and sculpture to study the human figure. Out of these researches came a simple, bold style in which color played a major role. A portrait of his wife, entitled *The Green Stripe* (Fig. 16-1), is made up of areas of intense warm and cool colors whose effect is enhanced by their juxtaposition. Warm colors, ranging from red purple to red orange and pink, are contrasted with cool colors, such as the dark blue of the hair and an intense blue green of the right background. The left-hand side of the face is yellowish and the right-hand side pink, and they are divided by an intense stripe of yellow green, so that the face seems lit by two different lights that are separated by a shadow—the green stripe. The intensities of the colors are such that they do not produce an illusion of reality but seem to have a strong independent existence separate from either form or light. Neither is there a logical explanation of the three separate colors that surround the head and destroy the sense of a continuous background plane.

Other artists of this time, seeking to achieve a comparable impact through color, joined with Matisse in an exhibition in 1905 that broke radically with the past and was to have an effect on the use of color in much subsequent painting. A shocked critic labeled these rebels *fauves* (wild beasts). One of the members of the group compared their use of color to an explosion of dynamite—though Matisse, as here, often restrained the explosive force of his color by firmly defining boundaries.

The artists of the Fauve movement went in different directions following their exhibition, but Matisse kept his interest in bold, experimental color throughout his long life. Soon after 1905 he began to combine color with simplified drawing, as can be seen in his *Goldfish and Sculpture* (Color Plate 4). There the impetuous brushstrokes have been replaced by a more relaxed application of paint that goes with the unpretentious but controlled manner of drawing. By using the same blue for the table and the walls, and the same blue green in both foreground and background, Matisse achieved a new level of tension between surface and space. The diagonals of the table edge and the sculpture create recessions

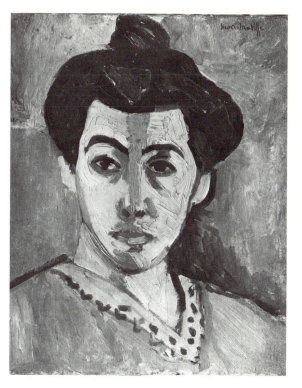

16-1 Henri Matisse, *The Green Stripe*, 1905. Oil on canvas, 16″ × 13″. Statens Museum for Kunst, Copenhagen (J. Rump Collection).

which are denied by the sameness of the areas of blue and blue green. There is another ambiguity in the right background where the shelf on brackets is seen as foreshortened, while the frame above it is a true rectangle and therefore appears parallel to the picture plane. Yet for all these tensions an overall order is felt, resulting in a serenity of expression that is characteristic of Matisse.

Cubism Fauvism was not the only important movement to develop in the first decade of the century. A Spanish artist, Pablo Picasso—evidently stimulated by the work of the Fauves—began to experiment with a radical style of his own which was particularly influenced by the paintings of Cézanne. For example, in the painting of Mont Sainte-Victoire (see Fig. 15-16), Cézanne used sequences of planes (as in the trees at the upper left) that generate a sense of three dimensions not by a modeling of the forms but by their effect of overlapping. Picasso combined this effect with another found in Cézanne's work: the

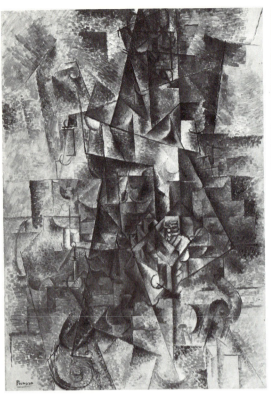

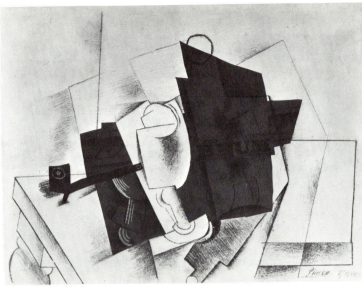

16-3 Pablo Picasso, *Pipe, Glass, Bottle of Rum*, 1914. Collage, 15¾" × 20¾". The Museum of Modern Art, New York (Gift of Mr. and Mrs. Daniel Saidenberg).

16-2 Pablo Picasso, *The Accordionist*, 1911. Oil on canvas, approx. 51¼" × 35¼". Solomon R. Guggenheim Museum, New York.

ambiguous relation of such planes to each other, as in the way the edges of the trees merge into the distant mountain. *The Accordionist* (Fig. 16-2) represents the full development of such ambiguity, as well as the drastic reduction of representation. We can see only a fragment of a figure, an instrument, and a chair in this complex of shifting planes, and it is impossible to separate figure from background. There is only a kind of swelling of the space toward the right center where the figure seems located—the result of the greater richness of the form and the stronger value contrasts here. The ambiguity sometimes consists of an effect of transparency: we seem to view some of the smaller planes through other, larger ones. This shattering and mixing of voids and volumes came to be known as Cubism.

At the time he painted this picture, Picasso was a close friend of Georges Braque, who was also a major contributor to the evolution of the new style (see Fig. 2-5). Both artists had reduced their palettes to colors of very low intensities—mostly grays, yellow-browns, and very neutral blues—in

order to concentrate on form. Partly because of this, their paintings have a great resemblance to relief sculpture in the way the elements build up from a background plane. But there is also a striking pictorial effect produced by the broad massing of areas of dark and light across the surface of the paintings. Revolutionary as Cubism was, it still dealt with problems that had preoccupied painters over the centuries: the exploration of qualities of surface richness simultaneously with those of spatial illusion.

These paintings by Picasso and Braque represent the early, or Analytic, stage of Cubism. The second stage of the style, called Synthetic Cubism, was marked by a shift to using fewer and larger planes, most of which were parallel to the picture surface. Picasso's *Pipe, Glass, Bottle of Rum* (Fig. 16-3) of 1914 reflects these changes and the new technique called *collage*—pasting pieces of paper and textured materials onto the surface of the picture. Ambiguities and transparencies can still be seen where the brown paper overlaps and is integrated with the pencil

drawing. The conflict between the receding table tops and the flat planes in other parts of the picture is typical of Cubist space in its fundamental break with the systematic space of perspective. In an earlier discussion of the evolution of perspective, two paintings by Juan Gris were used to demonstrate this break with perspective projection (see Figs. 6-19 and 6-20).

Synthetic Cubism continued in the work of all three of these artists and influenced many others well into the century. Picasso was to change styles frequently, but in Braque's much later painting, *The Salon* (Color Plate 5), the flat, ambiguous shapes are still suggestive of their origin as cut paper.

The Spread of Cubism The Cubists and Matisse come under the general heading of formalism. That is, like Seurat and Cézanne, they were primarily concerned with the formal structure of art and suppressed qualities of human emotions. Another direction was taken by the Dutch artist Piet Mondrian. Under the influence of Analytic Cubism, Mondrian broke down forms of nature to flatter planes than Picasso's and Braque's; he soon arrived at an art of complete abstraction that had no reference to nature or real things. (Picasso and Braque always had external objects in mind or, in their collages, actual objects incorporated into the painting.) By the 1920s Mondrian's paintings consisted of rectangular divisions produced by black lines against a white background. In this pure setting, where there is not even the space of overlapping planes, interest is introduced by subtle variations of proportion in the rectangles, slight variations in the width of the lines, and occasional areas of pure color—red, yellow, or blue (Fig. 16—4). He had carried the process of abstraction to its conclusion—but not the only conclusion, as we shall see in later versions of pure abstraction. As with many modern movements, Mondrian's art was accompanied by a theory. He saw vertical lines as active and vital, and horizontal lines as tranquil. His general approach to art was almost mystical, as is suggested by his remark that "the balanced relation is the purest representation of universality." Mondrian influenced many younger artists in their search for greater simplicity, though few carried it as far

as he did, and echoes of his white rectangles and blocks of pure color continued to appear in commercial design for several decades.

A very different growth of Cubism appeared in Italy in the years just before the outbreak of the First World War. A group of artists, whose practice was heavily buttressed by theory, established a movement called Futurism. It was the opposite of Mondrian's art in that it was based on the dynamics of physical motion and a fascination with speed as an expression of modern life. Umberto Boccioni produced the group's most important paintings and sculptures. His *Dynamism of a Soccer Player* (see Color Plate 20) clearly shows its derivation from Cubism in its faceted surfaces and its structure based on planes moving in and out of space. But instead of starting with still-life subjects, as the Cubists tended to do, the Futurists started with machines or people in action and played up the directional forces they felt in the subject matter.

Expressionism in Germany It was in Germany that the movement called Expressionism devel-

16-4 Piet Mondrian, *Composition in White, Black, and Red*, 1936. Oil on canvas, 40¼″ × 41″. The Museum of Modern Art, New York (Gift of the Advisory Committee).

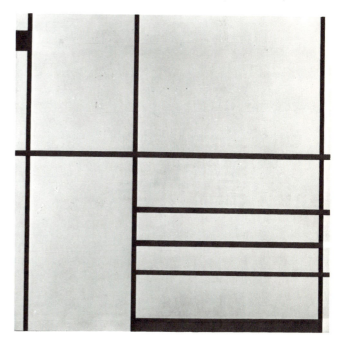

oped during the first decade of the century. Following van Gogh's lead, German Expressionists used intense colors to produce visual equivalents of strong emotions, and from the Fauves they also learned the degree of emphasis possible when color and energetic use of the brush are combined. But the best of the Expressionists, who thought of life and art as inseparable, were motivated by the depth of their feelings about their subject matter, while the Fauves remained

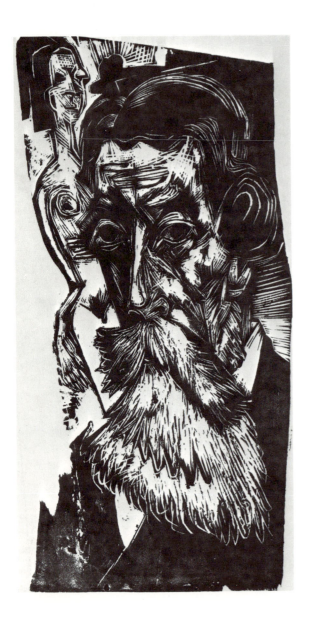

more neutral in relation to theirs. Several German Expressionists formed a group in 1905 which they called The Bridge. One of their leaders, Ernst Kirchner, was both a painter and a graphic artist. In his portrait of a friend (Fig. 16-5), the slashing strokes of the gouge resemble the rapid brushwork in his paintings. Both are directly expressive of the intensity of the artist's feelings, which seem to be stimulated by the psychological tenseness of the subject of the portrait—the source of which may be the female figure visible at the left. Intense feelings are expressed by means of the enlarged eyes and the elongation of the head that seem to minimize the sense of a real physical being. These exaggerations are combined with linearism and strong contrasts in a search for emotional expressiveness. Kirchner's portrait reflects the psychological pressures of the period of the First World War. Among the themes favored by members of The Bridge were sex, the tenseness of city life, and the artist's own image—all suggestive of a concern with the feelings of the individual and the relation of these to the social environment.

Wassily Kandinsky, a Russian-born artist who settled in Germany, shared an interest in emotional expression with members of The Bridge, but in his art took a more abstract direction. As the leader of another group called The Blue Rider, which was based in Munich, he produced completely abstract paintings in the critical years 1912 to 1914, when Mondrian and other artists were also divesting their art of any sign of representation. Kandinsky's *Improvisation* (Fig. 16-6) reveals a knowledge of the overlapping and ambiguous planes of Cubism, but the free-flowing forms and the intense colors create a very different feeling—one suggestive of the swelling and diminishing of the emotions themselves. Kandinsky's impulsive execution seems more the result of feeling than of thought—an abstract kind of Expressionism that anticipated a similar movement in the 1950s. He thought of his art as analogous to the abstract and emotionally rich art of

16-5 Ernst Ludwig Kirchner, *Portrait of Ludwig Schames*, 1917. Woodcut, 22¼" × 10½". The Brooklyn Museum.

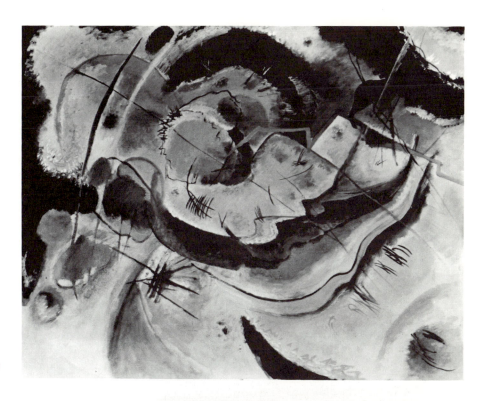

16-6 Wassily Kandinsky, *Improvisation*, 1914. Oil on canvas, 30¾″ × 39½″. Philadelphia Museum of Art (Arensberg Collection).

music, and chose for this series of paintings a title that is common in music.

Fantasy and Surrealism In addition to formalism and expressionism, a third trend, fantasy, played an important role in the art of the twentieth century. Fantasy, or the free imaginings of the creative mind, has shown up throughout the history of art. We have met it in the creations of Kamakura Buddhist art (see Fig. 10-11) and in those of Hieronymus Bosch in the fifteenth century (see Fig. 13-5). It also appeared during the Romantic period and began to emerge as an important modern trend during the 1890s. Paul Klee, a Swiss-German artist who was in Munich when Kandinsky was producing his Improvisations, was a master of the art of fantasy. His *Adventure of a Young Lady* (Fig. 16-7) is one of his many small watercolors that combine a childlike naivety with a sophisticated awareness of Cubist

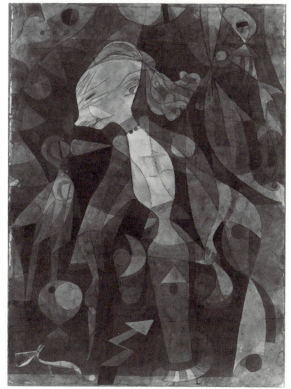

16-7 Paul Klee, *Adventure of a Young Lady*, 1922. Watercolor, 17″ × 12⅝″. The Tate Gallery, London.

16-8 Marcel Duchamp, *Bicycle Wheel*, 1951; third version, after lost original of 1913. Mixed media, 50½" high. The Museum of Modern Art, New York (Gift of the Sidney and Harriet Janis Collection).

especially those who were associated with the movement known as Dada, which was founded in Zürich during the First World War. Reacting to the brutality of the war, several writers and artists turned as well against many aspects of the civilization that produced it. They espoused a random approach, such as the simultaneous recitation of three poems in three different languages and, in the visual arts, creating by means of accident and automatism—that is, by letting the undirected movement of the hand produce works. Their deliberate cultivation of an "anti-art" stance entailed the rejection even of such modern styles as Cubism. In New York, another branch of Dada was represented by Marcel Duchamp, a French artist whose "ready-mades" were usually commonplace objects taken in another context that forces our perception of them to be readjusted. In his *Bicycle Wheel* (Fig. 16-8), by juxtaposing the wheel and the stool, the artist has rendered both useless, but we find irony and humor in the unexpected combination. Some annoyance at the perversity of the act may influence our response as well. Since Duchamp and other Dada artists were interested in completely reorienting the viewer's reactions to things, preferably away from any notions of beauty, they did not object to such a response. Duchamp was admired by later artists as a man of ideas, as someone who could use his agile mind and wit to suggest new directions for art, though he himself had nearly given up the practice of art decades before his death.

Out of Dada grew Surrealism, a movement that, like Dada, lacked faith in logic but sought more vivid combinations of images than Dada had. One branch of Surrealist art used naturalistic images and placed them in contexts that are logically impossible. The Belgian artist René Magritte painted an eye with an iris of sky and clouds and called it *The False Mirror* (Fig. 16-9). Both eye and clouds are naturalistic and highly finished. The conflict between the closeness of the magnified eye and the infinite distance of the sky suggests the impossible nature of many dream images. Dreams were regarded by Surrealists as perhaps more important than reality because they represent preconscious thought undirected by reason. Magritte once said that "pictorial experi-

techniques. The decorative gradations and the subtle nuances of color contribute to the feeling of movement as the young lady encounters a bird on her walk. It is humorous and whimsical and yet it was done by an artist who was a serious student of the theoretical basis of visual art and an influential teacher.

In Klee's art, ideas are associated in an almost random way instead of rationally. Other artists carried the illogical and the random even further,

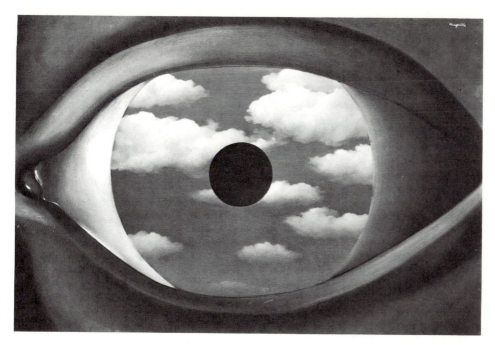

16-9 René Magritte, *The False Mirror*, 1928. Oil on canvas, 21¾″ × 31⅞″. The Museum of Modern Art, New York.

ence which puts the real world on trial inspired in me belief in an infinity of possibilities now unknown to life." This illusionist branch of Surrealism often transferred objects and figures in an uncanny and disturbing way.

The other branch of Surrealism was more abstract, developing out of the Dada belief in randomness as a method of producing art. Automatic drawing provided the basis for much of abstract Surrealism, as seen in the work of its best representative, the Spaniard Joan Miró. In his *The Beautiful Bird Revealing the Unknown to a Pair of Lovers* (Fig. 16-10), one of a series of paintings done in the early years of the Second World War, the free forms of automatic drawing are tempered by a disciplined control of the intervals and shapes and a decorative use of color. The black lines and the lively shapes of black, white, and intense color seem to float in front of an atmospheric background. As the lines flow freely across the surface of the paper or move from point to point, they define abstract shapes and simple images which account for the title he gave the series: *Constellations*. Miró wrote that they were suggested by "the night, music, and the stars," elements that can be readily felt. The title of the picture, like many surrealist titles, is a part

16-10 Joan Miró, *The Beautiful Bird Revealing the Unknown to a Pair of Lovers*, 1941. Gouache on paper, 18″ × 15″. The Museum of Modern Art, New York (Lillie P. Bliss Bequest).

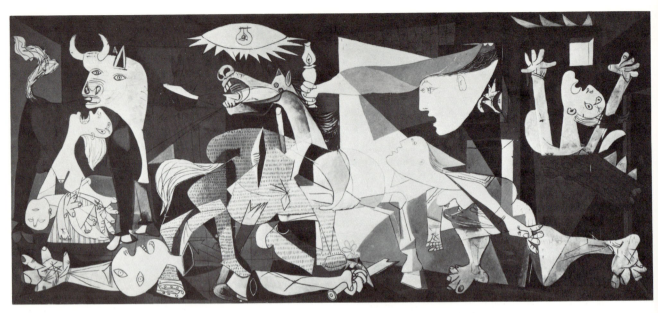

16-11 Pablo Picasso, *Guernica*, 1937. Oil on canvas, 11'5½" × 25'5¾". Cason del Prado, Madrid.

of the message, though a logical relation between words and images should not be expected. The bird's head shows in the upper right and presumably the lovers are below, and between them is an extra eye that belongs to no one.

In this and other late works, Miró was bringing the most active period of Surrealism to a close. But the attitudes of Surrealism were to affect many other artists in one way or another right down to the present. Some developed automatic drawing, some transformed images, and many were intrigued by enigmatic combinations of images, shapes, and titles.

Later Work of Picasso It is impossible to fit Picasso into any one of the categories into which twentieth-century art is divided. From about 1908 to about 1925—the period in which Cubism ran its course—he was primarily a formalist. But in his work prior to 1908 he had been mostly concerned with the expression of emotion, and in the late twenties his distortions again were directed toward a disturbing emotional expression. This trend in his art was given a specific direction when civil war broke out in his native Spain. In the spring of 1937 the antigovernment

forces made use of Hitler's German bombers to carry out a new kind of warfare in the saturation bombing of the town of Guernica. Picasso had already been asked by the government to execute a painting for the Spanish pavilion in the Paris World's Fair of that year; the bombing provided him with a subject, and within six weeks he had completed *Guernica* (Fig. 16-11).

Nearly every observer of *Guernica* is impressed by the tragic nature of the painting. The size assists in this impact: it is over twenty-five feet long. Though no modern weapons are shown, one recognizes it as an allegory of modern warfare. Agony, fear, and the most inhuman kind of destruction are conveyed partly through Cubist ambiguities and jagged intersecting planes. What had previously been formal devices, whose expressive force had little relation to the scale or the emotions of reality, now embodied these qualities. The influence of Surrealism is felt in the metamorphosed forms, like the arms and head of the woman rushing out of the burning building toward the center. Four women, a child, and a wounded warrior are the victims; Picasso did not explain the symbolism of the horse and the bull. By avoiding specific references, Picasso

universalized his interpretation of the horrors of war. As it turned out, *Guernica* was prophetic of the most horrible of wars; in a little over three years the Nazis were bombing London.

American Painting to 1940

The tradition of realism in American painting, which has been observed in the eighteenth and nineteenth centuries, continued to some extent into the twentieth. This tradition was hardly affected by European modernism before the New York Armory Show of 1913, when Post-Impressionist and early-twentieth-century works were first shown to a broad audience in the United States. After this, Cubist forms entered into the paintings of several artists who were more oriented toward nature than their European contemporaries. Georgia O'Keeffe's *Abstraction* (Color Plate 8) is made up of crisp planes and graded tones like those of the Cubists but, while they are completely abstract, they seem to

render three-dimensional forms with less ambiguity and with more feeling for sensuous surfaces than are found in French Cubism. The sharp-edged, clean shapes and the subtle tonal gradations were typical of O'Keeffe's work and were still present, along with a comparable simplification of forms, in paintings of the 1960s.

There is no exact parallel, in European art of the twentieth century, to the realistic approach of Edward Hopper in such paintings as *Freight Cars, Gloucester* (Fig. 16–12). Like Winslow Homer, Hopper depicted purposeful activities, such as a freight train servicing a town through its back doors. The simplified shapes and the sunlight provided the artist with his favorite material for constructing a painting: blocky and angular forms starkly revealed by contrasts of light and shadow. He also liked the effect of a road or railway tracks cutting horizontally through a painting because it gives a sense of space continuing beyond the frame. The detail in the church spire provides relief from the simplicity of the right side of the picture and suggests, as well, that the town has a

16–12 Edward Hopper, *Freight Cars, Gloucester,* 1928. Oil on canvas, 29″ × 40″. Addison Gallery of American Art, Phillips Academy, Andover, Massachusetts.

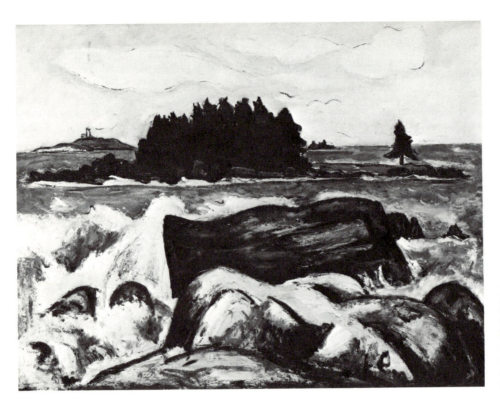

16-13 Marsden Hartley, *Fox Island, Maine*, 1937. Oil on board, 21½" × 28". Addison Gallery of American Art, Phillips Academy, Andover, Massachusetts.

pleasanter aspect. But there is not much room for sentiment in a painting with such realistic objectives.

Marsden Hartley was more affected by European modernism, having been introduced to it by the photographer Alfred Stieglitz. In Germany Hartley developed a style derived from Expressionism, which was later modified by a study of Cézanne. In *Fox Island, Maine* (Fig. 16-13) we sense both an expressionistic force and a Cézanne-like solidity of forms. It was the experience of American landscape, particularly in his native Maine, that brought about the successful fusion of these influences, one directing Hartley to the wild energy of the sea and the other to the firm masses of rocks and islands forming an orderly progression into the picture space.

American painting took varied directions during the thirties. Some artists were more drawn to an abstract art based on European models than O'Keeffe, Hopper, and Hartley. Others looked to the American scene and developed an art of "regionalism" that reflected their interest in the appearance and the traditions of their own localities. The latter movement was brought to a rather sudden conclusion by the Second World War.

Sculpture: 1900–1940

Though early twentieth-century sculptors acknowledged a debt to Rodin, they all turned away from his Romanticism and his pictorial mode of representation. Aristide Maillol, the first major sculptor of the century, created simple figures composed of large masses and bounded by clean edges (see Figs. 3-10 and 3-11). His inspiration was the art of ancient Greece, and his works convey the closest thing to a classical serenity in modern times. The closed composition and the absolute stability of the figure are typical of classicism, and yet the new statement of these appears modern because of the degree of simplicity Maillol gave to the forms.

But Maillol did not carry his simplicity to the point of abstraction as Constantin Brancusi did. Brancusi's *Muse* (see Fig. 8-7) was carved directly

in marble, a practice sculptors had almost abandoned, preferring to leave to artisans the task of rendering their models in stone. As a result of this dedication, Brancusi's highly finished surfaces and subtle nuances of form have an appeal to the sense of touch—or to that aspect of visual perception which is related to touch. The forms are basically egg-shaped and the features have almost disappeared into them. Not long after finishing this piece, Brancusi was producing marble and brass sculptures that were completely abstract but that kept their relation to organic forms rather than to the forms of pure geometry.

Naum Gabo, a Russian artist who came to the United States after practicing in Berlin and Paris, belonged to a movement called Constructivism, which explored the aesthetic aspects of geometric spatial constructions. His *Linear Construction in Space* (Fig. 16-14) is made of transparent plastic wrapped with steel wire—new materials used to explore new forms. The molding of space by transparent materials and strings or wires gave spaces a dominance over solids.

Many sculptors working in the second and third decades of the century found that Cubism was adaptable to their art form. Jacques Lipchitz's *Nude with Guitar* (see Fig. 1-9) has tensions similar to those found in contemporary Synthetic Cubism: a fusing of abstract form with recognizable elements, a positive use of negative shapes, and the simultaneous existence of object and image. These qualities were to be very fruitful in the sculpture of the next several decades, though not always with as much relation to Cubism. The English sculptor Henry Moore preferred organic forms to the intersecting planes found in Cubist sculpture. His *Reclining Figure* (see Fig. 8-8) has fewer angles and edges, though it does have the positive use of voids. In arriving at his abstract forms, Moore was responding to the material—wood, with its grained surfaces—as well as to organic human forms, which seem related to those of the wood itself.

The American sculptor Gaston Lachaise was also unaffected by Cubism. His small bronze *The*

Mountain (see Fig. 7-15) is like Moore's figures in belonging to the earth, as the title suggests. His naturalism is stronger, more like Maillol's, but Lachaise was no classicist; the femaleness of his model is exaggerated in a kind of celebration of fleshiness that is almost Expressionist.

One of the significant technical innovations of the century occurred in 1928 when Picasso and his Spanish friend Julio González began welding iron rods and wires together to produce sculpture. González's *Woman Combing Her Hair* (Fig. 16-15) indicates how the technique made possible a new linear emphasis in sculpture and a new manner of defining and enclosing space. The figures produced by both artists have a surreal effect created by the tenuous connection between the material and the idea. Here the gesture of combing seems to be suggested—but with so few

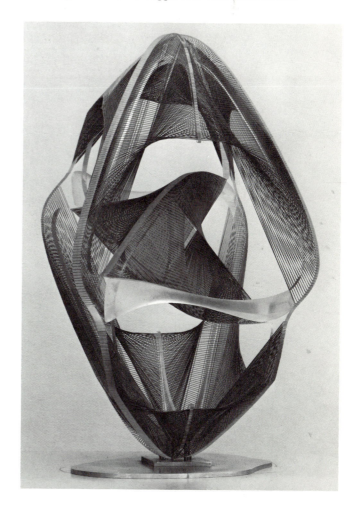

16-14 Naum Gabo, *Linear Construction in Space, No. 4,* 1958. Transparent plastic and stainless steel, 40″ × 21″ × 21″. Whitney Museum of American Art, New York.

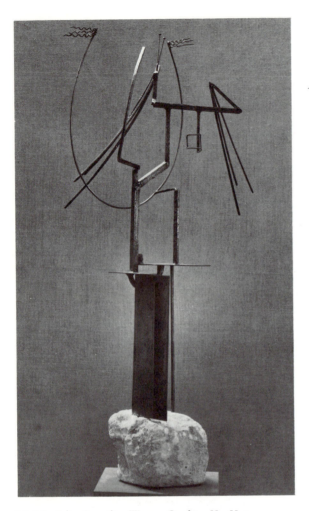

16-15 Julio González, *Woman Combing Her Hair*, c. 1930-33. Welded iron, 57″ high. Moderna Museet, Stockholm.

recognizable elements that the metamorphosis of the subject is extreme.

The first American sculptor to employ welding techniques in an original way, Alexander Calder, directed his art more toward lighthearted fantasy (see Fig. 1-7). A new, formal challenge emerged when he began to introduce actual movement into his sculpture: space was now defined by three-dimensional arcs described by wires with weighted ends made of flat metal forms. This theme provided Calder with material for a long career and placed him clearly in the forefront of American artists who participated in the mainstream of European modernism.

Architecture: 1900–1980

In the first decade of the century, Frank Lloyd Wright developed a new kind of domestic architecture. His houses in and around Chicago were the first to embody a new fluidity in plan and a new relationship between interior and exterior space. In the Robie House (Fig. 16-16) the rooms are grouped around the large central chimney and extend in both directions along a long axis paralleling the street. The vertical of the chimney contrasts with the dominant horizontality of roofs and balconies, giving the name "prairie houses" to these low-lying buildings. Because the design was determined largely by the spaces of the rooms and because Wright wanted an interrelation between the rooms and the exterior, there is no simple exterior wall. Thus the extension of the roof over both the porch and the living room makes the porch look like a continuation of the inside room. The entrances are tucked around the corner of the brick wall as a sunken garden occupies the narrow strip between the house and the street.

This kind of designing, which Wright called "organic," culminated nearly thirty years later in his *Fallingwater* (see Fig. 1-10). Here, because of the setting and the purpose of the house, he carried the integration of outdoors and indoors much further.

In Europe, the hallmark of the new architecture of the second and third decades of the century was the acceptance of steel and glass as the primary building materials of the age. These materials were most compatible with the feeling for clean, rectilinear design, like that seen in the paintings of Mondrian. In Germany, a new school for the teaching of the visual arts—painting, sculpture, architecture, industrial arts and crafts—was established in 1919 by the architect Walter Gropius. When the Bauhaus, as it was called, moved to Dessau, Gropius designed a building for it that exploited the new materials of steel and glass and clearly expressed the varied functions of different parts of the structure (Fig. 16-17). The wing seen at the right contains classrooms and is connected to the rest of the building across a street by means of a bridge of smaller rooms. This interlocks with the

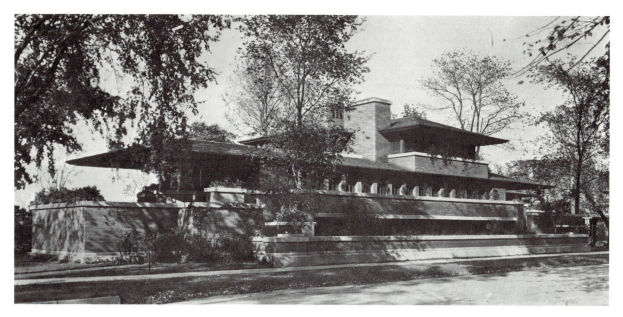

16-16 Frank Lloyd Wright, Robie House, Chicago, 1907-09.

classroom wing, as can be seen in the pattern of windows. At the lower left is the studio block and at the upper left the workshop unit. This four-story building is completely sheathed with glass, its supporting piers located behind the external glass skin.

From such functional design and purposeful use of materials the International Style of architecture emerged. During the next several decades it became the predominant manner of designing industrial and urban office buildings. Perhaps the most imaginative example of the International

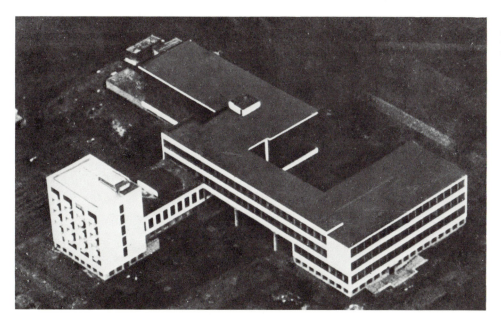

16-17 Walter Gropius and the Bauhaus Workshop, Bauhaus, Dessau, 1925-26.

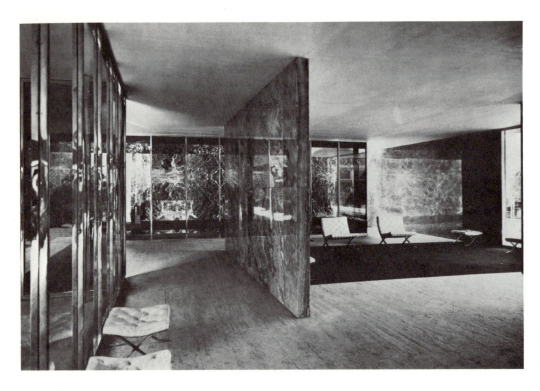

16-18 Ludwig Mies van der Rohe, German Pavilion, Barcelona International Exhibition, 1929.

Style was a building designed by a German, Ludwig Mies van der Rohe, for an international exhibition in Barcelona in 1929 (Fig. 16-18). Since the German Pavilion was hardly more than a covered space with no separation between exterior and interior, it was the most perfect vehicle for demonstrating the compositional openness possible in the new style. The plan (Fig. 16-19) is based on Mondrian-like rectangles forming an assymmetrical whole (the only symmetry is found in the flat roof set upon eight metal piers). Visitors could walk freely around walls of polished marble and tinted glass. Their attention was called to the perfection of these materials and to the chrome-plated steel of the supports and the furniture (where it was combined with leather). While synthetic materials dominated in the Bauhaus, here the steel and glass are relieved by the natural grained marble and by two pools, one reflecting the marble at the rear of this view and the other set into the platform on which the building is placed and reflecting the sky.

By mid-century the wave of the International Style had swept over the world, producing "glass-box" architecture on every continent. Office buildings were needed everywhere modern business was conducted, and buildings so expressive of efficiency were much in demand, especially since their steel skeletons and glass sides made them practical as well. The energy-inefficiency of this type of construction had not yet become a major issue. Mies van der Rohe's Seagram Building (see Fig. 8-4) was one of the most distinctive of these sleek skyscrapers. With the assistance of another prominent architect, Philip Johnson, Mies incorporated refinements

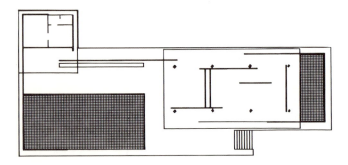

16-19 Plan of the German Pavilion.

similar to those in the Barcelona pavilion: elegant proportions, beautifully finished details, and the finest materials. As a nonmechanical touch, two reflecting pools play a part in the design here just as they did in the tiny exposition building.

Other projects called for different shaping of spaces. The tremendous increase in airport construction produced new designs like that of the TWA terminal at Kennedy airport by Eero Saarinen (Fig. 16-20). This is an extraordinarily supple building that expresses the free flow of flight itself; its exterior has great curved roofs that resemble airplane wings. The movement of people through the interior further animates the paths of stairs and ramps that are made possible by the versatility of concrete. Since the understanding of complex stresses must precede any such design as this, the engineer has clearly become more important in architecture than ever before.

One of the pioneers of architectural modernism was Le Corbusier, a Swiss native who spent much of his life in France but who received major commissions for buildings in several countries. Though he contributed to the formation of the International Style, he was also one of the first to point the way out of the "tyranny of the slab." At

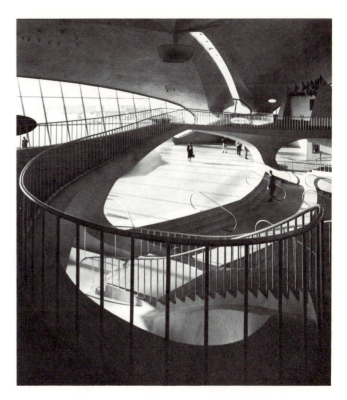

16-20 Eero Saarinen and Associates, Trans World Airlines terminal, John F. Kennedy International Airport, New York, 1958-62.

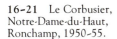

16-21 Le Corbusier, Notre-Dame-du-Haut, Ronchamp, 1950-55.

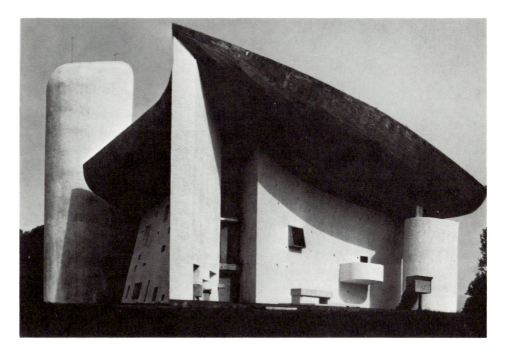

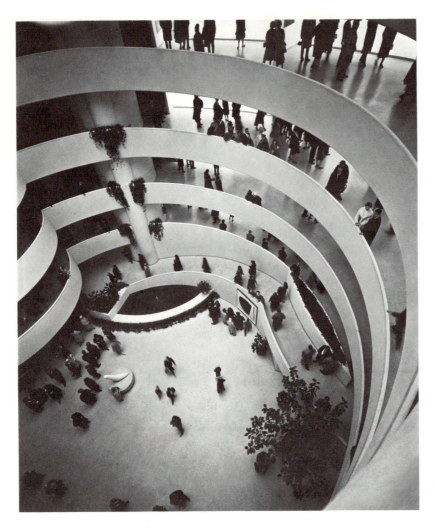

16-22 Frank Lloyd Wright, Solomon R. Guggenheim Museum, New York, 1943-59.

about the same time that he was working with other architects on the giant slab of the United Nations Secretariat building in New York, Le Corbusier was designing a highly fluid and irregular church in eastern France. Notre-Dame-du-Haut at Ronchamp (Fig. 16-21) has more curves than straight lines in its major forms. Its soaring profile, thick walls, and small windows, which provide dim and mysterious lighting for the interior, seem to be the antithesis of the U.N. Building.

In his later years Frank Lloyd Wright, who never espoused the International Style, designed the Guggenheim Museum with attention to the way people move from object to object as they view painting and sculpture (Fig. 16-22). The re-

sult is a beautifully simple spiral, larger at the top, where one begins the journey, and growing smaller as one descends. As the arcs diminish (or increase as one looks upward), gradations in all dimensions enrich the visual environment. Yet the visual richness of paintings and sculptures seen in varied relationships to each other has been to a large extent sacrificed to the single line of movement dictated by the spiral. Wright's building is the antithesis of the International Style but it is still stridently "modern" in that it proclaims its uniqueness as the creation of an artist with a strong personality, like the paintings of Picasso or Jackson Pollock.

In contrast to the Guggenheim Museum, the Center for British Art at Yale University suggests

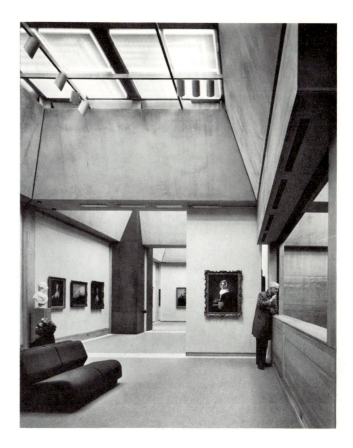

what has been termed a "postmodern" point of view (Fig. 16-23). This is the last work of Louis Kahn, another major architect of the generation following Wright, who designed a number of aggressively modern works but who here seemed to be taking a direction that appeals to today's younger architects. The exterior of the building has a rather anonymous appearance—its lower story is primarily devoted to shops and is thus integrated into the New Haven neighborhood. Moving upward inside are two floors devoted to the library and research areas of a university building. The third floor also has a gallery for the display of watercolors, so important in the history of British painting, and its light is somewhat dimmed because watercolors are subject to fading. On the top floor are painting galleries where the more important works are shown in favorable lighting from skylights and the less important ones accessible in galleries adjacent to these. The rooms are small and dignified, with finely finished wood trims, which provides an ideal setting for viewing works of art in relation to each other. Here Kahn has interpreted architecture as the art of creating sympathetic and evocative surroundings for a particularly humanizing occupation, the study and enjoyment of works of art.

A similar humanizing trend has emerged in a field of architecture that is of the greatest importance today, the design of cities. In the heyday of urban renewal, during the 1950s, there was a widespread belief that our cities were on the whole ugly and that it was best to destroy the old and dirty and rebuild according to the new, clean architecture of the International Style. But the rebuilding that occurred did not produce an improved society, as some had thought it would—chiefly because the value of the neighborhood was overlooked. Now, in what seems to be a "postmodern" era, old buildings are viewed with a new respect. Present-day urban renewal places more emphasis on preserving the old and adapting the new to the old. Older facades and interiors offer a satisfying diversity in appearance and

in adaptability. We will continue to build new cities and parts of cities but we will probably not soon again forget that it is the character of neighborhoods that has always given cities their warmth.

Painting And Sculpture Since 1940

The most obvious fact about the art world in the 1940s was the shift of the center of activity from Paris to New York. The war itself was one reason for this; another was the presence in the United States of a number of important artists who came here because the cultural climate favored innovation or because they had been driven from Germany by Hitler's anti-Semitism and hatred of modernism. Mondrian, Lipchitz, and Gropius were among these immigrants, as were other artists who were to have an influence on young

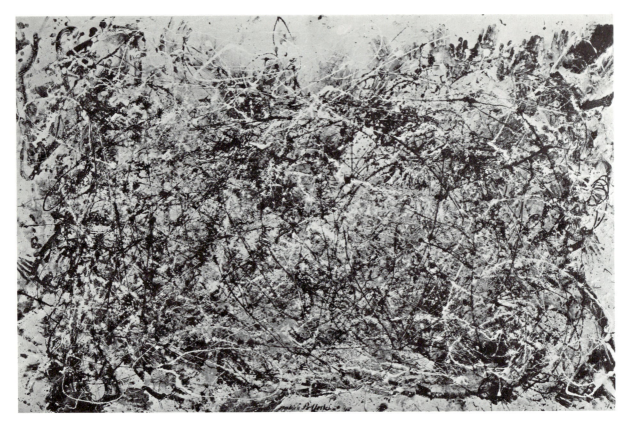

16-24 Jackson Pollock, *Number 1, 1948*. Oil on canvas, 5′8″ × 8′8″. The Museum of Modern Art, New York.

Americans. Some of the artists worked in styles that were bold and painterly—that is, executed with a broad brush, often loaded with paint—and others in styles that were hard-edged—that is, composed of flat colors cleanly separated by sharp boundaries. It was the painterly approach which was to characterize most of the new work of the 1940s.

Abstract Expressionism A number of American artists were part of the surge of creative energy in New-York at this time. Jackson Pollock had come there from the west and had been doing paintings with surrealist imagery and violent energy somewhat like that in Picasso's *Guernica*. Then the images disappeared and he began to apply paint by pouring it from the can onto canvases laid out on the floor. *Number 1, 1948* (Fig. 16-24) is more than eight feet wide and is made up of a maze of lines that reflect the motion of the artist's outflung arms as the paint is poured

and dripped. The overlaying of color upon color and the variations of thin and thick paint give a spatial quality to the painting that does not show up in a small reproduction. This was different from the Cubist treatment of space that many abstract painters before Pollock had favored; the composition also represented a break from the grouping of parts and the relating of forms to enframement that were common in Synthetic Cubism. Instead, there is an all-over composition and a restless flux throughout the canvas that seems to be a portion of a universal pulsating energy. Kandinsky had painted pictures filled with free energy, but with Pollock the combination of large scale, bodily action, and the liquid character of house paint gives his expressionism a much more physical character.

Willem de Kooning came to New York from Holland as a young man and painted semiabstract figures before turning to an energetic abstract style. When he adopted the large, painterly

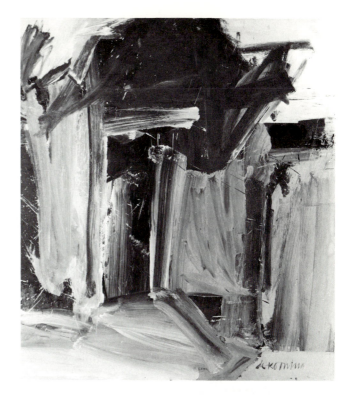

16-25 Willem de Kooning, *Door to the River,* 1960. Oil on canvas, 6'8" × 5'10". Whitney Museum of American Art (Gift of the Friends of the Whitney Museum of American Art and Purchase).

method of Abstract Expressionism, he soon became a leader among a growing number of adherents. Sometimes the figure of a woman emerges from his impetuous treatment, while at other times just the paint is there, as in *Door to the River* (Fig. 16-25). The loose rectangle suggests a door and its opening, but the picture is more about the artist's rapidity of execution and the excitement behind it. An explosive kind of execution is recorded in strokes of a broad brush—the vertical on the left side is about five feet long and accompanied by splatters from the loaded brush. The kind of painting done by Pol-

16-26 Mark Rothko, *No. 10 (1950).* Oil on canvas, 7'6⅜" × 4'9⅛". The Museum of Modern Art, New York (Gift of Philip C. Johnson).

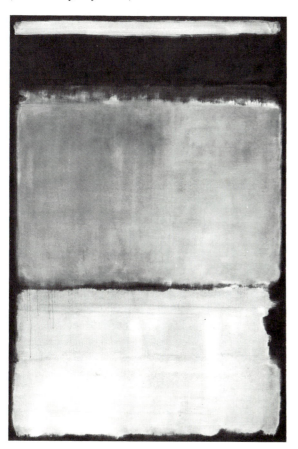

lock and de Kooning acquired the name *action painting.*

Another branch of Abstract Expressionism was just the opposite—the quiet, unaggressive expressiveness typified by the art of Mark Rothko (Fig. 16-26). His rectangular areas are reminiscent of Mondrian's in the simplicity of their existence within the area of the enframement. Similar to Mondrian also was Rothko's almost mystical approach to art and the distillation of formal problems to an elemental state. But Rothko's paintings are much larger and the rectangles not as firmly fixed in relation to the whole; rather, their diffused borders seem to make them float in front of an indefinite ground. In contrast to the last two paintings we have discussed, this one is hesitant and motionless. The paint has a less material quality as well, seeming to have the atmospheric nature of thin clouds—here, yellow and white clouds seen against purple.

Abstract Expressionism had many adherents during the fifties and into the sixties. It soon became an international movement with important representatives in a dozen countries. It also became a vehicle for the development of highly

personal styles, like those of the three painters illustrated, as the way in which an artist "attacked" a canvas became as autographic as handwriting. It began as a radical movement on the part of artists who were expressing their independence from the high degree of conformity that pervaded postwar culture, and it had the expected shocking effect on the audience. Ironically, it was not long before Abstract Expressionist paintings began to be regarded as just the kind of visual contrast needed in the rather blank interiors of International Style buildings. Large and highly personalized, they added a human reference to buildings that had been stripped of all traditional ornament.

A sculptor already considered in this book, Louise Nevelson, developed her distinctive style during the Abstract Expressionist period of the fifties (see Figs. 3-8 and 10-16). Because she frequently created her assemblages from found objects, the contrast between the previous, often practical use of such objects and their present, primarily aesthetic use is particularly striking. Her larger wall sculptures produce the effect of an

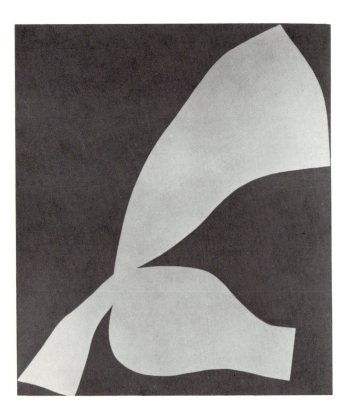

environment that overwhelms the observer—not unlike the effect of a large painting by Pollock—but because of their defined structure and uniform color we are overwhelmed by their serenity in contrast with the excitement generated by a Pollock.

Later Abstract Art Out of Abstract Expressionism developed a trend known as color-field painting, whose manifestations include many different ways of applying paint to a surface. Many color-field paintings reveal the process of their execution—that is, *how* the paint was applied—spattered, brushed, stained, scraped, and so on—as did Abstract Expressionism. Others more or less hide the process in a smooth-surfaced, hard-edged treatment. One of these artists, Ellsworth Kelly, works on a large scale with few shapes and colors, as in his *Green White* (Fig. 16-27). There is considerable figure-ground effect here: the white shape is seen as figure overall, while the dark points in the lower part seem to change from ground to figure as we look at them; they are in effect pulled forward in relation to their surroundings. The contact of four white corners with the border incorporates the total rectangle into the configuration of shapes rather than leaving it simply as a passive background area. The organic character of the shapes themselves reflects Kelly's interest in plant forms: most of his drawings are direct studies from nature done in pure line.

Frank Stella based one large series of his geometric abstractions on circles and semicircles, giving them names of cities in Asia Minor (see Color Plate 3). In these so-called protractor paintings he allowed the interior shapes to determine the overall shape of the painting; since the canvas was stretched over a rather thick wooden frame, the whole took on the character of a huge, flat, geometric object hung on the wall. Thus the idea of the work of art as an object is made evident again, and in his more recent works this idea is emphasized even more. As with most geomet-

16-27 Ellsworth Kelly, *Green-White*, 1961. Oil on canvas, 5'9" × 5'6". The Hood Museum of Art, Dartmouth College, Hanover, New Hampshire (Gift of Julian J. and J. Jean Aberbach).

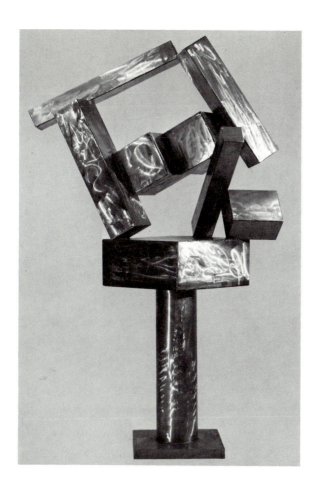

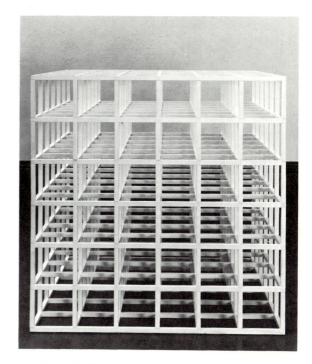

16-29 Sol LeWitt, *Open Modular Cube*, 1966. Painted aluminum, height, 60″. Art Gallery of Ontario, Toronto (Purchase, 1969).

16-28 David Smith, *Cubi XVII*, 1963. Stainless steel, 8′11¾″ × 5′4⅜″. Dallas Museum of Fine Arts (The Eugene and Margaret McDermott Fund).

ric abstractions, there is little temptation to read meaning into this work, which is based on the order of geometry made particularly lively by the intense colors and the presence of slight optical illusions, such as the swelling of the long vertical bands near the center of the circle and the bending of the surface where the two semicircles join. As Stella has said about his work, "What you see is what you see."

During the twenty years before his death in 1965, David Smith had been one of the most important American sculptors. His last works, the *Cubi* series, are composed of simple cubic and cylindrical forms of stainless steel (Fig. 16-28). The blocks are related to each other in an apparently weightless manner, as if they had been caught as they were about to tumble. The conflict between heaviness and lightness produces a tension that animates the work, while another

purely visual kind of animation results from the more or less random burnishing of the surface of the steel with a power tool.

Increasingly, formalism in the sixties moved toward Minimal Art, which in sculpture sometimes reached extreme simplicity. Sol LeWitt's *Open Modular Cube* (Fig. 16-29) was perfectly executed in painted aluminum according to the artist's specifications, but as is characteristic of large-scale Minimal Art, not by him. What tension there is exists between the idea of a cube made up of many small cubes, which is a simple concept, and the visual experience of the object, which, as one moves around it, is quite complex.

Pop Art and Its Ramifications Abstract Expressionism was soon followed by a movement that seemed deliberately to be as different from it as possible—Pop Art. It incorporates images or

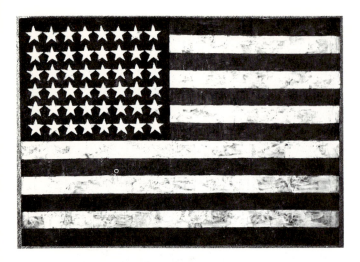

16-30 Jasper Johns, *Flag*, 1954-55. Encaustic, oil, and collage on fabric, 42¼″ × 60⅜″. The Museum of Modern Art, New York (Gift of Philip Johnson in honor of Alfred H. Barr, Jr.).

real objects from everyday experience which seem to be chosen for their banality and are then brought to our attention in a novel way. As early as the mid-1950s, Jasper Johns did a series of flag paintings (Fig. 16-30) in which the familiar symbol is recorded so literally that the only difference between the painting and a real flag is that one is obviously painted. Johns used the technique of *encaustic*, in which pigments are mixed with hot wax which, when cool, gives considerable body to the paint. The brushstrokes are obvious and are applied with subtle changes in color. The painting has the surface quality of a sensitively executed work, and yet the subject is the very familiar and otherwise unmodified flag. The effect is to make us look, and look again, at something we would give only a passing glance in

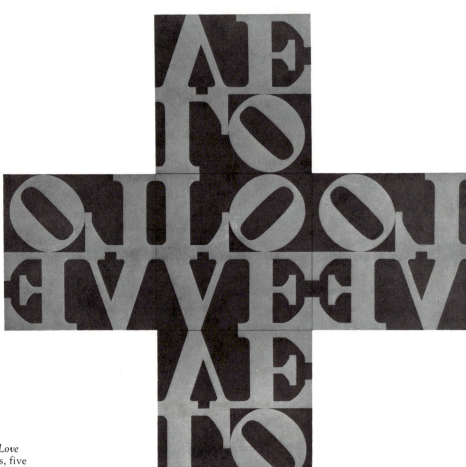

16-31 Robert Indiana, *Love Cross*, 1968. Oil on canvas, five panels, each 5′ square. Menil Collection, Houston.

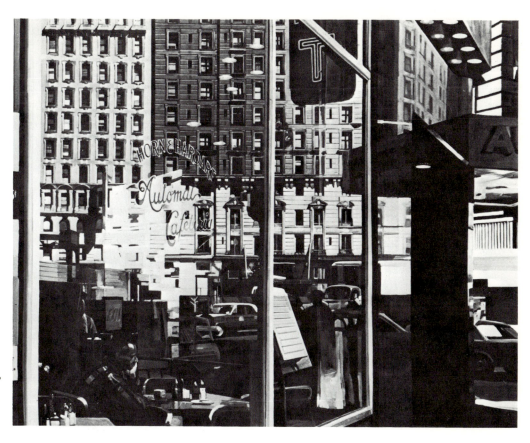

16-32 Richard Estes, *Horn and Hardart Automat*, 1967. Oil on masonite, 48" × 60". Private Collection.

its normal context. In variations on the flag theme, Johns assigned different colors to the red and blue fields and even did versions in gray and white.

Robert Indiana is particularly fond of block letters, such as those seen in his *Love* series of paintings and silk-screen prints. To intensify the visual impact of his *Love Cross* (Fig. 16-31), he reversed each letter of the central block on both horizontal and vertical axes, thus creating an overall central symmetry. The four axial symmetries produce new shapes that have strong figure-ground effects, which are enhanced by primary colors, making his work as close to hard-edge abstraction as it is to Pop Art. Another dimension of his art relates to the significance of the words themselves. Many refer to basic human drives that also have a particular relation to the culture—such as the theme of love in the sixties and early seventies.

Among the familiar objects that Claes Oldenburg has transformed into works of art are type-

writers, lipsticks, kitchen appliances, Good Humor bars, and bathroom fixtures (see Fig. 8-11). All are in some way symbols of our civilization. When a washstand is transformed (his term is "metamorphosed") into soft plastic and becomes something to be contemplated, we are likely to perceive the real object more vividly—as sculptors of the past made us more conscious of our bodies by representing them in marble. Oldenburg has also made many drawings for gigantic structures, none yet executed, in which commonplace things are envisioned as parts of grand urban plans.

Directions in Recent Art The diversity we have seen growing in art since midcentury continued and increased during the late sixties and throughout the seventies. Along with Minimal Art a new realism had emerged, some of it based directly on the photograph and known as Photo-Realism. Richard Estes, in his *Horn and Hardart Automat* (Fig. 16-32), started with a color photo-

16-33 Michael Heizer, *The City—Complex One*, 1972-76. Earth mound with concrete framing, height 23'6".

graph of a city subject deliberately chosen because of the complexity of its surfaces and reflections. The challenge to the artist was to make all this complexity of color and shape cohere on the surface of the painting by maintaining an equal visual attraction across the whole picture, while at the same time remaining generally faithful to the factual record produced by analyzing what we see. The right third of the picture is a direct view of the structure around the entrance and the bottom of the neon sign, beyond which we see a street with cars and buildings on the further side. The left section consists entirely of the glass wall of the restaurant, which we see as a surface only around the metal supports and where the lettering occurs left of the center. All the other visual information is either reflected from the glass or seen through it. Nearly two thirds of the picture is composed of reflections, about the same proportion as in Manet's *Bar at the Folies-Bergère* (see Fig. 15-10). But while Manet enlivened the area of the mirror with his brushstrokes, Estes accepted the monotony of repeated windows as part of the city scene. Estes maintains an attitude of detachment toward his subject; he is a reporter, not an interpreter, of the scene.

A similar detachment has already been noted in the Photo-Realist art of Chuck Close (see Fig. 10-15). The almost mechanical reproduction of photographic details in both his work and that of Estes should not obscure the fact that they pay particular attention to the color refinements in their large canvases and are especially sensitive to maintaining an overall interest that separates their paintings from both reality and the photograph.

Some artists reduced their work to the point of only stating the idea, or concept, without actually executing it. Instead, it is often put in the form of words or numbers and the art experience is expected to occur in the conception and contemplation of the idea. Such creative endeavors come under the heading of Conceptual Art, but since they often do not exist in visual form, they are clearly beyond the scope of this book.

One of the most interesting developments during the seventies was that of environmental art, one branch of which is called Earthworks. Some artists moved hundreds of tons of earth and rocks to modify the shape of the landscape. Michael Heizer had a huge gash cut into the Nevada mesa, following the ideas of the prehistoric people of Peru who created long lines and large patterns on

mountain tops that are visible only from the air. His *The City—Complex One* (Fig. 16-33) is a mound of earth twenty-three feet high shaped like an ancient Egyptian tomb. It was made more permanent by supporting walls of concrete, and the form was enriched by steel elements that extend it into the surrounding space. The construction resembles works of Minimal Art, but by being large in scale and virtually a part of the land, it is essentially different in intent.

The most spectacular of any environmental project of the seventies was Christo's *Running Fence* (see Fig. 2-6). The Bulgarian-born artist, now living in the United States, had previously wrapped part of the rocky Australian coast in fabric in such a way that its massive shapes were emphasized, and he had divided a valley in half with a giant nylon curtain. With the *Running Fence*, however, he did not simply modify the landscape; he evoked the beauty of the rolling hills of Marin County in an extraordinary way.

As art moved into the 1980s, it had a larger number of available avenues of development than at any other time in history. Some seem to have passed their time of fulfillment: it would be difficult to become more minimal than some works of the 1970s. The sixties and seventies had produced various types of "performances," some involving the bodies of the performers as a way of effecting a more personal art. One element notably lacking was the commonality of any style, or even several styles, as artists shared methods but not languages of expression. It is an open question whether such languages will be essential to the healthy development of art from this point on.

GLOSSARY

This section is not a glossary in the strictest sense, since a few of the terms discussed do not appear in the text. Its aims are to provide a basic vocabulary for the visual arts and basic information about artists' tools and methods. In the interest of consistency, all terms appear in their noun forms.

The Glossary does not include words identifying perceptual concepts, such as *gradation* and *uniformity*, which are defined in the text. Highly specific words, such as *mihrab*, are also omitted here, and are defined where they appear in the text.

Italicized terms are themselves listed in the Glossary.

A

aisles In a church of longitudinal plan, the spaces on either side of the *nave* and separated from it by *columns* or *piers*.

altar A table or platform on which sacrifices or other rituals are performed or upon which ritual objects are placed in religious ceremonies. The altar is therefore the focal point for religious activity and for religious architecture.

altarpiece A work of art, usually a painting or an organized assemblage of paintings, made to be placed on or behind and above an altar.

apse The space located behind the altar in a Christian church. It is most typically a small, semicircular extension of the *nave* surmounted by a half-dome.

aquatint A variation of *etching* in which the *resist* has been applied or treated in such a way that the acid will bite tiny pits in portions of the plate's surface. These portions will print as tones of granular appearance. Aquatint is often added to a plate that already has etched lines.

arcade A row of *arches* supported by *columns* or *piers*.

arch One of the fundamental elements of architectural construction. An arch spans the distance between supports by means of a structure, round or pointed in shape, that converts the downward force of gravity to an outward or lateral force. The lateral force from the shoulder of an arch may be counteracted by several means. In an *arcade* the inner arches are supported by their neighbors on either

side. Otherwise the shoulders or bottom of an arch may be strengthened by *buttresses.*

architrave The horizontal row of stones immediately above the columns in one of the classical *orders.* The architrave consists of the stone lintels of *post-and-lintel* architecture, and is almost always undecorated.

assemblage See *sculpture techniques.*

avant-garde French for "vanguard." It refers to experimental art—and the artists who create it—which has not yet achieved recognition by the general public, but in whose direction the public taste may be expected to follow.

B

baluster A short post, usually decorative in shape, that is part of a row supporting a railing. Such a row is called a **balustrade.**

baptistry The portion of a church or group of church buildings set aside for baptismal services.

barrel vault See *vault.*

bas relief See *relief sculpture.*

basilica A Christian church of a longitudinal plan, so called because it was originally adapted from the design of certain Roman courthouses called basilicas.

batik A method of making color designs on fabric with dye, by first blocking out with wax the areas not to be dyed. Originated in Indonesia.

bay A segment of the nave of a longitudinal plan church which is set off by columns or piers. Each bay is identical, or nearly so, with its neighbors and has a complete unit of vaulting on the ceiling. See also *central plan.*

binder or *binding medium* A substance that holds *pigment* against the surface on which it is applied. The binding medium of oil paint is the drying oil, such as linseed oil, with which the pigments are mixed, but does not include the spirits, such as turpentine, which evaporate during drying.

blind arch An architectural decoration that resembles an *arch* but covers a recessed portion of the wall, rather than an opening through the wall. A blind arcade is a row of blind arches.

book of hours A book containing the "canonical hours," prayers to be said at certain times of the day, according to some branches of Christianity.

bronze The name for a variety of casting alloys, all made principally of copper, which have commonly been used for sculpture. After *casting,* the surface of bronze acquires a pleasing green or brownish patina as oxidization takes place. The sculptor can attain the desired patina by treating the surface with chemicals.

buttress A body of masonry that bears against the shoulder of an *arch* or a *vault* and prevents it from expanding outwards. In transverse arches, which extend from one wall to another inside a building, buttressing can consist of a thickening of the outside wall. A **flying buttress** is set apart from the wall and connected to it by a half-arch.

C

capital The ornament at the top of a *column* which serves as a transition to the element the column supports.

cartoon In its original sense, a preparatory drawing for a painting which will be transferred directly to the painting's permanent *support* and serve as a guide in executing the final work.

carving See *sculpture techniques.*

casting In sculpture, the process of making an object by pouring liquid into a mold, and removing the mold when the liquid has become solid. The most popular material for cast sculpture is *bronze,* and since early classical times the most popular method of casting has been the lost-wax process. This is a way of making hollow bronze sculpture by executing it first in a layer of wax over a refractory core. The founder provides channels for the entering bronze and escaping gases, and adds pins to hold the mold firmly to the core. A plaster mold is then built around the sculpture in such a way that when the molten bronze is poured in, the wax vaporizes and is replaced by the bronze.

cathedral The central church of an ecclesiastical district, containing the throne of a bishop (*cathedra:* chair).

central plan One of the two basic types of plan for Christian churches (the other is **longitu-**

dinal plan). The space in a central-plan church is organized around a central point; central-plan churches are round, square, or regular polygons, or have arms of equal length.

ceramics The art of making things of baked clay; the objects made.

choir (also **chancel, santuary**) A portion of the space of a church continuous with the *nave*, often located behind the altar. The choir, which is reserved for the clergy and for the singers, is sometimes set apart from the nave by a choir screen.

clerestory A portion of a masonry wall, usually close to the ceiling, that contains a horizontal row of windows. In a church of longitudinal plan the clerestory is located above the *arcade* of the *nave*.

cloisonné A technique of jewelry-making in which enamels (colored glass melted into place) are set into a metal matrix so that the areas of color are separated by slender bands of metal (usually gold).

coffers In architecture, depressions cut or cast into a *dome*, ceiling, or *vault* in a regular pattern. Coffering lightens a structure without reducing its strength.

collage A two-dimensional work of art made, wholly or in part, of things pasted onto its surface.

colonette A small column; especially in medieval architecture colonettes are often elongated and can be placed together in bundles to form a compound *pier*.

colonnade A row of columns.

color mixing Most colors used by painters are not available as individual pigments but are obtained by mixing two or more colors. There are two means of doing so: additively and subtractively. Additive mixing occurs when spots of two or more colors are closely juxtaposed so that, at the appropriate distance, they appear to fuse. When the process is not quite complete a condition of near-fusion occurs. In subtractive mixing, paints are combined before they are applied. When colors are mixed subtractively the new color is darker and less intense than either of the component colors; when they are mixed additively it is not. See also *Pointillism*.

column One of the most ancient and basic ar-

chitectural members. A column is a supporting post that has both a shaft and a *capital*. Although the greatest pressure from the weight of any building occurs at the bottom, the column, by directing our attention to the capital at its top, visually locates the meeting of the upward thrust of support with the downward crush of gravity at that point. So simple and convincing is this device that it has been in continuous use since early Egyptian times. *Colonettes, pilasters,* and *engaged columns* are nonsupporting architectural members related to the column. See also *orders; post-and-lintel*.

Corinthian order One of the three original Greek *orders* of architectural decoration. The Corinthian order reached its mature form in the fourth century B.C. as a variation of the *Ionic order*. It differs from the Ionic mainly in its *capital*, which is carved to resemble a bundle of acanthus leaves.

cornice A carved band of decoration or molding that projects from a wall. Specifically, in the Greek *orders*, the cornice is the band that appears above the *frieze*. A **raking cornice** is one that follows the pitch of the roof.

crossing In a church with a cross-shaped *plan*, the area where the arms of the cross meet—that is, where the *transept* meets the *nave*.

D

dentils A type of ornamental band used in architecture, consisting of a row of rectangular, toothlike forms that project downward from a *cornice* or other molding.

diptych A two-part painting or relief sculpture. Sometimes the parts are hinged so that the whole may be folded.

dome A hemispherical covering for an architectural space. Ordinarily, a dome works on the principle of the arch—that is, the downward force is converted to an outward force, which may be controlled in various ways. Chains or cables may run round the dome; a massive ring of masonry, called stacking, may be built around its shoulder; or radiating *buttresses* may bear against it.

Doric order The simplest of the three original Greek *orders*. The Doric reached its mature form during the late sixth and fifth centuries

B.C. It is characterized by simple, padlike *capitals* and a *frieze* made up of square panels called metopes, separated by three-lobed panels called triglyphs.

drawing techniques There are many materials for drawing, of which the following are the most common. **Chalk:** originally a soft stone, it has for centuries been manufactured from natural substances. The most common colors are black, red (sanguine), and white. **Charcoal:** a charred stick, which can also be manufactured by pressing powdered charcoal into sticks. **Graphite pencil:** the common pencil, not manufactured until the late eighteenth century. **Ink:** usually applied with a pen or brush. When a brush is used to apply ink or watercolor, the resultant effect is called a *wash.* **Pen:** before the nineteenth century when steel pens came into use, pens were made either of quills or reeds. **Silverpoint:** done with a silver-tipped implement on coated paper which has sufficient "tooth" to hold some of the metal. This slight deposit oxidizes with time so that the drawing darkens somewhat. It resembles a drawing done with a hard graphite pencil.

drum A cylindrical form on which a *dome* is sometimes placed in order to raise it higher and to provide for the placement of windows just beneath the dome.

drypoint A method of *intaglio printmaking* in which the ink is carried by the incised line and by the burr raised when the printmaker scratches the smooth surface of a plate with a hard, sharp stylus. Fewer copies of a design can be made by this procedure compared to other intaglio techniques, since the delicate burr soon wears away during printing. See also *engraving.*

E

elevation A formal drawing of a building (sometimes showing it in cutaway form), as the building is seen from a horizontal viewpoint. (The two most basic types of architectural drawing are *plan* and elevation.)

encaustic A method of painting of great antiquity, in which the *pigments* are suspended in a hard wax that is applied hot.

engaged column A *column* attached to a wall and therefore essentially nonsupporting. Engaged half-columns are, in effect, columns carved in relief.

engraving (also **line engraving**) A method of *intaglio printmaking* in which the printmaker cuts grooves in a plate with an awl-like tool called a graver. Unlike *drypoint,* in engraving the burrs are trimmed off, so that the printed lines are typically sharp-edged, smoothly curved, and taper to a sharp point.

entablature In the architectural *orders,* the part of the order located above the columns—that is, the combination of *architrave, frieze,* and *cornice.*

etching A form of *intaglio printmaking* in which acid cuts the grooves in the metal plate. The process begins with a coat of acid-resistant material, *resist,* laid on the plate, through which the printmaker scratches the design. An acid bath can then bite the lines as deeply as the artist wishes. Etched lines typically appear more freely executed and more blunt-ended than lines in an *engraving.* The etcher may choose to protect some of the lines with an additional application of resist, and to subject the rest to another acid bath, a procedure called multiple biting, which results in lines of various strengths. *Aquatint* is a variation of etching.

expressionism An aesthetic attitude and a type of art, especially of the past one hundred years, that emphasize emotional expression and use distortion and striking visual effects to achieve it. See also *formalism.*

F

facade The principal side or front of a building, which contains its main entrance.

formalism An aesthetic attitude and a type of art, especially of the past one hundred years, that emphasize formal structure over emotional expression. See also *expressionism.*

found object An object displayed as a work of art (or part of one) which was not man-made or made with artistic intent.

fresco Painting done on fresh *plaster.* When a painter applies *pigments,* mixed only with water, to a fine plaster that has set but has not

yet cured, against a wall that does not suffer from seepage, the painting has great stability. The painter must apply at one time only as much plaster as can be painted in one day.

frieze A continuous horizontal band of *relief sculpture* or painting. In the classical *orders*, the band of masonry on the *entablature* between the *architrave* and the *cornice*. In the *Ionic* and *Corinthian* orders, the frieze is unbroken and is often provided with a lengthy narrative relief.

G

gallery In church architecture, the area above the *aisles* opening onto the *nave*, from which it is separated by an *arcade*.

genre Art which represents ordinary people identified not as individuals, as in portraiture, but as examples of their type (housemaids, farmers, etc.). In a broader meaning, genre refers to any of several traditional categories of representational art distinguished according to their subjects. Portraits, landscapes, still lifes, etc. are different "genres" of art.

gesso A white coating *(priming)*, usually made of plaster of Paris and glue, applied to a wooden panel to prepare the surface for painting.

gilding The application of an extremely thin layer of gold *(gold leaf, gilt)* to the surface of an object.

glaze A glass or glassy finish applied to ceramic objects and fixed by firing. Also, a semitransparent oil paint, applied as the outermost layer of an *oil painting*.

gold leaf Gold hammered to an extremely thin foil, which is applied (by *gilding*) to the surface of a sculpture, painting, or building.

gouache A variation of *watercolor* in which the pigments used are relatively more opaque and less transparent than those used in watercolor.

graphic arts In the most general sense, the two-dimensional arts. As ordinarily used, however, the term excludes painting and refers specifically to the various techniques of printmaking and their products. See also *print*.

I

iconography (From "icon," meaning image.) The imagery in a work of representational art, particularly as it conveys the meaning of the subject matter. The use of symbols is an important aspect of iconography. Also, the study of visual symbols and their meanings.

impasto A noticeably thick application of *oil paint*. Certain pigments, most notably lead white, have sufficient body and stability, when mixed with oil, to retain their shape when applied heavily.

intaglio printmaking A scratch made on a polished metal plate will—when the plate is inked, wiped, covered with damp paper, and run through a heavy press—print a line on the paper. This, in general, is the process of *intaglio printmaking*. The method of working on the plate by scratching is called *drypoint*, the simplest and least durable of intaglio techniques. Other important ways of working the plate are *aquatint, engraving, etching,* and *mezzotint*. Since it is the grooves and scratches (rather than raised areas) on the plate which carry the ink, intaglio is the reverse of *relief printing*.

Ionic order One of the three original Greek *orders*, the Ionic reached its mature form in the fifth century B.C. It differs from the *Doric* in having more elaborate moldings; an unbroken *frieze; capitals* decorated with volutes or scroll-shapes, and more slender, less tapered shafts set upon a base.

L

lacquer A natural varnish made in the Far East from the sap of a sumac; traditionally it has been extracted with the help of the lac beetle, which forms a crust of hardened sap around itself. Lacquer is used as a varnish, as a *binder (binding medium),* or as a medium for small sculptures, for which it is built up in layers.

lantern An open structure crowning a *dome* which is both decorative and useful in allowing light to enter at the peak of the dome.

lithography A method of printmaking on a flat surface. Lithographs are traditionally made on a special type of fine-grained stone. The printmaker applies a design to the stone with a greasy, crayon-like substance. When the stone is moistened with water and then inked, the greased parts resist the water and carry the ink. The stone can then be covered with paper and run through a press. See also *print*.

local color The color of an object or portion of an object as it is seen unmodified by varying effects of light or shadow or neighboring colors. Also called "object-color."

longitudinal plan See *central plan.*

M

mass A large, heavy solid that may actually exist, as in architecture or sculpture, or may be represented by *modeling* in drawing or painting. See also *volume.*

medium The singular form of the term *media.* In the visual arts, the word refers to a set of related materials, tools, and processes that make up a single means of expression. *Oil painting* on canvas, television, and *lithography* are examples of *media.* In more limited use, *binder* (or binding medium).

mezzotint A method of *engraving* in which the surface of the plate is roughened by a toothed wheel, or rocker. The artist may smooth out portions of the roughened surface to produce lighter areas. The tiny burrs are as delicate as *drypoint* and suitable only for short runs on the press, but the technique is capable of a velvety blackness and subtle gradations of tone attainable by no other means of *intaglio printmaking.*

mixed media The practice of using more than one conventional (or unconventional) *medium* in a single work of art.

mobile A *sculpture* with movable parts which can be easily set in motion, ordinarily by a current of air.

modeling In drawing and painting, the suggestion of the three-dimensionality of forms by the relative illumination of their surfaces (i.e., from light into shadow). See also *sculpture techniques.*

monotype A method of making a *print* in which only one copy is made for each preparation of the plate. In one variation the artist paints a picture on glass, presses it onto paper, and for the next "copy" repaints the picture, following traces of the image left on the plate.

monumentality The quality of some works of art by which they express endurance or permanence. They may be abstract (like the Washington Monument) or representational, large or small; in any case, the forms making up the

composition itself are relatively static and simple.

mosaic A design made by setting colored stones (tesserae) or other materials into mortar. Byzantine artists made brilliant mosaics of brightly colored bits of glass and *gold leaf* sandwiched between layers of clear glass.

movement For much of the art of the last two centuries it is difficult to use the term *style* because the term implies a more consistent set of visual characteristics than are present. The term *movement* is more appropriate because it suggests a concurrence of ideas about how and for what purpose works of art are made while not implying a similarity of visual characteristics (e.g., Romanticism is a movement rather than a style).

mullion A vertical divider, usually in a window.

N

naturalism The faithful visual depiction of nature. See also *realism.*

nave The large central space of a longitudinal plan church.

O

ogee (or *ogee arch*) A type of *arch* whose opening resembles an inverted onion, made from two S-shaped curves which meet at a sharp point in the center.

oil painting A method of painting in which the artist's *pigments* are carried by a drying oil, typically nut or linseed oil. Oil paint is capable of a vast range of effects; its handling qualities and appearance can be controlled by adding to it a variety of oils, driers, and spirits, and by choosing from a variety of fabrics (canvas) or panels as a *support.* This versatility has given rise to a number of technical traditions emphasizing one or another of the medium's properties; among these we can distinguish three that are central. **Flemish:** In the early years of the fifteenth century, oil painting was used for the first time as an artistic medium, and became an indispensable ingredient in the new Flemish style. Oil *glaze,* applied over an oil (or perhaps *tempera*) underpainting, held the grains of pigment suspended in a transparent film and gave

a richness of color and a delicacy of gradation unattainable before. **Venetian:** Painters of many countries have added to oil's repertory of effects, but the most dramatic expansion took place in sixteenth-century Venice. Users of the expanded medium painted (and still paint) pictures in which the brushwork, the texture of the canvas, the texture and body *(impasto)* of the paint, and the layered structure *(support, ground, drawing, underpainting, glaze)* of the painting itself can be visible and contribute to the final effect. **Direct painting (alla prima):** This simply means painting in oil in one layer, so that it appears to have been painted all at once.

orders In the sixth, fifth, and fourth centuries B.C. Greek architecture developed three distinct systems of decorating *post-and-lintel* architecture, the *Doric, Ionic,* and *Corinthian* orders. Each specifies the proportions and decoration of the various parts of a post-and-lintel structure—*columns, capitals, architrave, frieze, pediments,* and so on. The orders have also been used in the decoration of nonstructural members such as *pilasters* and *engaged columns* and half-columns. In Roman times they were adapted to methods of construction other than *post-and-lintel*—for example, *arches* and *vaults.*

P

painting techniques See *encaustic, fresco, gouache, oil painting, pastel, tempera, watercolor.*

panel A *support* for either oil or tempera painting. Originally made of a single wooden board or closely fitted boards, a panel may now be made of plywood or hardboard.

parchment Animal skin prepared as a surface for writing and painting.

pastel A type of crayon, chalky in texture, which is hardened from a paste consisting of *pigments* bound together by a small amount of adhesive. Pastel paintings are fragile, since the grains of pigment are held onto the paper mostly by the fibers of the paper itself. They may be stabilized by spraying with a fixative.

pediment The triangular panel (gable) at the end of a pitched roof. The word is used especially in connection with the Greek *orders,*

where the pediment is bounded by the horizontal *cornice* below and by the raking cornices above. It is often decorated with sculpture in high *relief* or in the round.

pendentives When a hemispherical dome rests on four semicircular arches arranged in a square, four more or less triangular openings are left between the arches. The opening can be filled with a *pendentive,* a smooth, curving surface that joins the dome and arches.

pier A supporting post. The term is generally used when the post does not strictly qualify as a *column*—that is, when it lacks a *capital*; when it is not round; when it is formed as a cluster of *colonettes* **(compound pier);** or when it is unusually stout.

pigments Colors in powdered form. Since painting which is intended to be permanent needs colors of great stability, pigments used by artists are insoluble, usually inorganic substances—principally colored earths or oxides—whose lasting qualities have been demonstrated.

pilaster A surface decoration frequently used in architecture, resembling a *column* carved in relief. (*Engaged columns* bulge outward, while pilasters are flat.)

plan The two most basic types of architectural drawing are *plan* and *elevation.* A plan is a diagram of a building showing a horizontal section as seen from above. A **ground plan** shows how the building is laid out on the ground, or at ground level. The word also refers simply to the way a building is arranged horizontally—for example, a church of *central plan.*

planographic printing Any of various methods of printmaking, especially *lithography,* in which the ink is laid on the flat surface, in contrast to *relief printing* or *intaglio printmaking.*

plaster Any of various powders which, when mixed with water, harden to form a solid that is predominately calcium carbonate. Plaster is used on interior surfaces in architecture, in *fresco* painting, and for varied purposes in sculpture.

Pointillism The application of paint in dots or small strokes which are juxtaposed in such a way that some mixture of color takes place op-

tically by means of near-fusion of the colors. See also *color mixing*.

portal A prominent, often elaborately decorated, doorway.

portico An open structure attached to a building providing shelter for the area outside a principal entryway, especially a gabled structure resembling the front portion of a Greek temple and decorated according to one of the Greek *orders*.

post-and-lintel One of the basic systems of architectural construction. The term refers to an element in which the distance between vertical supports (posts) is spanned by an unbroken horizontal member, or lintel.

priming A coat of durable, relatively nonabsorbent substance for preparing the painting's *support*. In *tempera* painting on *panel*, for example, the painter primes the wood with *gesso*.

print One of a number of copies of a two-dimensional work of art. The most common techniques of printmaking are the relief, intaglio, and planographic methods. *Relief printing* is used for *woodcut*; *intaglio printmaking* for *aquatint, drypoint, engraving, etching,* and *mezzotint; planographic printing* for *lithography* and *monotype*; and a screen process for *silkscreen*.

A print is distinguished from a reproduction by the extent to which the artist is involved in the production of the final copy. When an artist performs all the tasks from the preparation of the plate, block, stone, or screen to the inspection and signing of the copies, there is no doubt that they are original prints. Sometimes the production of the print is carried out by technicians who are responsive to the artist's aims, though many artists prefer to do the presswork (inking and printing) themselves.

R

realism The depiction of real events or subject matter. The connotations of the term have more to do with what is shown than with how it is portrayed. The opposite of idealism. Also, the nineteenth century movement called Realism, which stressed the unsentimental depiction of everyday life, particularly that of the poor. See also *naturalism*.

relief printing Any of various methods of making *prints*, most notably *woodcut*, in which the ink is carried on the raised portion of the block.

relief sculpture Sculpture that is part of, or intended to be set against, a surface, as distinguished from sculpture "in the round," which can be seen from all sides. **Low relief** or **bas relief** is relief done with a minimum of projection from the surface, like the portraits on coins. **High relief** projects further.

resist An acid-resistant substance, generally a resin, applied to an *etching* plate before it is worked.

rib In architecture, a device used in *vaulting*. Ribs are moldings which appear at the creases (groins) of a groined vault. Ribs were constructed as free-standing *arches* before the remainder of the vault was filled in. Since they provide support during construction, they made possible the rapid building of complex vaults.

S

sculpture techniques The techniques of sculpture are divided into three categories: **assemblage, carving,** and *modeling*. Carving involves cutting away a hard substance like stone or wood. Modeling is the making of sculpture from a softer substance like clay or wax by building and pushing. The results can be transferred to a harder medium by *casting*, or transformed by drying or baking into a hard substance. Assemblage involves putting together things whose individual forms have already been established (junk, or preshaped parts, for example). Carving is known as a subtractive process, while modeling and assemblage are called additive processes.

silkscreen A method of making *prints* in which the artist uses a rubber blade to force ink through a tightly stretched fine fabric. Portions of the fabric that correspond to the area to be left blank are either treated to prevent the ink from passing through or are covered with a prepared stencil. Also called **serigraphy**.

social realism A nineteenth- and twentieth-century movement in which realistic means are used to focus attention on social issues.

spandrel In an *arcade*, the roughly triangular

area between *arches,* sometimes used as a field for painting or *relief sculpture.*

stained glass　A method of rendering a design by assembling pieces of colored glass. The pieces are held together by strips of lead, and the color is frequently carried by a layer of densely colored glass fused to a layer of clear glass. The artist may supplement the design by painting finer details on the glass itself.

style　Qualities of appearance that a work of art shares with other works. **Period styles** are those in which certain characteristics (e.g., the linear verticality of Gothic art) are shared by virtually all of the art produced in a particular time and place. **Personal style** refers to those characteristics unique to the work of a particular artist.

support　The base on which a painting is made. Preferred supports in oil painting are fabric, especially linen canvas stretched over a frame, or a wooden panel or closely fitted wooden panels. For watercolor, the preferred support is paper.

symbol　In the visual arts, an image which signifies something else, either by convention or by association.

T

tapestry　A fabric with a design or picture rendered by weaving with colored yarns. Such a fabric is a tapestry—rather than a rug—when it is intended to be hung on a wall.

tempera　A technique of painting used from antiquity to the present, especially in the Middle Ages and Renaissance. *Pigments* are "tempered" by mixing them with a *binder,* usually egg yolk, and water is used for thinning.

terracotta　Baked clay (Italian for "cooked earth"). Describes objects which retain the characteristic reddish color of roofing tiles and flowerpots.

transept　One or both of the arms of a church with a cross-shaped *plan.*

triptych　A three-part painting or relief sculpture. Sometimes the parts are hinged so that the wings, or outer panels, may be used to cover the center panel.

V

vault or **vaulting**　A masonry ceiling whose means of support is based on the principle of the *arch.* Variations include **barrel** (or **tunnel**) **vaults** and **groined vaults,** the latter formed by two barrel vaults intersecting at right angles.

varnish　The final, transparent protective coating frequently applied to oil or tempera paintings.

volume　Three-dimensionality. An object or figure has volume when it appears to occupy three-dimensional space. A defined space itself may also be termed a volume.

W

wash　A thin, semitransparent film of color applied with a brush, using either ink or *watercolor.*

watercolor　A method of painting in which the *pigments* are suspended in water and applied to paper. A very small amount of *binder,* ordinarily gum arabic, is mixed with the pigment, but the pigments are also held in place by the matted fibers of the paper itself.

woodcut　A method of *relief printing* in which the ink is carried on the raised portion of the surface of a wooden block. **Wood engraving** is also a relief process, in which the design is cut on the end-grain rather than the face of the wood, using tools similar to those used in *engraving.*

INDEX

Picture Credits

1-1 Reproduced by permission of the Syndics of the Fitzwilliam Museum, Cambridge, England; **1-2** Lloyd Birmingham; **1-7** Hirshhorn Museum and Sculpture Garden, Smithsonian Institution; **1-10** Courtesy Western Pennsylvania Conservancy, Photo by Paul Mayen; **1-11** Courtesy of the New York Public Library, Astor, Lenox and Tilden Foundations.

2-1 Lloyd Birmingham; **2-3** Lloyd Birmingham; **2-4** Crown Copyright Victoria and Albert Museum; **2-6** Photo © Jeanne-Claude; **2-9** Deutsches Archäologisches Institut, Athens; **2-11** Lloyd Birmingham; **2-12** The Alfred Beit Foundation, Blessington, Ireland; **2-13** Lloyd Birmingham.

3-1 Alinari/EPA; **3-2** Cliché des Musées Nationaux, Paris; **3-4** Lloyd Birmingham; **3-7** Hirmer Fotoarchiv, Munich; **3-8** Hirshhorn Museum and Sculpture Garden, Smithsonian Institution; **3-9** Dorsky Gallery, Photo by William Dyckes; **3-10** and **3-11** © SPADEM, Paris/VAGA, New York, 1982, Photos by William Dyckes; **3-12** Alinari/EPA; **3-14** Kunstmuseum, Basel.

4-1 Howard T. Fisher; **4-2** through **4-5** Lloyd Birmingham; **4-6** Archives Photographiques, Paris.

5-1 © SPADEM, Paris/VAGA, New York, 1982; **5-2** Archives Photographiques, Paris; **5-3** Cliché des Musées Nationaux, Paris; **5-4** Deutsches Archäologisches Institut, Athens; **5-5** Hirmer Fotoarchiv, Munich; **5-7** Photo by George Cushing; **5-9** Keystone Japan/Katherine Young; **5-10** Alinari/EPA; **5-11** Courtesy of The Board of Trinity College, Dublin; **5-14** Anderson/EPA; **5-15** Reproduced by courtesy of the Trustees of the British Museum; **5-20** Photo by Eric Pollitzer.

6-1 Reproduced by courtesy of the Trustees of the British Museum; **6-4** Lloyd Birmingham; **6-7** Courtesy of Dumbarton Oaks, Center for Byzantine Studies, Washington, DC; **6-8** The Pierpont Morgan Library (M.638, f.28v.); **6-10** and **6-11** Lloyd Birmingham; **6-12** Alinari/EPA; **6-13** Giraudon, Paris; **6-15** Alinari/EPA; **6-17** Photo by Berenice Abbott, Federal Art Project "Changing New York," Museum of the City of New York.

7-4 Courtesy of the Freer Gallery of Art, Smithsonian Institution, Washington, DC; **7-5** Reproduced by courtesy of the Trustees of the British Museum; **7-6** Reproduced by gracious permission of Her Majesty Queen Elizabeth II, copyright reserved; **7-8** TAP Service, Athens; **7-9** Cliché des Musées Nationaux, Paris; **7-10** TAP Service, Athens; **7-11** Reproduced by courtesy of the Trustees of the British Museum; **7-13** Kupferstichkabinett Staatliche Museen Preussischer Kulturbesitz, Berlin, Photo by Jörg P. Anders; **7-16** Alinari/EPA; **7-19** Alinari/EPA.

8-1 and **8-2** Courtesy of Dumbarton Oaks, Center for Byzantine Studies, Washington, DC; **8-4** Ezra Stoller © Esto; **8-5** Photo by William Dyckes; **8-6** Alinari/EPA; **8-9** Photo by William Dyckes; **8-10** Lauros/Giraudon, Paris; **8-11** Photo © Hans Hammarskiöld/Tio, Stockholm; **8-14** Photo by Geoffrey Clements.

9-3 through 9-6 Alinari/EPA; 9-10 and 9-11 Cliché des Musées Nationaux, Paris; 9-12 Photo courtesy The Metropolitan Museum of Art, NY; 9-13 Cliché des Musées Nationaux, Paris; 9-18 Giraudon, Paris.

10-2 and 10-3 Foto Marburg; 10-4 Giraudon, Paris; 10-5 Archives Photographiques, Paris; 10-6 and 10-8 Alinari/EPA; 10-9 Anderson/EPA; 10-10 Art, Prints and Photographs Division, The New York Public Library, Astor, Lenox and Tilden Foundations; 10-12 M. Sakamoto. All reproduction rights reserved; 10-13 From Robert Treat Paine and Alexander Soper, *The Art and Architecture of Japan* (Pelican History of Art, 2nd rev. ed., 1974). Reprinted by permission of Penguin Books Ltd.; 10-16 and 10-17 Photo by William Dyckes; 10-18 Fred R. Conrad/New York Times Pictures.

11-1 Alinari/EPA; 11-4 and 11-5 Hirmer Fotoarchiv, Munich; 11-6 Alison Frantz; 11-7 Reproduced by courtesy of the Trustees of the British Museum; 11-8 TAP Service, Athens; 11-9 EPA; 11-10 Staatliche Museen zu Berlin; 11-11 Fototeca Unione, American Academy, Rome; 11-13 © by Gamet-Tourisme/Documentation Française Photothèque; 11-14 *Papers of the British School at Rome,* Vol. XII, Plate X, Macmillan, London and Basingstoke, 1932, courtesy of the General Research Division, The New York Public Library, Astor, Lenox and Tilden Foundations.

12-1 Hirmer Fotoarchiv, Munich; 12-3 Anderson/Art Reference Bureau; 12-7 Archives Photographiques, Paris; 12-9 Cambridge University Collection; 12-10 Fotocielo, Rome; 12-11 and 12-12 Jean Roubier; 12-13 W. S. Stoddard; 12-14 Photo by Bruno Balestrini, courtesy of Electa Editrice, Milano; 12-15 Lloyd Birmingham; 12-16 Aero-Photo, Paris; 12-18 and 12-19 Anderson/EPA.

13-1 Giraudon, Paris; 13-4 Alinari/EPA; 13-5 Giraudon, Paris; 13-6 Anderson/Art Reference Bureau; 13-7 EPA; 13-8 and 13-9 Alinari/EPA; 13-10 Giraudon, Paris; 13-11 and 13-12 Alinari/EPA; 13-13 EPA; 13-14 Fototeca Unione, American Academy, Rome; 13-16 M. Grimoldi/Francesco del Priore; 13-18 Anderson/EPA; 13-19 Giraudon, Paris; 13-21 Anderson/Giraudon, Paris.

14-1 Direktion der Bayer. Staatsgemäldesammlungen; 14-3 Anderson/Scala/EPA; 14-5 Foto Marburg; 14-6 Helga Smidt Glassner; 14-12 Reproduced by courtesy of the Trustees of the British Museum; 14-15 Interphotothèque/Documentation Française; 14-17 Reproduced by courtesy of the Trustees of the British Museum; 14-18 Art, Prints and Photographs Division, The New York Public Library, Astor, Lenox and Tilden Foundations; 14-20 Alinari/EPA; 14-21 Photographie Bulloz, Paris; 14-23 Harvard University, Portrait Collection.

15-4 and 15-6 Giraudon, Paris; 15-7 Deutsche Fotothek, Dresden; 15-18 Collection National Museum Vincent van Gogh, Amsterdam; 15-21 Bettmann Archive; 15-22 and 15-23 Photos by Richard Cheek, Cambridge, MA; 15-25 Photo courtesy of The Museum of Modern Art, NY; 15-26 Hedrich-Blessing, Chicago.

16-1 through 16-3 © SPADEM, Paris/VAGA, New York, 1982; 16-4 © BEELDRECHT, Amsterdam/VAGA, NY, 1982; 16-7 © SPADEM, Paris/VAGA, NY, 1982; 16-13 Addison Gallery of American Art, Phillips Academy, Andover, MA; 16-14 Photo by Geoffrey Clements; 16-16 Chicago Architectural Photographing Co.; 16-17 and 16-18 Photo courtesy of the Museum of Modern Art, NY; 16-20 Ezra Stoller © Esto; 16-21 Lucien Hervé; 16-22 The Solomon R. Guggenheim Museum; 16-23 Photo by Cervin Robinson; 16-25 Photo by Geoffrey Clements; 16-31 Photo by A. Mewbourn; 16-33 Giorgione Gorgoni/Contact Press Images.

Color Plates
CP 5 Cliché des Musées Nationaux, Paris; CP 8 Photo by Geoffrey Clements; CP 10 and CP 11 Giraudon, Paris; CP 12 © VAGA/NY, 1982, (Photo by Roy Elkind); CP 16 Scala/EPA; CP 22 Photo by John Gotman; CP 23 and CP 25 Scala/EPA; CP 26 and CP 28 Giraudon, Paris; CP 32 Photo by Brian Vanden Brink.

A 2
B 3
C 4
D 5
E 6
F 7
G 8
H 9
I 0
J 1